Our National Parks

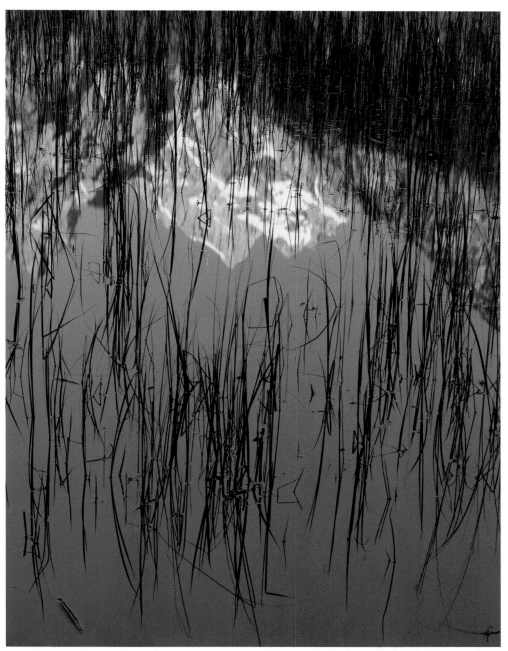

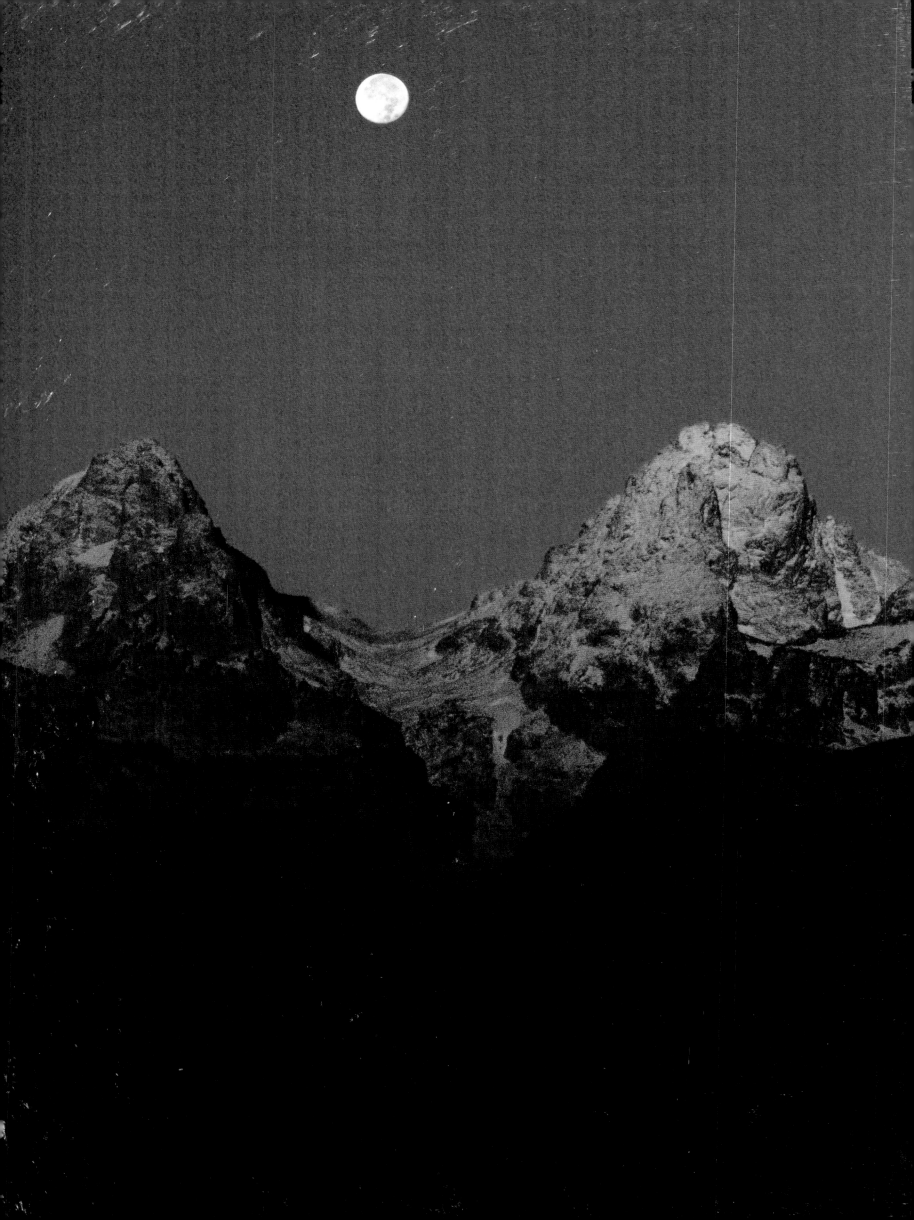

Our National Parks

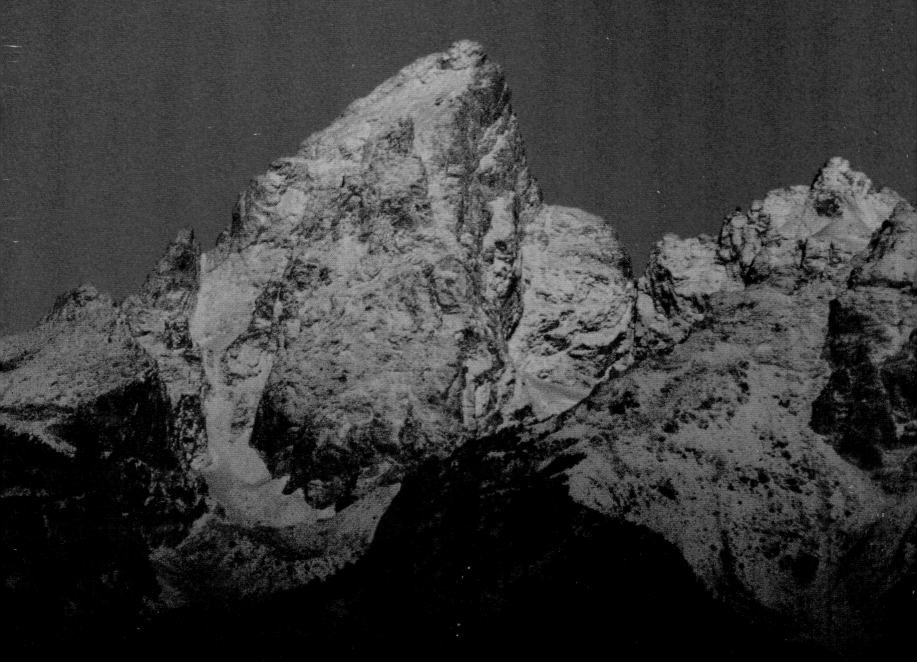

DAVID MUENCH

Essay by Ruth Rudner

FOREWORD BY TOM KIERNAN, PRESIDENT, NATIONAL PARKS CONSERVATION ASSOCIATION

GRAPHIC ARTS BOOKS

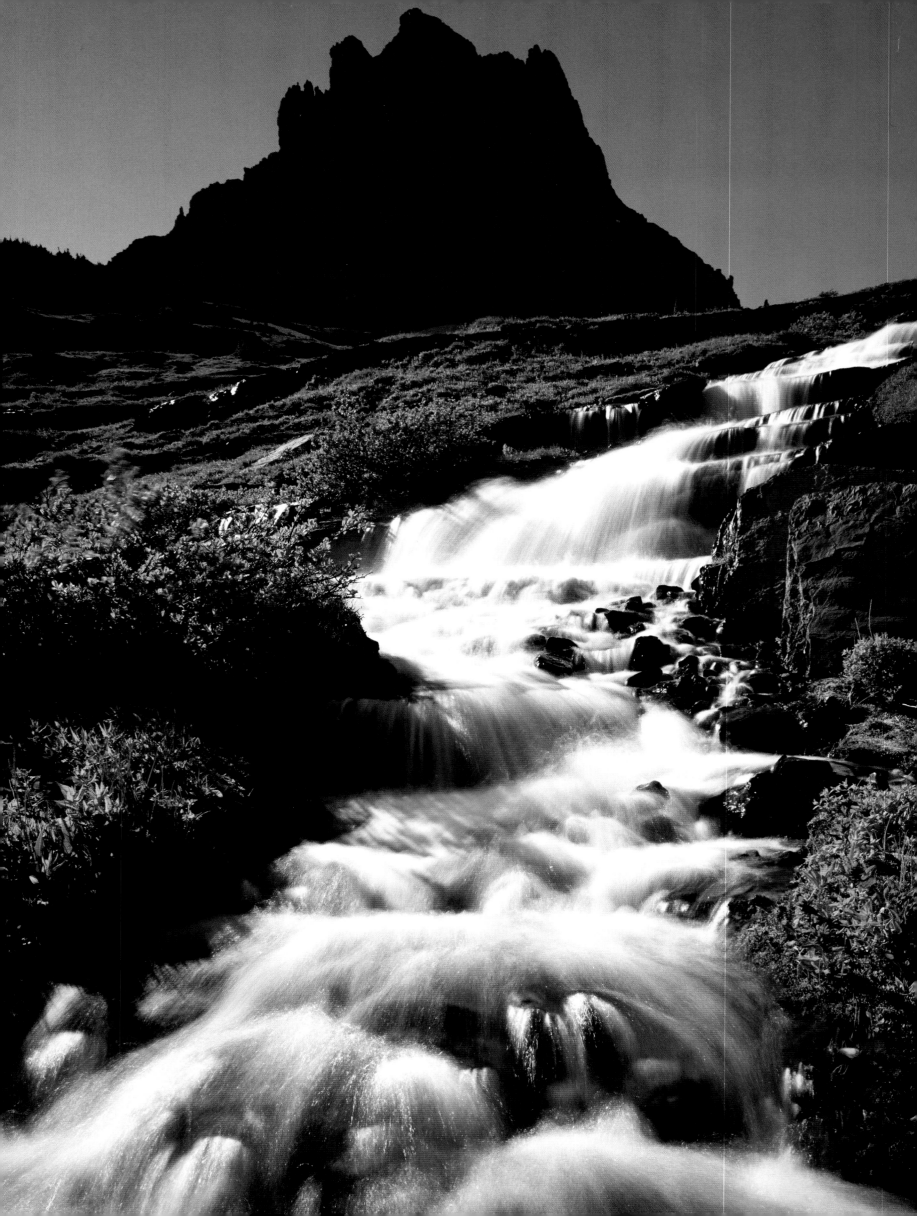

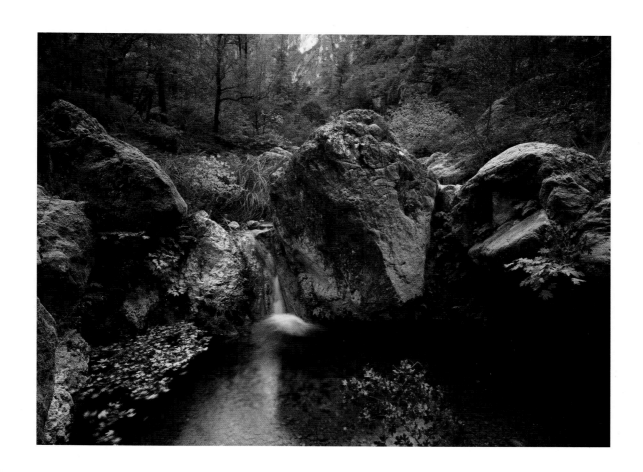

To those with the foresight to set aside parts

of America's original wildlands, and

to those with the fortitude to protect them in our national parks,

to the framers of the Wilderness Act and

to those who uphold its tenets, often against preposterous odds,

we offer what we can—our images, our words, our thanks.

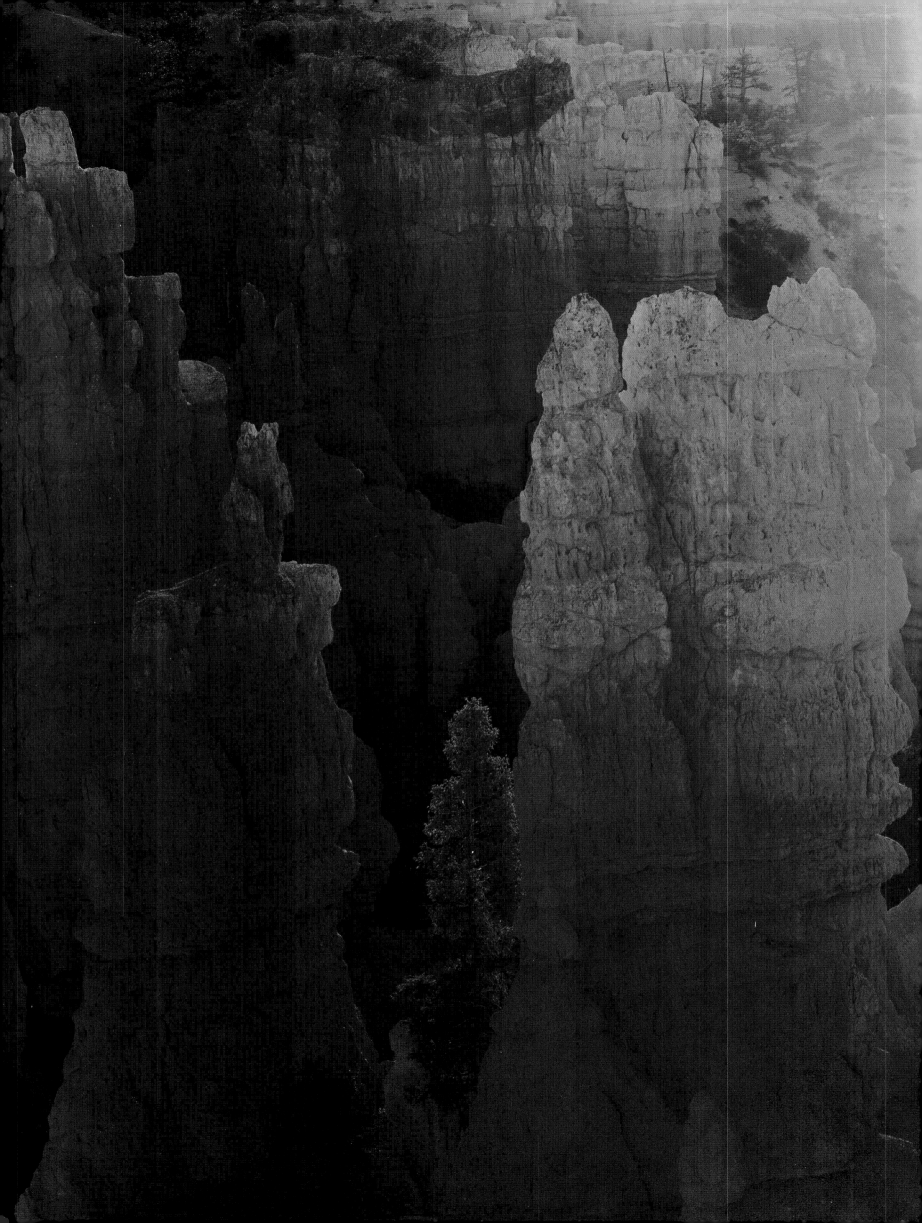

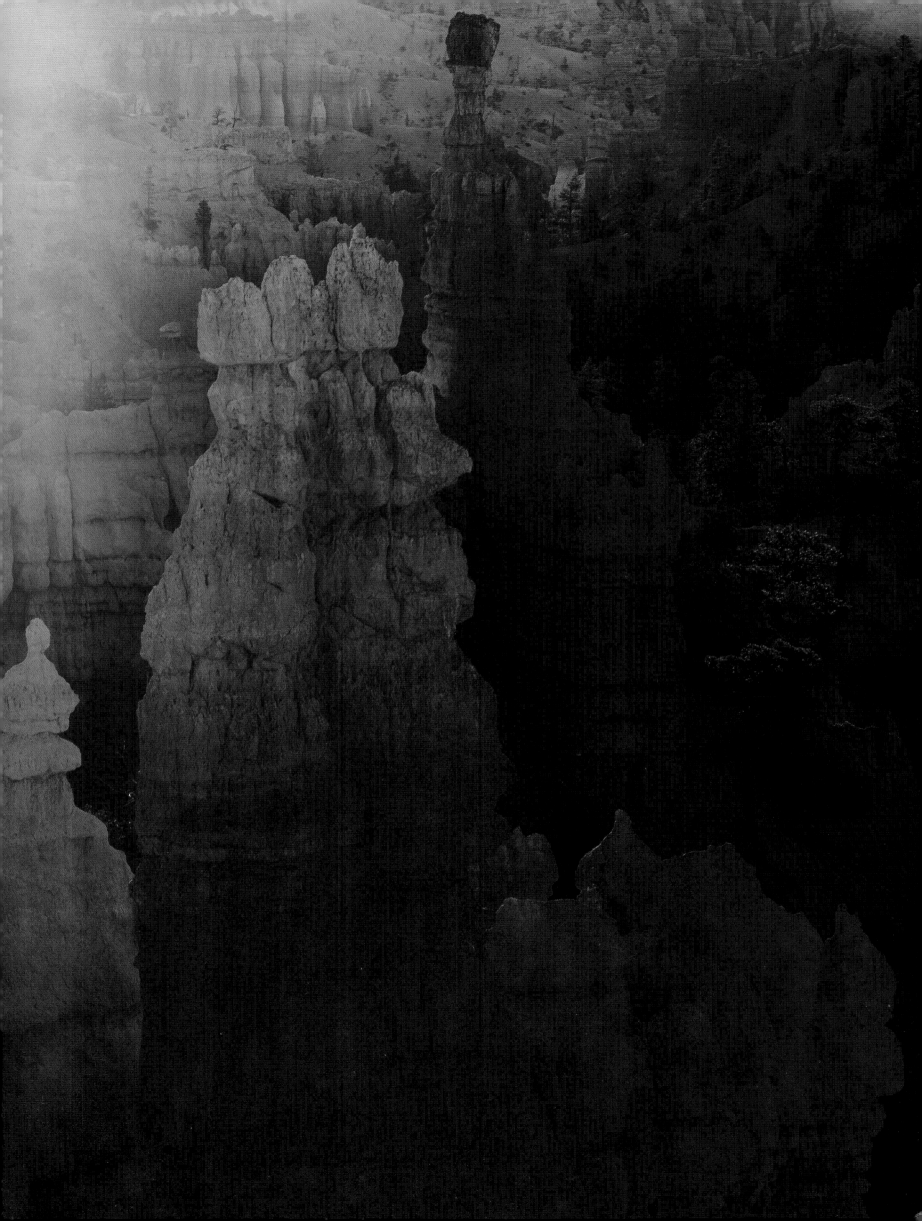

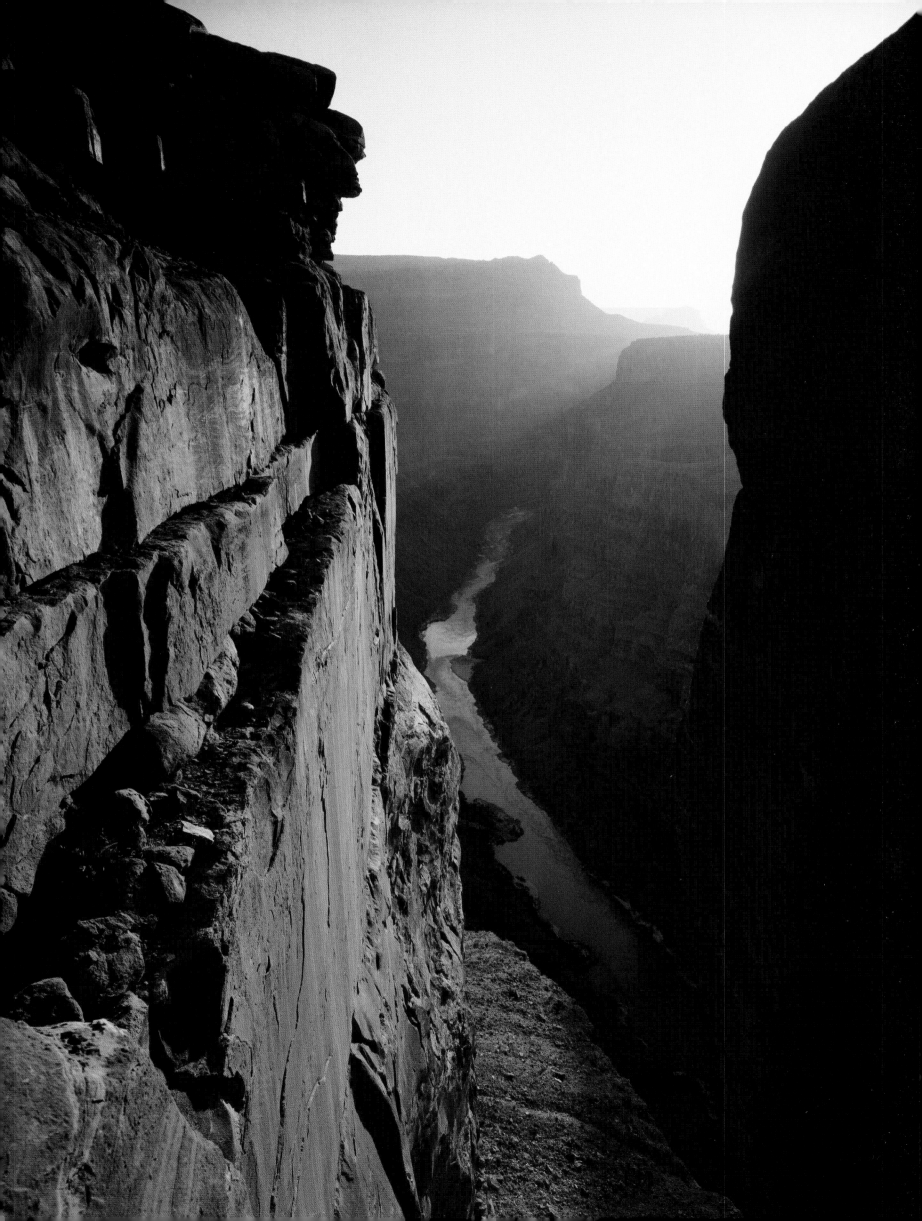

Foreword

Several years ago, we invited David Muench to do a photo-essay for *National Parks,* the National Parks Conservation Association's award-winning magazine. For the piece, David chose Death Valley National Park in California. At first, it seemed odd to focus on such an unforgiving place. Its bone-crushing heat, bitter cold, and arid landscapes seemed so remote and forbidding when there were so many other soul-soothing landscapes from which to choose, such as the soaring trees of Sequoia, the expansive chasm of the Grand Canyon, or the rich and varied wildlife of the Everglades.

But after looking at David's photographs and reading the essay by Ruth Rudner, I realized that it was the natural art of the place and its wildness that appealed to him: the stark contrasts of the sky with the vast landscape, the mysteries of the Raceway, where rocks appear to move on their own, the burst of colors each spring in a seemingly monochrome land, and the dark, star-studded skies of the desert that make you feel a part of something so much greater and so alone.

This feeling comes through the power of David's photography and Ruth's writing in this grand book on our country's national parks. David and Ruth, who often work together, photograph and write about some of the greatest places in the world—America's national parks and wildlands. They understand the importance of preserving these amazing places that represent our nation's legacy. The national parks—called by some the greatest idea America ever had—are one of our most precious treasures. Some have said that if the Smithsonian is the nation's attic, then the national parks are the whole house.

The national park idea began with the establishment in 1872 of Yellowstone National Park, the world's first. Since then this very American invention has grown to encompass more than 84 million acres and 388 national park units, including all of the Civil War battlefields, Grand Canyon, Death Valley, and Everglades National Park, the Statue of Liberty and Ellis Island National Memorial, and recently, the Flight 93 Memorial.

These places preserve our shared history, our most soaring moments of achievement, as well as some of our most sorrowful events. There is more to the national park story than stunning natural landscapes. As you will see from reading Ruth's essay that accompanies David's photographs, this is something they understand keenly.

They know that almost from the beginning, the national parks have faced a variety of challenges. Whether it was from those who wanted to fell the mighty redwoods or hunt the wildlife protected in these sanctuaries, the parks have since the beginning been viewed by some as places from which to extract the natural riches or as profit-making lands on which to build. Fortunately for our children, the great majority of the American public sees these sites as places to preserve and as a legacy to pass on to the next generation.

Over the next decade, we have an opportunity like no other. The National Park System will be celebrating its centennial in 2016, a milestone that offers park advocates the opportunity to encourage decision makers to live up to the national park ideal set forth nearly 100 years ago. The legislation that created the National Park System on August 25, 1916, said that "these areas derive increased national dignity and recognition of their superb environmental quality through their inclusion jointly with each other in one National Park System preserved and managed for the benefit and inspiration of all people of the United States."

As the centennial approaches, we should recommit ourselves, to funding the parks and to maintaining their "superb environmental quality" for the benefit and inspiration of all. The proper preservation and stewardship of these natural and cultural resources is our obligation. It is the only way to ensure that our national parks continue to represent our most significant landscapes and historic sites.

Through his stunning photography, David Muench has made thousands of people aware of these national treasures and their challenges. For his efforts, David received the National Parks Conservation Association's Robin W. Winks Award for Enhancing Public Understanding of the National Parks, only the second person to do so. This annual award acknowledges the work of individuals contributing to public education about national parks through works in the arts, media, or academia.

As the leading voice of the American people in protecting and enhancing our National Park System, the National Parks Conservation Association wholeheartedly endorses this book. We hope that this powerful collection of images and words, as well as David and Ruth's continuing photographic and writing efforts, will further educate the public about the importance of preserving our nation's parks. As you take a virtual tour of the national parks through this book, remember that each of us plays a role in their protection. We are all stewards of the land.

Thomas C. Kiernan
President of the National Parks Conservation Association

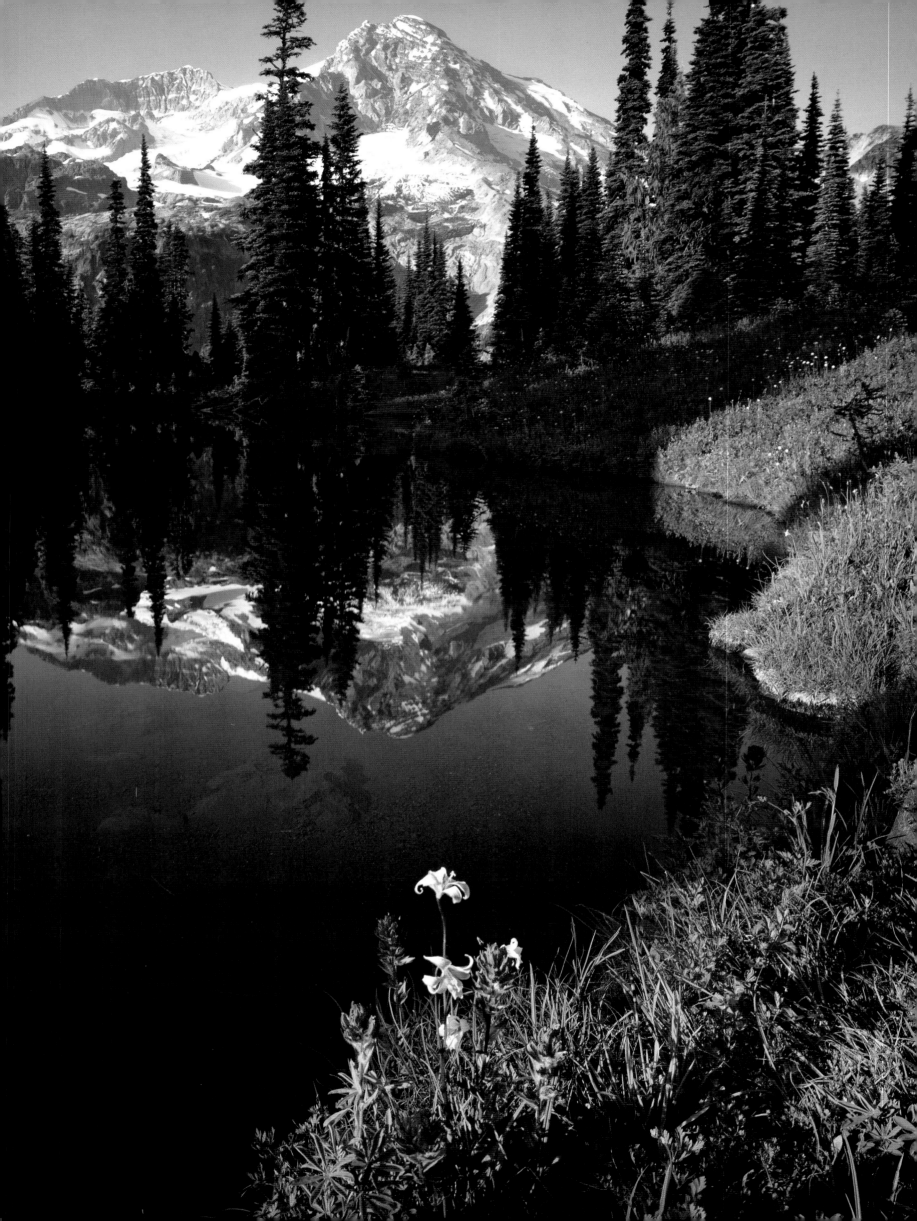

Contents

Foreword 9 Map 12 Introduction: An American Invention 14

Green type denotes essay included

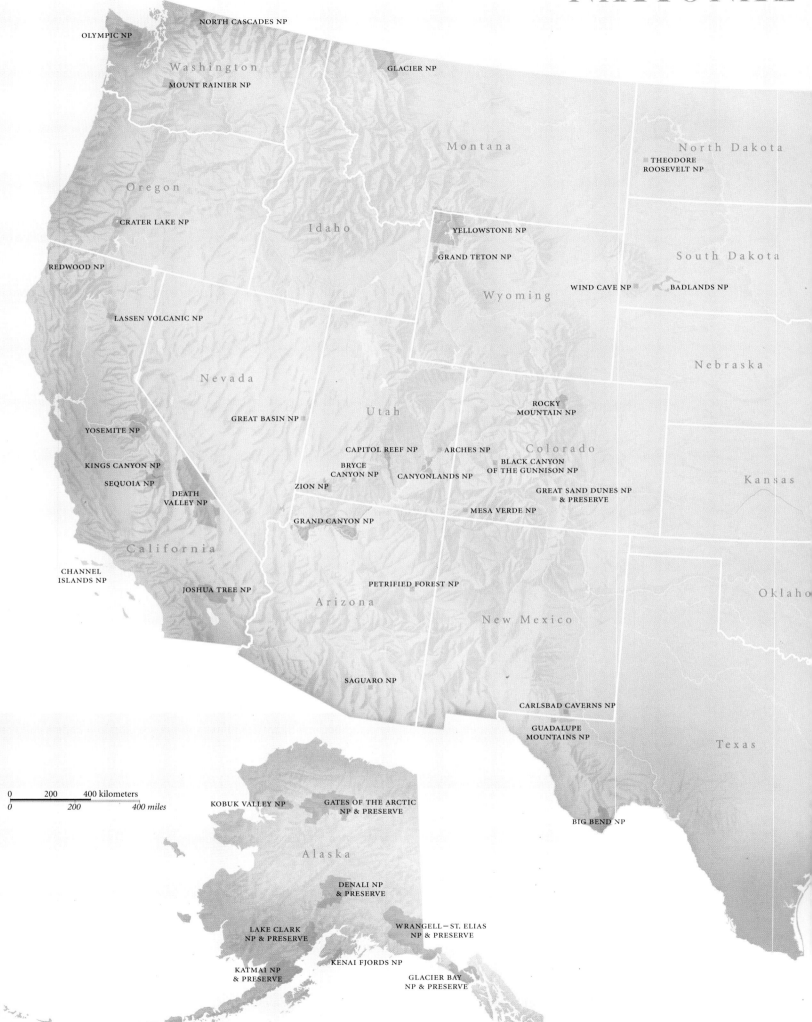

OLYMPIC NP

NORTH CASCADES NP

Washington

MOUNT RAINIER NP

GLACIER NP

Montana

North Dakota

THEODORE
ROOSEVELT NP

Oregon

CRATER LAKE NP

Idaho

YELLOWSTONE NP

GRAND TETON NP

South Dakota

REDWOOD NP

Wyoming

WIND CAVE NP

BADLANDS NP

LASSEN VOLCANIC NP

Nevada

Nebraska

GREAT BASIN NP

Utah

ROCKY
MOUNTAIN NP

YOSEMITE NP

CAPITOL REEF NP

ARCHES NP

Colorado

Kansas

KINGS CANYON NP

BRYCE
CANYON NP

CANYONLANDS NP

BLACK CANYON
OF THE GUNNISON NP

SEQUOIA NP

ZION NP

GREAT SAND DUNES NP
& PRESERVE

DEATH
VALLEY NP

MESA VERDE NP

GRAND CANYON NP

California

CHANNEL
ISLANDS NP

PETRIFIED FOREST NP

Oklaho

JOSHUA TREE NP

Arizona

New Mexico

SAGUARO NP

CARLSBAD CAVERNS NP

GUADALUPE
MOUNTAINS NP

Texas

0 200 400 kilometers
0 200 400 miles

KOBUK VALLEY NP

GATES OF THE ARCTIC
NP & PRESERVE

BIG BEND NP

Alaska

DENALI NP
& PRESERVE

LAKE CLARK
NP & PRESERVE

WRANGELL—ST. ELIAS
NP & PRESERVE

KENAI FJORDS NP

KATMAI NP
& PRESERVE

GLACIER BAY
NP & PRESERVE

PARKS OF AMERICA

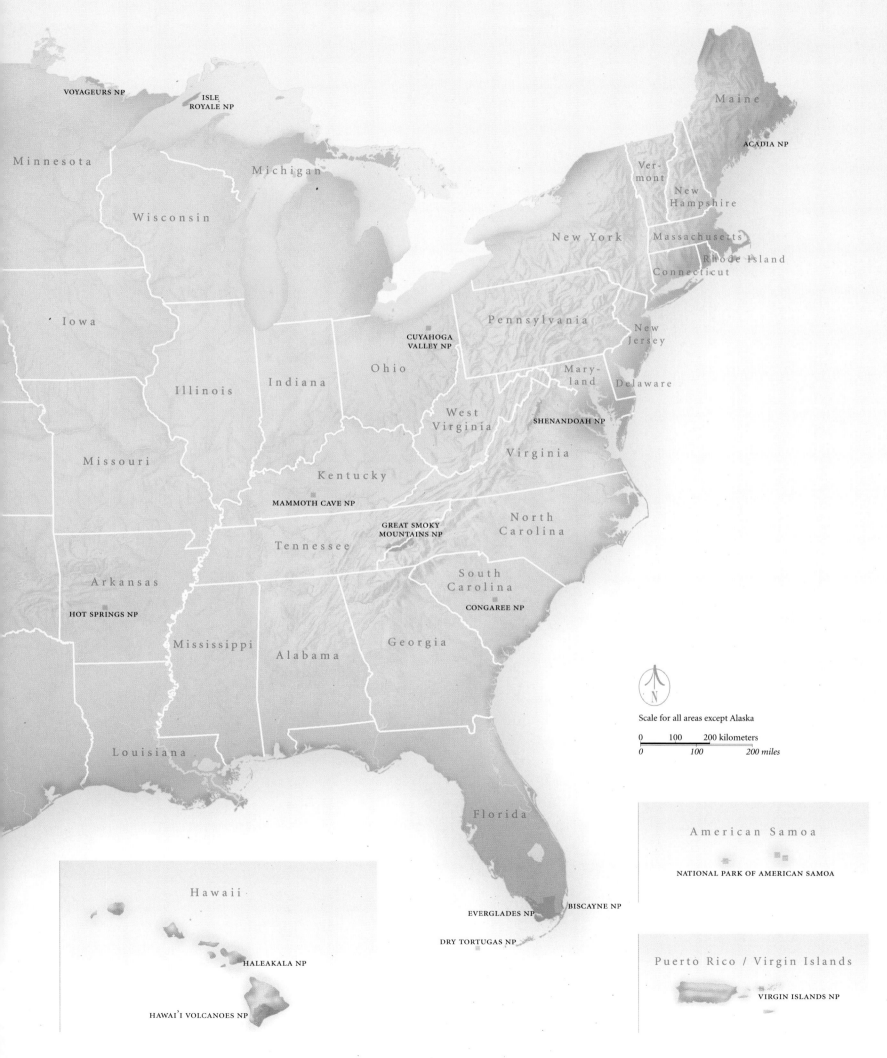

VOYAGEURS NP

ISLE ROYALE NP

Minnesota

Michigan

Maine

ACADIA NP

Wisconsin

Vermont

New Hampshire

New York

Massachusetts

Rhode Island

Connecticut

Iowa

Pennsylvania

New Jersey

Illinois

Indiana

Ohio

CUYAHOGA VALLEY NP

Maryland

Delaware

Missouri

West Virginia

SHENANDOAH NP

Virginia

Kentucky

MAMMOTH CAVE NP

North Carolina

Arkansas

Tennessee

GREAT SMOKY MOUNTAINS NP

HOT SPRINGS NP

South Carolina

CONGAREE NP

Mississippi

Alabama

Georgia

Louisiana

Florida

American Samoa

NATIONAL PARK OF AMERICAN SAMOA

Hawaii

BISCAYNE NP

EVERGLADES NP

DRY TORTUGAS NP

Puerto Rico / Virgin Islands

HALEAKALA NP

VIRGIN ISLANDS NP

HAWAI'I VOLCANOES NP

Scale for all areas except Alaska

0 100 200 kilometers

0 100 200 miles

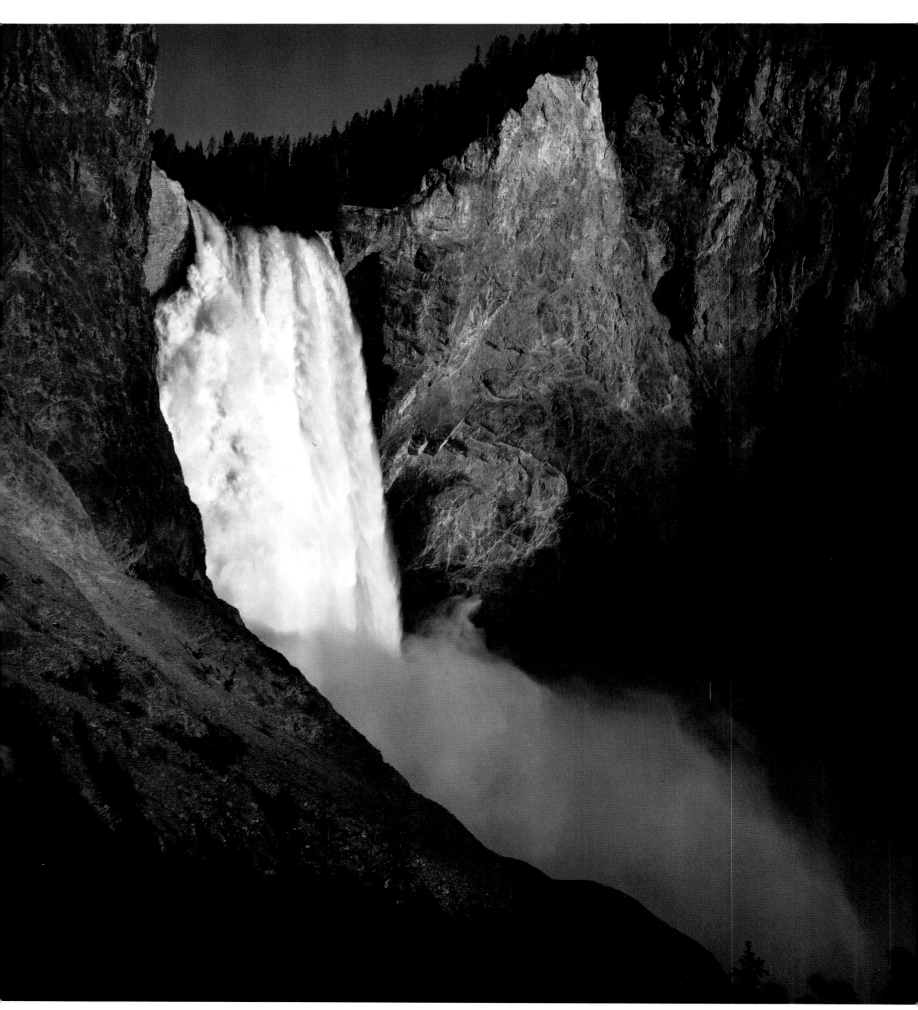

▲ LOWER FALLS, YELLOWSTONE RIVER, *Yellowstone National Park, Wyoming*

▶ BISON IN HAYDEN VALLEY, *Yellowstone National Park, Wyoming*

An American Invention

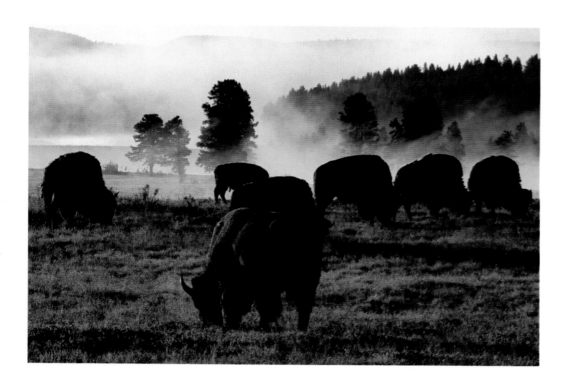

The national park is an American invention. Expression of the American soul, the parks are our treasures, our history, our pride, and our solace. In the immensity of their diversity, they provide us the fullest sense of who we are. By setting aside pieces of America's original wildland, we have protected our birthright for ourselves and given an enormous gift to the world. Our national parks represent us to the world with honor.

Since the inception of the national park idea with the designation of Yellowstone National Park in 1872, fifty-eight U.S. national parks, units of the National Park System (NPS) celebrating the country's natural values, have so far been designated. Altogether, there are 388 units of a variety of designations in the National Park System. Emulating our idea, more than 100 other countries have designated over 1200 national parks. Some parks, repositories of wildness, protectors of millions of acres of biologically diverse areas, are recognized as World Heritage Sites and Biosphere Reserves by the United Nations for their importance to Earth.

Within the parks, managed wilderness offers us the perpetuity of wildness. It offers us hope and memory. It offers us the earth as it was and, so long as its protection remains intact, as it will be.

Although they are legislated facts—entities with defined borders, infrastructures, administrations, natural history associations, and constituencies of dedicated partisans who will fight for their protection forever—no park is big enough or isolated enough to be totally protected. Polluting industries at their boundaries, acid rain, invasive exotic species, suburban sprawl and the roads and traffic it creates, mining, logging, gas and oil extraction at park edges are serious problems. Equally so are chronic lack of funding proscribing adequate ranger staff, resource protection, and necessary maintenance. Even those defined borders are often a problem. Drawn to protect a specific feature or features, they are frequently without reference to the area's true

By setting aside pieces of America's original wildland, we have protected our birthright for ourselves and given an enormous gift to the world. Our national parks represent us to the world with honor.

ecological boundaries, so that lands vital to the ecosystem are left vulnerable to sprawl, extractive industries, road building, and other developments.

From the start, the national parks have had to fight for appropriate funding. There was none allocated to Yellowstone for the first six years of its existence. Even the founding of the National Park Service in 1916 did not inspire Congress to appropriate enough money for the parks' needs. Adequate funding is further threatened during administrations that regard the welfare of our parks as less important than resource development, although the National Park Centennial Act, before Congress as of this writing, is designed to make the National Park System healthy by its hundredth anniversary in 2016. Its goals are monumental, and necessary to eliminate maintenance backlogs in the parks, provide better protection for the natural and cultural resources the parks were created to preserve, and enable Congress to eliminate an annual $600 million operations shortfall throughout the system. Closing some national park units in order to provide resources for others is an inappropriate alternative. As National Park Service Chief Historian Dr. Dwight Pitcaithley said to me, "Given the monumental natural, historical, and cultural resources the Park Service administers, it doesn't reflect well on us as a people to so underfund the parks."

Our national parks contain the sacred possibilities for life, health, and faith offered us by aboriginal America. They are, perhaps, our greatest educational tool. Offering us myriad opportunities for study, wonder, solitude, and recreation, they extend to us, as well, community with all the forms of life on this continent. In return, they demand of us responsibility. It is always necessary for those who love the parks, and those who recognize the necessity of wild space for our national health—spiritual, psychic and physical—to become watchdogs, constantly monitoring the state of the parks, and to let Congress know when things go wrong.

But even this doesn't always work. In the late 1990s, Yellowstone National Park officials, in accord with the overwhelming wishes of park visitors, let Congress know that snowmobiles were not acceptable in Yellowstone because they impaired both the resource and the values of the park. They disturbed winter-stressed wildlife, created extreme noise and air pollution, and turned the park into a playground (readily available in surrounding national forests) as opposed to preserving the deep and necessary silence of a pristine season. Ten years of study went into the NPS decision. The majority of responses from the public to the Environmental Impact Statement supported a phaseout of snowmobiles. In November 2000, President Clinton issued a decision calling for that phaseout over a two-year period.

A month later the International Snowmobile Association sued, and in 2001 the Bush administration overturned the phaseout plan. Six months later the suit was settled when the Department of the Interior agreed to another study. In February 2003, a final decision was released, reiterating the 2000 study—that, indeed, snowmobiles were impairing the resource and snowcoaches were a better decision for the park—but snowmobiles should be allowed anyway, a decision the Bush administration formalized a month later. This decision was challenged by a number of major conservation groups.

Support for a ban grew steadily during the first four years of the Bush administration. By the end of 2004, the National Park Service had received over half a million comments on the issue, the greatest number of comments in its history. In December 2003, the D.C. District Court reinstated the Clinton-era ban—with the original gradual phaseout. This sent the International Snowmobile Association back to district court in Wyoming, where, in January 2004, the judge, deciding the phaseout caused too much hardship on the communities around the park, increased the allowed snowmobile use. After that, the NPS said it would look at the whole thing again, make temporary rules for the 2004–5 season that would be in effect for three years, collect more data and evaluate it, and reach a final decision. Again.

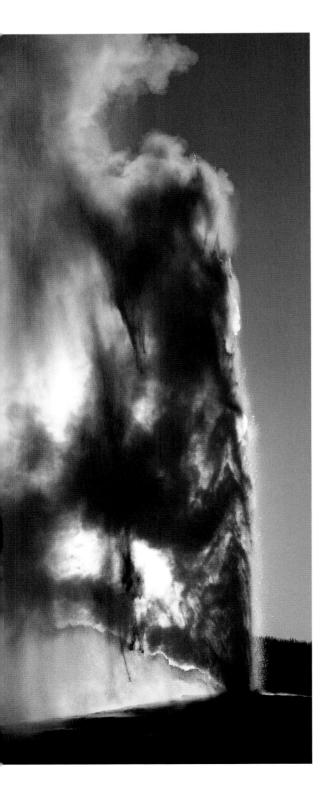

There are more positive stories. Black Canyon of the Gunnison National Monument (Colorado) and Cuyahoga National Recreation Area (Ohio) were upgraded to national parks in 1999 and 2000 respectively. The first park protects 14 miles of a dramatic 48-mile-long, narrow, dark, sheer-walled canyon. The entire area below the canyon rims is designated wilderness. The second park includes 33,000 acres of greenspace and history along 22 miles of the winding Cuyahoga River between Cleveland and Akron.

In 2003, Congaree Swamp National Monument (South Carolina) became Congaree National Park. Over half (15,010 acres) of its 22,200 acres is designated wilderness. Preserving the largest intact tract of old-growth bottomland hardwood forest in the United States, the Congaree forest is one of the most diverse in North America. Twenty-two different ecosystems include more than 75 species of trees, providing habitat for over 170 bird species. In 2004, Great Sand Dunes National Monument (Colorado) was upgraded to a park. Great Sand Dunes National Park and Preserve gained 40,512 acres of wilderness by incorporating the Sangre de Cristo Wilderness within the preserve (formerly administered by the U.S. Forest Service), and 32,643 wilderness acres in the Great Sand Dunes Wilderness within the park. This latter is slated to be increased by another 2363 acres.

In this book we are focused on the wilderness aspects of our national parks. Wilderness, in all the forms we present here, is a kind of metaphor for the well-being of the parks in general. Without a thriving wildland, which depends on a functioning ecosystem, a park becomes

Offering us myriad opportunities for study, wonder, solitude, and recreation, our national parks extend to us, as well, community with all the forms of life on this continent.

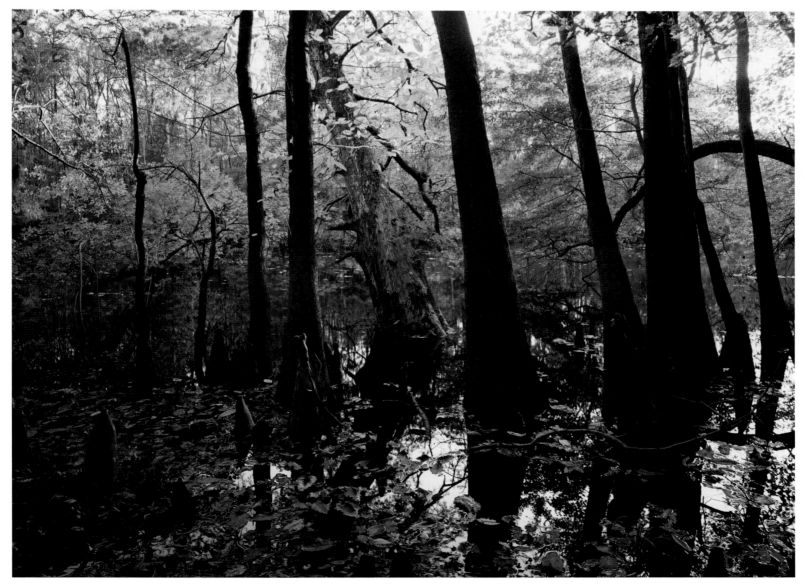

◄ OLD FAITHFUL GEYSER, *Yellowstone National Park, Wyoming*

▲ AUTUMN DAWN AT WESTON POND, *Congaree National Park, South Carolina*

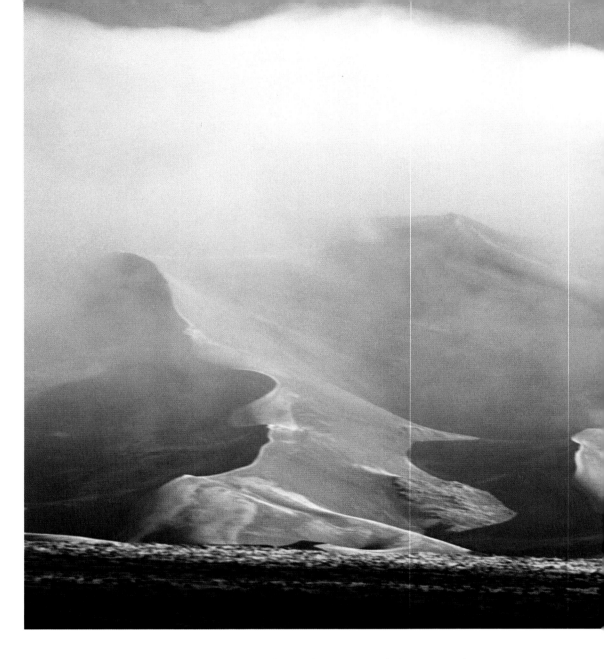

nothing more than a museum, a storehouse for artifacts of a land that was, and is no more. While our parks were devised to protect examples of significant natural (as well as cultural and historical) places, the natural places cannot exist out of context. To protect them, that context—the ecosystem—also needs to be protected.

Few visitors to most parks ever get more than a mile from a road. Yet even those who never leave their vehicles except to go into a lodge or restaurant or visitor center are exposed to some of the parks' natural attributes as they drive through them. Occasionally someone in a vehicle is intrigued to look deeper. Some parks, such as Zion, Grand Canyon, Acadia, and Yosemite have developed superb bus systems to decrease serious traffic problems and cut some measure of pollution on their roads. In Denali, travel is primarily by bus. These bus systems are hugely successful in getting people out of vehicles and onto trails. However brief a first foray, it often invites people to explore further. In that instinct to explore, to experience, lies the future of the parks.

A hundred years after the United States invented national parks by establishing Yellowstone as the first, it presented to the international community the idea of the World Heritage Convention—a treaty in which all participating countries pledge to identify and protect their own key sites (natural and cultural) as humanity's heritage, and to cooperate in that endeavor. When this initiative, launched during the Nixon administration, was adopted by UNESCO (United Nations Educational, Scientific and Cultural Organization) in 1972, the United States was the first country to sign the agreement. To date, 156 other nations have also signed. By inspiring other countries to recognize their own sites of world importance, the World Heritage

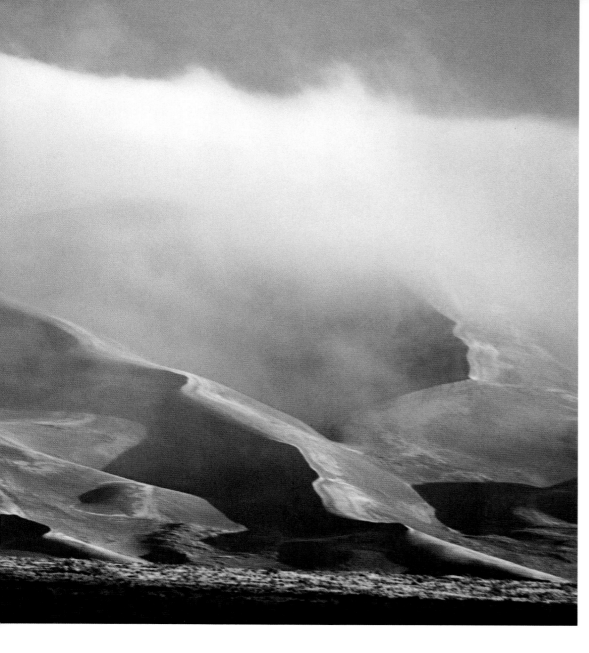

Convention has had a huge impact on the planet. In actual fact, it is simply the American national park idea carried out across the world.

A World Heritage Site possesses outstanding natural (or cultural) values that are recognized and protected by the country in which the site is located, and over which that country has sovereignty. Sovereignty is the operative word here. Those who fear the UNESCO designation means some sort of takeover of U.S. land are misunderstanding the rules. No country has rights over any other country's land. The World Heritage Committee reviews nominations that are made by the country of which they are a part, and provides assistance and advice. With the concurrence of the nation in question, it can place areas on the List of World Heritage in Danger, but it has no legal jurisdiction over any nation's land. Being listed merely brings attention and, hopefully, incentive to mitigate the threats to the site. When Everglades and Yellowstone National Parks were placed on the endangered lists in 1993 and 1995 respectively, it was with U.S. government consent. Yellowstone has since been removed, while in the Everglades the single largest restoration plan ever conceived is under way in an attempt to rectify serious alterations made to the region's hydrological regime by Florida's explosive population growth.

By 2004 the World Heritage List included 582 sites in 114 countries, 20 of which are in the United States. Fourteen of these are national parks. Most U.S. World Heritage Sites in our country are administered by the National Park Service.

Biosphere Reserves, which grew out of UNESCO's Man and the Biosphere Program, began as a biological initiative in which researchers looked at the earth's various biomes, studying how to sustain ecosystems worldwide. The Man and the Biosphere Program is a voluntary effort aimed at encouraging land users and conservationists to find ways to make use of the world's resources without depleting the world's biodiversity. Its intention is to stimulate education and

Without a thriving wildland, which depends on a functioning ecosystem, a park becomes nothing more than a museum, a storehouse for artifacts of a land that was, and is no more.

MORNING FOG, *Great Sand Dunes*
National Park, Colorado

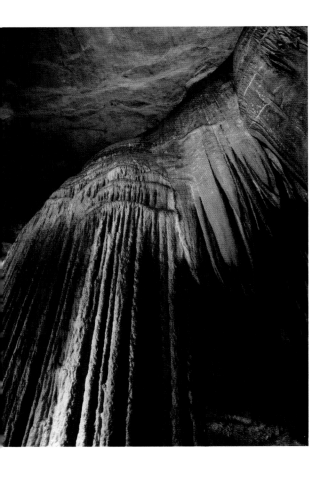

When I visit a national park that is a

World Heritage Site or Biosphere

Reserve (or both), I feel I have come

upon a special place, a rare and honored

celebration of the health of the earth.

I am always impressed by the

designation, and curious about the

attributes that make this particular

place of world importance.

research, and to make models of sustainable development. Biosphere Reserves are ecosystems (terrestrial and coastal) that are internationally recognized for unique ecological qualities within the framework of the Man and the Biosphere Program.

Congress has not passed legislation establishing Biosphere Reserves in the United States, but in the mid 1970s, the United States and Russia jointly agreed to designate Biosphere Reserves to protect biodiversity. Even if it were a political device to present an aura of cooperation to the world, it still served to benefit the earth.

The similarity in Biosphere Reserves and World Heritage Sites is that both recognize places of great value to the world. National parks are included in both programs. In the United States, where the evolution of the Biosphere Reserve Program is away from specific pieces of ground with boundaries (like national parks) and toward a cooperation across boundaries, Biosphere Reserves are usually partnerships within local communities. Mammoth Cave National Park in Kentucky is a good example. When scientists realized the vast underground cave system was at risk because of activity in the above-ground environs, the park worked with local development to insure that area inhabitants could build sustainable livelihoods without jeopardizing the environment. Although Mammoth Cave National Park was established as a World Heritage Site in 1981, the Mammoth Cave Area, which includes the national park and its surrounding ecosystem, was recognized as a Biosphere Reserve in 1990, and then expanded in 1996.

When I visit a national park that is a World Heritage Site or Biosphere Reserve (or both), I feel I have come upon a special place, a rare and honored celebration of the health of the earth. I am always impressed by the designation, and curious about the attributes that make this particular place of world importance.

All of this is important to the story of protected wild land. In a spectacular example of protection, two American parks—Wrangell–St. Elias National Park and Preserve and Glacier Bay National Park and Preserve in Alaska—contiguous with Canada's Kluane National Park and Reserve in the Yukon and the Tatshenshini–Alsek Wilderness Provincial Park in British Columbia now form a single natural World Heritage Site. The combined land area of these four parks comes to more than twenty-four million acres, forming the largest protected expanse of land in the world.

Ace and I led a line of twelve guests on horses up Pelican Valley on a clear Yellowstone day, a day of crystal air. The water in Pelican Creek sparkled. Sandhill cranes rode the length of the sky, their ululating as primeval as the place. Scattered across the valley, small groups of buffalo grazed tall, yellowing grass, the grass barely moving in the calm noon. Pelican Valley is where America's last twenty-three wild buffalo were found, the twenty-three that brought wild buffalo back from the edge of extinction.

Our trail followed the edge between meadow and forest. On both sides of the trail, grass almost reached Ace's chest. He walked comfortably in territory familiar to him. I watched the forest for movement—a grizzly bear, a wolf, a deer. Twice in the past, when a deer appeared out of nowhere as we rode through forest, Ace reared and bolted, reacting instantaneously to the sudden appearance of a creature. Twice I had to drop the rope to the three mules I led so that I could freely turn him and calm him and get him back into his place in line.

Ace is a good lead horse. He is strong and agile and he knows the Yellowstone trails as intimately as I know the rooms in my house. But horses are prey animals. In their genes, they are always wary. Unexpected things scare them. So I have learned to watch for those things, to see them first, before Ace does.

I didn't see the grizzly bear. And Ace didn't rear. He simply stopped in his tracks, ears up,

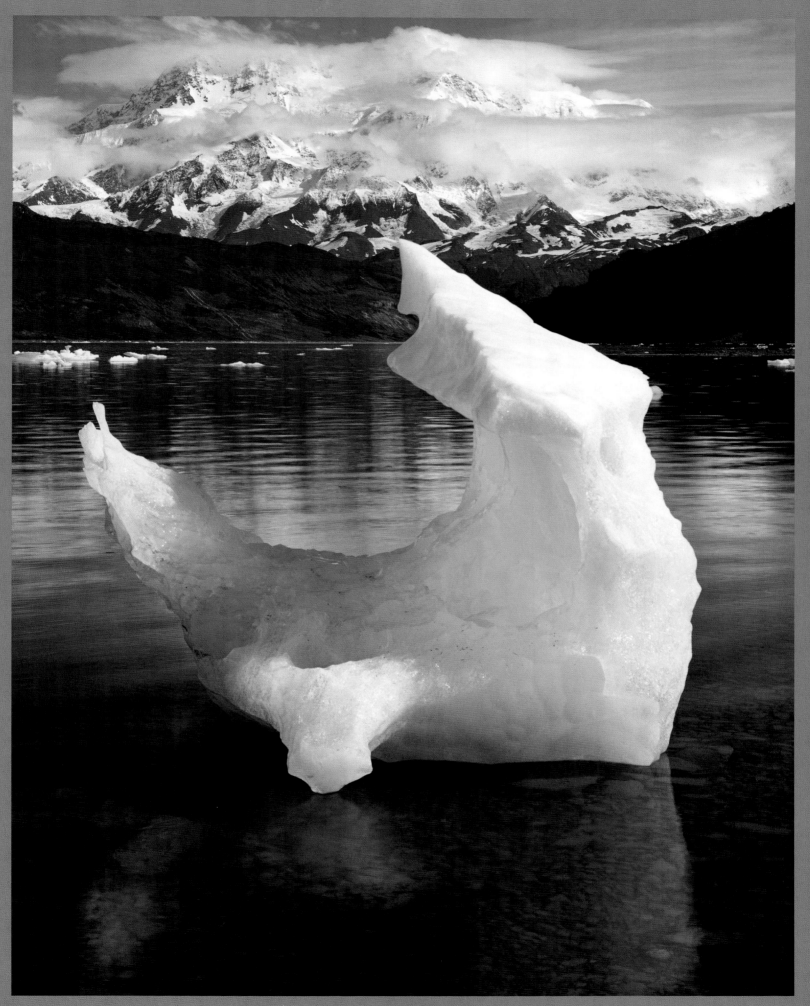

◄ FROZEN NIAGARA, *Mammoth Cave National Park, Kentucky*

▲ ICE SCULPTURE, MOUNT ST. ELIAS, *Wrangell–St. Elias National Park and Preserve, Alaska*

forward, his whole body alert, like a dog on point. Fifty feet ahead of us a row of grass moved like a wave from the meadow up to the trail. A two-year-old grizzly emerged from it, crossed the path, and continued toward the forest. He crossed the path without looking at us, as if we were nothing on his morning errands. For an instant I could see his back as he moved through the grass. I thought he might circle back to the trail. I thought there might be a Mama Bear somewhere that would follow him through the high grass and across the path. Bears usually stay with their mothers for two or three years before setting off on their own. When Ace stopped and I held up my hand, the riders behind me took out binoculars and cameras, but the bear disappeared in the grass so that all any of us could see was a line of grass moving until a wind came up and all the meadow grass moved. I did not see him enter the forest, but when no sow appeared and he did not reappear in a reasonable time, we rode on.

Pelican Valley is a wild place. The primeval land itself is wild. The ancient buffalo, here for 10,000 years, are wild. The sound of the cranes, the stream coursing through the meadow, the silence, the time that has neither beginning nor end—all of this is wildness. The bear too, but sight of the bear goes beyond objective wildness. The adrenaline rush the sight generates in us connects us to our own memory of wildness. Adrenaline, producing the instinctive energy to flee or to fight, is what allowed us to survive the wildness into which we were born. We feel the bear in all our nerve endings, the bear a trigger setting off the alertness—the presence in this exact moment—that is the heart of wildness. Wildness is the necessity to be alert to the possibility of animals, of weather, of terrain, of light and dark and summer and winter, of being in

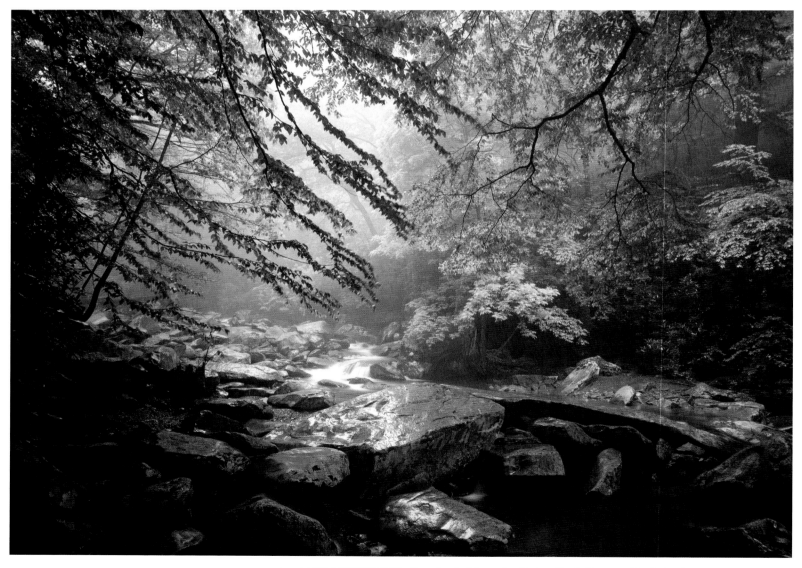

▲ LITTLE PIGEON RIVER, *Great Smoky Mountains National Park, Tennessee/North Carolina*

▶ BLUE WALL, CATTAIL CANYON, *Big Bend National Park, Texas*

situations we do not control, of finding our own way into harmony with what we cannot control.

In the presence of the bear, or the ancient buffalo or the primeval landscape, we become a conduit for the memory of wildness. Exactly so are protected wild landscapes conduits for the memory of this land. This is what our national parks are—the memory of this land. In spite of the fact that wilderness now means *managed* wilderness, and although parts of the memory are missing, areas of national parks, national forests, Bureau of Land Management (BLM) and Fish and Wildlife lands managed for their wilderness values are the closest thing we've got to a recollection of our own genesis.

Our wildernesses are not perfect. Numerous plants are gone—some replaced by exotics from other regions of the earth. Wildlife rarely has the balance or the territory in which it evolved. Corridors on which it once traveled between areas are closed by roads and fences and human settlement. Introduced exotic animals usurp habitat. Natural fire is not allowed free reign beyond proscribed bounds and prescribed conditions. Pollution generated outside the parks' borders affects air and water quality inside the parks, which in turn affects everything that lives inside the parks. The earth's own natural management has been curtailed.

But perhaps, as Rick Potts, National Wilderness Program Manager for the National Park System, says: "Our greatest danger comes from the apathetic masses who become more and more distant from wilderness." When John Muir invited everyone to "come into the mountains and get their good tidings," and when Yellowstone was proclaimed a "pleasuring ground for all people," we may have invited crowds into our wildlands, but it was a vital way to bring attention to the land. Without that attention, not much would have been preserved. These days, wilderness managers, educators, and philosophers within the parks bring an increasing awareness of the necessity of wilderness to the public mind. There are nearly forty-four million acres of officially designated wilderness spread across forty-seven units of the National Park System. Most of these are national parks. The remaining wilderness exists in monuments, seashores, and recreation areas. Nearly 53 percent of national park land is wilderness. (The largest is the 9,078,675 acres of Alaska's Wrangell–St. Elias National Park and Preserve; the smallest, the 747 acres of the Ansel Adams Wilderness Area in California's Devils Postpile National Monument, although this is part of 231,000 acres on adjoining national forest land.)

Approximately twenty-seven million acres exist as study areas proposed or recommended for wilderness and managed for their wilderness values, keeping them unimpaired for that moment when they will become officially designated wilderness. Among the national parks with wilderness recommendations are Yellowstone, Glacier, Grand Teton, Great Smoky Mountains, Big Bend, Arches, Bryce Canyon, Canyonlands, Capitol Reef, Crater Lake, and Zion. Seven other NPS units have also had wilderness recommendations forwarded to Congress. Most of this activity occurred in the 1970s.

Even outside of the designated wilderness areas of parks, there are aspects of wilderness, vignettes of wilderness, we cannot destroy. These may be fleeting, like the grizzly bear crossing the path in Yellowstone. They may be edged by throngs of tourists as are so many easily accessible viewpoints, but they are real. The absolute power of water plunging over a falls in Yosemite, the venerable age and history of a bristlecone pine in Nevada's Great Basin National Park, the eons of chemistry forming a stalagmite in New Mexico's Carlsbad Caverns, the silent depth of forest in Olympic National Park in Washington or the Smokies of North Carolina/Tennessee, the violence of a Great Lakes storm battering at Michigan's Isle Royale are all moments of wildness.

At Katmai National Park and Preserve in Alaska, where a viewing platform allows visitors easy sight of grizzly bears, the bears are no less wild. The land itself is no less wild. Encountering a bear on the path there has the same potential for danger as encountering a bear on a path anywhere. In Denali National Park and Preserve, when a bus transporting visitors on the single park road stops for a look at a wolf crossing the tundra, or a moose in a pond or a sow and cubs

This is what our national parks are—

the memory of this land.

All these moments offer us the memory of wildness, of connection to a natural world. I believe that all connection to wildness is no less than wildness itself. Each time we feel that connection, we understand more deeply its necessity to ourselves and to the earth.

walking far below along the river, the land in which the bus stops is a wild land, regardless of the road. The animals may sometimes use the unpaved road for easy travel, but they are not tamed by it. When a buffalo herd causes a traffic jam in Yellowstone's Hayden Valley, the buffalo do not become domesticated. If you get out of your vehicle to get a close-up photo, it is a wild buffalo that may toss you out of the way. The wildfires that took over in Yellowstone in 1988 were an inviolable act of wildness, an event only nature itself could control. For all the money and manpower poured into the attempt to end them, only autumn snow finally possessed the power to do it. Here was wildness asserting itself for the good of the land. That many people thought it should be controlled was irrelevant to the earth.

All these moments offer us the memory of wildness, of connection to a natural world. I believe that all connection to wildness is no less than wildness itself. Each time we feel that connection, we understand more deeply its necessity to ourselves and to the earth.

The Wilderness Act of 1964, one of the most remarkable pieces of legislation ever enacted by the U.S. Congress, provides us an official definition of wilderness. "A wilderness, in contrast with those areas where man and his works dominate the landscape, is . . . an area where the earth

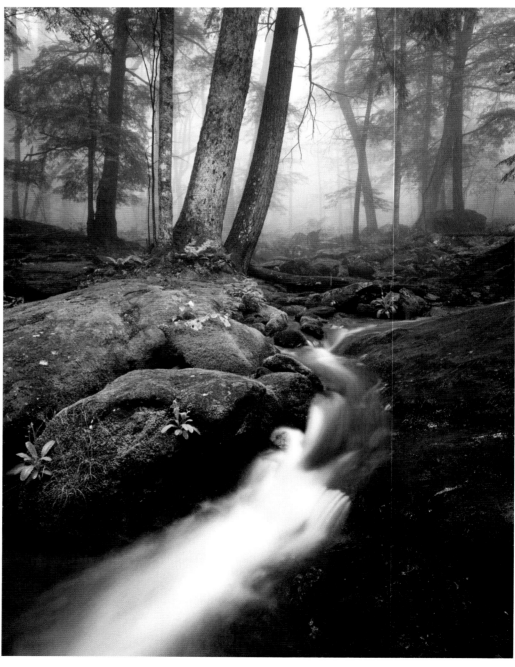

▲ CASCADE IN HEMLOCK FOREST, *Shenandoah National Park, Virginia*

▶ LADY SLIPPER BLOOMS, *Shenandoah National Park, Virginia*

and its community of life are untrammeled by man, where man himself is a visitor who does not remain . . ."

"Untrammeled" is a key word. Unrestrained. Allowed to be what it is. Cole Porter got it right: "Give me land, lots of land, under starry skies above; don't fence me in." It could have been the earth singing.

The Wilderness Act defines designated wilderness as:

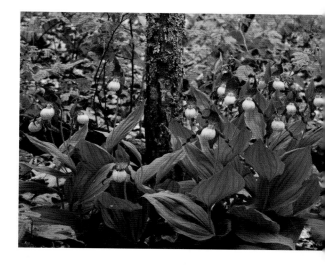

> . . . an area of undeveloped Federal land retaining its primeval character and influence, without permanent improvements or human habitation, which is protected and managed so as to preserve its natural conditions and which (1) generally appears to have been affected primarily by the forces of nature, with the imprint of man's work substantially unnoticeable; (2) has outstanding opportunities for solitude or a primitive and unconfined type of recreation; (3) has at least five thousand acres of land or is of sufficient size as to make practicable its preservation and use in an unimpaired condition; and (4) may also contain ecological, geological, or other features of scientific, educational, scenic or historical value.

But is the idea of wilderness compromised if you look at the fact of "protection" meaning management? Can a place that is managed be truly wild? Yet if we do not manage for wilderness, we will ultimately have no wild country left. In our urge to use any piece of land—for resource extraction, for road building, for development of human habitation and business, and nonwild recreation—only land that is protected for eternity has the chance of staying wild. Or, as in Shenandoah National Park, returning to the wild.

For two centuries before becoming a national park in 1936, the area of Shenandoah had been heavily used by humans. By 1936, less than 1 percent of its primeval forest remained. Writer Darwin Lambert, whose life has been dedicated to the idea of "earthmanship"—the link between humans and nature—was the new park's first ranger. He organized the Shenandoah Nature Society and wrote the park's first guidebook. In his 1972 book, *The Earth-Man Story,* he wrote, "Shenandoah is the only large 'nature' park that wasn't 'saved' in any appreciable degree but was won back after it had long been lost." In a 1973 article for *National Wildlife,* he asked, "How could such an astonishing restoration of the wilderness be accomplished? Simply by removing man as a resident and allowing nature to take her own miraculous, restorative course."

About 40 percent of Shenandoah is designated wilderness. With its proximity to Washington, D.C., and other major eastern cities, Shenandoah is in the special situation of having a vocal constituency for protection. In a sense, it is a place to come to learn about wilderness or, as Shenandoah's Steve Bair and Laura Buckheit (respectively, the park's Branch Chief, Backcountry Wilderness & Trails, and Education Specialist focused on Wilderness) put it, Shenandoah is a sort of "beginner's wilderness."

The Wilderness Act (Public Law 88–577), signed into law on September 3, 1964, created a National Wilderness Preservation System, specified the purposes of this system, defined wilderness, and provided general guidelines on how to manage wilderness. The National Park Service, U.S. Forest Service, Bureau of Land Management, and U.S. Fish and Wildlife Service all manage wilderness, but the biggest piece of it—42 percent—is managed by the National Park Service.

To some extent, the NPS fulfilled tenets of the Wilderness Act even before there was a Wilderness Act. The 1916 Organic Act that created the National Park Service states that the purpose of the national parks is to "conserve the scenery and the natural and historic objects

It is our intention in this book to

explore the idea of wildness in our

national parks, and the necessity of

wilderness for the American soul.

and the wild life therein and to provide for the enjoyment of the same in such manner and by such means as will leave them unimpaired for the enjoyment of future generations."

But there is a flaw in the original park mandate. A flaw, or a moment of brilliant insight. As national park historian Richard West Sellars notes in *Preserving Nature in the National Parks,* the national park idea owes its very survival to its utilitarian nature—that is, the public's use of the parks provides the necessary rationale for them to exist. For Sellers, "the concept that development for public use and enjoyment could foster nature preservation on large tracts of public lands would form an enduring, paradoxical theme in national park history."

Responding to this perceived need to promote visitation, early park managers saw much of their job as developers. The Organic Act sets no limits on development. The Park Service built roads and trails, visitor centers, employee housing and infrastructure, patrol cabins, communications towers, airstrips and helipads, campgrounds, livestock enclosures, and other recreational facilities. The growing development through the 1930s, '40s, and '50s caused an equally growing concern in the environmental community that the NPS was placing emphasis on development to the detriment of the preservation of pristine lands. It was this concern that led Congress to include the National Park System within the scope of the Wilderness Act. What the Wilderness Act does is provide *additional* protection for national park backcountry resources, a counter to the idea of development.

The Wilderness Act echoes many of the words of the Organic Act, but it provides a much greater degree of protection to the resources of the National Park System, directing that, even within national parks, wilderness areas "shall be administered for the use and enjoyment of the American people in such manner as will leave them unimpaired for future use and enjoyment as wilderness." The Wilderness Act places a supplemental layer of administrative protection on wilderness areas within the national parks.

To minimize administrative differences and visitor confusion among the various agencies within the National Wilderness Preservation System, interagency cooperation and coordination were written into the rules. Park managers are responsible for ensuring that wilderness management within the park unit is coordinated with the management of surrounding federal, state, and local land managers, federally recognized Indian tribes, and other public and private organizations. In requiring cooperation among agencies whose instincts seem to hover rather more in the "this is my turf" arena, the National Wilderness Preservation System probably did at least as much for the land as the establishment of the park system itself.

It is our intention in this book to explore the idea of wildness in our national parks, and the necessity of wilderness for the American soul. We celebrate the Wilderness Act as our greatest hope for preservation of our wild country, but we also extend the idea of wildness beyond that extraordinary legislation to those places that have provided us days or moments of nondesignated wildness. Some of the parks described are true wilderness parks. Others have offered us experiences of wildness.

Our exploration becomes personal in the choice of particular images and words, the gathering of impressions and events over the course of years we have each spent wandering in our national parks. While David's photography presents most of the fifty-eight national parks, my writing focuses on several that have provided me deep experiences of wild country. Together, our intention is to use these personal selections to celebrate wildness in all our parks.

The national parks in the book are arranged according to a geography that generally flows from our Pacific west eastward to the Atlantic.

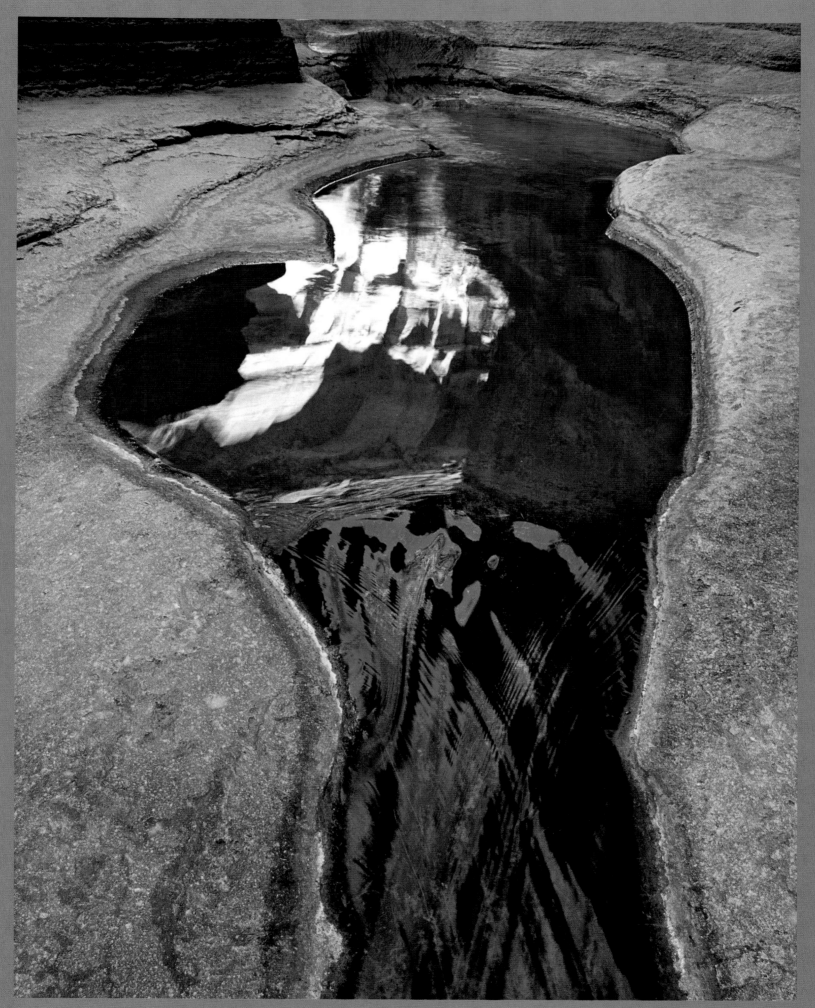

CANYON REFLECTIONS, NATIONAL CANYON, *Grand Canyon National Park, Arizona*

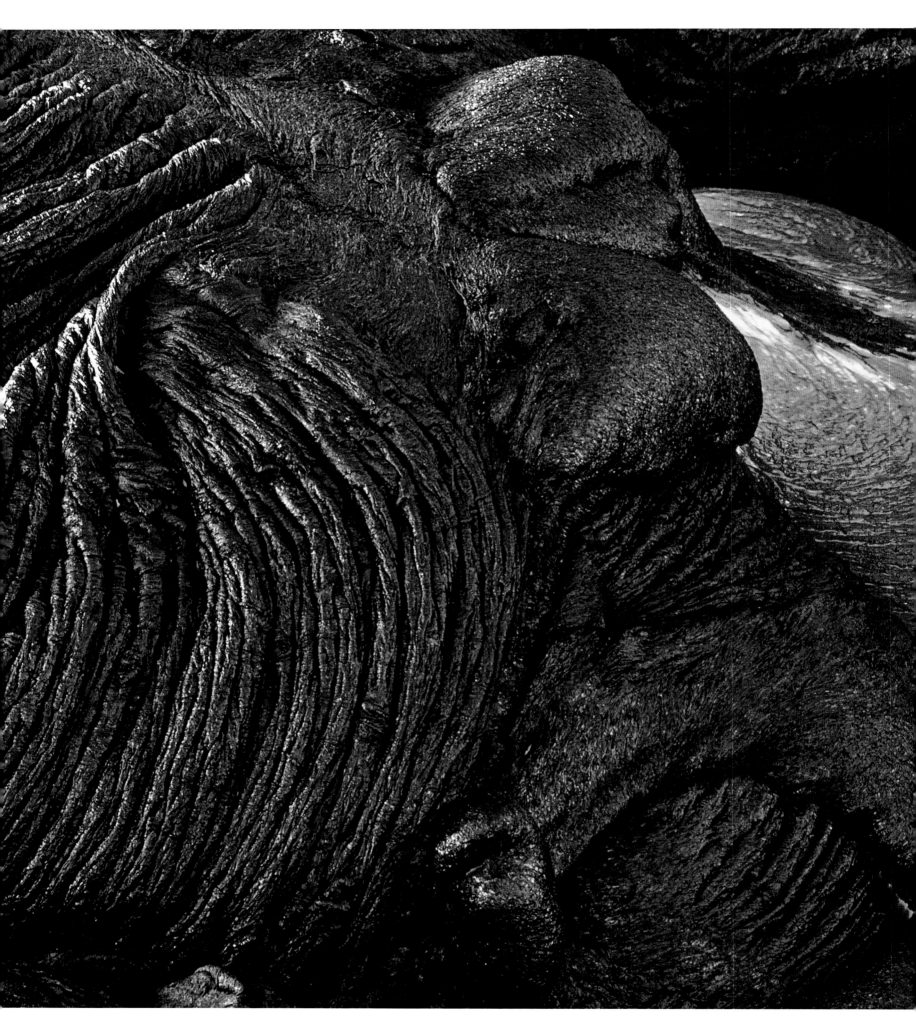

▲ PAHOEHOE LAVA FLOW, KAMOAMOA

► AMAU FERN AND OHIA LEHUA

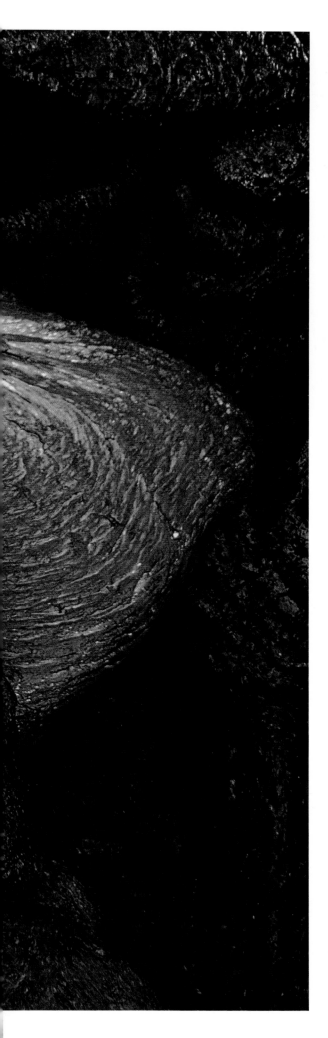

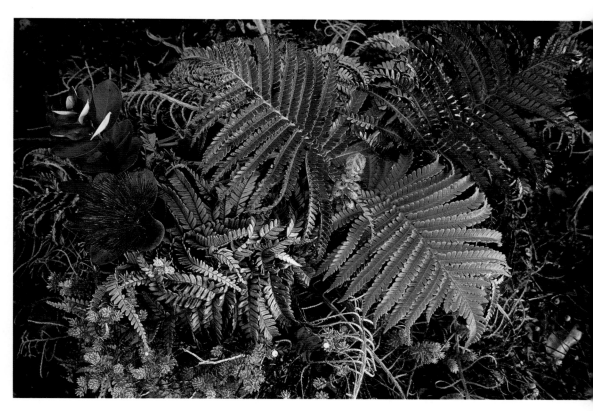

Hawai'i Volcanoes

NATIONAL PARK, HAWAI'I

We crossed the caldera on smooth lava, worn lava, tortured convulsed lava, thin-crusted buckling lava, deeply cracked lava where the earth's crust—split—fit together like a puzzle, or would if one could push the two sides together across the intervening chasm. The walkways were like trails across the moon, inviting us into the dream the moon creates. Compelled by the beauty and the path, my friend Bev and I followed the dream. In places where there had been time enough on this new earth for new growth to take hold, ferns sprouted in cracks in the rock; ferns and the red-flowered ohi'a lehua tree. A gentle mist annihilated all reference to sky, all reference to worlds beyond this raw land.

In the course of our fifteen-mile April walk, we passed places where heat and steam issued out of the earth, although everywhere here, steam or not, you feel the immediacy of the earth's forming. The black rock across which we walked mirrored forms we had watched evolving the previous night when we stood in a lava field near the coast. Red molten lava pushed, flowed, folded out of the black rock slope formed by this same process. Tongues of viscous fire pulsed like red fire-blood, creating earth as they covered earth, the acts of destruction and creation one and the same.

Exposed to air, lava cools quickly, turning into formations of *pahoehoe*—smooth, ropy lava, and *aa*—clinkery blocks of lava with the sharpness and texture of overburned bricks. The lava creeps downslope, oozing out beneath cooling black crust, cooling as it runs, folding into layered whipped cream folds, pouring out fire-red again when pressure for a new passage forces it farther down the slope. It flows, crackling, bubbling, shooting out hot, tiny fragments. Heat waves hover over the entire flow, emanating out of the braided black crust. The 2000-degree heat felt burning on my neck and face. I took a step back.

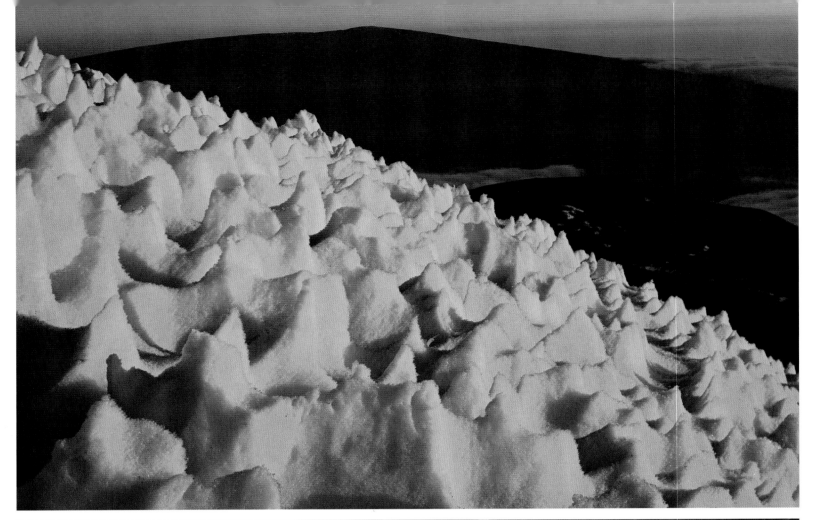

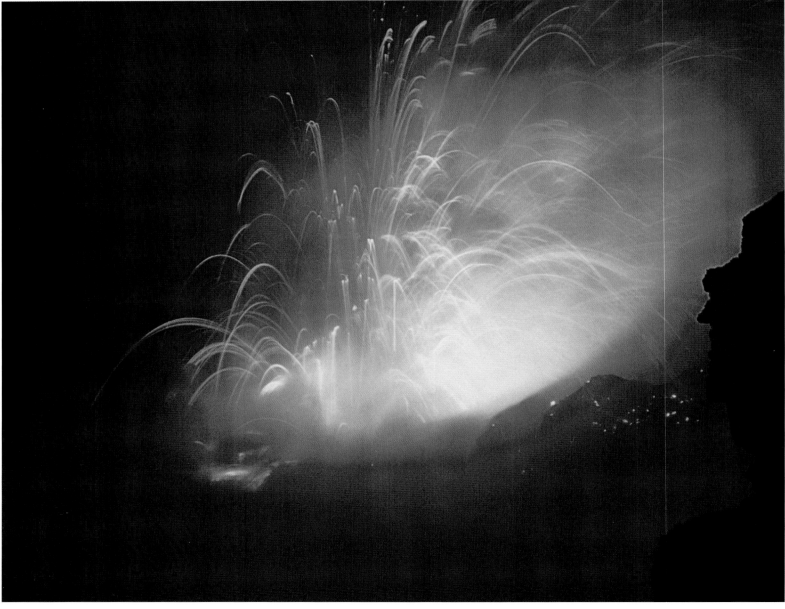

▲ ▲ MAUNA LOA FROM MAUNA KEA, *Hawai'i Volcanoes National Park*

▲ LAVA EXPLOSION IN PACIFIC OCEAN, *Hawai'i Volcanoes National Park*

On the hillside to the right, a hundred red fires from lava flowing down the black slope looked like the fires of a hundred camps. The camps of new earth forming.

Not much is wilder than new earth.

In 2003, the purchase by The Nature Conservancy and Hawai'i Volcanoes National Park of a 116,000–acre ranch, Kahuku, added those acres to the park. Kahuku, on the southwest rift of Mauna Loa, is currently open to the public occasionally, during which times visitors will encounter rangers on horseback, geologists, and biologists to provide them on-the-ground information about the area. Towering above Kahuku, Mauna Loa is, like Kilauea rising from its southeastern flank, an active volcano, although it has not erupted since 1984. Looming 13,679 feet above sea level, Mauna Loa measures 56,000 feet high, the tallest mountain on earth if you start counting from the ocean floor. Kahuku is about the thirtieth addition to the park since its establishment as Hawai'i National Park in 1916, when Hawai'i was still a U.S. Territory. The planning process for Kahuku includes managing it for its potential as designated wilderness. While final decisions for Kahuku are a long way off, perhaps one day it will add significant acres to the park's wilderness.

A land of erupting volcanoes, rare and endangered plant and animal communities, and prehistoric sites on the island of Hawai'i, the park was established as part of Hawai'i National Park in 1916, renamed in 1961. Wilderness designated in 1978. A Biosphere Reserve and World Heritage Site. Acreage—330,086. Wilderness area—130,790 acres.

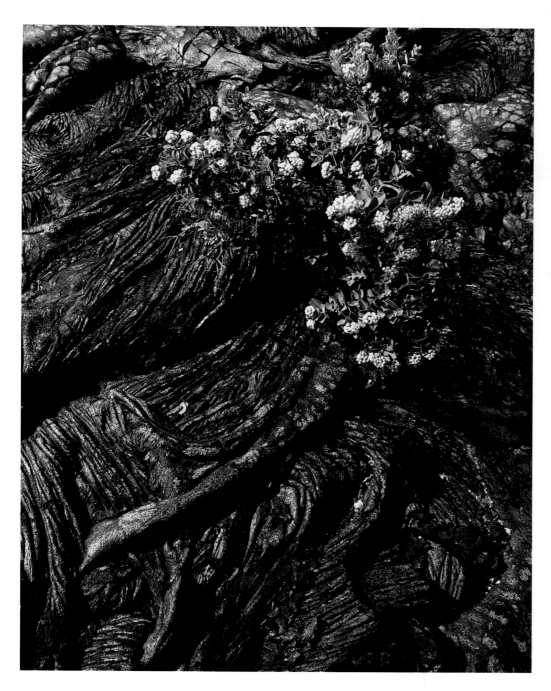

◄ OHIA LEHUA ON PAHOEHOE LAVA FLOW, HOLEI PALI, *Hawai'i Volcanoes National Park*
▲ RAIN FOREST AT THURSTON LAVA TUBE, *Hawai'i Volcanoes National Park*

Haleakala NATIONAL PARK

From the summit of the giant dormant volcano that forms the eastern end of Maui to rain forest and ocean, this park protects fragile native Hawaiian ecosystems. Established as part of Hawai'i National Park in 1916, renamed in 1960. Wilderness designated in 1976. A Biosphere Reserve. Acreage—30,183. Wilderness area—24,719 acres.

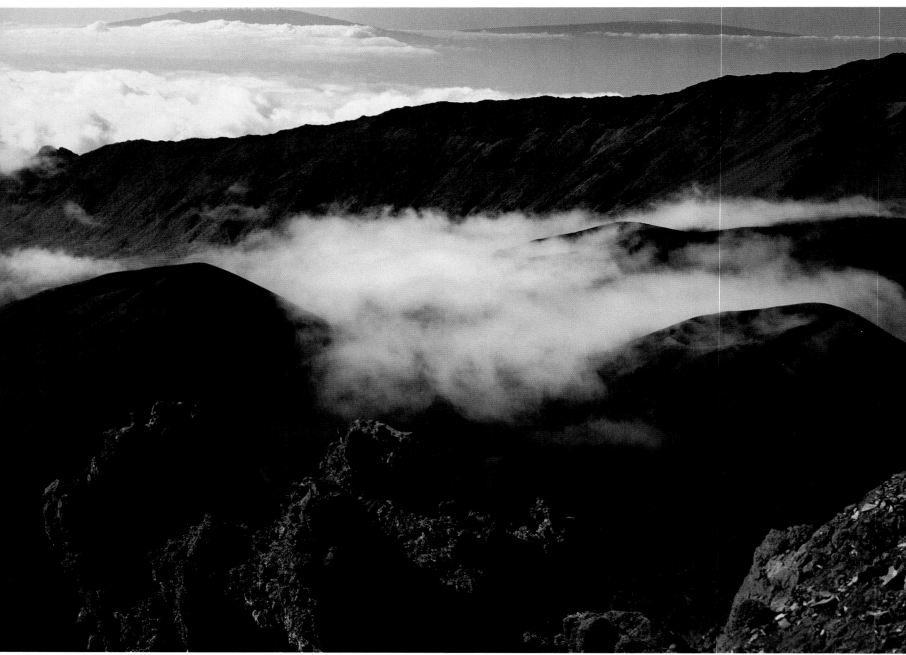

▲ ▲ SUNRISE AT OHEO GULCH

▲ FOG IN HALEAKALA CRATER

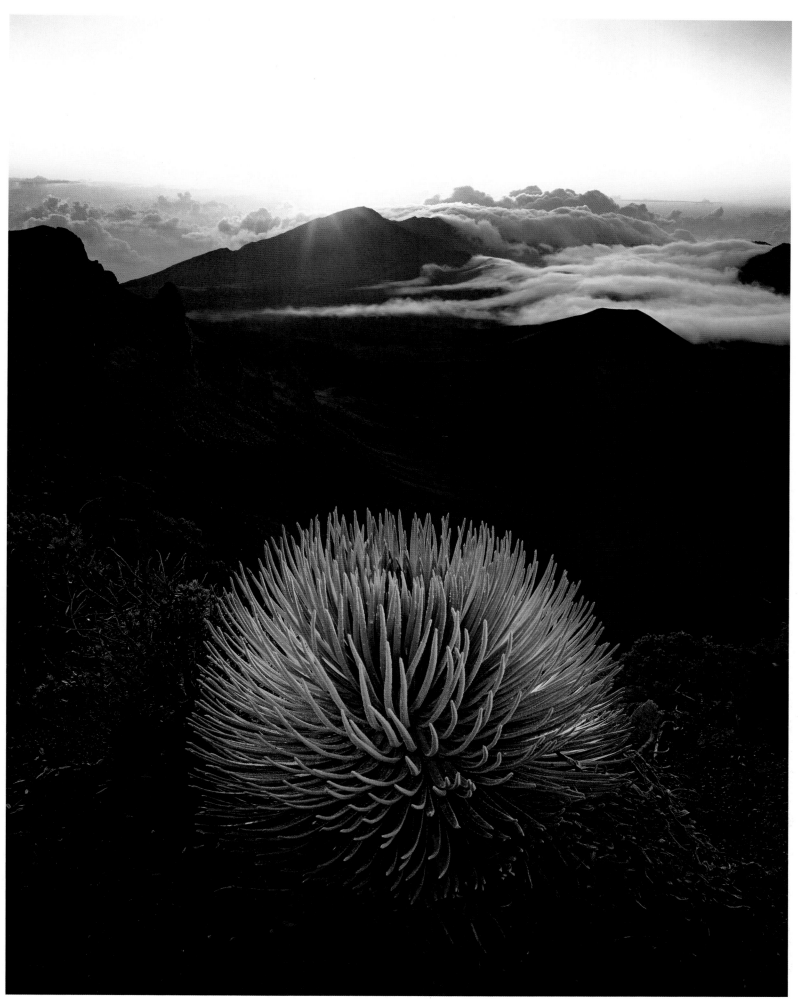

SILVERSWORD AND HALEAKALA SUNRISE

NATIONAL PARK OF American Samoa

This park, on three South Pacific volcanic islands of paleotropical rain forests, coral reefs, and white sand beaches, was authorized in 1988 on leased land. A fifty-year lease was signed in 1993. Acreage—9000. Water area—2500 acres.

SUNUITAO PEAK, OFU ISLAND

SUNRISE, SANTA CRUZ ISLAND

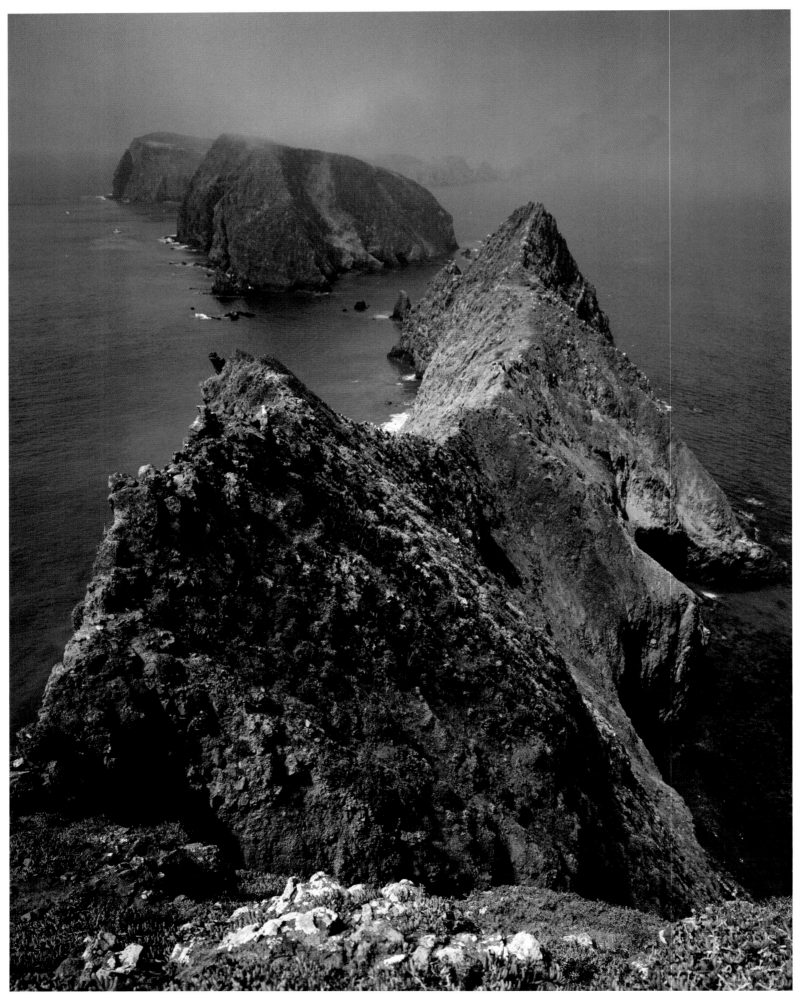

ANACAPA ISLAND

Five islands off Southern California provide habitat for unique vegetation, nesting seabirds, and sea lions. Proclaimed a national monument in 1938, redesignated a park in 1980. A Biosphere Reserve. Acreage—249,353.77.

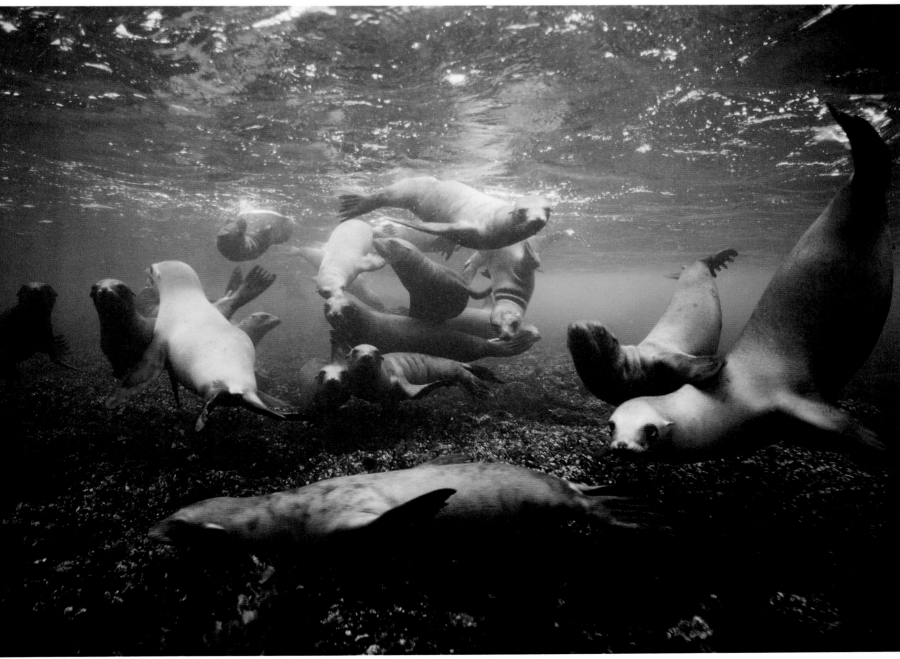

▲ ▲ GARIBALDI

▲ SEA LIONS, SANTA BARBARA ISLAND

Redwood NATIONAL PARK

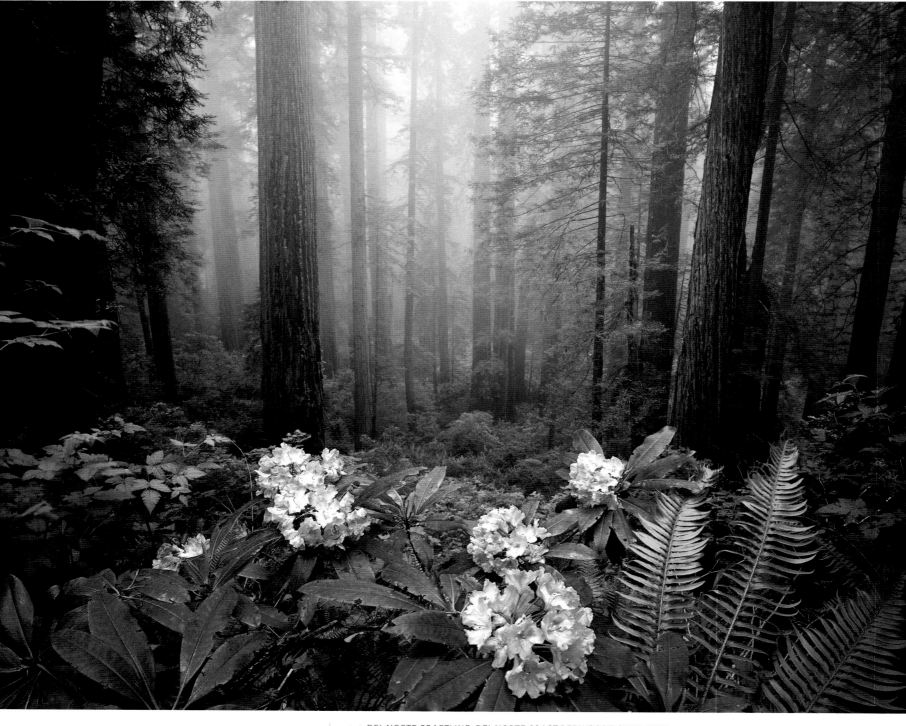

▲ ▲ DEL NORTE COASTLINE, DEL NORTE COAST REDWOODS STATE PARK

▲ RHODODENDRON, DEL NORTE COAST REDWOODS STATE PARK

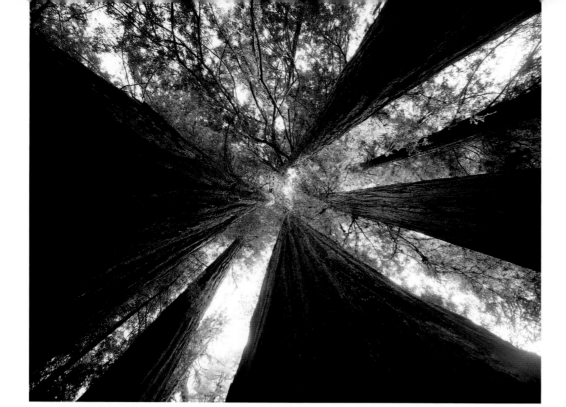

Coastal redwood forests containing virgin groves of ancient trees, including the world's tallest, are preserved in this combination of national and state parks along a foggy forty miles of Pacific coastline in Northern California. Established 1968. A Biosphere Reserve and World Heritage Site. Acreage—105,516.

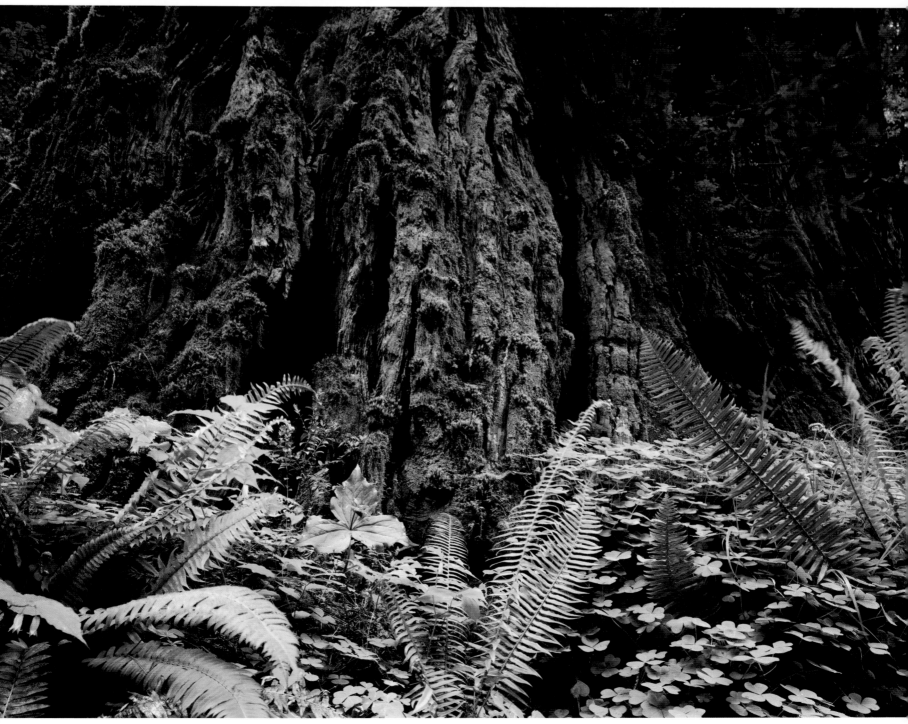

▲▲ PRAIRIE CREEK REDWOODS, PRAIRIE CREEK REDWOODS STATE PARK

▲ REDWOOD BOLE, JEDEDIAH REDWOODS STATE PARK

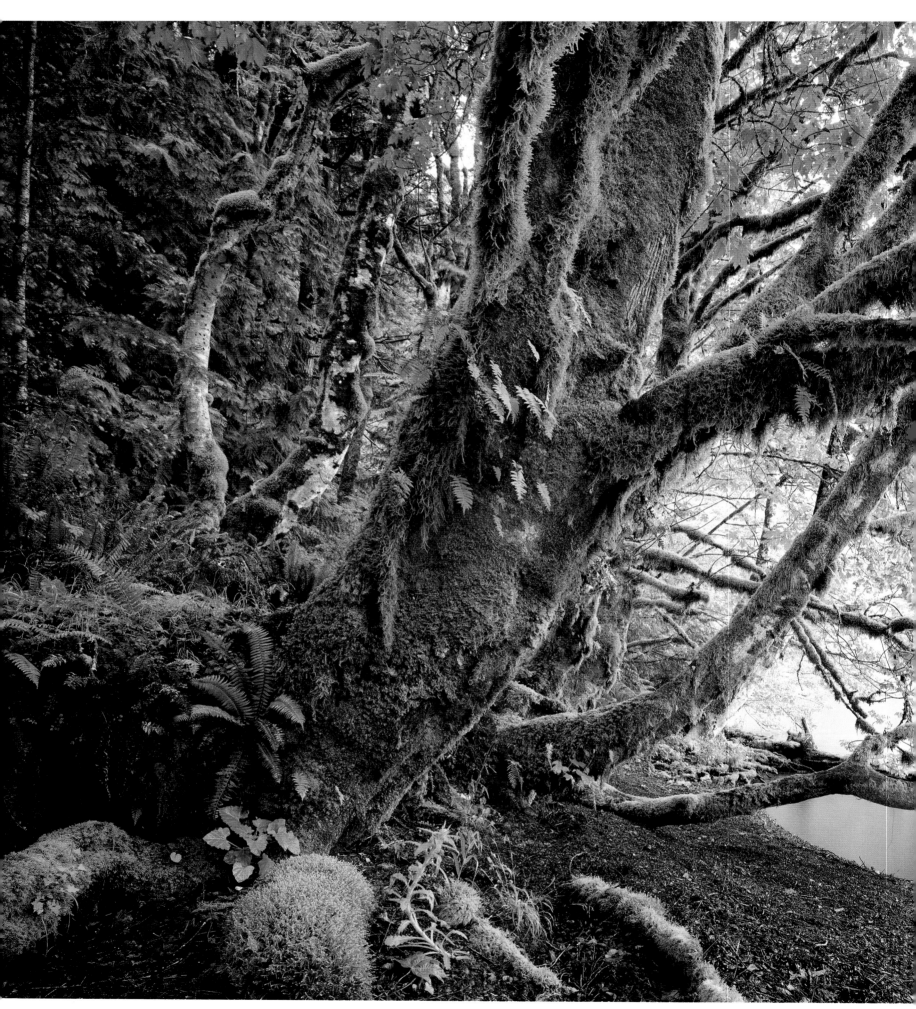

▲ MAPLE ALONG LAKE CRESCENT ▶ HOH RAIN FOREST

▶▶ EVENING COASTLINE AT OZETTE

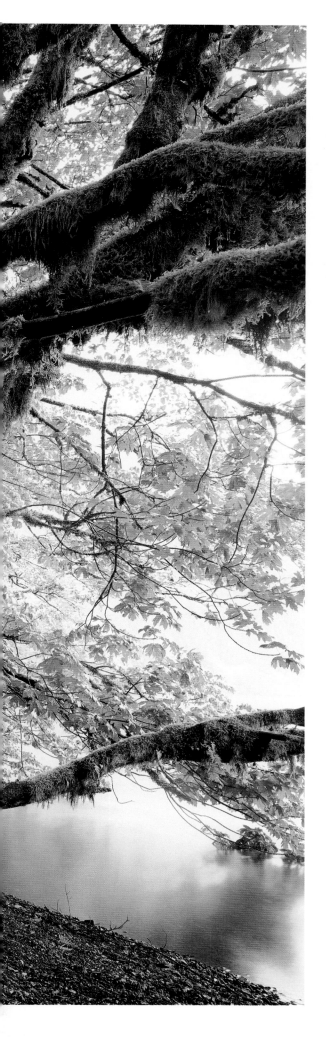

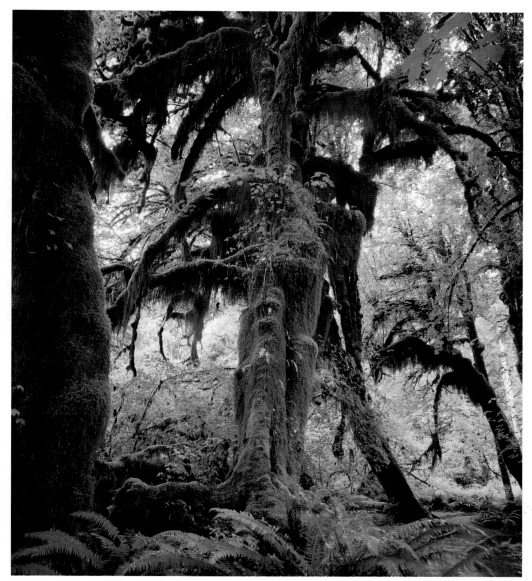

Olympic

NATIONAL PARK, WASHINGTON

My first trip to Olympic National Park was a cross-park backpack from Whiskey Bend along the turbulent, green Elwha River and over Low Divide to the rain forest of the Quinault. It was also my first contact with big trees. I felt awe in this forest of huge and ancient conifers—Douglas fir and Sitka spruce soaring upward with the grandeur of mountains, or, fallen, stretching long across the forest floor, nursemaid logs whose deaths give birth to new forests. Where streams of sunlight reached the forest floor, Nootka roses lined my path. Silver threads of spider webs, woven into ephemeral necklaces, stretched across the trail from tree to tree, glittering in those reaches of the sun. Deer were everywhere, like a medieval tapestry of the peaceful, game-rich forest. Once when I stopped for lunch, a deer emerged from shadow to lie near me, like a big dog.

Days later I found the discarded hair of a deer killed by a mountain lion strewn across the path. Cleaned bones lay scattered on the bank alongside. In the peace of this forest, I had forgotten about things that could eat me. It would be odd for that to happen because there are plenty

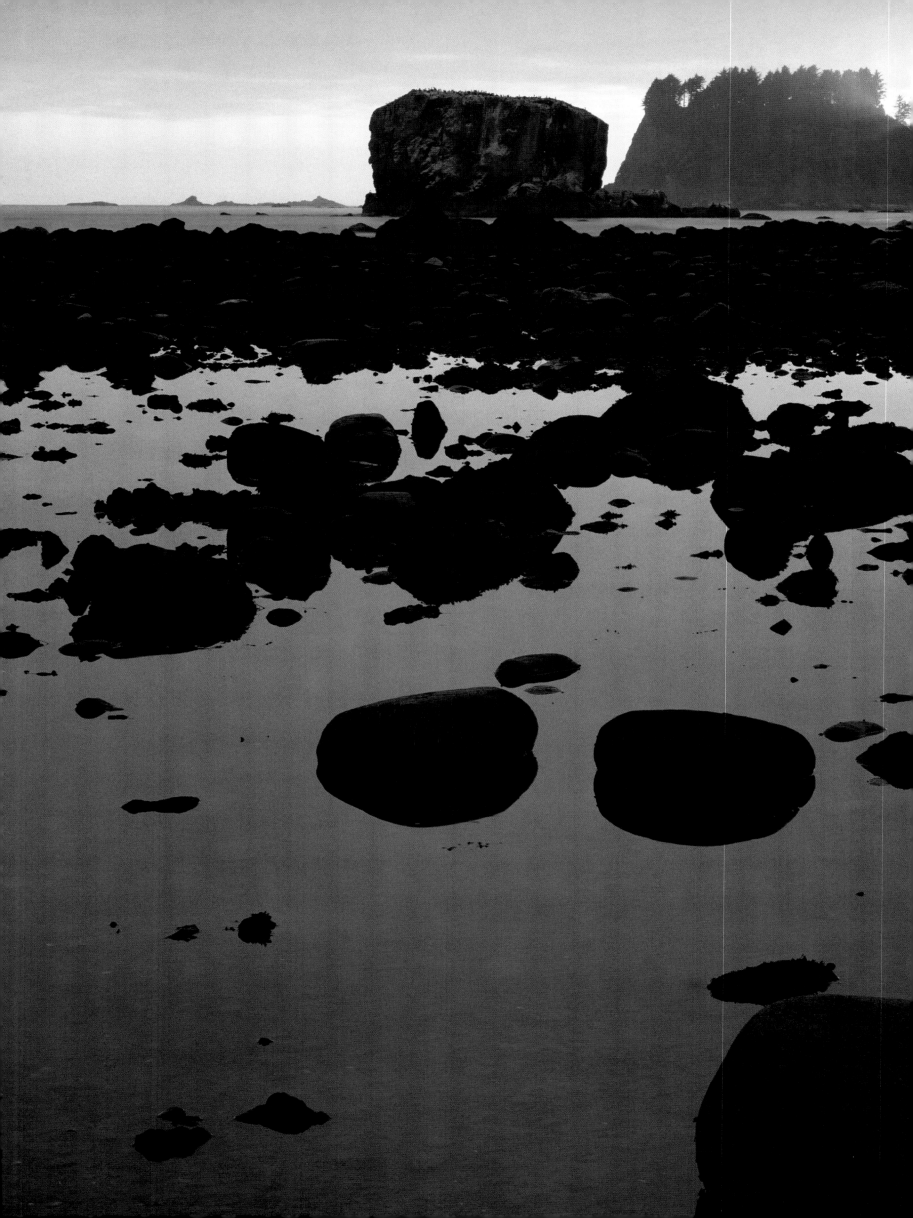

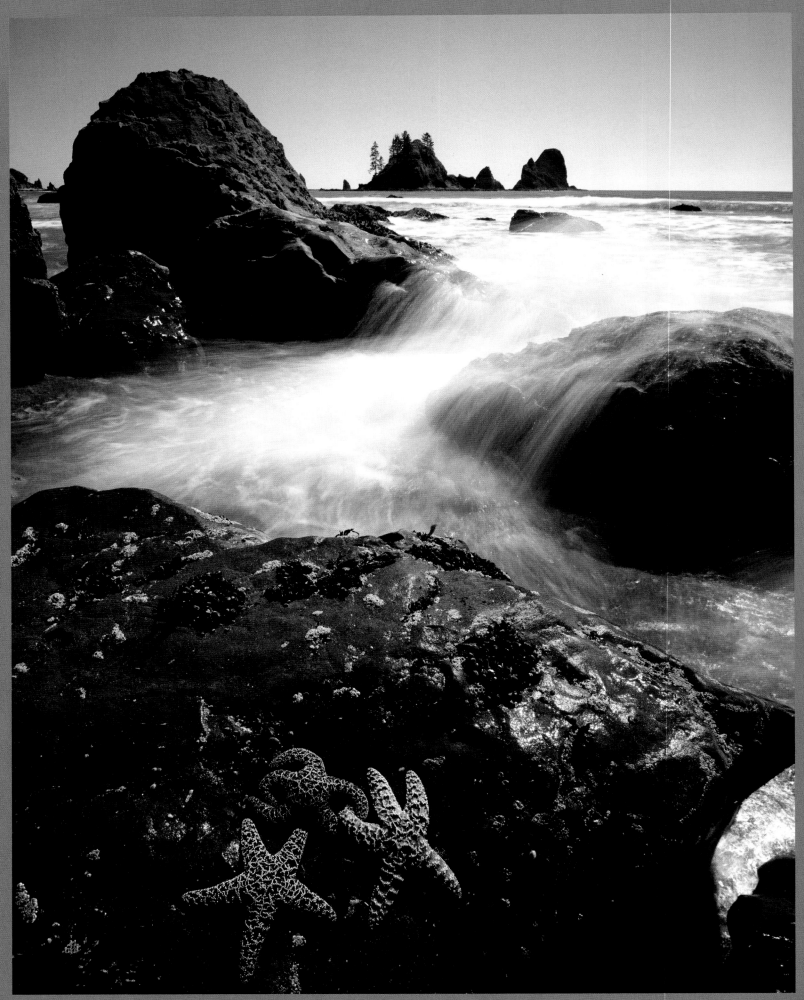

OLYMPIC COASTLINE AT THIRD BEACH

of deer here, and Roosevelt elk (whose protection was part of the reason the park was created) to feed lions, the only predator on them. But I still felt a moment of primal fear, a moment of remembering what wildness really is, of remembering that I enter wildness for qualities other than inordinate beauty. In wildness, I remember all that is lost in the centuries of my domestication. I see how unconscious I am, even when I believe myself alert. I noted the hair and the cleaned bones, then hurried through this territory that seemed to me quite claimed.

In the old-growth Quinault Rain Forest, I entered a luminescent world hugely different from the fir forest. Unearthly light edged tree trunks covered by moss—western hemlock, bigleaf maple, Douglas fir, and western red cedar. Curtains of moss dripped from the limbs of arching vine maples. The floor was soft with centuries of rotting wood and fallen leaves, and blankets of moss and fern and wood sorrel that covered, as well, the fallen decaying logs. There was hardly an inch of space without something growing in it. In this place I discovered the color of silence, a green, deep, primordial silence, a sanctuary built of green silence.

Nearly 95 percent of Olympic National Park is wilderness. Besides its variety of forest (rain forest, lowland, montane, and subalpine), wilderness here celebrates a sixty-mile-long Pacific Coastline, where waves crash forever against a fog-shrouded shore while, in the interior, glaciers carve the highest peaks. This is, indeed, a sanctuary.

Glaciers, spectacular temperate rain forest, giant trees, lush meadows and deep valleys, and miles of pristine beaches providing habitat for great numbers of wildlife, this park is almost entirely wilderness. Proclaimed Mount Olympus National Monument in 1909, renamed and redesignated in 1938. Wilderness designated in 1988. A Biosphere Reserve and World Heritage Site. Acreage—922,650.68. Wilderness—876,669 acres.

LUPINE ON HURRICANE RIDGE, AND MOUNT OLYMPUS IN THE DISTANCE

Glacier Bay NATIONAL PARK AND PRESERVE

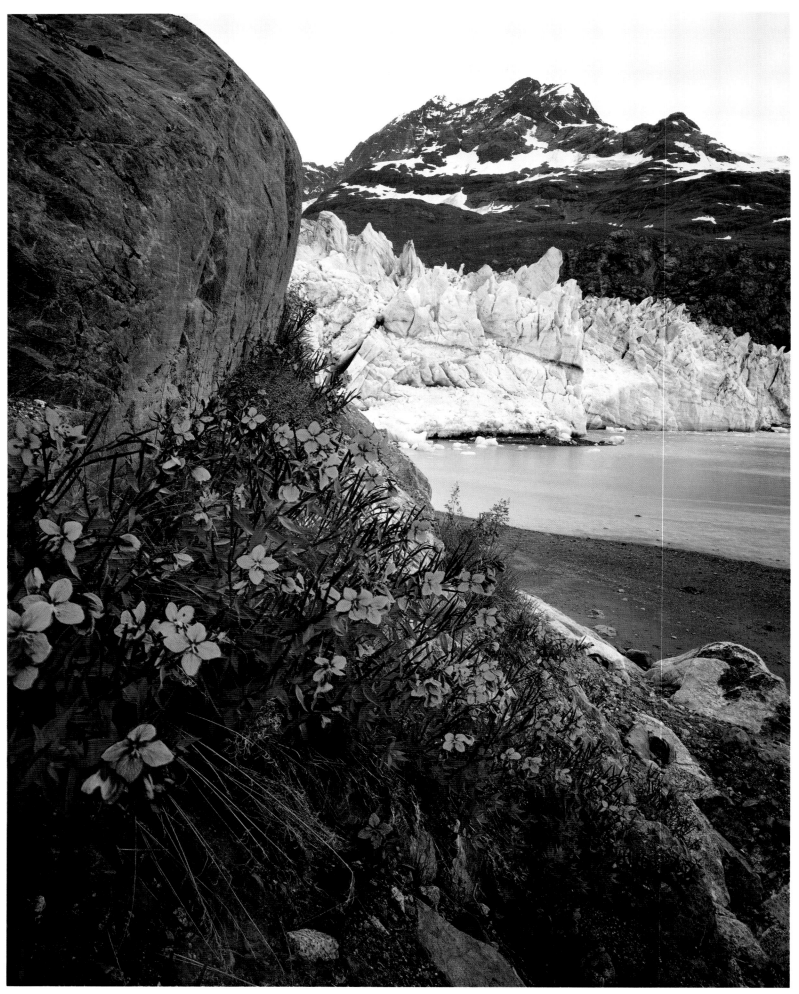

DWARF FIREWEED AND LAMPLUGH GLACIER

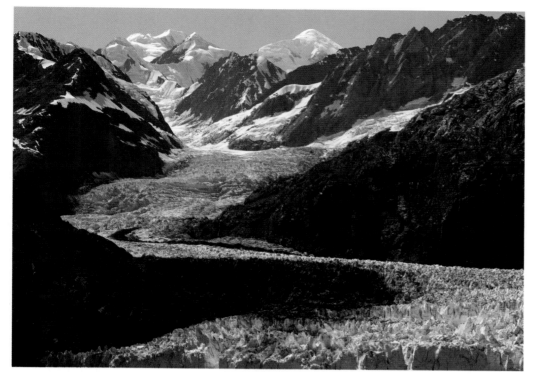

Tidewater glaciers and temperate rain forest are part of an evolutionary landscape that provides habitat to grizzly bears, whales, seals, and eagles. Proclaimed a national monument in 1925, established as a national park and preserve in 1980. Wilderness designated in 1980. A Biosphere Reserve and World Heritage Site. Combined park and preserve acreage— 3,283,199.55. Wilderness—664,876 acres.

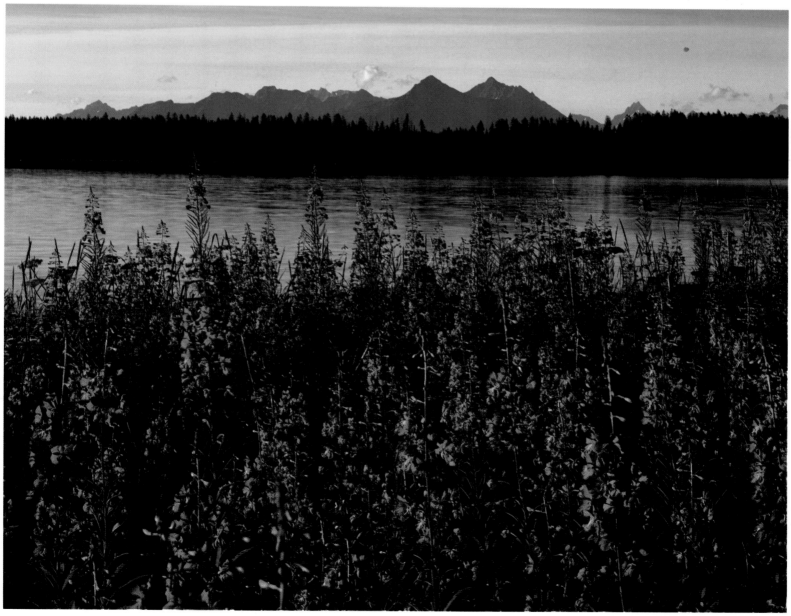

▲▲ MARGERIE GLACIER AND MOUNT FAIRWEATHER

▲ FIREWEED ALONG BARTLETT COVE

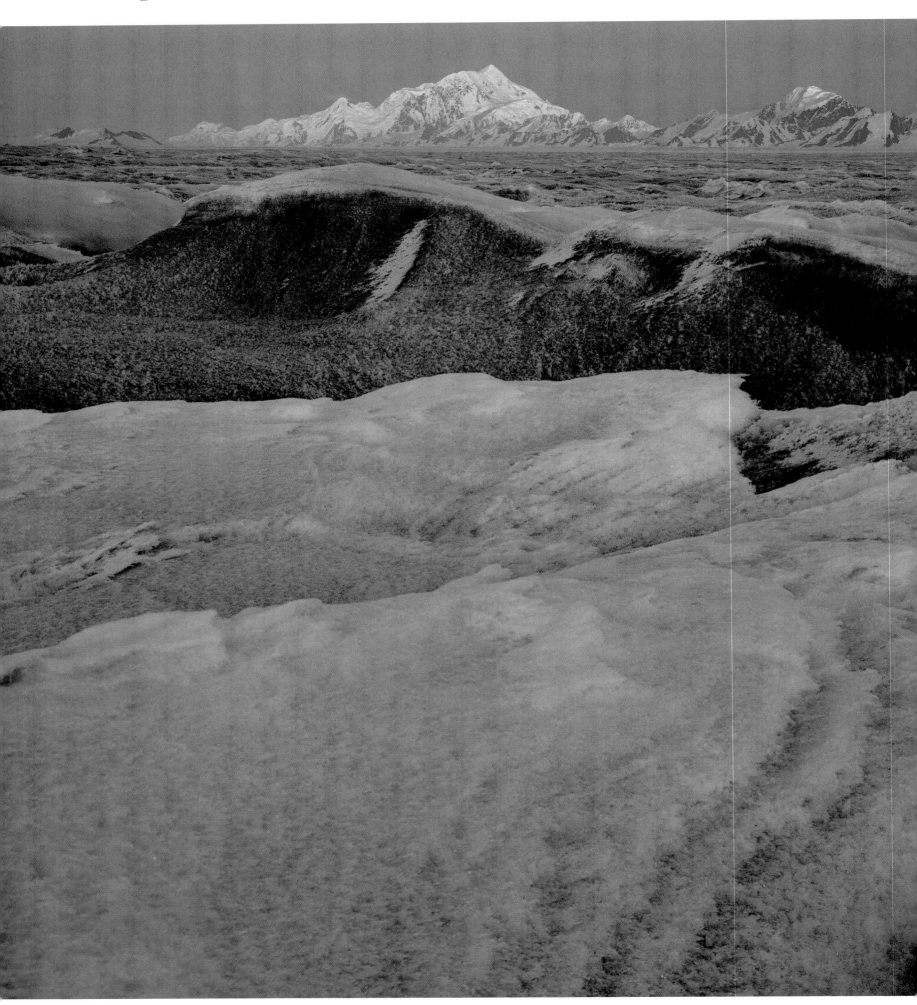

▲ MOUNT ST. ELIAS ABOVE BAGLEY ICEFIELD

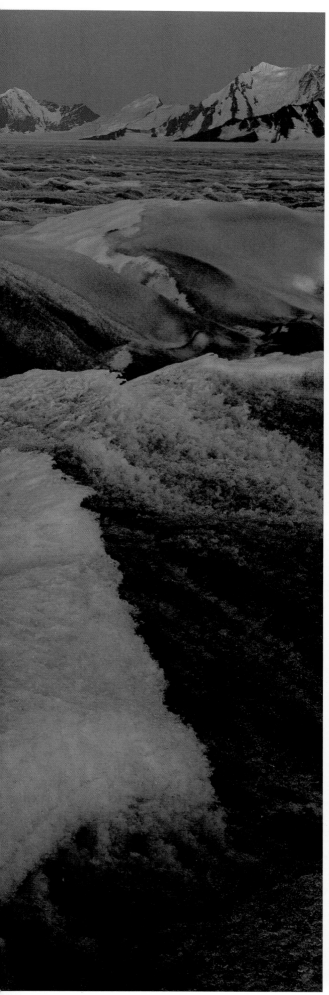

The continent's largest assemblage of glaciers and greatest collection of peaks above 16,000 feet are included in this largest unit of the National Park System. Mount St. Elias—18,008 feet—is the second-highest peak in the United States. Proclaimed a national monument in 1978, established as a national park and preserve in 1980. Wilderness designated in 1980. A World Heritage Site. Combined park and preserve acreage—13,176,390. Wilderness—9,078,675 acres.

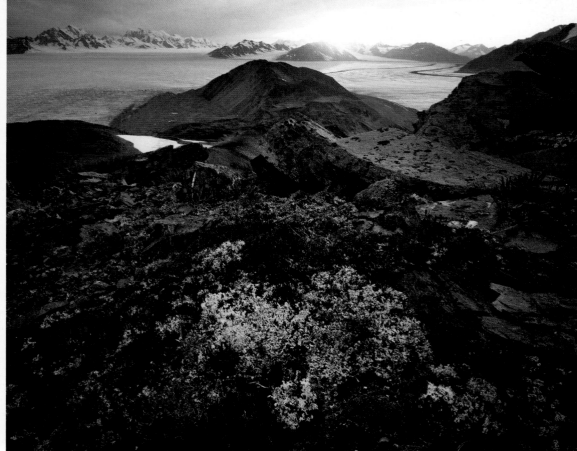

▲ ▲ AUTUMN, MOUNT SANFORD ▲ JUNIPER ISLAND AND BAGLEY ICEFIELD
► ICE WALL, UNIVERSITY RANGE

49

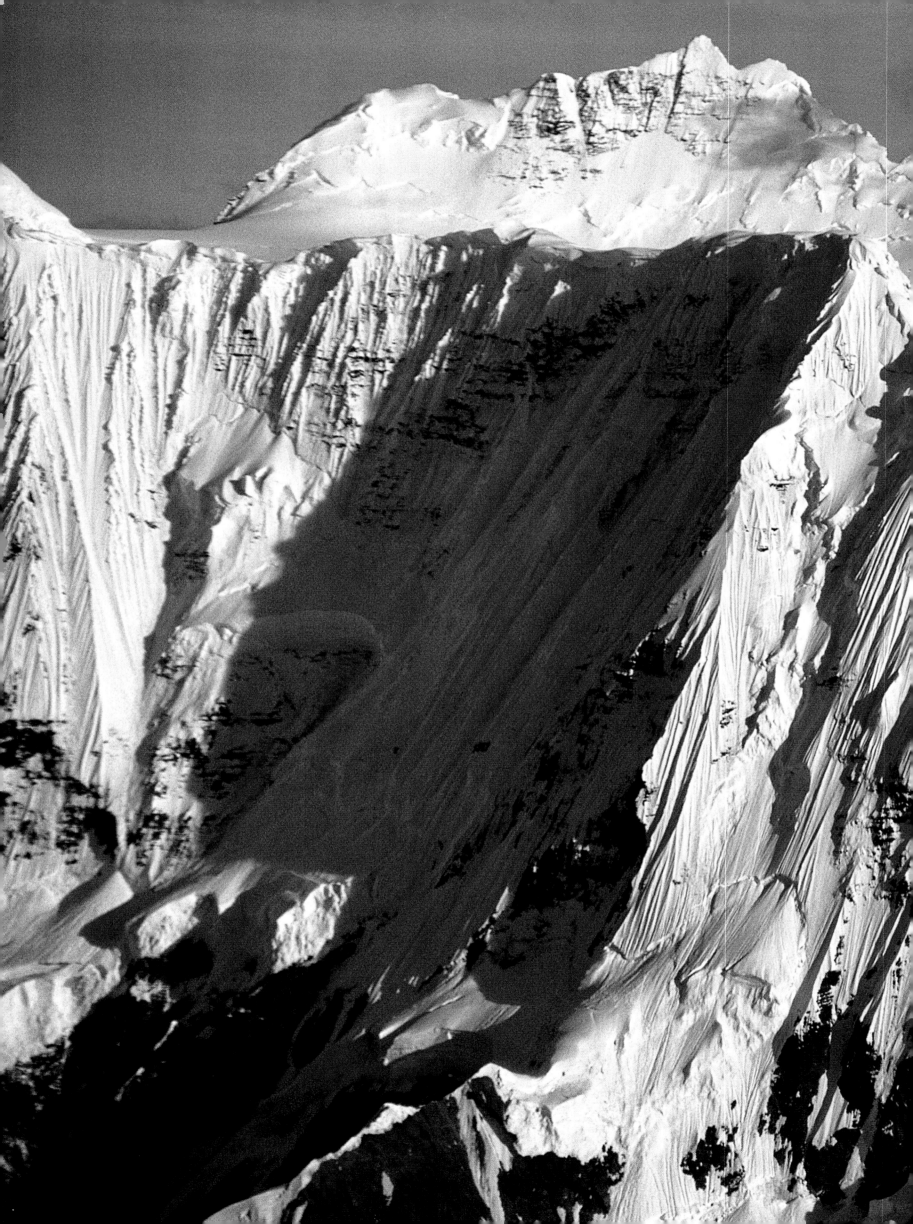

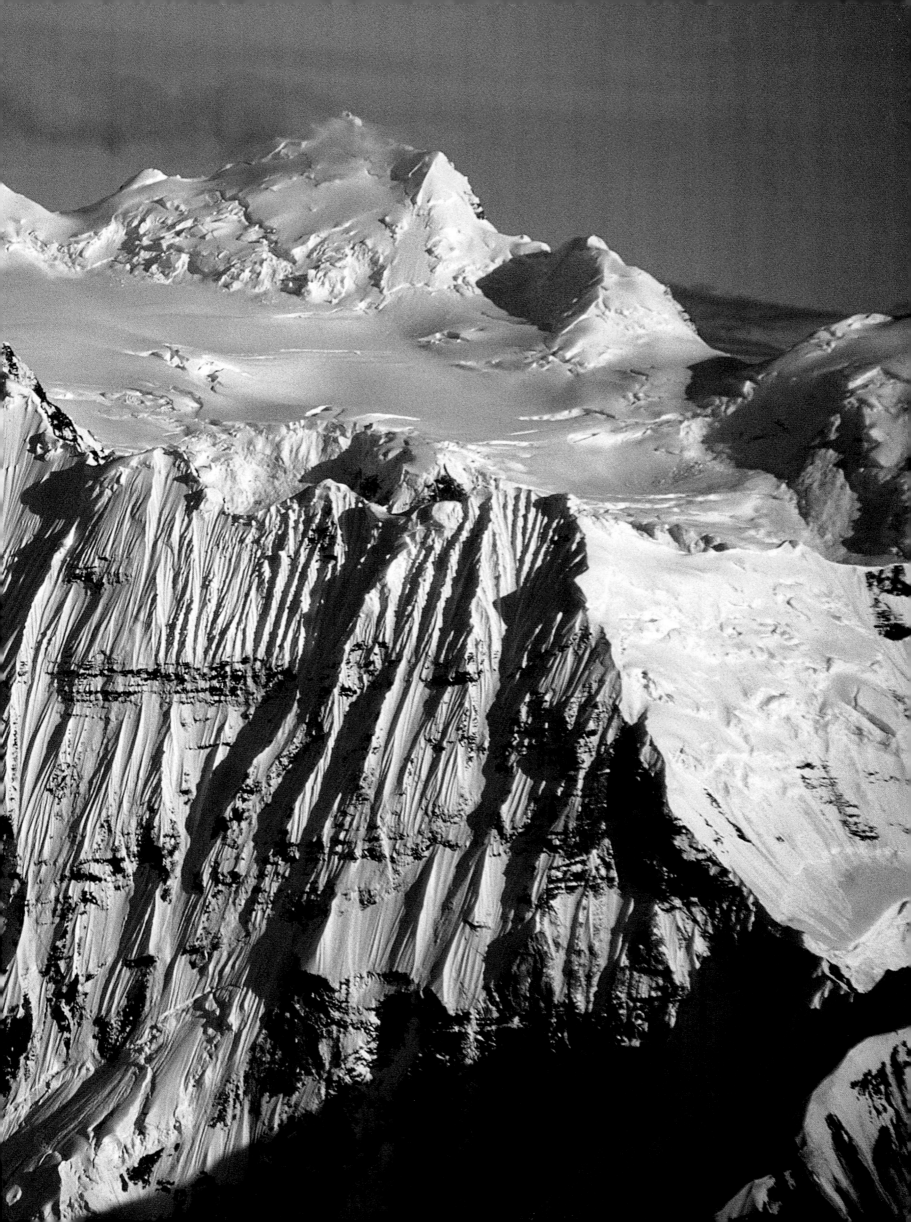

Kenai Fjords NATIONAL PARK

Coastal fjords and rain forest provide habitat for tens of thousands of breeding birds, while the sea supports sea lions, otters, and seals. The 300-square-mile Harding Icefield is one of the four major ice caps in the United States. Proclaimed a national monument in 1978, established as a national park in 1980. Acreage—669,982.99.

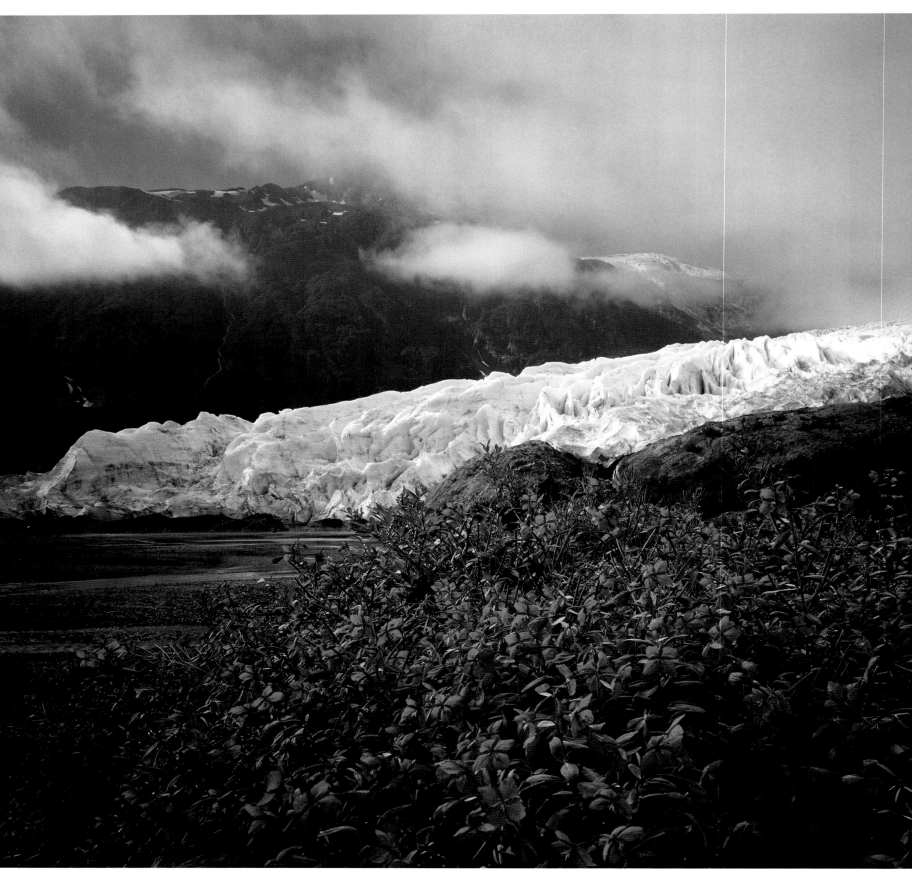

EXIT GLACIER AND FIREWEED

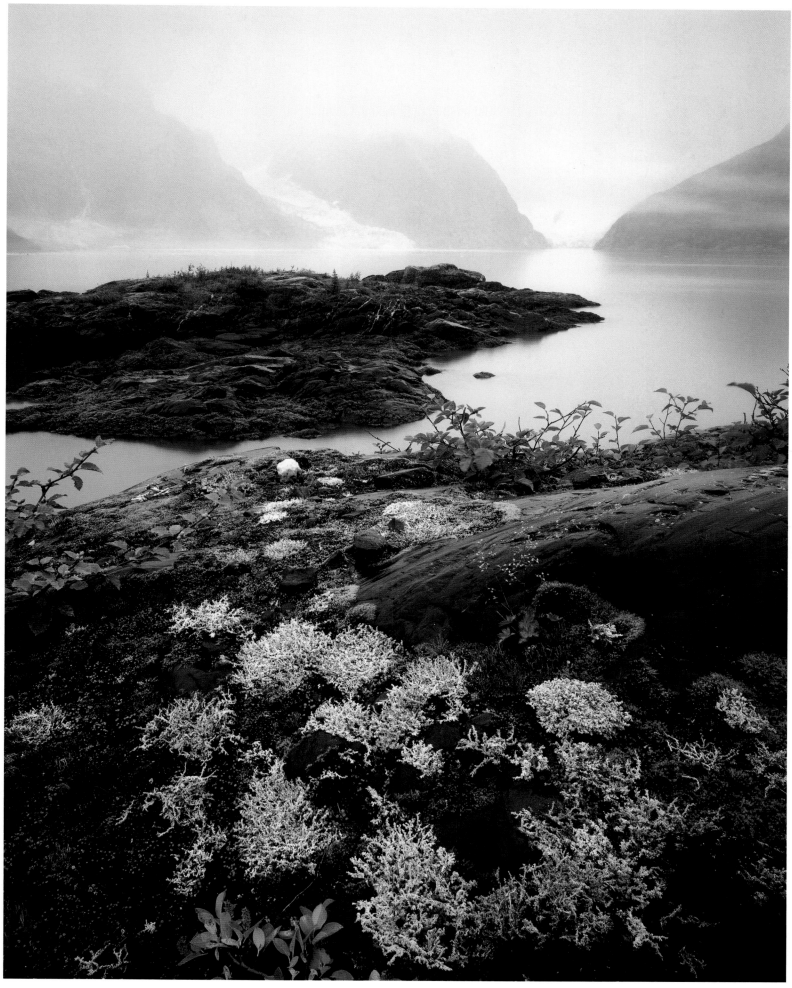

NORTHWESTERN GLACIER AND LAGOON

Katmai NATIONAL PARK AND PRESERVE

Mountains, forests, lakes, marshlands, and wild rivers abound in wildlife. The Alaska grizzly bear—the world's largest carnivore—thrives here, amply sustained by the red salmon spawning in rivers and lakes. Proclaimed a national monument in 1918, established as a park and preserve in 1980. Wilderness designated in 1980. Combined park and preserve acreage—4,093,228.8. Wilderness—3,384,358 acres.

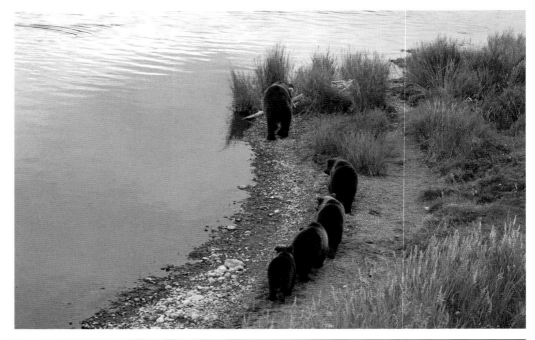

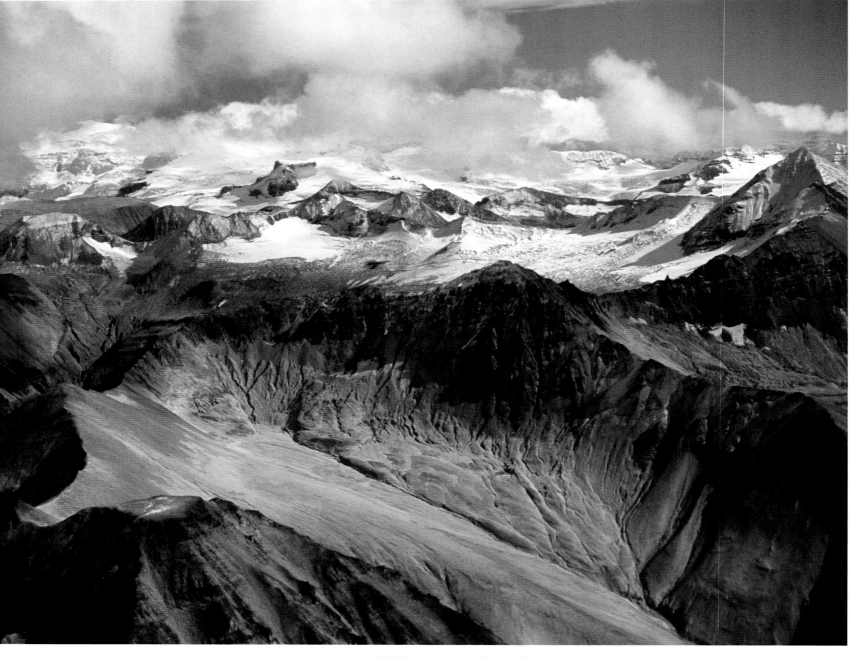

▲▲ GRIZZLY SOW LEADING FOUR CUBS

▲ BARRIER RANGE AND VOLCANIC ASH, VALLEY OF THE 10,000 SMOKES

Lake Clark NATIONAL PARK AND PRESERVE

Jagged peaks, granite spires, two symmetrical active volcanoes, and glacially carved lakes form a land of great geologic diversity. Lake Clark, over forty miles long, is the headwaters for red salmon spawning. Proclaimed a national monument in 1978, established as a national park and preserve in 1980. Wilderness designated in 1980. Combined park and preserve acreage—4,030,500. Wilderness—2,619,550 acres.

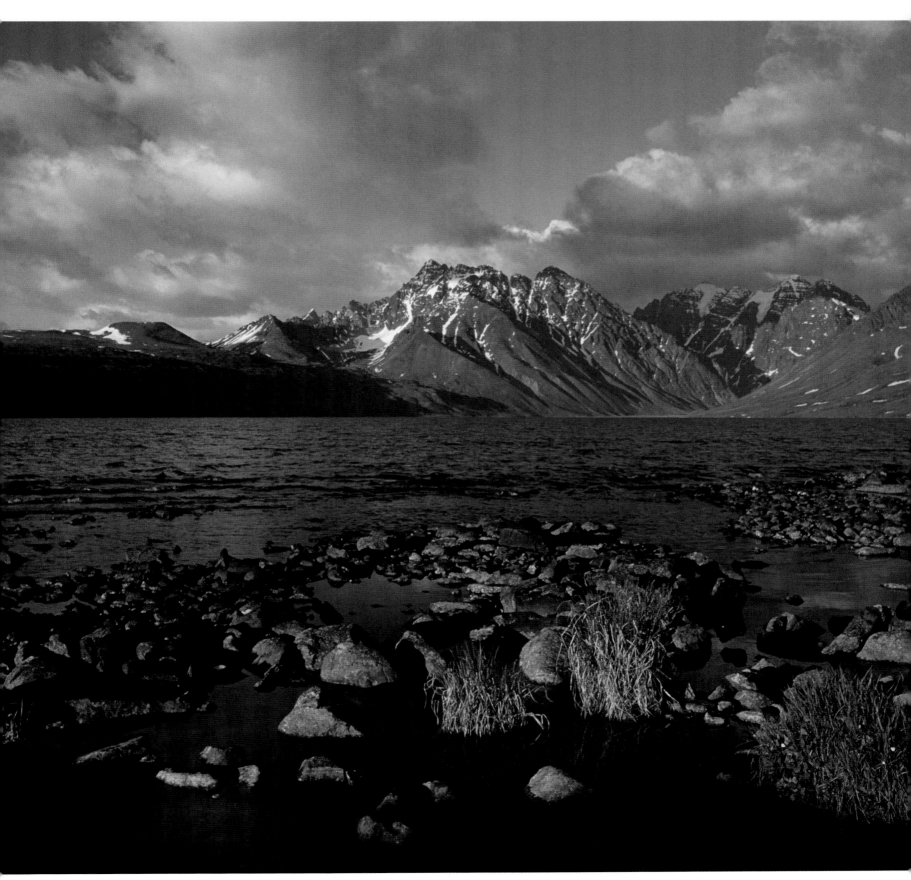

EVENING LIGHT, TURQUOISE LAKE, CHIGMIT MOUNTAINS

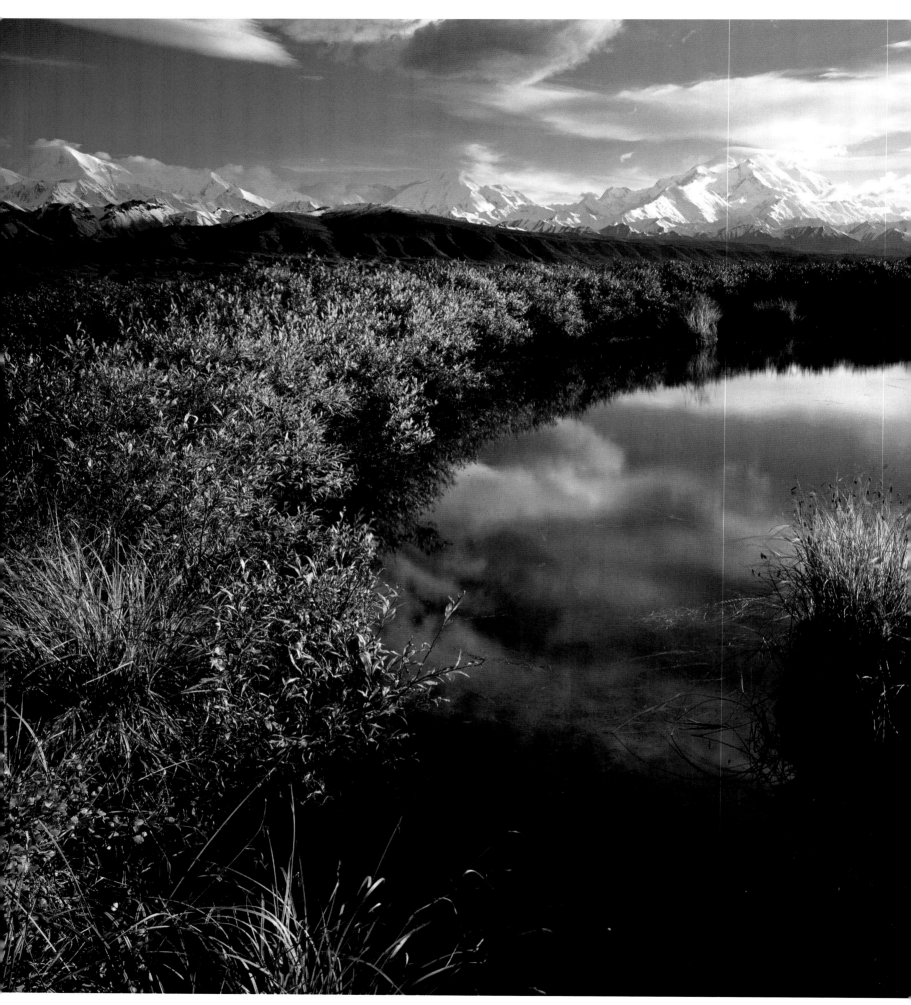

▲ AUTUMN POND, ALASKA RANGE

▶ AUTUMN TUNDRA, MOOSE CREEK

Denali

NATIONAL PARK AND PRESERVE, ALASKA

People wait weeks for the clouds to lift, revealing the Great One, the highest mountain in North America, the reclusive, spectacular 20,320-foot Denali. Mount McKinley. A man I met at Wonder Lake, where every photographer to reach the park goes hoping to photograph the mountain's reflection, told me he had been coming there for fourteen years and, on that day, saw Denali for the first time.

The first time I saw the mountain was my first trip to Alaska, a winter flight from Anchorage to Fairbanks. The sky was completely clear and the mountains free of clouds. The pilot dipped a wing in homage to the mountain as we passed. The next time I saw it was eight years later, when David and I spent about two weeks in the park in late August and September 2001. We woke to a view of it, or rather, to bits and pieces of a view, each of our ten mornings at Camp Denali near the end of the single, ninety-three-mile-long park road. Clouds, formed by moisture coming off the Gulf of Alaska to the west, bump up against the Alaska Range, of which the mountain is a part. The clouds lift off the lower peaks, which range from 13,000 to 17,000 feet. They often do not lift off Denali/Mount McKinley. (*Denali*, an Athabascan word for the peak meaning "the High One," seems to me its rightful name and I refer to it by that name. It is the official name of the national park.) In the days we were there, the mountain emerged fully a couple of times at sunset, but mostly we saw only sections of it as cloud veils drifted and lifted and settled across its faces.

Denali National Park, country of wide-open tundra and taiga and blue glaciers, of twisting braided rivers and an extraordinary diversity of plant and wildlife, is among the largest and most intact natural areas in the United States. The two-million-acre Mount McKinley National Park, established in 1917 to protect wildlife, was designated as wilderness in 1980 when

Congress also added four million acres of surrounding lands and renamed the whole thing Denali National Park and Preserve. In 1976 UNESCO named it an International Biosphere Reserve.

The absence of private vehicles in the park keeps road maintenance to a minimum and controls human interference with wildlife. During our stay at Camp Denali, a camp bus, with its naturalist driver, took us out along the narrow unpaved road daily. When animals were sighted, he stopped so we could watch or photograph. There was no lack of wildlife. A bull moose stood

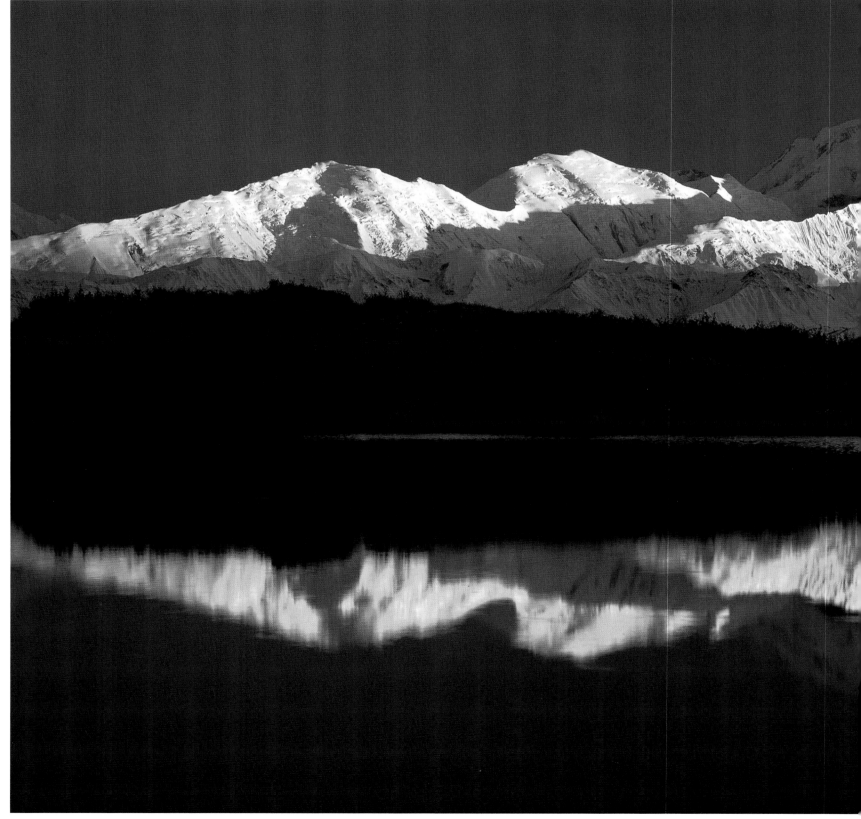

MOUNT McKINLEY REFLECTIONS

in a pond, his antlers dripping with vegetation and old velvet. Caribou posed along the skyline. Dall sheep moved about the hillsides. Grizzly bears, preparing for winter, gorged on plentiful tundra berries. A sow and two cubs ambled along the road. I scanned the tundra for wolves and bears, for blueberries to eat, for soft dry tussocks on which to sit.

We often left the bus to hike or to photograph. In late August and early September, the tundra lay in brilliant colors—deep red, gold, chartreuse, mauve, and purple. One cold, wet day the bus drove in and out of snowstorms for six hours. Stopping in late afternoon in sight of a pond

People wait weeks for the clouds to lift,

revealing the Great One, Denali.

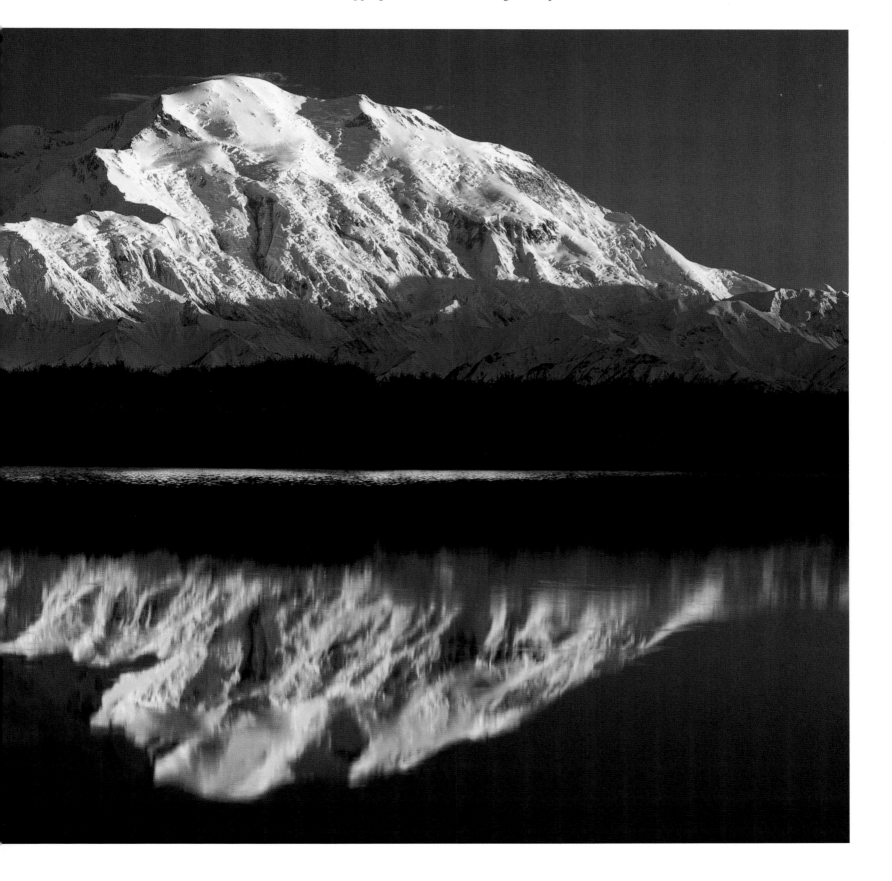

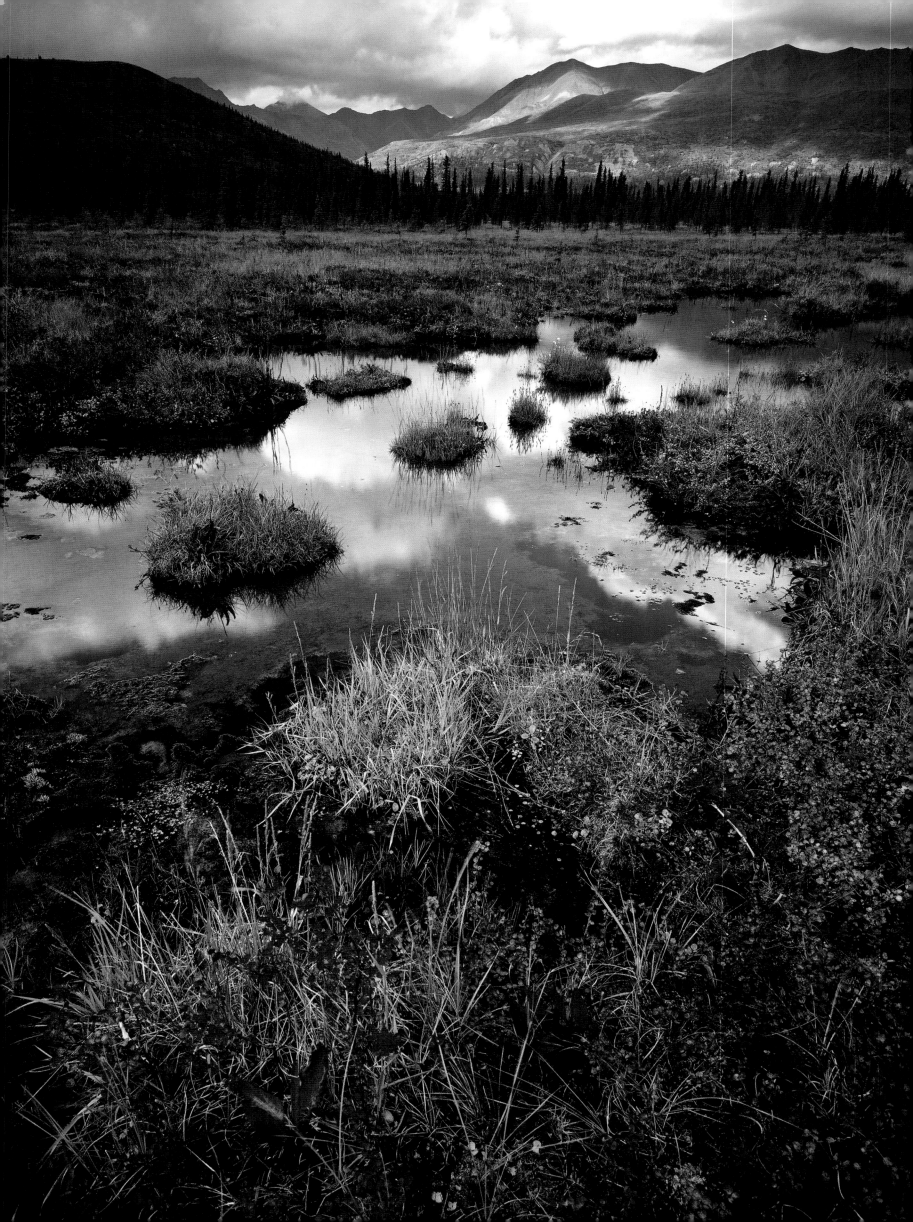

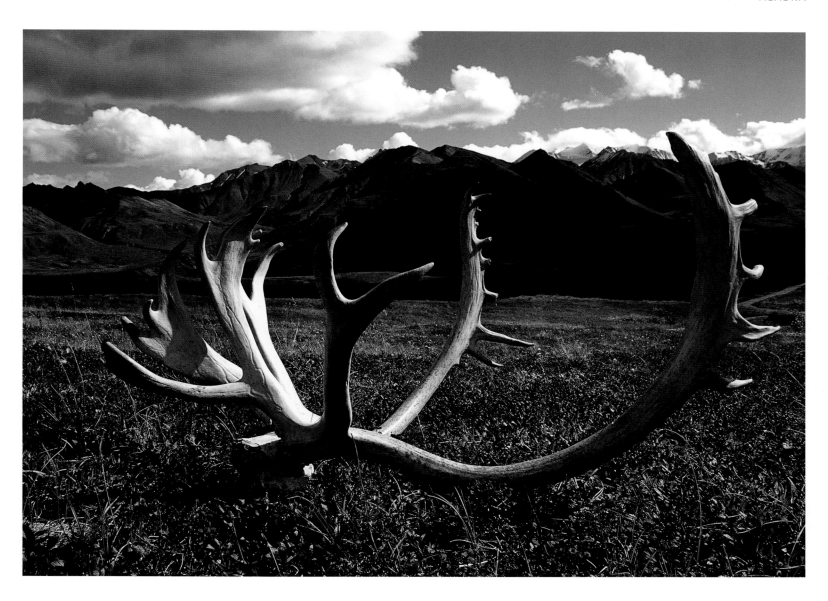

scoured out of the earth by some ancient passing glacier then lined with soft green grasses rising above a thin layer of snow, we waded thigh-deep through wet, tangled brush to reach it. At that moment, 10,000 sandhill cranes passed overhead. Riding the sky 5000 miles south from Alaska's Kuskokwim Delta to Mexico, they came in wave after wave after wave, the sky filled with their trumpeting sound.

On September 9, we moved to the Denali Backcountry Lodge in the Kantishna Hills, the northernmost foothills of the Alaska Range, the absolute end of the road. Although the air had cleared, a nonstop wind started, marring any possible reflection in Wonder Lake. We wandered about the tundra and the banks of Moose Creek. On the morning of September 11 we heard the news of New York from a man who had happened to call his office before breakfast.

Everything in Denali National Park, as in all the Alaska national parks, is remote from the rest of America. Wildness comprises its own world and its own time. The concerns of "civilized" worlds are essentially irrelevant. At the lodge, there is no television and no radio. There is one public pay phone. Cell phones don't work. Somebody managed to get a hookup between the office speakerphone and CNN, and we sat in the lodge living room, listening to the news. At the literal end of the road in a wild place, all we could do was listen.

We drove out to Wonder Lake. It was mirror still. The cloud-scudded sky was deep blue, the willows golden, the tundra colors dazzling, the mountain entirely clear. There was a sweetness in the air, a clarity. It was like the dawn of Earth. It was as if the universe wanted us to know that beauty and nature and life exist.

Large glaciers, vast tundra and taiga, and, towering above it all, the Great One, 20,320-foot Mount McKinley—Denali—the highest mountain in North America, mysterious, elusive, magnificent. Here is habitat for grizzly bears and wolves, Dall sheep, moose and caribou. Established as Mount McKinley National Park in 1917 and Denali National Monument in 1978, combined and established as Denali National Park and Preserve in 1980. Wilderness designated in 1980. A Biosphere Reserve. Combined acreage—6,075,106.7. Wilderness— 2,146,580 acres.

◄ SEPTEMBER REFLECTIONS, ALASKA RANGE, SOUTH

▲ CARIBOU ANTLERS, ALASKA RANGE

Gates of the Arctic

TAIGA FOREST GRASSES IN AUTUMN, ENDICOTT MOUNTAINS

▲ ▲ BIRCH BOLES, ENDICOTT MOUNTAINS

▲ ARCTIC COTTON

The park and preserve include a portion of the
Brooks Range, the northernmost extension of the
Rocky Mountains. Here, north of the Arctic Circle,
jagged peaks, gentle arctic valleys, lakes and wild
rivers combine with adjacent Kobuk Valley
National Park and Noatak National Preserve to
form one of the largest park areas in the world.
Proclaimed a national monument in 1978,
established as a national park and preserve in
1980. Wilderness designated in 1980. A
Biosphere Reserve. Combined acreage—
8,472,441.7. Wilderness—7,245,600 acres.

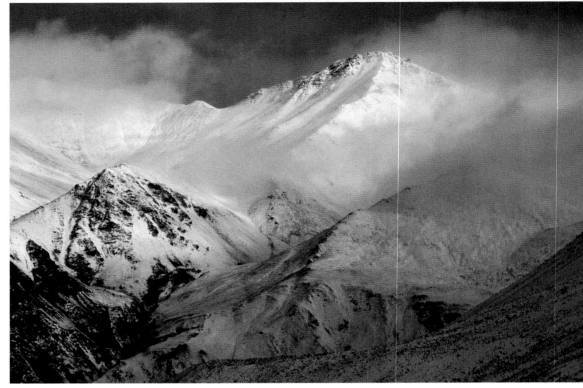

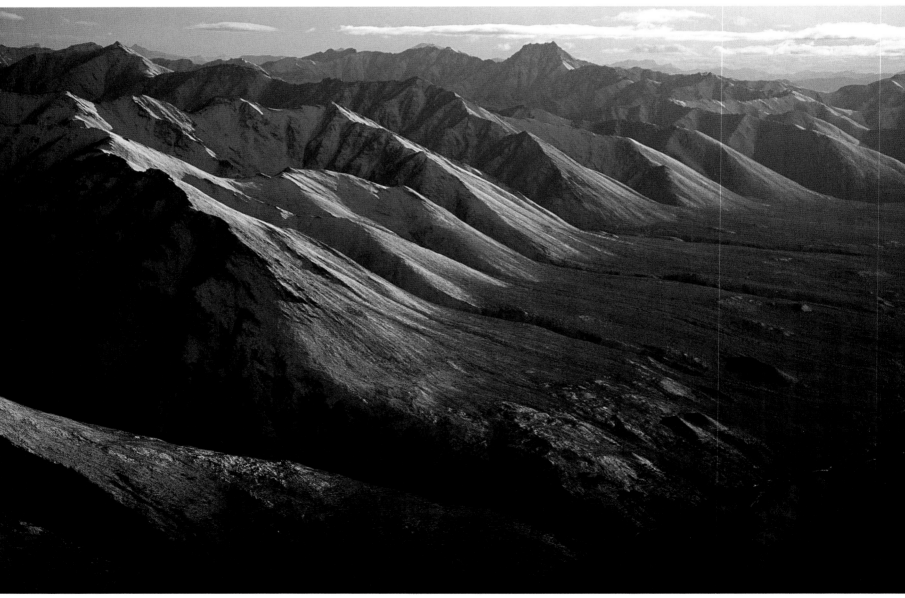

▲ ▲ FRESH SNOW, BROOKS RANGE

▲ GATES OF THE ARCTIC

Kobuk Valley NATIONAL PARK

Embracing the central valley of the Kobuk River in the northernmost extent of the boreal forest, the park provides habitat for a rich array of arctic wildlife—grizzly bear, wolf, fox, and caribou. Proclaimed a national monument in 1978, established as a national park in 1980. Wilderness designated in 1980. Acreage—1,750,697.75. Wilderness—174,545 acres.

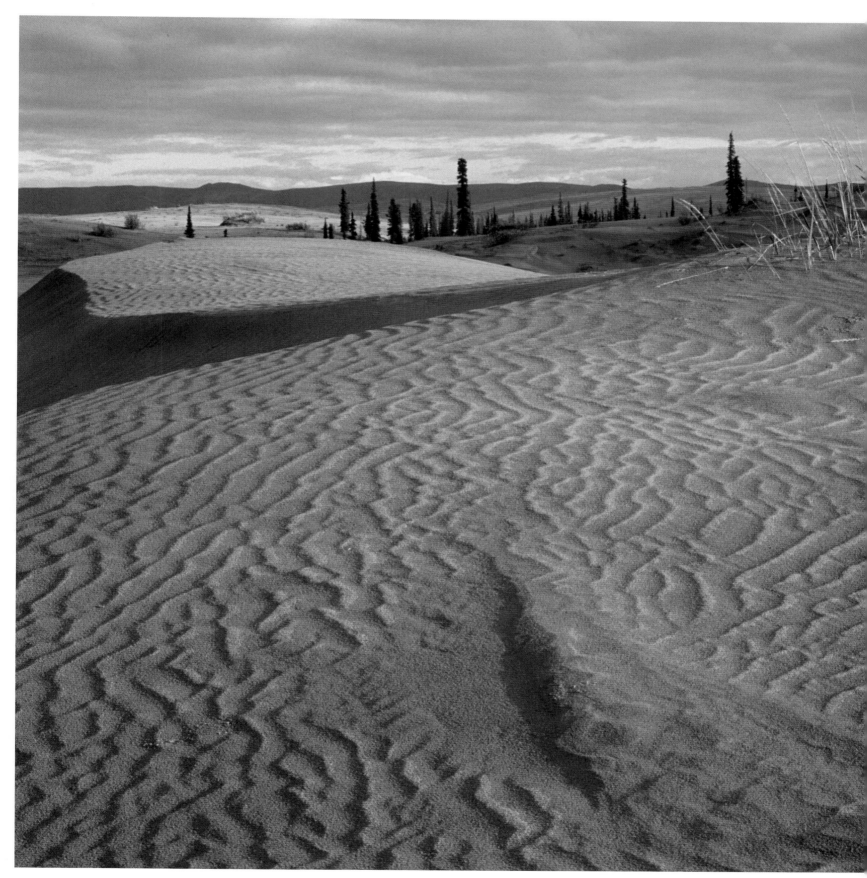

GREAT SAND DUNES, FALL

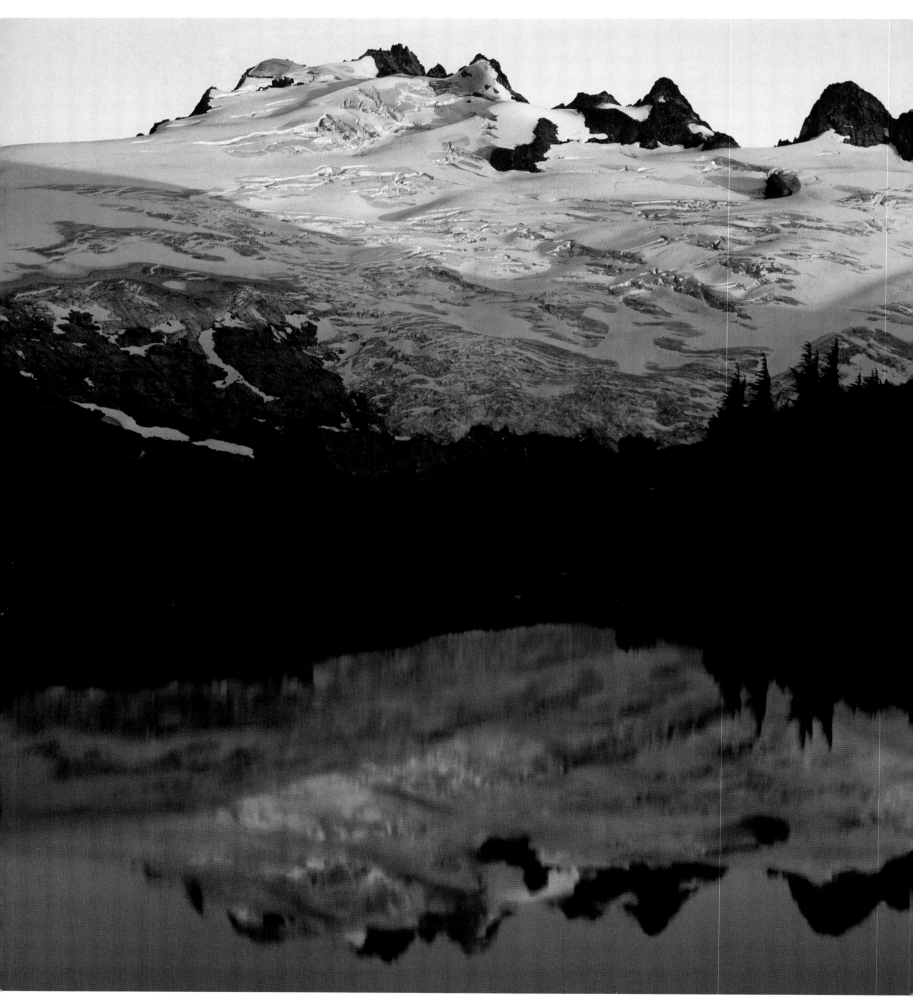

MOUNT CHALLENGER AND CHALLENGER GLACIER

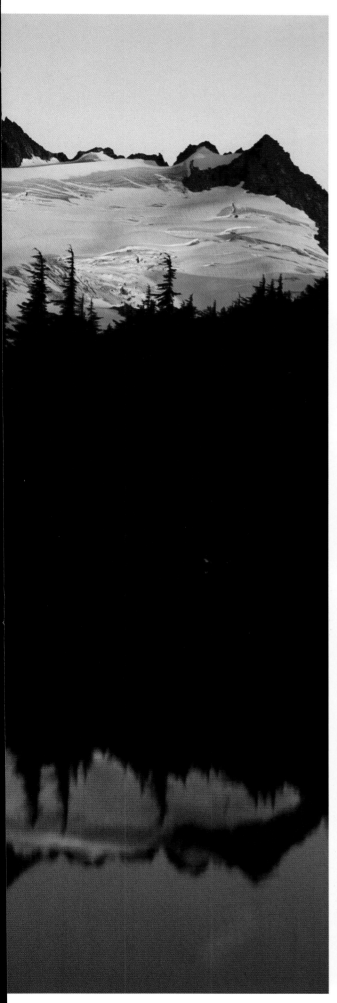

The wild, high, jagged peaks of this wilderness park intercept moisture-laden winds to produce glaciers, waterfalls, rivers, lakes, and lush forests. The Stephen Mather Wilderness Area extends beyond the park into the Lake Chelan and Ross Lake National Recreation Areas. Established in 1968. Wilderness designated in 1988. Acreage—504,780.94. Wilderness—634,614 acres, making a combined wilderness area greater than the park acreage.

MOUNT SHUKSAN FROM KULSHAN RIDGE

Mount Rainier NATIONAL PARK

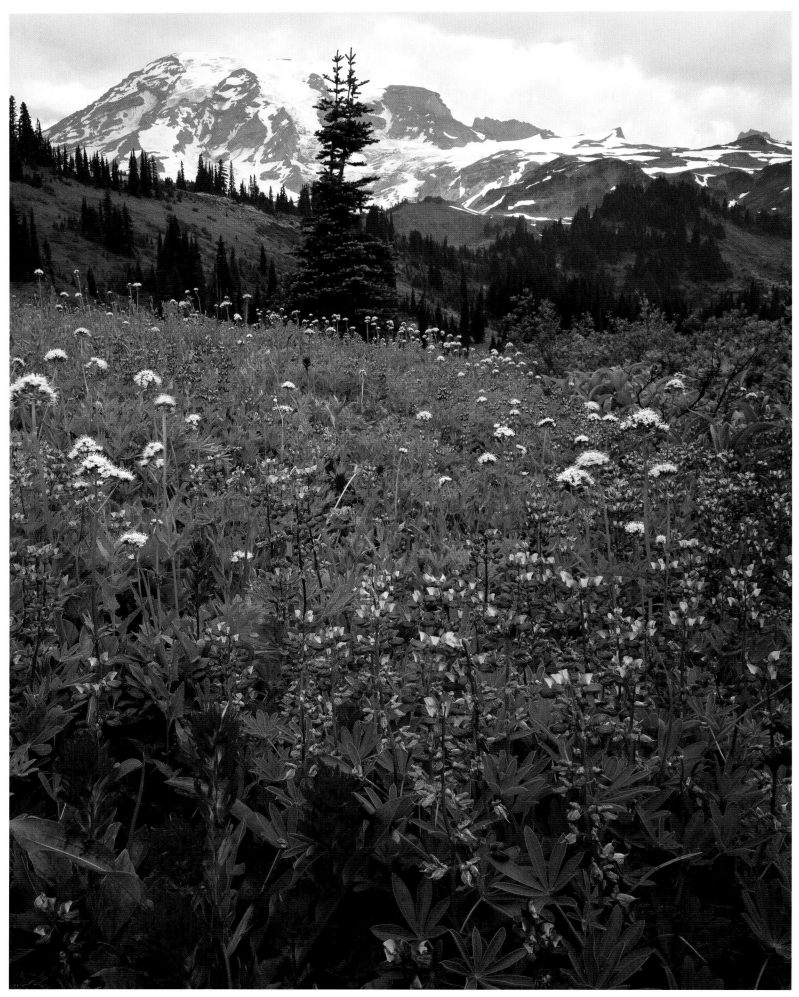

MOUNT RAINIER FROM PARADISE VALLEY

The greatest single-peak glacial system in the United States radiates from the summit and slopes of an ancient volcano. Deep forest and subalpine meadows cover the land below the glaciers. Established in 1899. Wilderness designated in 1988. Acreage—235,612.50. Wilderness—228,480 acres.

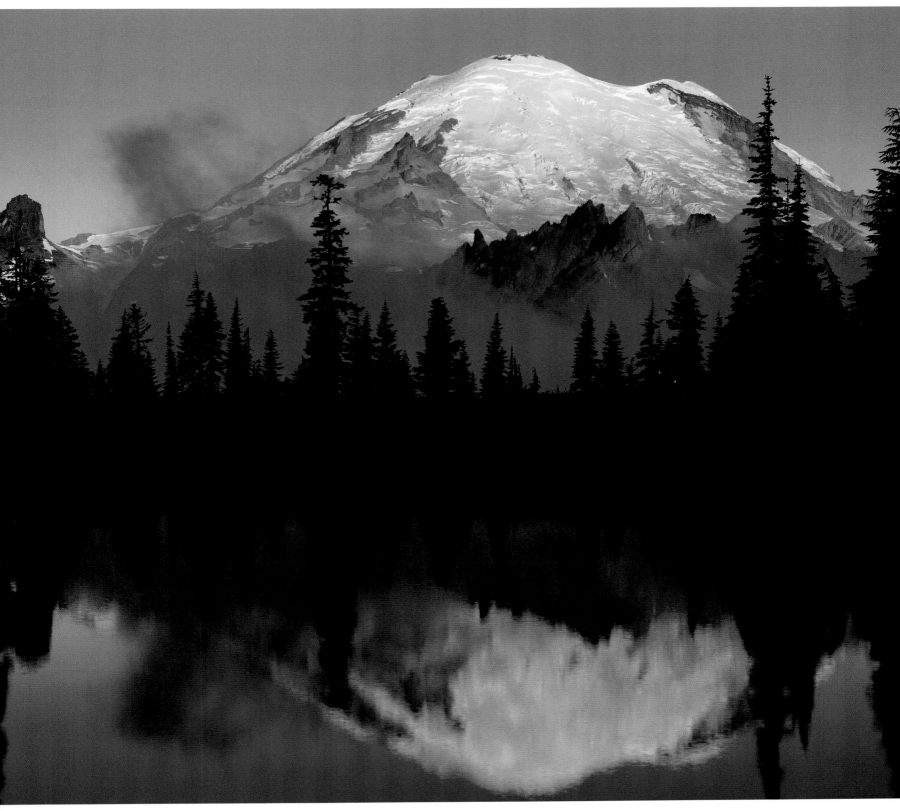

MOUNT RAINIER FROM CHINOOK PASS

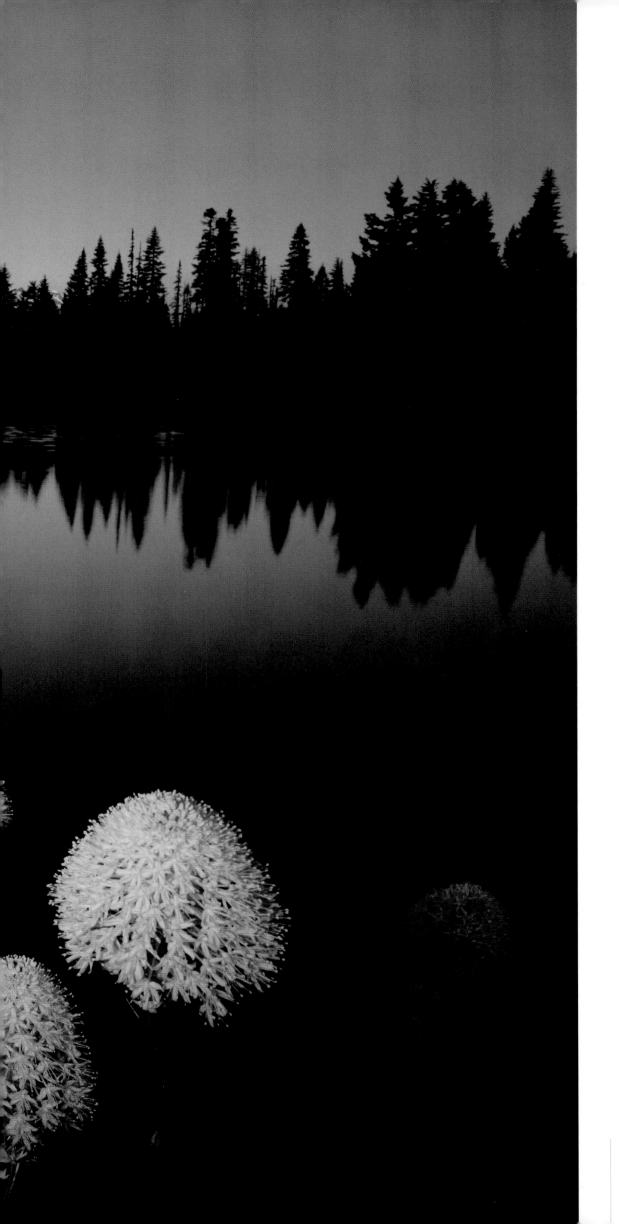

BEARGRASS AND MOUNT RAINIER, EUNICE LAKE,

Mount Rainier National Park

71

Crater Lake NATIONAL PARK

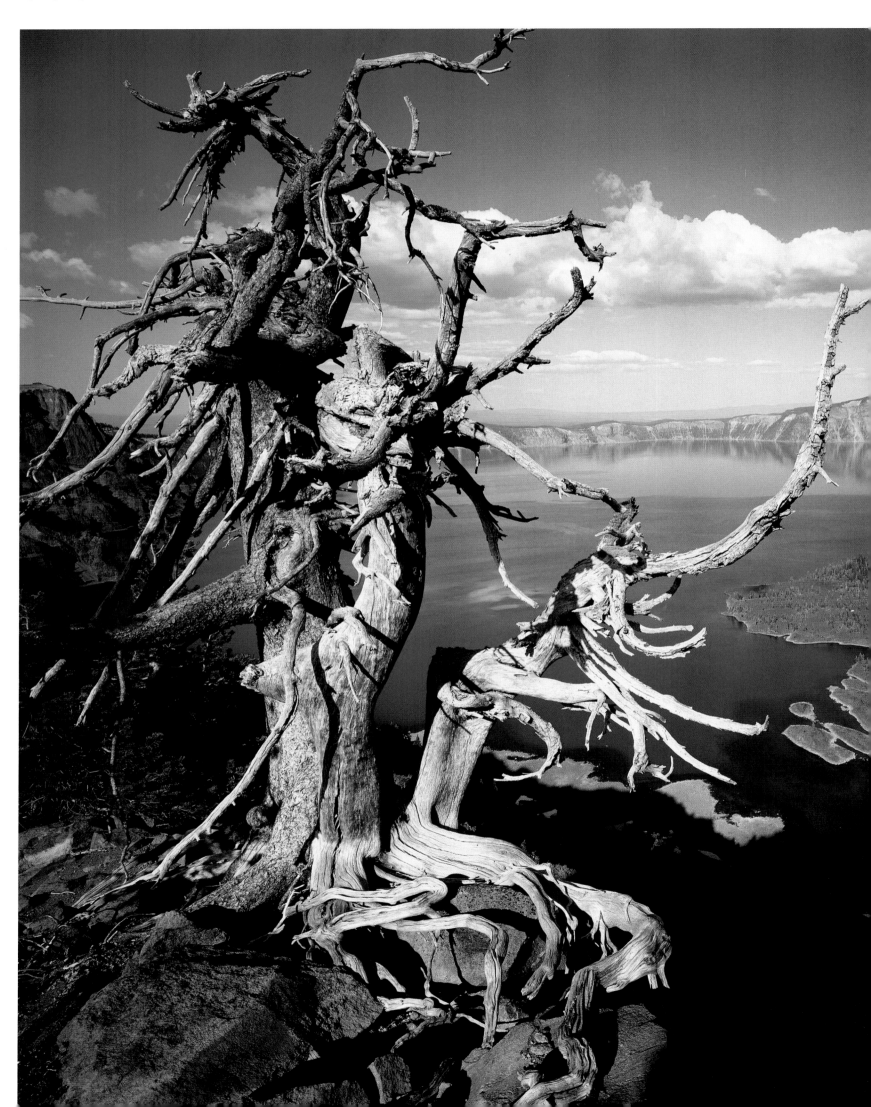

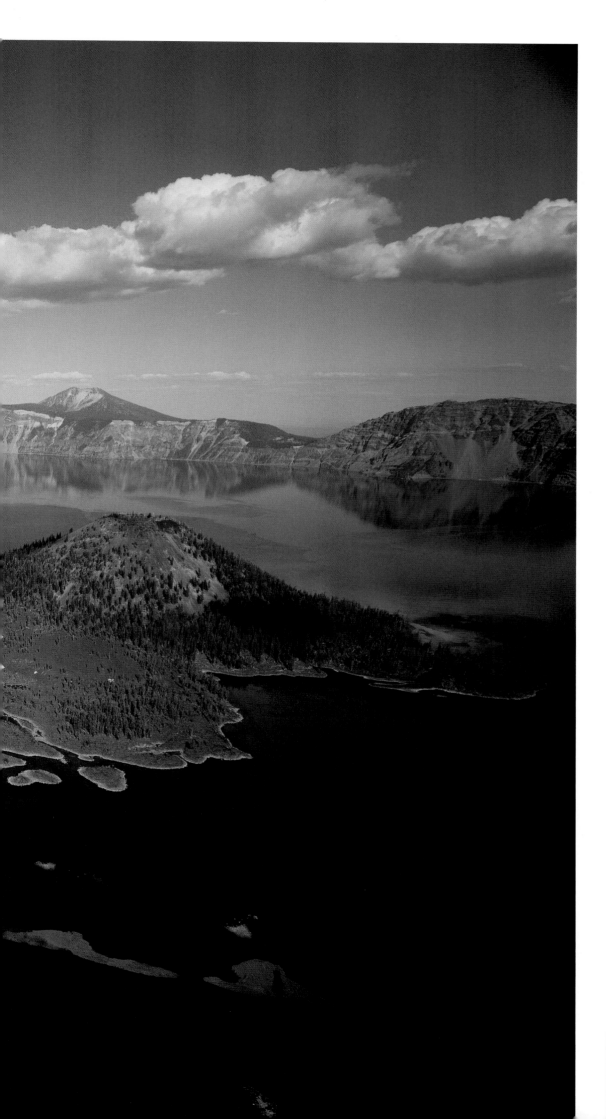

A pristine blue lake—at 1932 feet deep, the deepest in the United States—lies within the caldera of the collapsed Mount Mazama, a volcano of the Cascade Range that erupted about 7700 years ago. Established in 1902. Acreage—183,224.05.

WHITEBARK GHOST AND WIZARD ISLAND

Lassen Volcanic NATIONAL PARK

Boiling springs, steaming fumaroles, mud pots, and sulfurous vents maintain the activity of this volcano that erupted intermittently between 1914 and 1921. Proclaimed Lassen Peak and Cinder Cone National Monuments in 1907, redesignated as part of Lassen Volcanic National Park in 1916. Wilderness designated in 1972. Acreage— 106,372.36. Wilderness—78,982 acres.

CINDER CONE SILHOUETTE

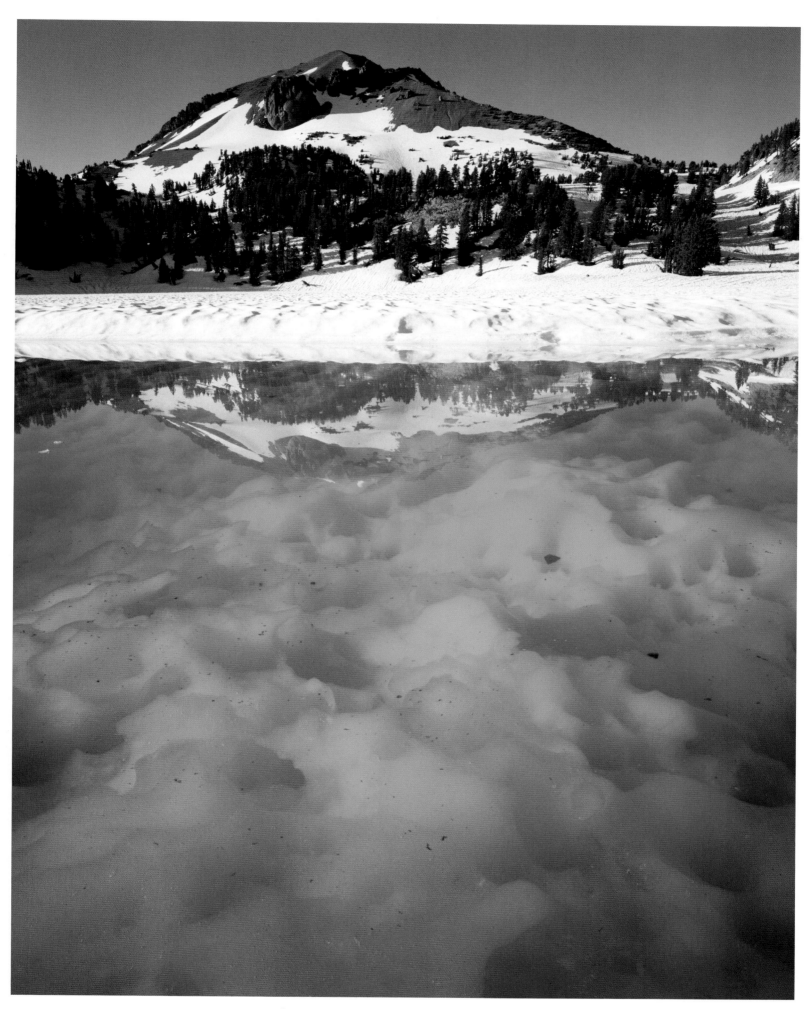

SNOWMELT, LAKE HELEN, LASSEN PEAK

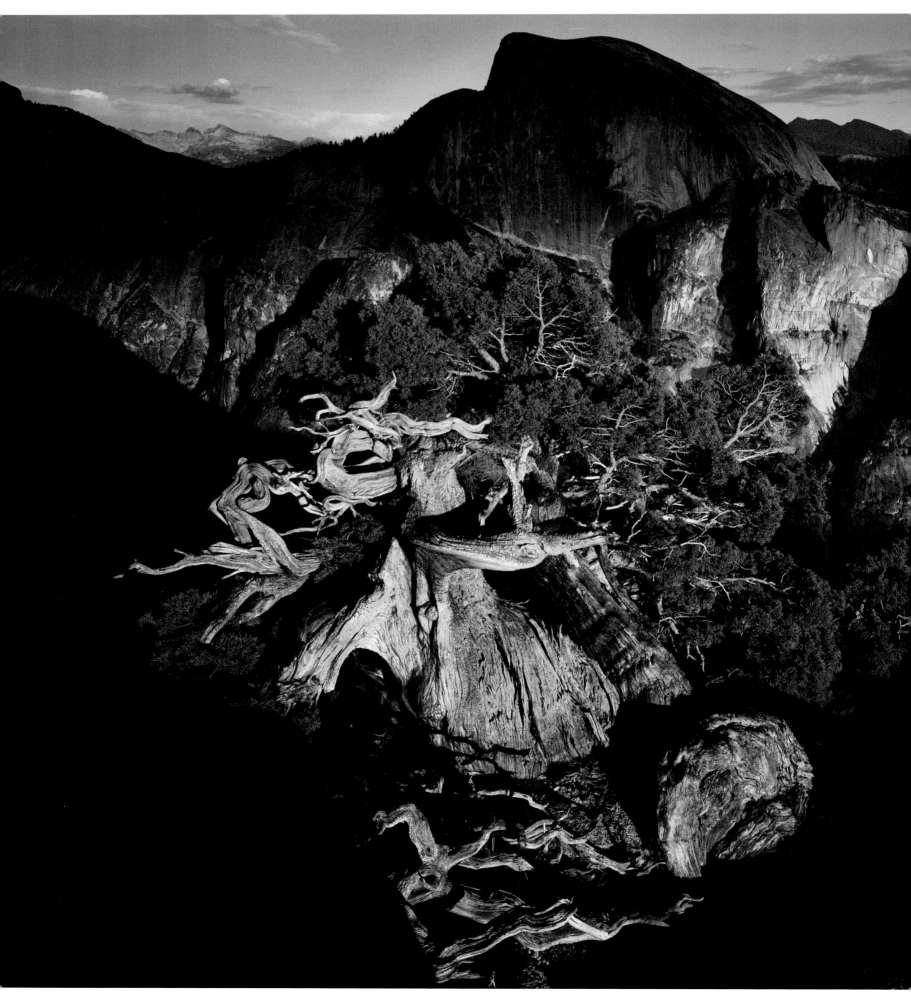

▲ SIERRA JUNIPER AND HALF DOME

▶ AUTUMN POND, YOSEMITE VALLEY

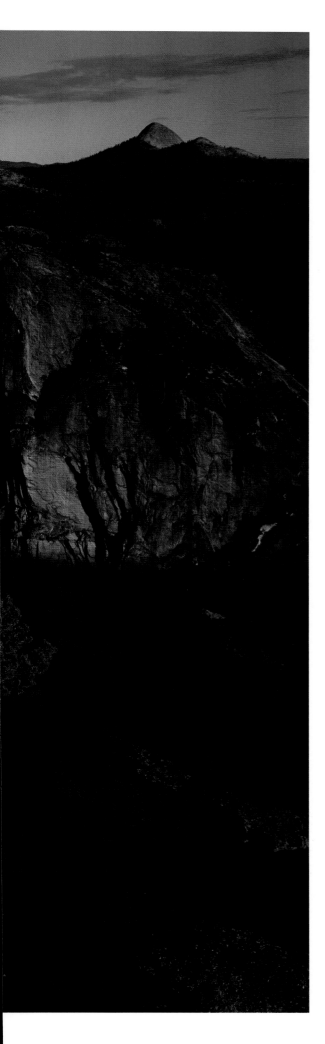

Yosemite

NATIONAL PARK, CALIFORNIA

I watched David climb the slope from the meadow toward Donahue Pass on the southwest and Mount Lyle, directly west. I could see Mount Lyle, where he was headed, and the glacier embracing it. He looked tiny, mounting the hill, vulnerable, in the hugeness of the Sierra wilderness. Wilderness, the constant reminder of who we are, makes us kin to the smallest alpine flowers clinging to rock in worlds above tree line. They thrive in this world. So do we.

I lay back on a white granite boulder contoured to my body. (There is no rock so comfortable as granite.) Red paintbrush, purple elephant heads, small white daisies waved across the green meadow. Gusts of wind blew up and depleted, like the earth breathing. Streams running from the surrounding heights fed a large pond and a small one. The singing of robins, an occasional whistle of marmots, pierced the sound of a waterfall plunging down the slope David climbed. Tiny pines, like Japanese bonsai, grew near the edge of the large pond. Hot sun, cold wind, crisp air, willows before me, a stand of pines on the rise behind me, silence, but for the wind, the waterfall, the lapping water in the big pond when the wind blew, the robins, the marmots. No other person. No cloud in the deep blue sky. I love the depth of blue in this sky, although David keeps searching for clouds for his photographs. I once read an article in which his father, the photographer Josef Muench, was quoted as saying, "I would feel lonely if there were no clouds."

Returning to camp, I continued down to a small pool below the waterfall almost directly downslope from camp, and, disrobing, climbed in. Shallow, it afforded me a place to sit, providing me a sense of connection with this place, a kind of personal baptism. Everywhere I go in wild country, I seek out a stream or a lake or a waterfall pool. Because we are made mostly of water, and because we come from water to begin with, entering water is literal connection with who we are.

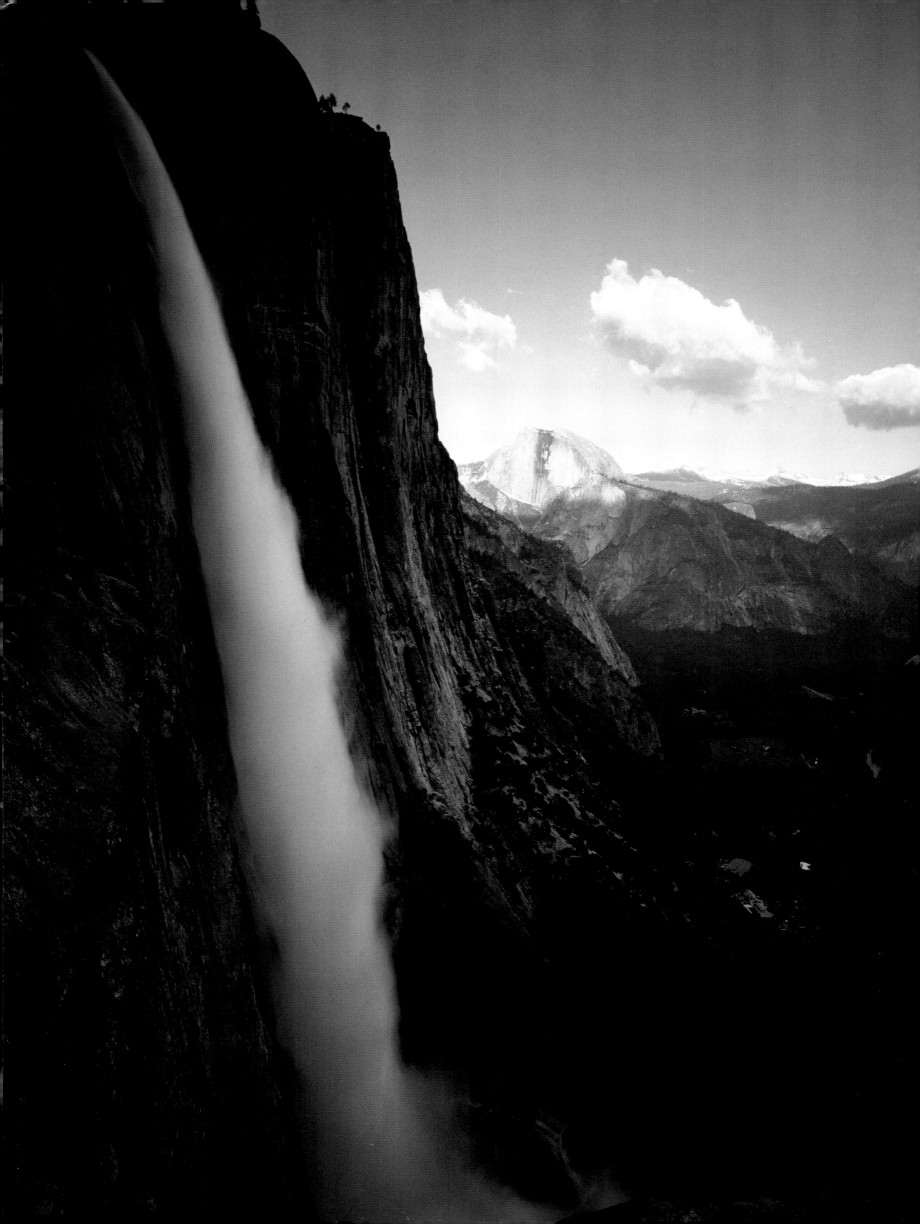

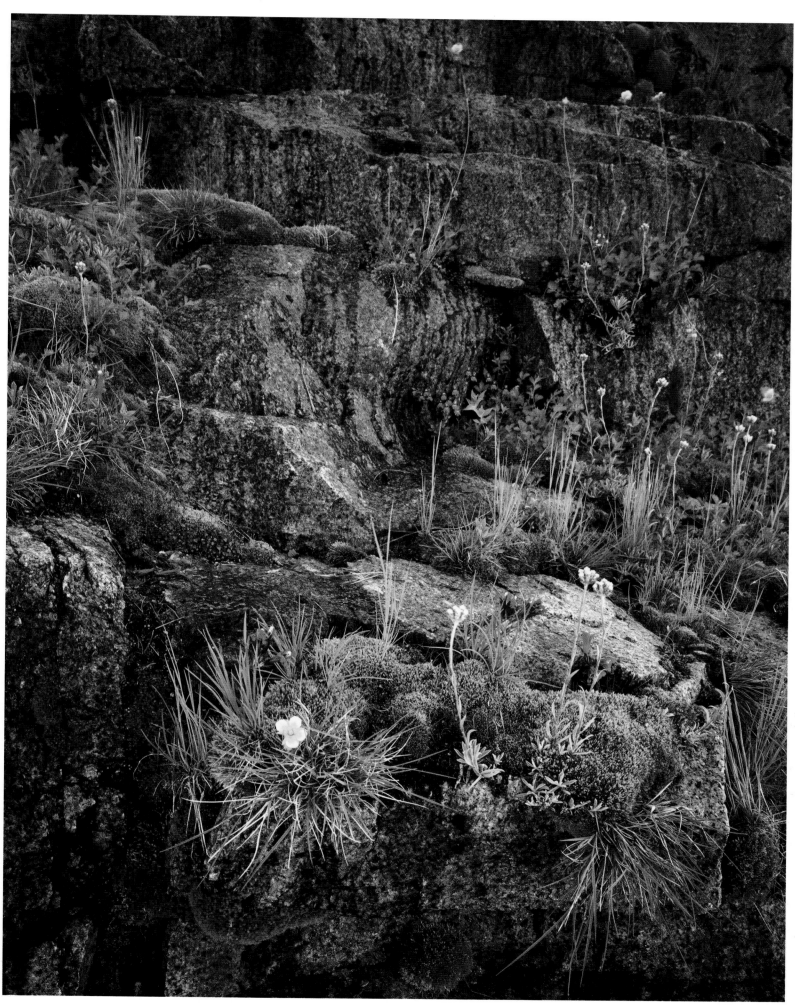

◀ YOSEMITE FALLS AND HALF DOME, *Yosemite National Park*

▲ GARDEN ON GRANITE WALL, SNOW CREEK CANYON, *Yosemite National Park*

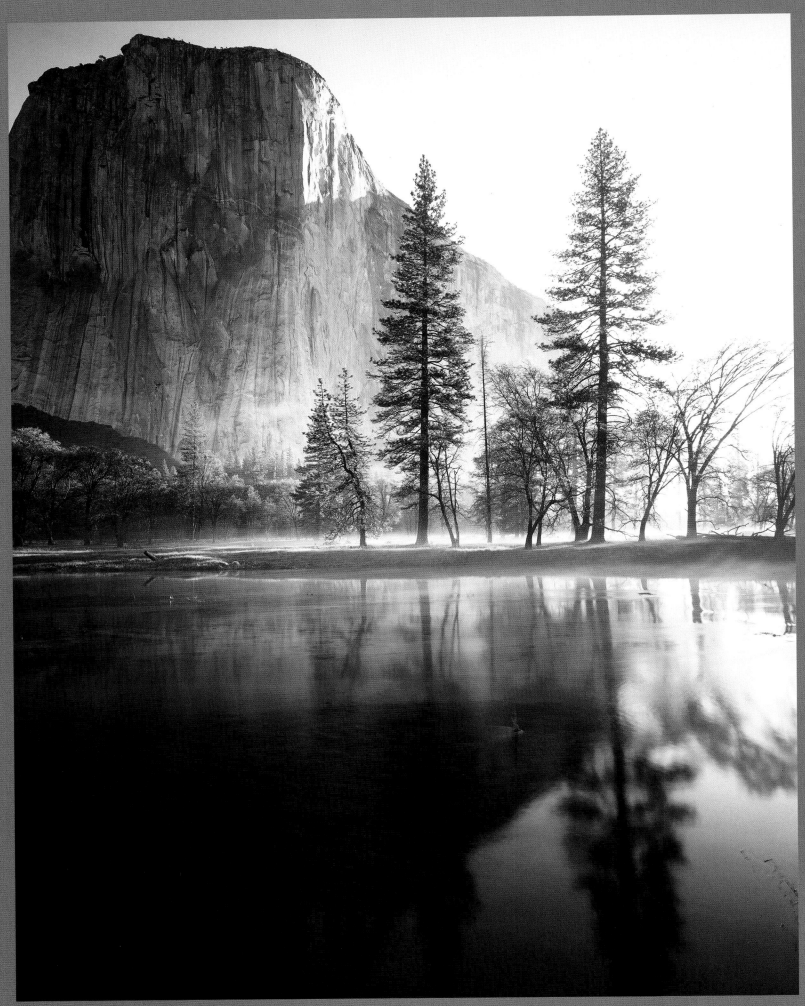

MERCED RIVER REFLECTIONS AND EL CAPITAN

Yosemite offers many water lessons. On an earlier visit, I climbed 600 stone steps to the top of Vernal Falls along with hundreds of other visitors, all of us looking like pilgrims on some Tibetan pilgrimage. Water spray from the falls whipped sideways across the steps and the pilgrims. Forced to pay attention to the steps in wet mist, everything else slid away from my mind. For the time it took to reach the top, this was all there was to life. On top, finding space on the dry, welcoming rock where the throngs ahead of me had sprawled out to dry in warm spring sun, I suddenly understood this hike as an initiation, another baptism.

In spring, snow-swollen streams plunge over every falls in Yosemite. All the force, the necessity, the urgency of the wild, explodes across an untrammeled earth. In this walk to the top of Vernal Falls—in spite of the steps built to accommodate tourists, in spite of the railing at the top of the falls to keep them from tumbling over it in that single irreversible moment that would forever unite them with the stream—this falls, this season, makes this a wild place. Sitting on top, alone, surrounded by all these people, I wondered about the definition of wilderness. Does the presence of people negate the force of wilderness, of wildness?

Before Yosemite was a national park, there were no steps to the top of Vernal Falls. And no fence. And yet this rock over which the river crashes in spring, the unharnessed water itself, the forest that surrounds it, the great rock walls that contain the forest—can one say this place is not wild merely because there are (too many) people in it?

In Yosemite's backcountry, I have walked miles and days across a less peopled landscape. On my first trip to Yosemite, I never even *saw* Yosemite Valley. Although I had heard of its crowds, I could not have conceived the immensity of them, or the radically different impression one gets there. Once I left the tent camp at Tuolumne Meadows for a six-day, 48.7-mile hike in which I

Granite peaks, domes and monoliths, sheer granite walls, spectacular waterfalls, rivers, lakes, broad meadows, and giant sequoias form this land in the heart of the Sierra Nevada. Established as a national park in 1890. Wilderness designated in 1984. A World Heritage Site. Acreage—761,266 (plus 1397.99 acres of El Portal administrative site, adjacent to park). Wilderness—704,624 acres.

SNOWMELT AND YOUNG LAKES, MOUNT CONNESS

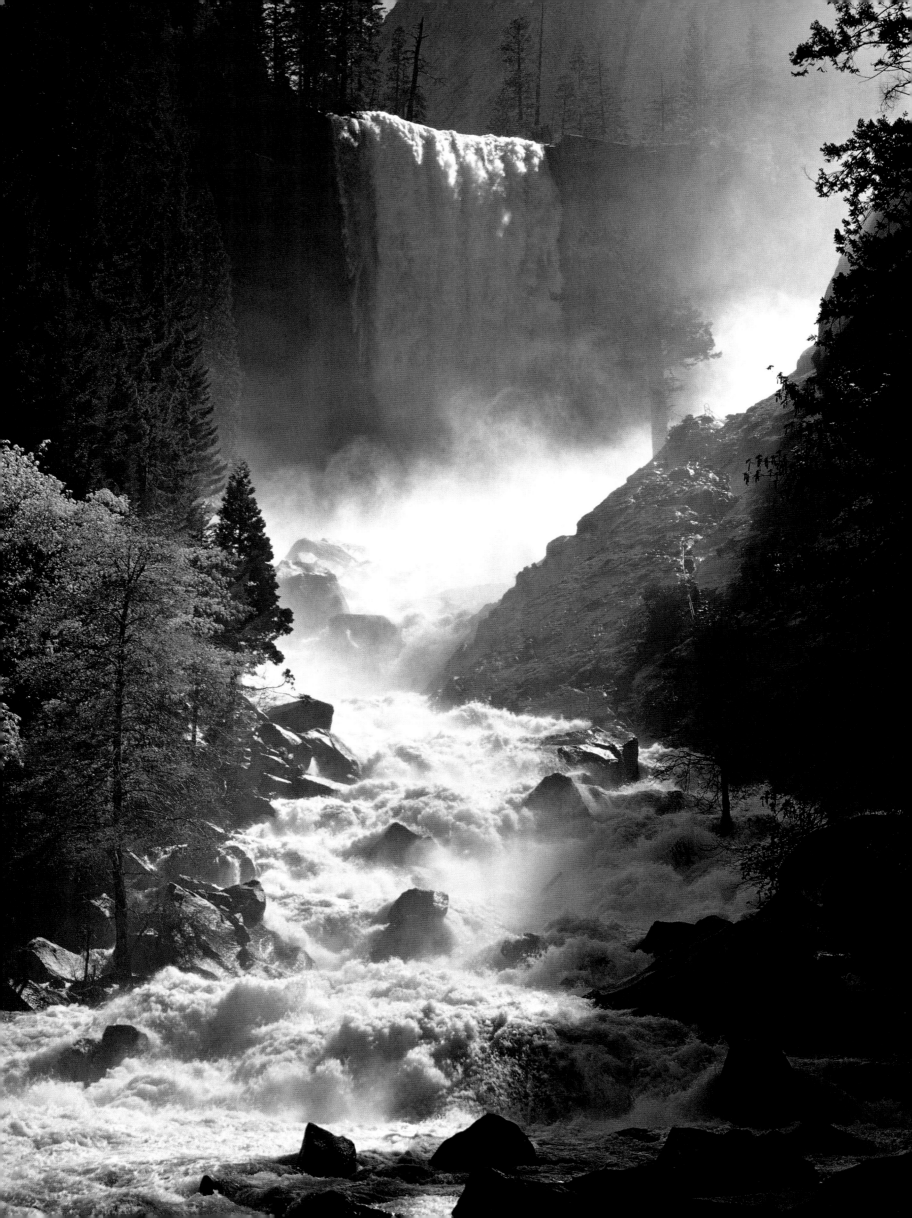

spent the nights in the High Sierra Tent Camps, Yosemite was, for me, a wild place of sun-hot rock as smooth as marble, where sparkling streams danced across rock, where wildflowers colored the meadows, and deep forest revealed bears who went their way, as I went mine, neither of us interrupting the other. (In the years since I made that hike, there have been many more problems with bears in Yosemite, or rather, many more problems with careless people.) A sunset I spent at the Glen Aulin Camp has colored every sunset I have watched since then. Sitting on the rock ridge sheltering the camp in the west, I watched the sun set as, simultaneously, the full moon rose in the east, the one glowing with fire, the other with memory.

The Yosemite I entered on my first trip into Yosemite Valley was a different place. I admire the park's attempt to lessen traffic by instituting a superb shuttle system and by centralizing parking so that no matter where one wants to go, it is a trek, which at least gets people out of their vehicles. But where was my beautiful wild Yosemite? David, wanting photographs, led me to waterfalls I would have ignored on my own. The fact that these waterfalls—Yosemite Falls, Bridalveil Falls, Vernal Falls, Nevada Falls—were icons was irrelevant to me, until I stood before them, misted with their spray, deafened by their roar, overwhelmed by the sheer power of their roiling, churning water plunging in irrevocable moment over the sky-high lips of the falls. How not call this wild? So what if five hundred people stood behind me at any given moment. It was all of us who were irrelevant—not this tumbling, pitching, surging, pounding catapult of absolute force insistent on the rights of streams, of water, of raging, billowing spring.

So I had to rethink everything. Seeing how wildness coexists with crowds was a revelation. Once I ignore my bias against crowds, nothing—short of building dams and harnessing the wild energy of the Yosemite's falls—can remove my sense of their wildness. In their presence, the crowds cease to exist.

> Yosemite was, for me, a wild place of sun-hot rock as smooth as marble, where sparkling streams danced across rock, where wildflowers colored the meadows, and deep forest revealed bears who went their way, as I went mine, neither of us interrupting the other.

◄ VERNAL FALLS, MERCED RIVER, *Yosemite National Park*

▲ MOUNT LYELL AND DWARF LUPINE, *Yosemite National Park*

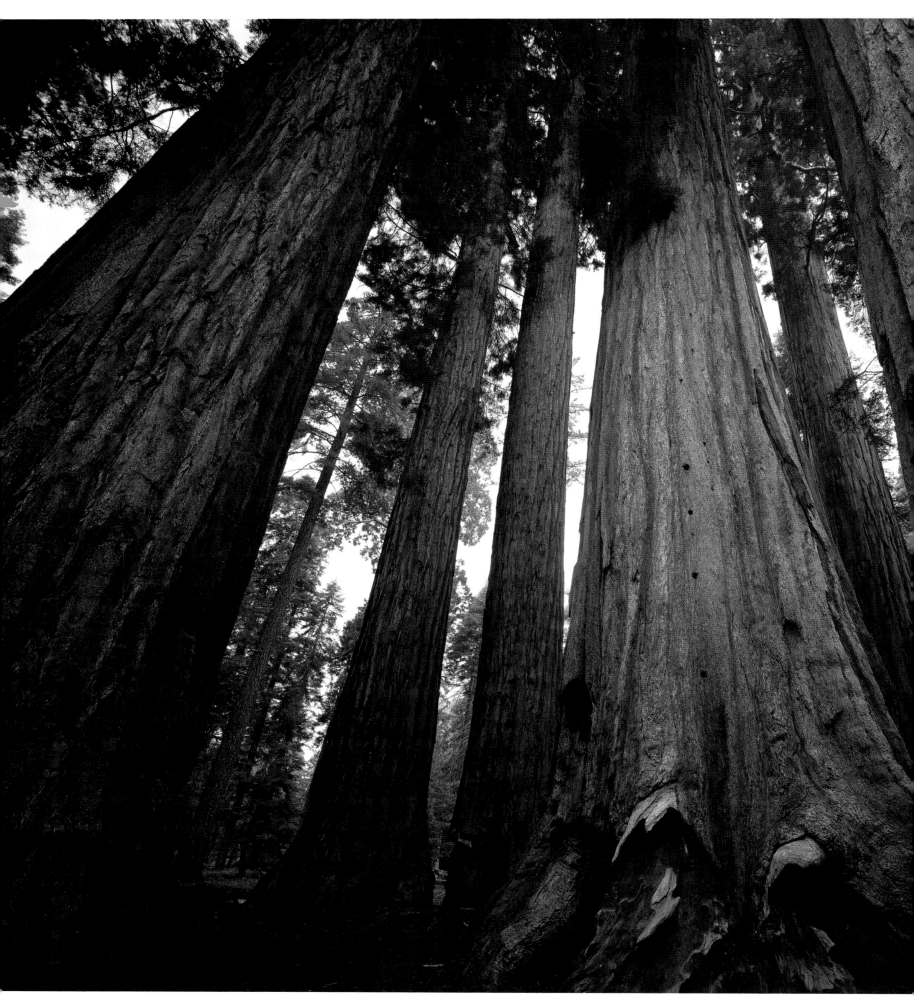

▲ PARKER GROUP SEQUOIAS ▶ ARCH IN GRANITE, MOUNT WHITNEY AND LONE PINE PEAK

▶ ▶ GRANITE SILHOUETTES AND MOUNT WHITNEY

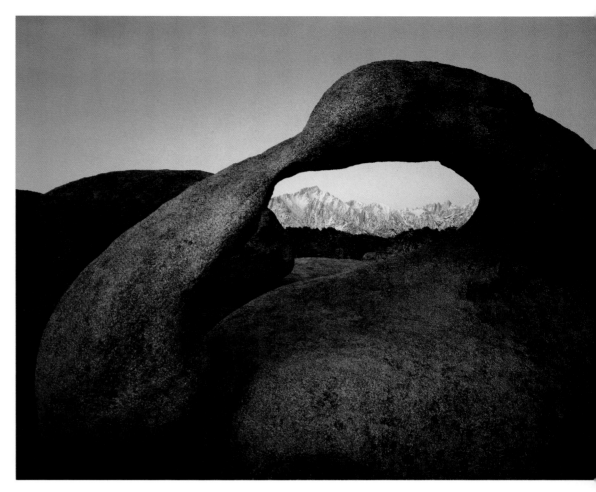

Sequoia

NATIONAL PARK, CALIFORNIA

The combination of Sequoia and Kings Canyon National Parks forms 1350 square miles of mostly wilderness. The eastern boundary of Kings Canyon and Sequoia National Parks runs along the crest of California's Sierra Nevada. The John Muir Wilderness abuts both parks on the east, and Kings Canyon on the northwest as well. Very little of this rugged country is accessible by road. Nowhere in the parks does a road cross the range. The single road into the South Fork Kings River Canyon is dead-end, open summers only.

This is country of the spectacular where everything happens in a big way—giant sequoias on the west side of the range; 14,496-foot Mount Whitney, highest peak in the contiguous United States, on the east side of Sequoia National Park. Four hundred miles long, sixty to eighty miles wide, the Sierra Nevada exceeds the entire Alps in size. Here are snowcapped peaks, alpine lakes, deep glacier-scoured canyons, untrammeled forests of hemlock, cedar, sequoia, and pine. The 211-mile John Muir Trail follows the Sierra crest from Yosemite to Mount Whitney, running through three national parks—Yosemite, Kings Canyon, and Sequoia—on its way.

Sequoia National Park is our second national park, established in 1890 to protect big trees that become, in themselves, experiences of wildness. If you don't count mountains or ecosystems or the planet itself as a single living organism—the General Sherman sequoia is the biggest living thing on Earth. General Grant National Park, created a week after Sequoia to protect the Grant Grove of giant sequoias, was incorporated into Kings Canyon National Park fifty years

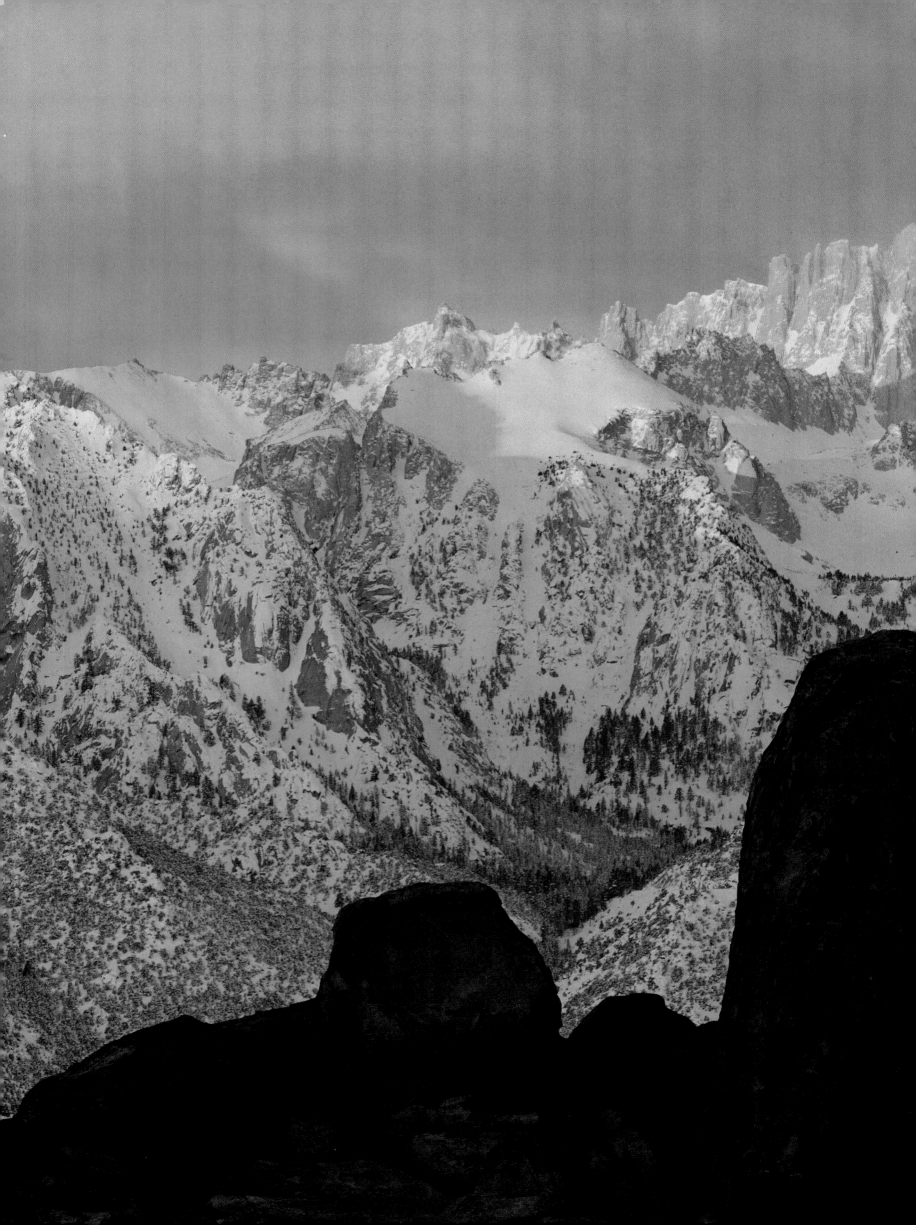

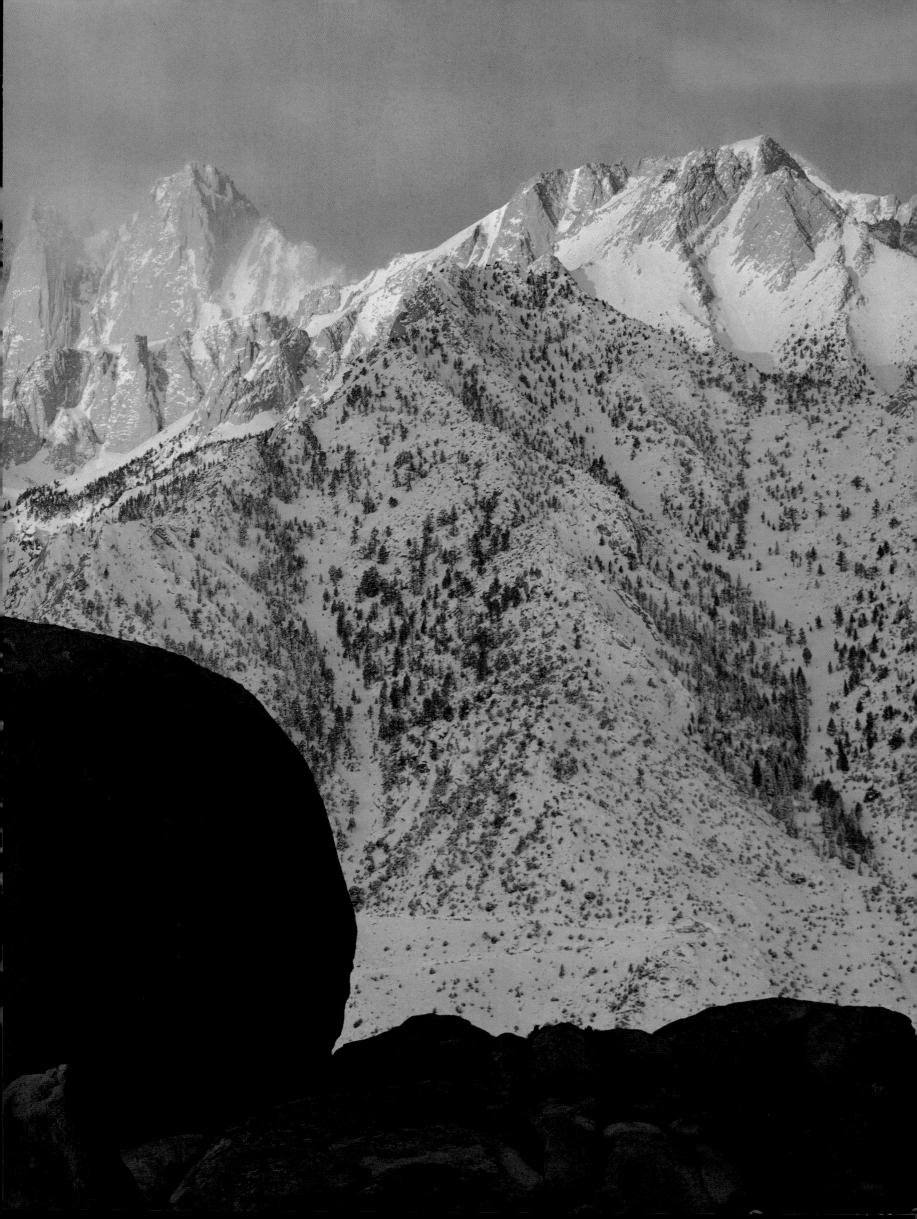

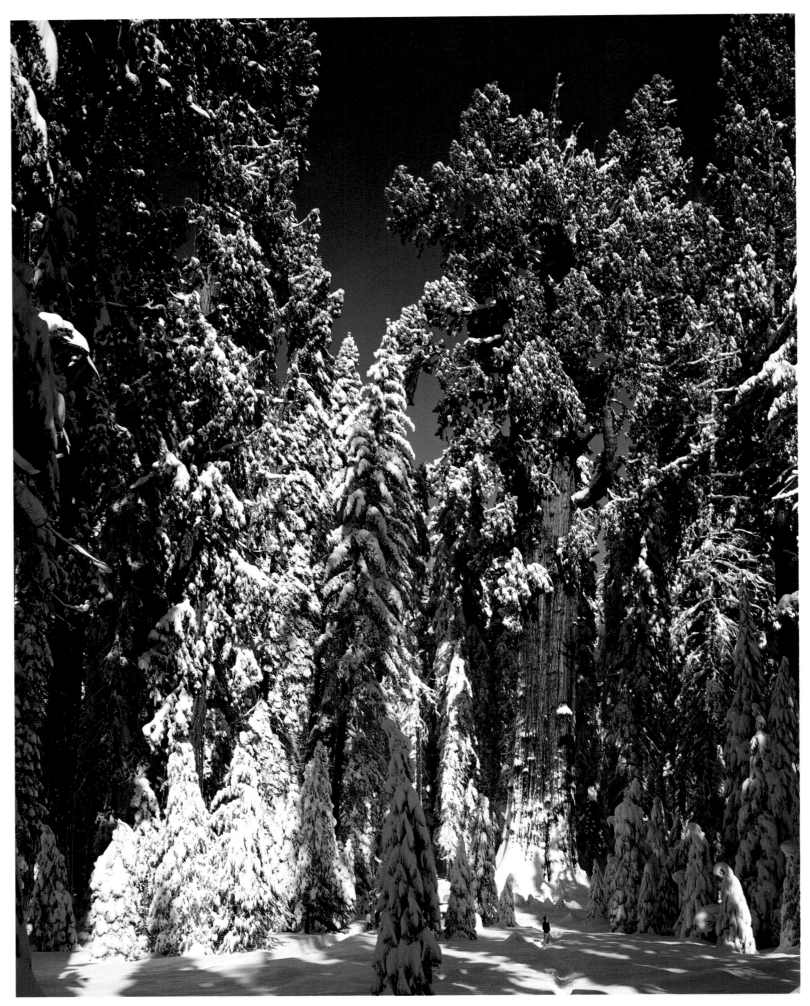

▲ GENERAL SHERMAN TREE, GIANT FOREST

▶ BULBOUS BASE, GIANT SEQUOIAS

later. Grant's name remains in the General Grant tree on the west side of Kings Canyon. The two parks have been managed together since 1943.

In Sequoia National Park, the Congress Trail, which is paved, is hardly wilderness, but after enough time spent with the trees to which it gives access, I have to—again—reassess what I think wildness means. Here I found myself lost in the trees themselves. The major trees along the Congress Trail are named. I find this silly (calling them *Sequoia gigantea* should be enough), but I understand it as one more nod to getting them protection by personalizing them. I was happier when we left the "tourist" trees and walked among those unnamed, those allowed to be what they are—giants of the forest without reference to American history. They are their own history. In *A Natural History of Western Trees*, Donald Culross Peattie calls them the king of the kingdom of plants. They contain the centuries of their lives, their burns, their deformities, their huge height, their healing bark, their hollows and arches and caves and dens, their years of fire and wind and storm carved into their very being, their great, bulbous feet so hugely connected to the earth.

Wildness in a single organism? If you can get lost in it, in contemplation of it, is it wildness?

This High Sierra landscape celebrates superlatives in its groves of giant sequoias, the world's largest living things, and Mount Whitney, the highest mountain in the Lower 48 states. Established in 1890. Wilderness designated in 1984. A Biosphere Reserve. Acreage— 402,510.05. Wilderness—280,428 acres.

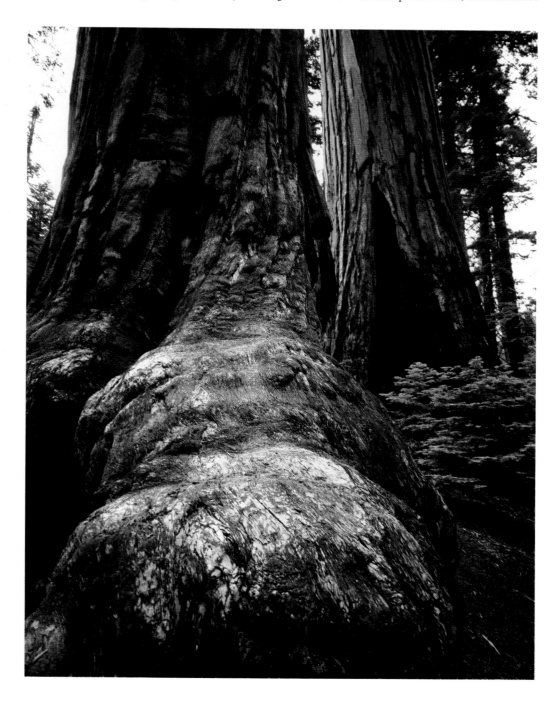

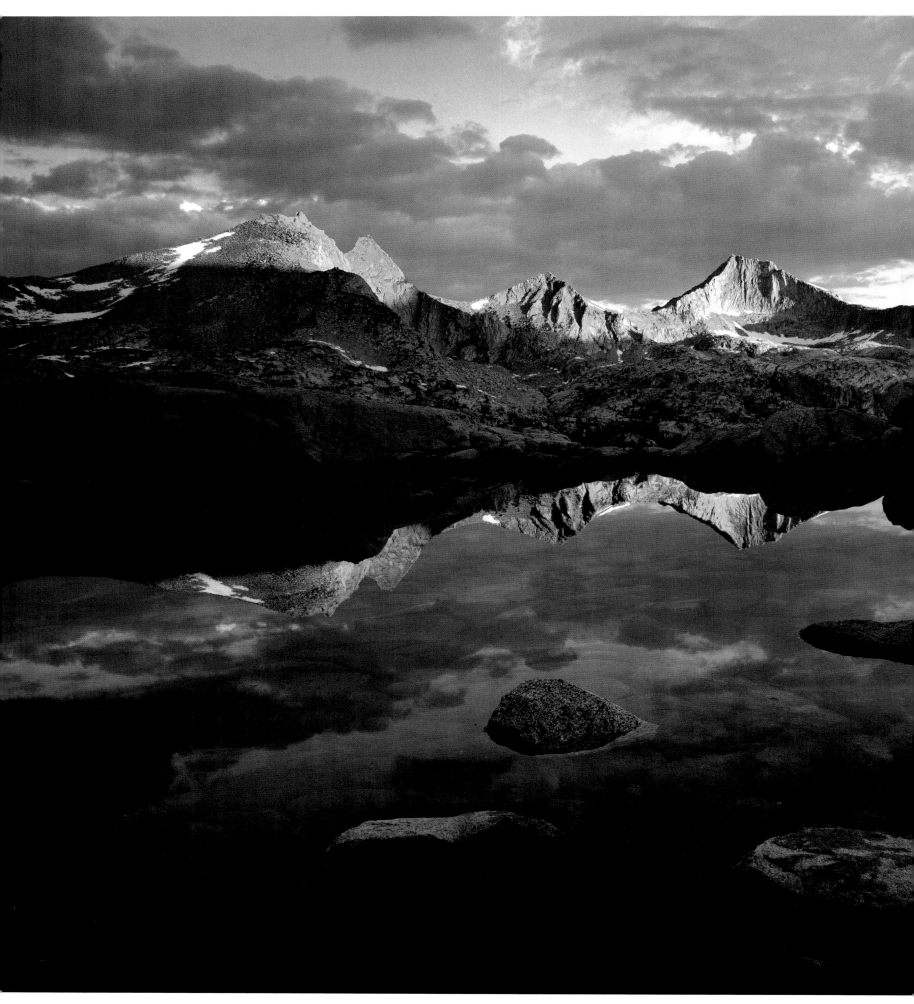

▲ MOUNT CLARENCE KING, SIXTY LAKES BASIN

► KEARSARGE PEAKS REFLECTION

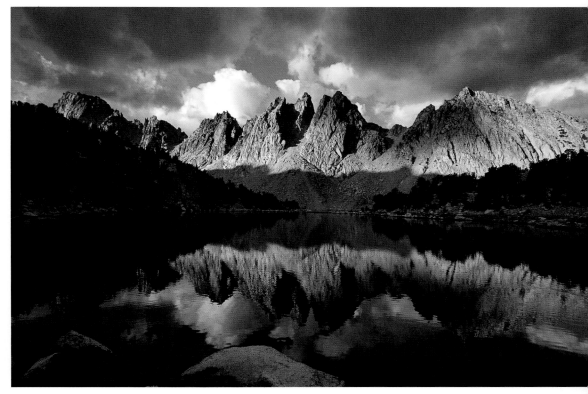

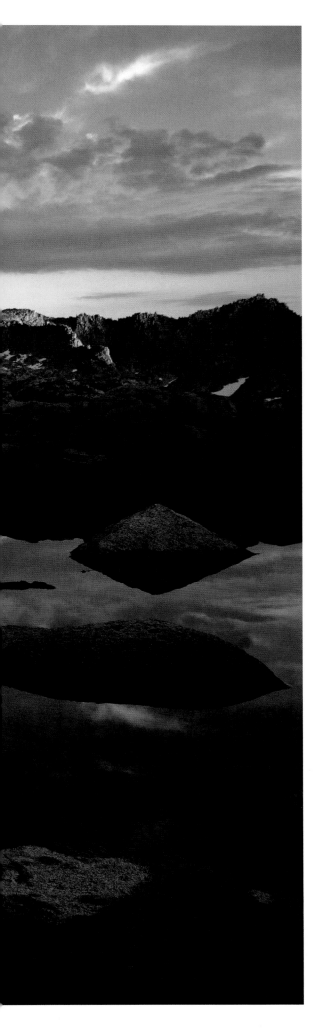

Kings Canyon

NATIONAL PARK, CALIFORNIA

In Kings Canyon, we rode the world's two best mules over 11,823-foot Kearsarge Pass and 11,978-foot Glen Pass into Rae Lakes, a place of unearthly (or, perhaps it is better to say, utterly earthly) beauty. At Kearsarge Pass we left the John Muir Wilderness, through which we had ridden the four miles from the Onion Valley trailhead, and entered the national park. As we headed north toward Glen Pass, we picked up the John Muir Trail, then followed it to Rae Lakes.

David's mule was named Jerome, mine was Ben. One rarely finds two beings so alike as David and Jerome. Jerome stopped at the turn in every switchback (much of the twelve miles from Onion Valley to Rae Lakes switchbacks) to look out across the mountains, taking in the entire earth before him, then cadging whatever green growing thing he could find nestled into the turn. Ben, on the other hand, walked like me, placing each foot carefully as he stepped, never moving in haste or without thought.

We rode uphill, then led the animals on the long, steep downhills. The steep, staircased trail is brutal for stock that must jump down the high steps, jolting their front legs in a way that will, ultimately, cripple them. Steps seem to be the current fashion in trail building. It may be a way of dealing with erosion on steep trails, but it is designed to cut out stock use, since no conscientious stock user will long subject good animals to this kind of treatment. This fashion may require some revisiting. Stock use in the American West is far more traditional than backpacking, and while, with the crowds our mountains now get, low-impact stock use becomes a necessity, it remains a good deal more natural, and cheaper, than using helicopters to supply trail crews, backpackers, backcountry rangers, etc.

Before we reached Glen Pass, when the trail still seemed an ordinary high mountain trail, we passed two backpackers coming down from the pass. On seeing the mules, one said to the

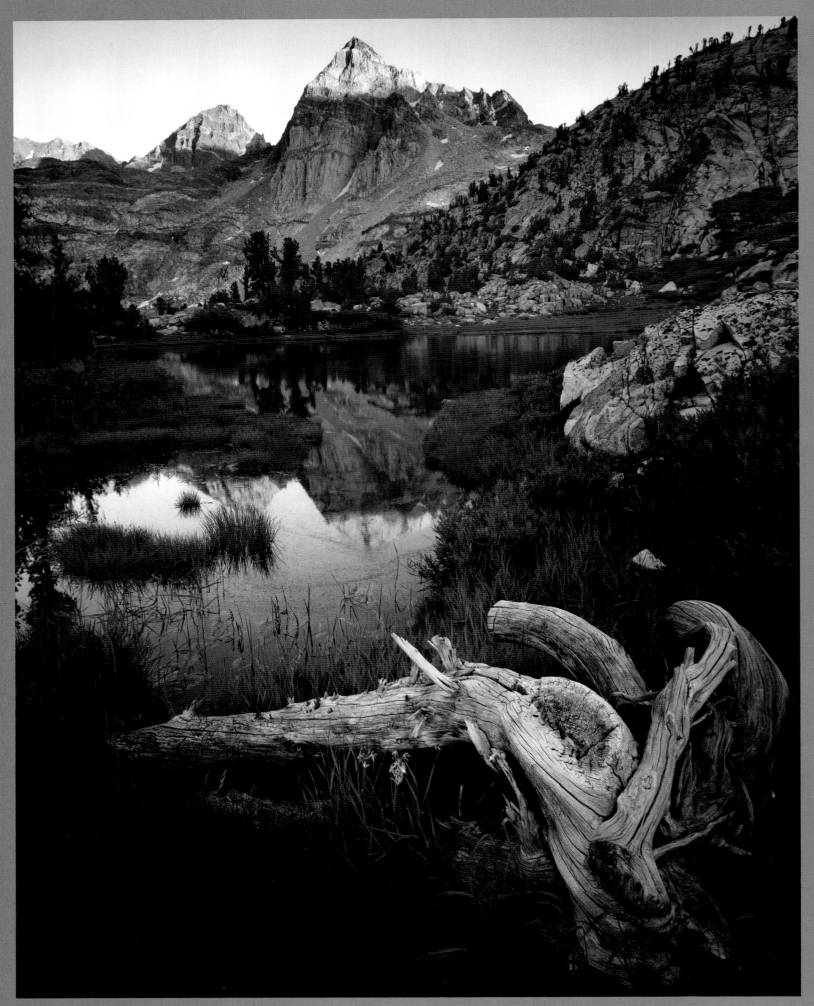

▲ PAINTED LADY ABOVE RAE LAKES

▶ SOUTH FORK, KINGS RIVER

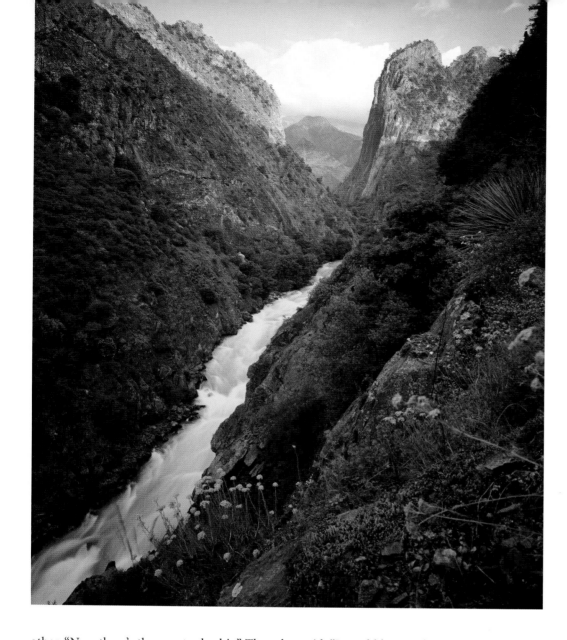

The summits of the High Sierra and two enormous canyons of the Kings River dominate this mountain world. Established as General Grant National Park in 1890, renamed and enlarged in 1940. Wilderness designated in 1984. A Biosphere Reserve. Acreage—461,901.20. Wilderness—456,552 acres.

other, "Now there's the way to do this." The other said, "I would be terrified." I thought he was simply afraid of riding, but once we began the real climb up to Glen Pass, and then the descent, I understood.

The top of Glen Pass is a level, mule-width ridge. We rode the animals across because there is no place on top to dismount before leading them down. Part of the trail switchbacking down a granite wall had been obliterated by a rockslide. For the mules to pass, outfitter Brian Berner and David had to build trail. (Hikers can climb up or down a cut in the switchbacks, but mules or horses cannot.) Moving boulders and heavy slabs of rock, they constructed a place where the animals could be led, one at a time.

It took longer than any of us expected, but we finally reached Rae Lakes, where Brian unloaded our gear and left with the mules. We set up camp in a world of gray granite and green-blue water, of rock walls and talus slopes, old whitebark pines and tall, straight foxtail pines. The water in the lake above which we camped was clear and inviting, and it was our morning luxury to descend the hill, throw off our clothes, and wade in until the water was chin high. Frigid at first, it warmed as we lingered in it, or we warmed as we became used to it, or the surface warmed from the sun. Even in cool air, there was hot sun to dry us on the rocks along the shore.

Late afternoon, the sun slid through the top branches of the huge old foxtail behind camp. It fell on pieces of polished granite on the mountain dividing Rae Lakes from Sixty Lakes Basin. It sparkled on the green water below us. I heard the water sparkling. In the backlit highest limbs of the foxtail, I saw the light of heaven. In the breeze I felt the movement of the earth, as if it were swept along in the winds of time, swept around the sun, twirled in its orbit into night and day. The sound of the waterfall plunging down from Dragon Basin to the east of camp was constant. The presence of the huge old foxtail, too big for the two of us to reach around and touch hands, defined our home in this place.

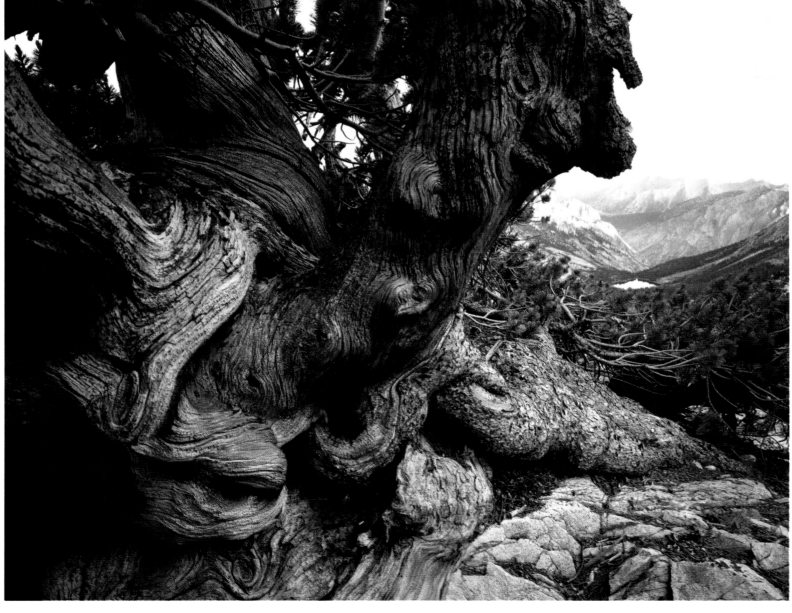

▲ ▲ PALISADE CREST FROM MOUNT SILL, *Kings Canyon National Park*

▲ WHITEBARK PINE, EAST CREEK, *Kings Canyon National Park*

Evenings we walked back along the trail winding among boulders, past walls hung with fuscia penstemon and red paintbrush. Two ancient whitebark pines, polished by years of wind and ice, hang on above the trail. Their trunks glisten where the bark is gone. Whitebarks crown little granite islands in the lakes. Grassy meadows edge the lakes. Flowers are everywhere. On our way in, I saw none of this. Perhaps others miss it, too. From camp, I noticed a few backpackers come up the trail from Glen Pass, but they were all too tired to look up. Those heading toward Glen Pass never looked up, either. It was as if our camp did not exist.

On the morning of our ride out, Brian, who had come up the night before, appeared with the mules. It was too soon. I had become used to the luxury of staying in a place of paradisiacal beauty. But I was glad to see Ben. The long climb up to Glen Pass went smoothly. Not only was it the first thing in the day, but it is far easier for the animals to climb up the high steps than to descend them. A large group of hikers already gathered on the narrow ridge hugged the sides of the pass so we could pass before dismounting for the two-mile, dusty, desert-hot descent in unabating sun. From the bottom of the pass, we rode into open forest of scattered lodgepole and foxtail pines for lunch, up Kearsarge Pass, and then down almost 3000 more feet to the pack station at the trailhead. The others went ahead while Ben stopped to drink from the stream before rounding the last bend into the corral yard. One last quiet moment for us both. I hated leaving that mule.

Rae Lakes, a place of unearthly

beauty . . . a world of gray granite

and green-blue water, of rock walls

and talus slopes, old whitebark pines

and tall, straight foxtail pines.

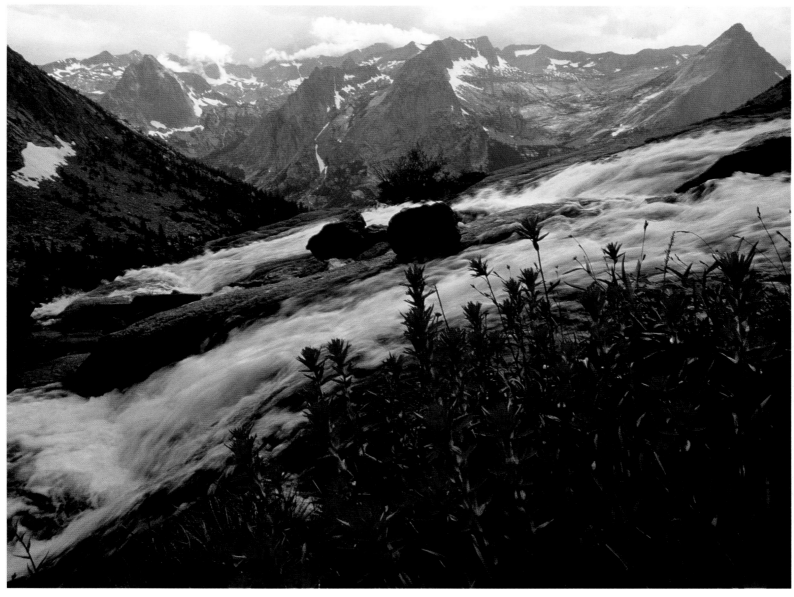

DUSY BRANCH AND LECONTE CANYON, *Kings Canyon National Park*

Death Valley NATIONAL PARK

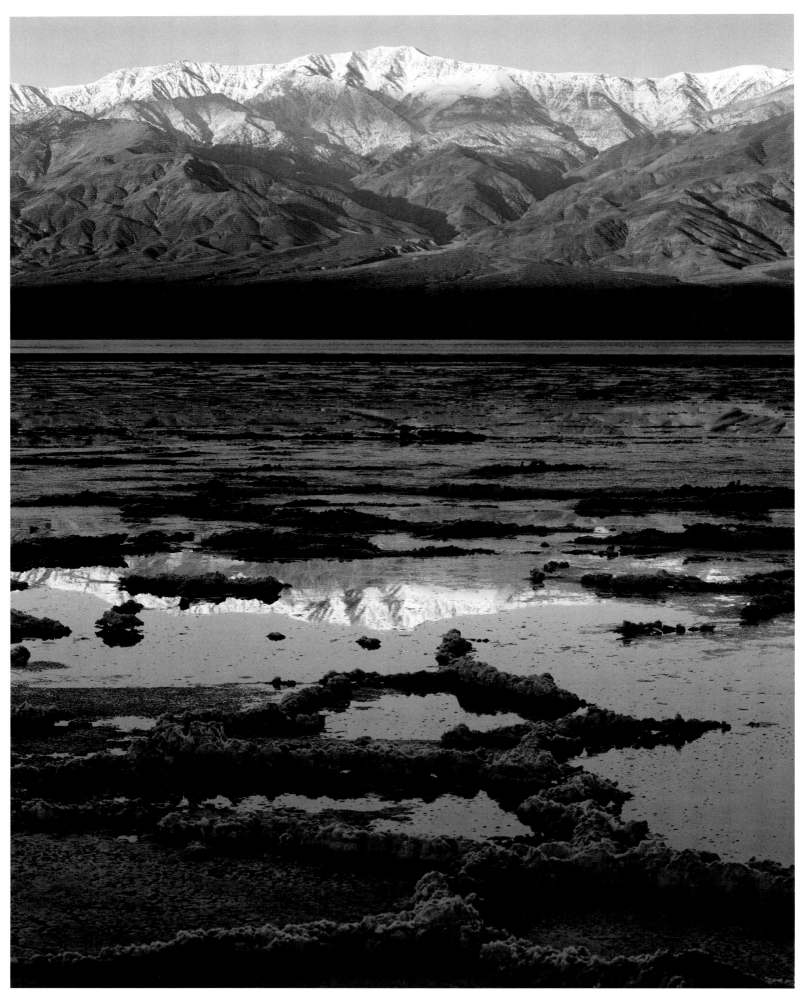

▲ TELESCOPE PEAK REFLECTIONS, BADWATER

An enormous desert nearly surrounded by mountains, the park contains the lowest point in the Western Hemisphere. Proclaimed a national monument in 1933, redesignated as a national park in 1994. A Biosphere Reserve. Acreage— 3,253,028.

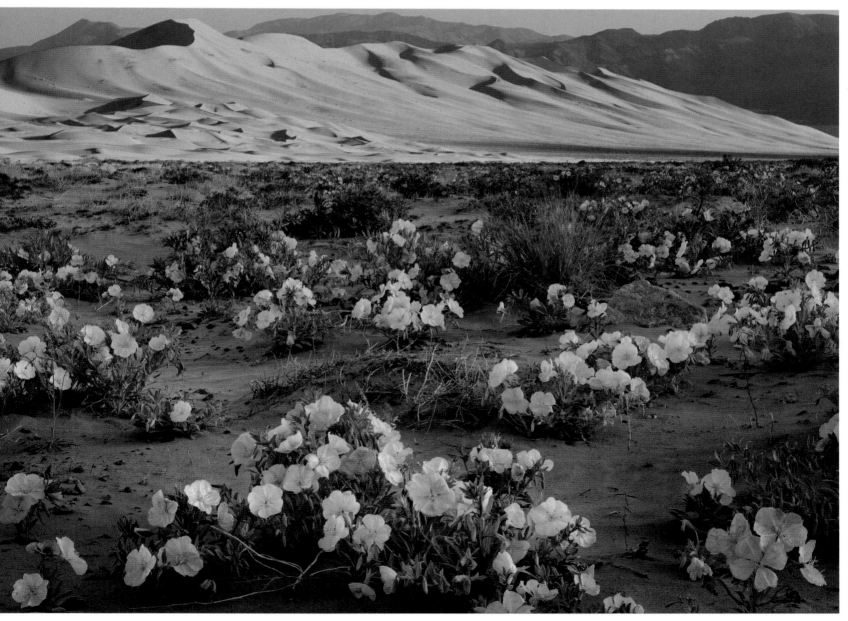

▲▲ ARTIST'S PALETTE, AMARGOSA RANGE ▲ SPRING FLORAL, EUREKA DUNES
▶ SAND DUNES, MESQUITE FLAT

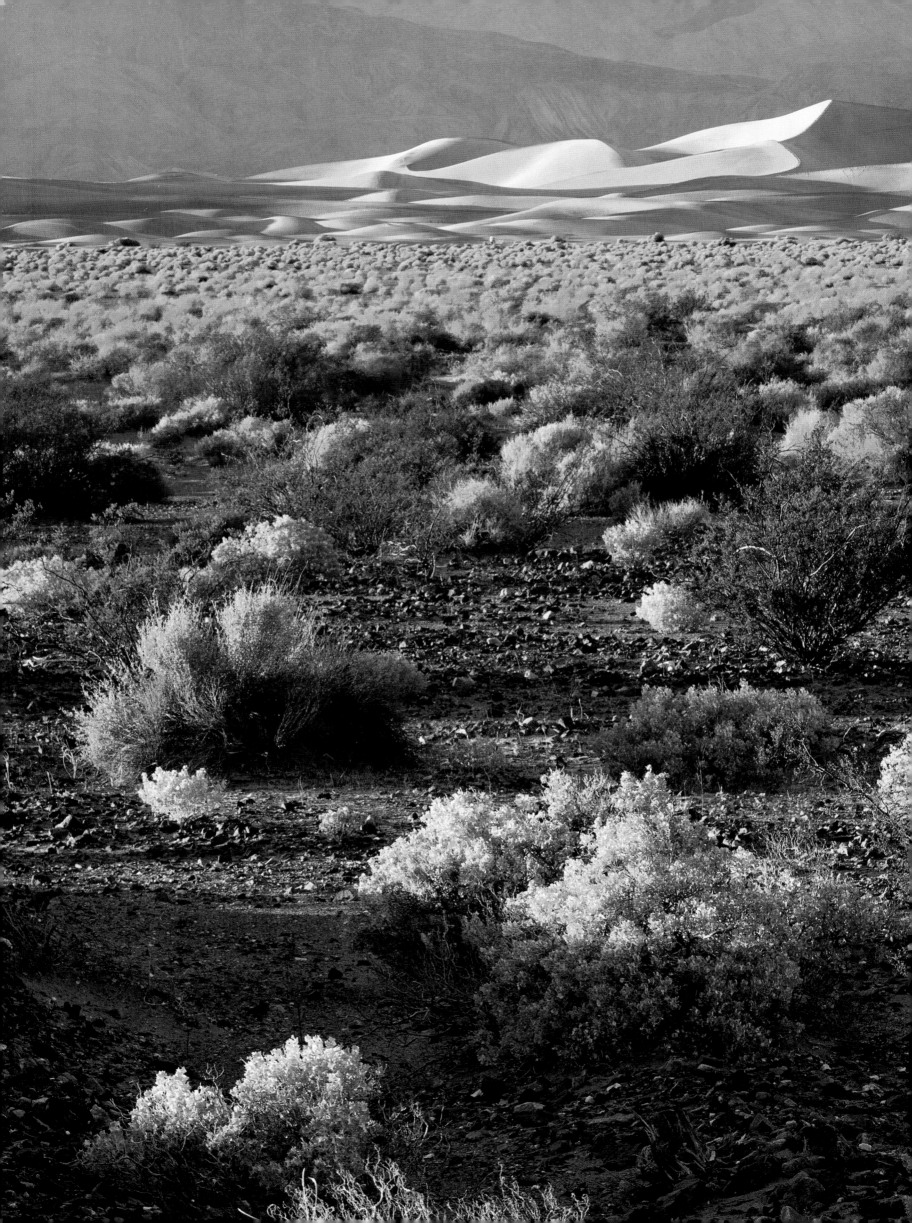

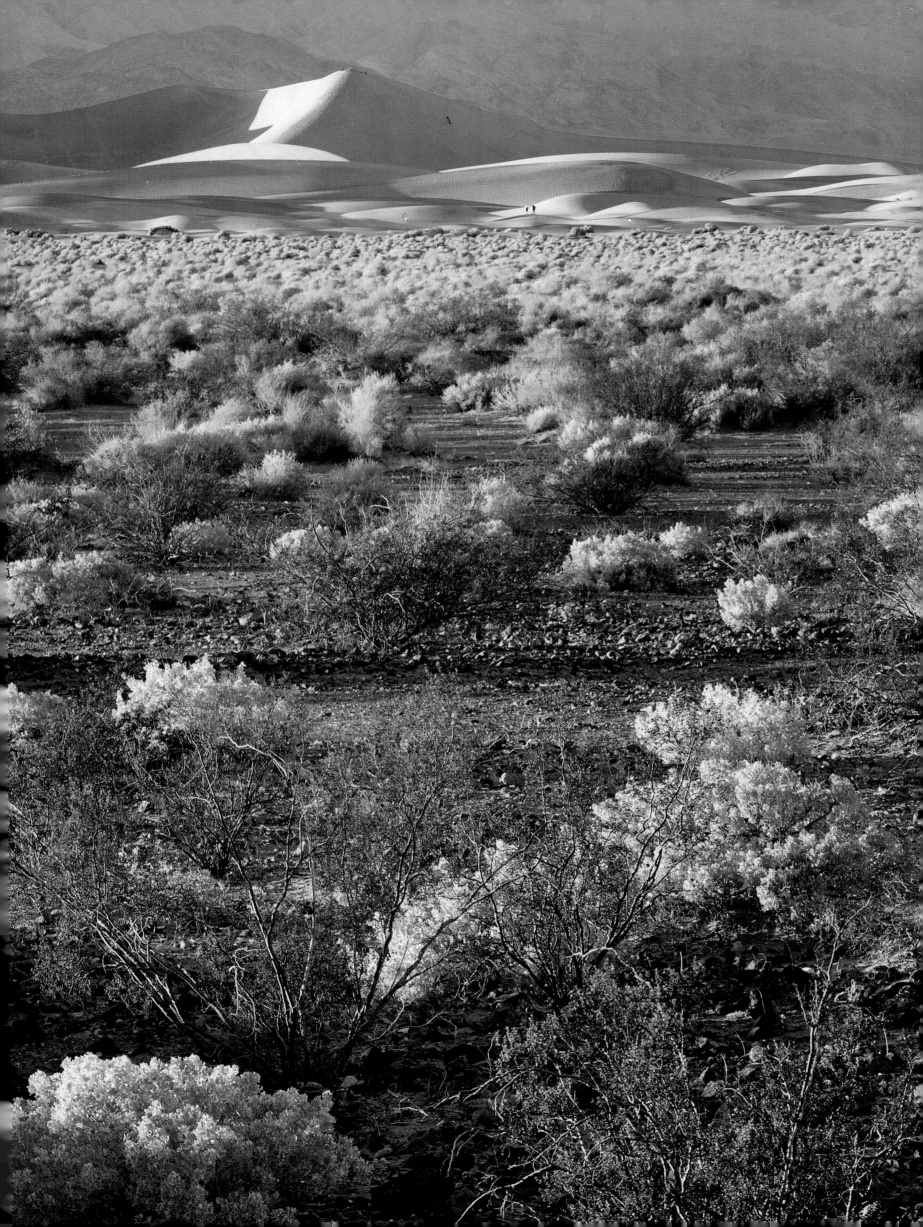

Joshua Tree NATIONAL PARK

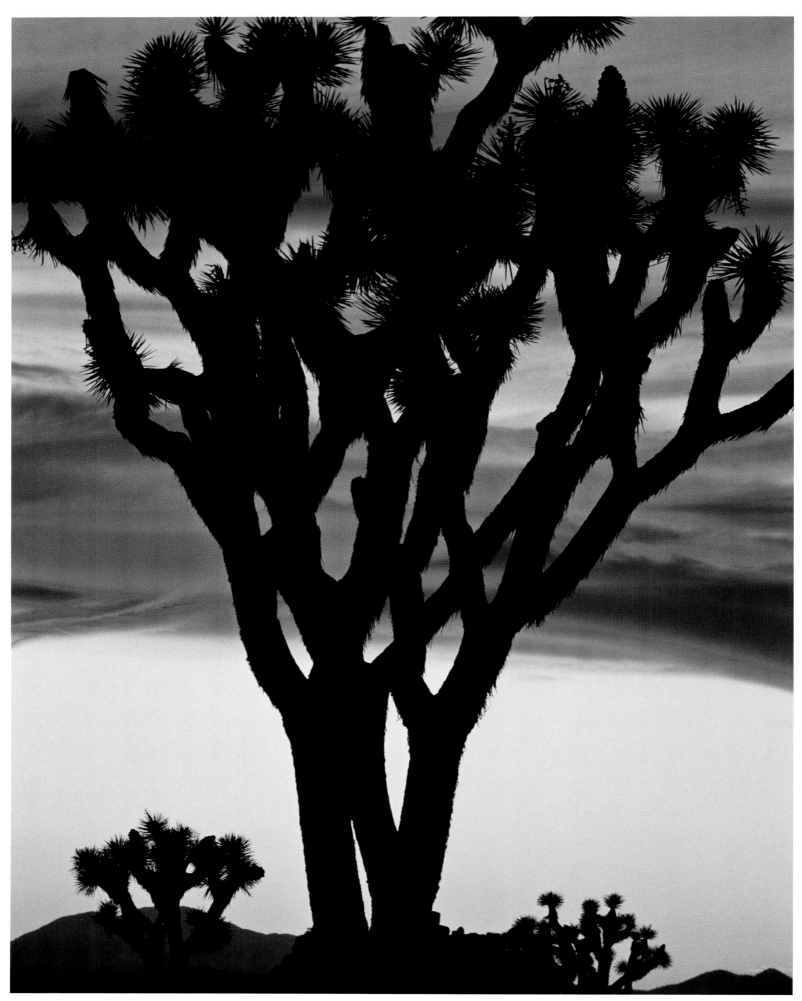

EVENING, JOSHUA TREES

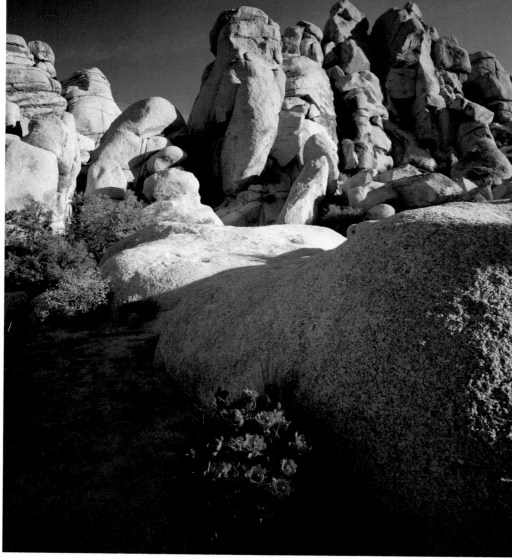

Two deserts—the Colorado below 3000 feet in the eastern half of the park, and the higher Mojave in the west—merge here. Together they produce a complex landscape of Joshua trees and palm oases, of creosote, cactus, and granite monoliths testifying to the forces that shaped this landscape. Proclaimed a national monument in 1936, redesignated as a national park in 1994. Wilderness designated in 1976. A Biosphere Reserve. Acreage—1,022,976.02. Wilderness—557,802 acres.

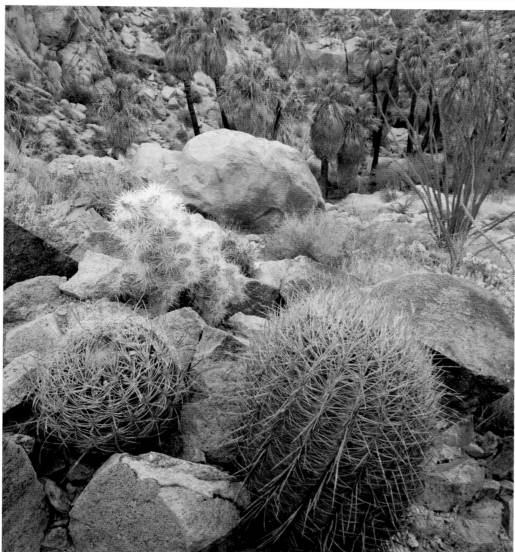

▲ ▲ MOJAVE MOUND CACTUS, JUMBO ROCKS AREA

▲ LOST PALMS OASIS

Saguaro NATIONAL PARK

Giant saguaro cacti cover this Sonoran Desert valley floor and rise into neighboring mountains. Five biotic life zones exist here—from desert to ponderosa pine forest. Proclaimed a national monument in 1933, it was redesignated as a national park in 1994. Wilderness designated in 1976. Acreage—91,445.96. Wilderness—70,905 acres.

▲ ▲ PETROGLYPHS, SIGNAL HILL ▲ ▲ ▶ CROWN OF BARREL CACTUS BLOOMS
▲ CHOLLA SILHOUETTE AND SUNRISE

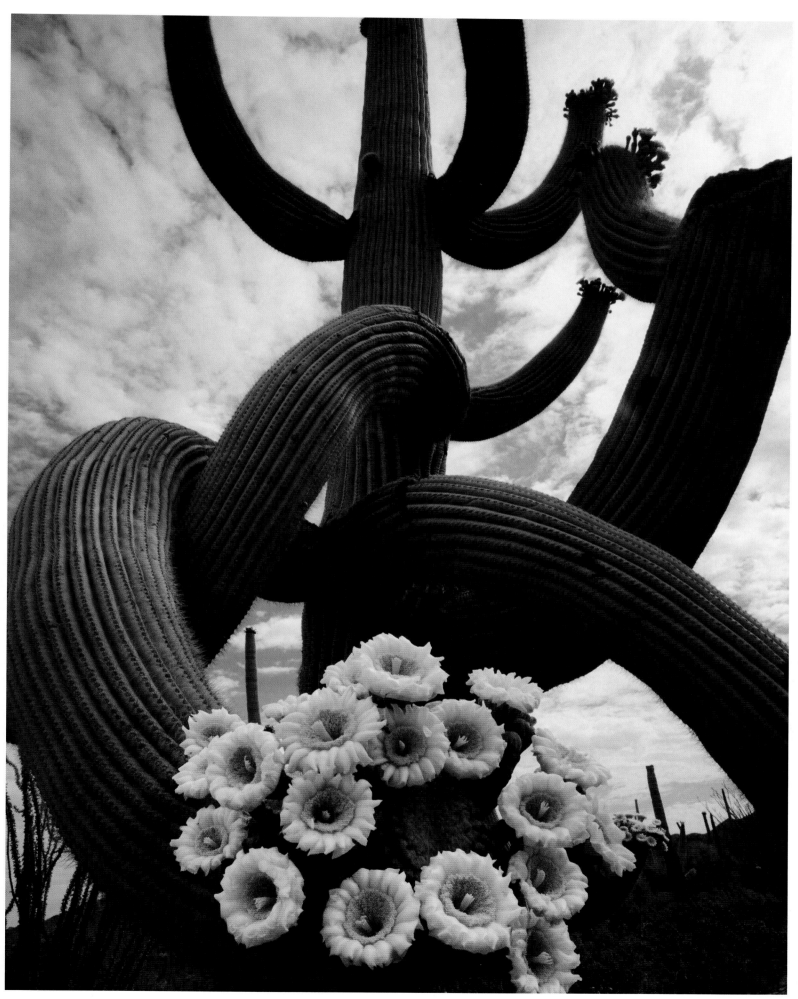

SAGUARO, *CARNEGEIA GIGANTEA*, WITH BLOSSOMS

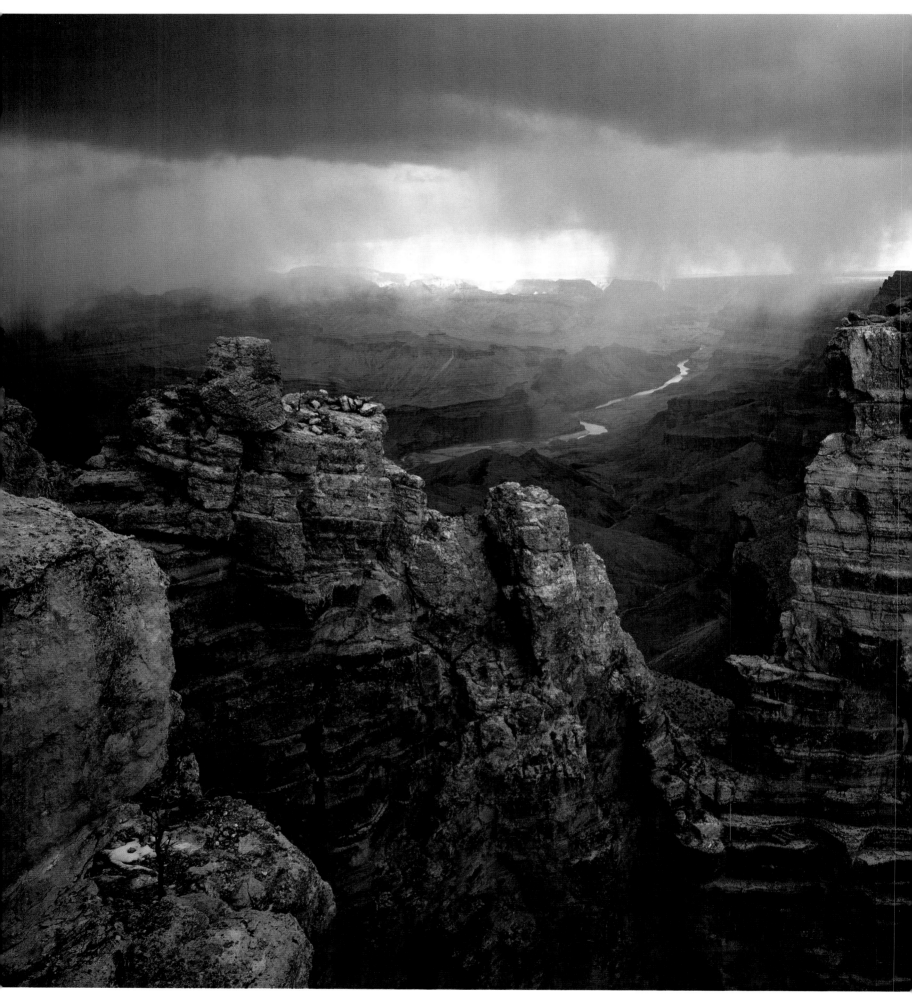

▲ GRAND CANYON STORM, SOUTH RIM

▶ SANDBAR COBBLES AND PRIMROSE, COLORADO RIVER

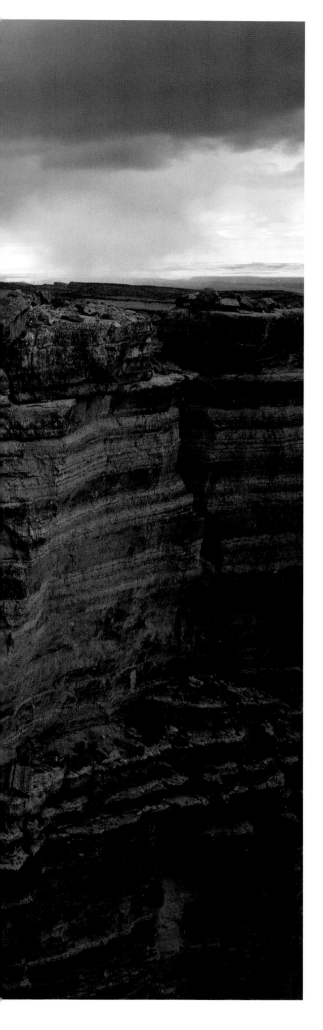

Grand Canyon

NATIONAL PARK, ARIZONA

It was below freezing when we left the South Rim on the Kaibab Trail early one February morning. Icy patches stretched from the top about a quarter mile down the trail. The air stayed cool even when we came into sun, a sharp northern cool, the cool of altitude, of the north, of a place where winter exists.

The trail switchbacks down the layers of time, down the hours of the day, the seasons. On the Tonto Plateau, we came out onto desert. Lower, on red sand, we saw a single bighorn sheep. At lunch a raven appeared. He called and called to his mate. When she arrived, the two touched bills, he opening his over hers like a kiss. She lowered her head and knocked on the rock in display to him. They stood there together, a long time, as unconcerned by our presence as if we were also ravens. Suddenly, the voices of hikers on the trail a hundred yards from us, unseen from our place at the edge of a cliff, carried to us and to the ravens. The ravens flew off, down, into the canyon.

The last long slope to the river switchbacks steeply as the Colorado invites, teases with its presence in the bottom of the canyon. You are almost here, it says. You are almost as far into the earth as you can go. Here, in this green paradise of grasses and cottonwoods and willows, of clear streams and soft breezes, you are finished with the canyon wall.

I was ready for an end. We had descended 4780 feet in 6.7 miles. "Thigh-pummeling," as John Annerino, longtime canyoneer and guide and author of the Sierra Club's *Hiking the Grand Canyon* puts it.

What happens to us, when we enter into the eons of time of the canyon's forming, enter into its history by making our way down through rocks offering us the history of the earth? In the presence of the earth's age, do we take on those years, the patina of time? Does something in

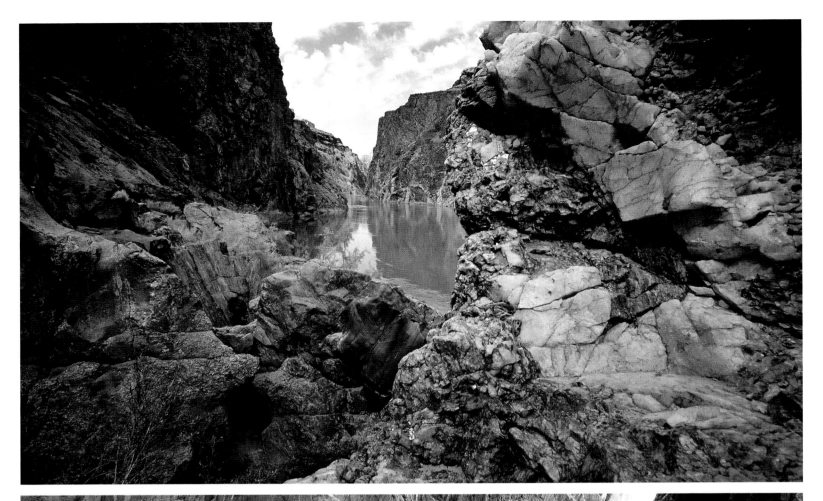

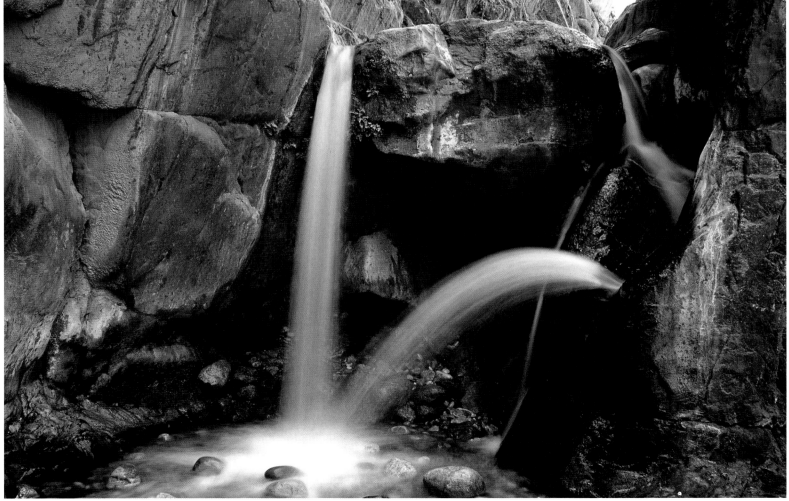

▲ ▲ MIDDLE GRANITE GORGE, COLORADO RIVER

▲ CASCADE IN LOWER SHINUMO CREEK

us remember the swirling gasses of our forming so that we and the rock know each other? What is our relationship to the earth, when we are inside it?

The Colorado River is responsible for this canyon. When you are walking down into the canyon, or walking up out of it, even when you cannot see it you are always aware of the river that carved it. The forming, altering source of this place too big to behold is the constant in your imagination. Drawn into its power, you cannot help but acknowledge that power. Even controlled by dams as this river is, its power still enters the imagination as the river moves through these ancient walls. Swirling into whirlpools and eddies and erupting into rapids where the channel becomes choked with debris at the mouths of side canyons, the river retains its capacity to excite, to engage, to draw one in. However we interfere with its natural workings,

The immense chasm carved by the Colorado River over millions of years presents an almost incomprehensible vastness while offering intimate views of the geologic events shaping the American Southwest. The park encompasses 277 miles of the river and its adjacent uplands. Proclaimed as Grand Canyon Forest Reserve in 1893, Grand Canyon Game Preserve in 1906, Grand Canyon National Monument in 1908, established as a national park in 1919. A separate Grand Canyon National Monument was proclaimed in 1932. Marble Canyon National Monument was proclaimed in 1969. All three units plus parts of Glen Canyon and Lake Mead National Recreation Areas were combined into a national park in 1975. A World Heritage Site. Acreage—1,217,403.32.

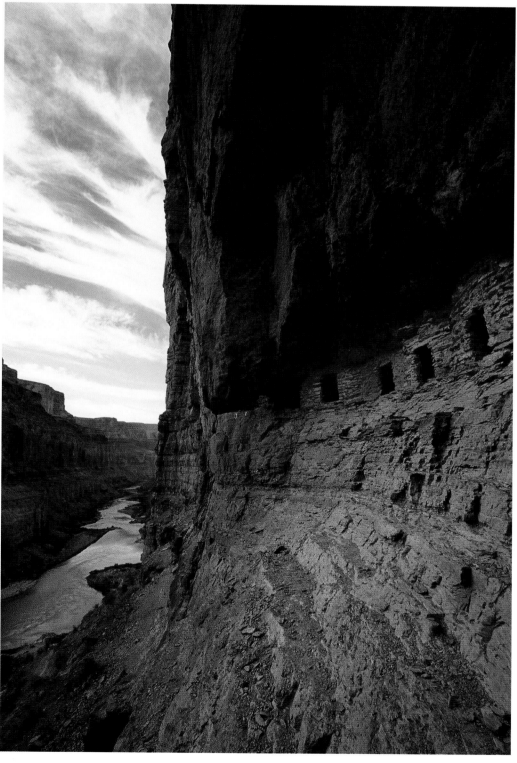

ANCIENT PUEBLOAN DWELLINGS, NANKOWEAP

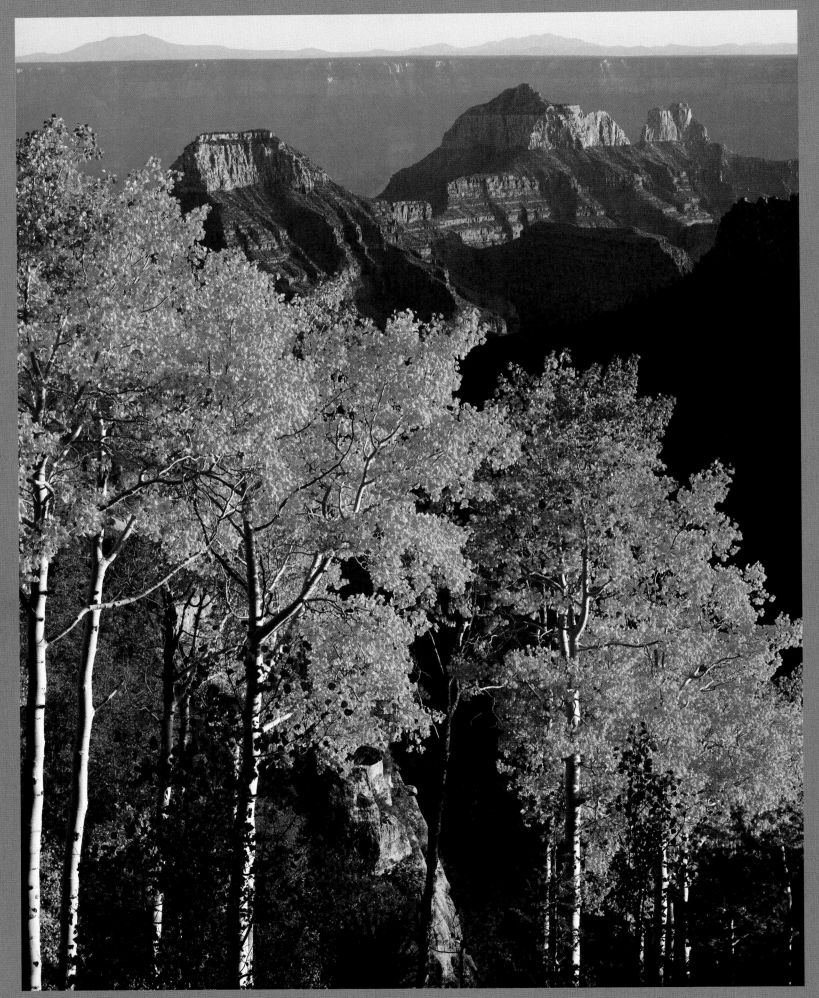

ASPENS, BRAHMA, AND ZOROASTER TEMPLES, NORTH RIM

its natural flooding, its natural mud color, its huge power to carve, to sculpt, to form and re-form rock and earth, we acknowledge its awesome power to create. Like God. Like artists. Like the earth itself.

On the day we hiked out of the canyon, David stayed behind at the river to photograph, while I walked up Bright Angel Trail toward the South Rim. Two and a half miles up the trail I encountered a small herd of mule deer browsing the spring green. The wind blew toward me so the deer did not catch my scent. I sat on a rock, watching as they moved from one side of the path to the other, coming down closer to me all the while. Occasionally one or another left off eating, lifting its head to garner a sense of what was happening around it. After the moments required to assure itself of safety, it returned to eating. I wondered if I should move, deliberately show myself, so that they would not be complacent in their morning, not be certain they were safe when there was, indeed, a predator nearby.

For I am a predator, aligned with wolves and mountain lions, coyotes and wolverines. Yet, I am also prey. Is it the lot of the omnivore to be both predator and prey? I cannot think of the grizzly bear, my fellow omnivore, as being prey. Unarmed and unwary, I would be no match for a mountain lion or a bear, both of which have attacked and eaten humans. Is it that I am both predator and prey that makes me human? I remember being taught in school that it was my opposable thumb. (A friend tells me she learned it was our ability to reason, but I think this is not consistent among humans.) My opposable thumb never seemed an interesting marker to me of the difference between me and other mammals, never seemed to me to be the thing that stretched my mind into human intellect. The awareness I must develop as both predator and prey is much more interesting.

Is it the lot of the omnivore to be both predator and prey?

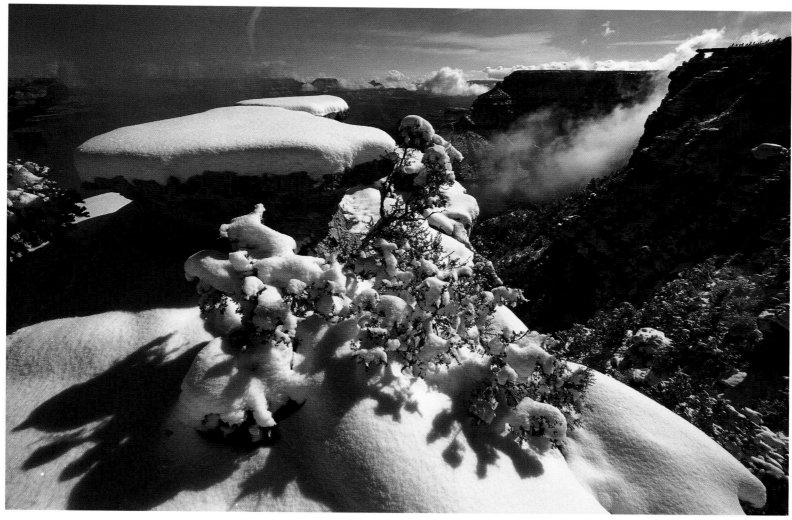

WINTERSCAPE, MATHER POINT

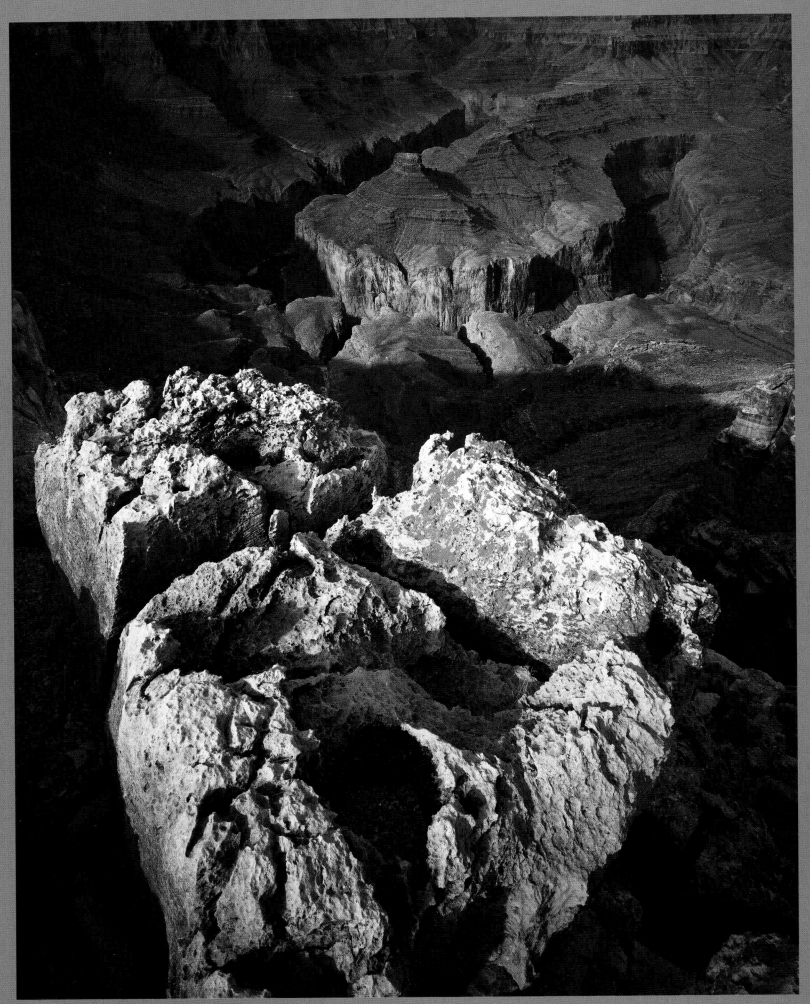

LIMESTONE RIM, ABOVE MARBLE CANYON

When David caught up to me an hour later, he said he had seen a bighorn sheep near the river, but the deer were gone by the time he walked up the trail.

I love Bright Angel Trail. It is longer and less steep than the South Kaibab; the views from it are not as spectacular, but the trail itself is more beautiful. It travels through a more varied and intimate country, climbing or easing as the layers of Earth dictate. Until we reached Indian Gardens, once the gardens of the displaced Havasupai, we had the trail to ourselves. Indian Gardens—a destination for a day hike as well as a major stop on the walk up from, or down into, the bottom of the canyon, and a source of water, outhouses, benches, shade (when the trees have greened out)—is a bit like coming into Grand Central Station. The place is a great assemblage of languages and ages and styles. The one thing everyone has in common is that they have walked downhill that far, at least (4.7 miles), and will have to walk that difficult uphill distance back to the South Rim. (It is not a hike to make in the heat of summer. None of the canyon is.)

Such is the fascination of the Grand Canyon that even people not used to serious hiking long for connection with this place, its beauty, its unfathomable enormity, its layers of time, the mystery of its space, its shadow and light and color and silence.

Such is the fascination of the Grand Canyon that even people not used to serious hiking long for connection with this place, its beauty, its unfathomable enormity, its layers of time, the mystery of its space, its shadow and light and color and silence.

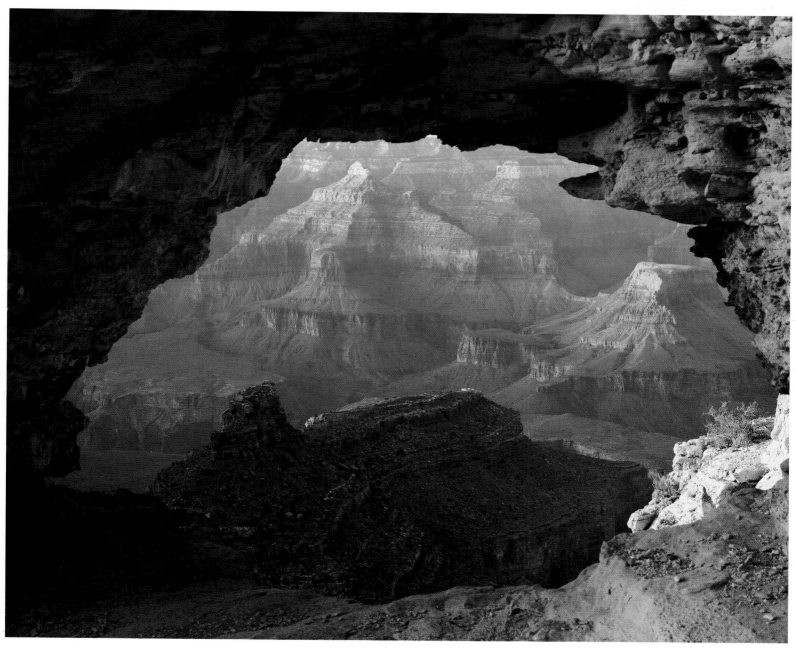

LIMESTONE WINDOW, SOUTH RIM

Petrified Forest NATIONAL PARK

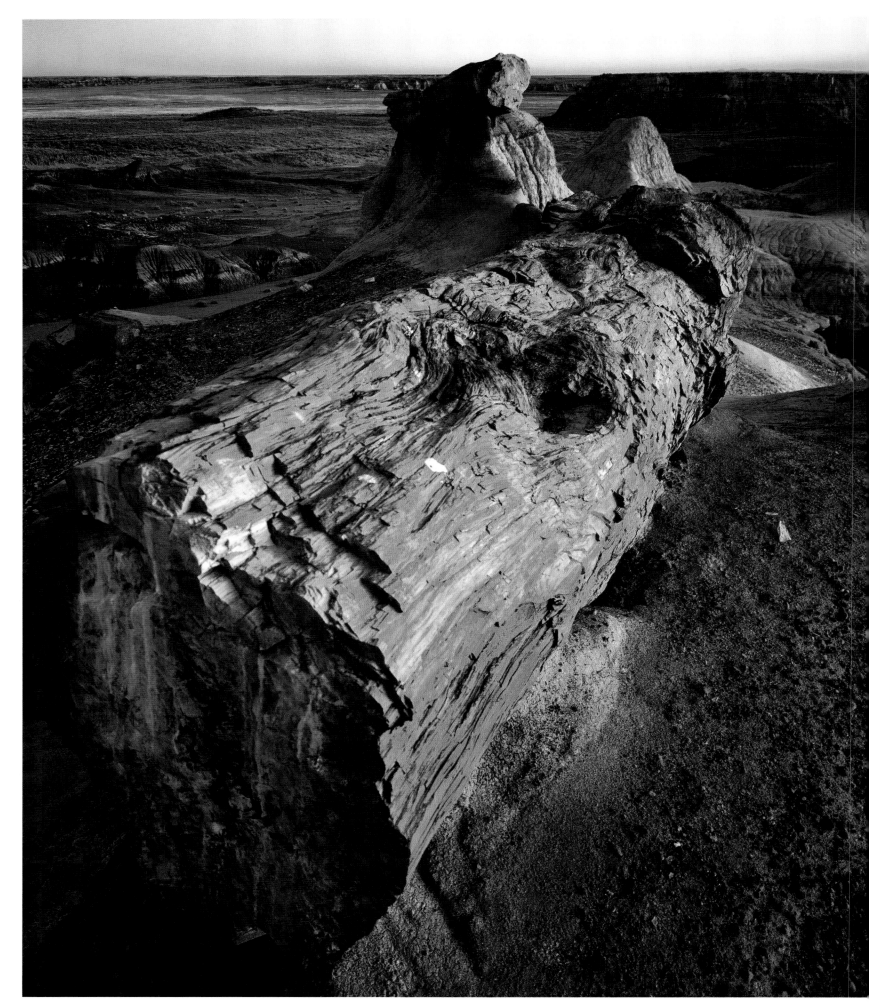

PEDESTAL LOGS, BLUE MESA

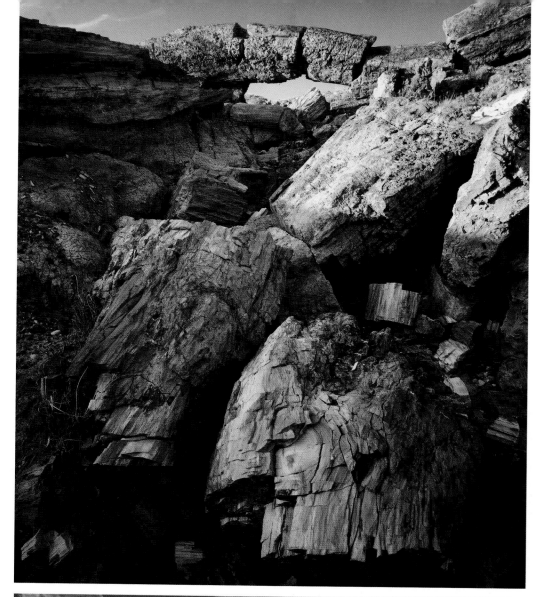

This ancient landscape contains the world's largest concentration of petrified wood—trees turned to multicolored quartz—as well as painted desert, and archaeological, paleontological, historic, and cultural resources. Proclaimed a national monument in 1906, redesignated a national park in 1962. Wilderness designated in 1970. Acreage—93, 533 (218,533 acres authorized in 2004). Wilderness—50,260 acres.

◄▲ PETRIFIED LOG BRIDGE

◄ LOG FRAGMENTS, RAINBOW FOREST

▲ ANCIENT PETROGLYPHS

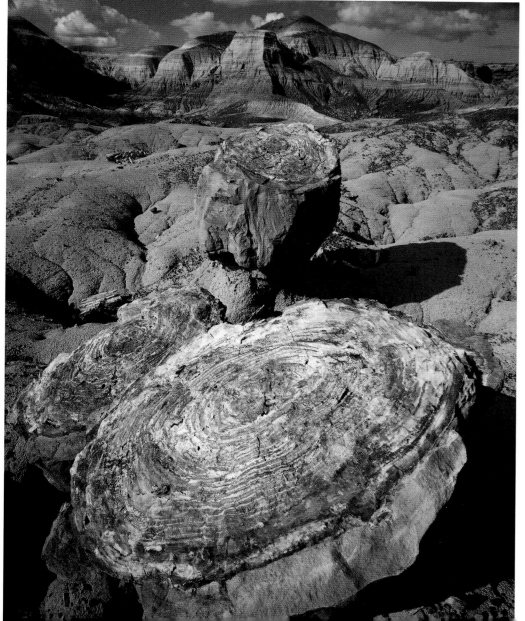

113

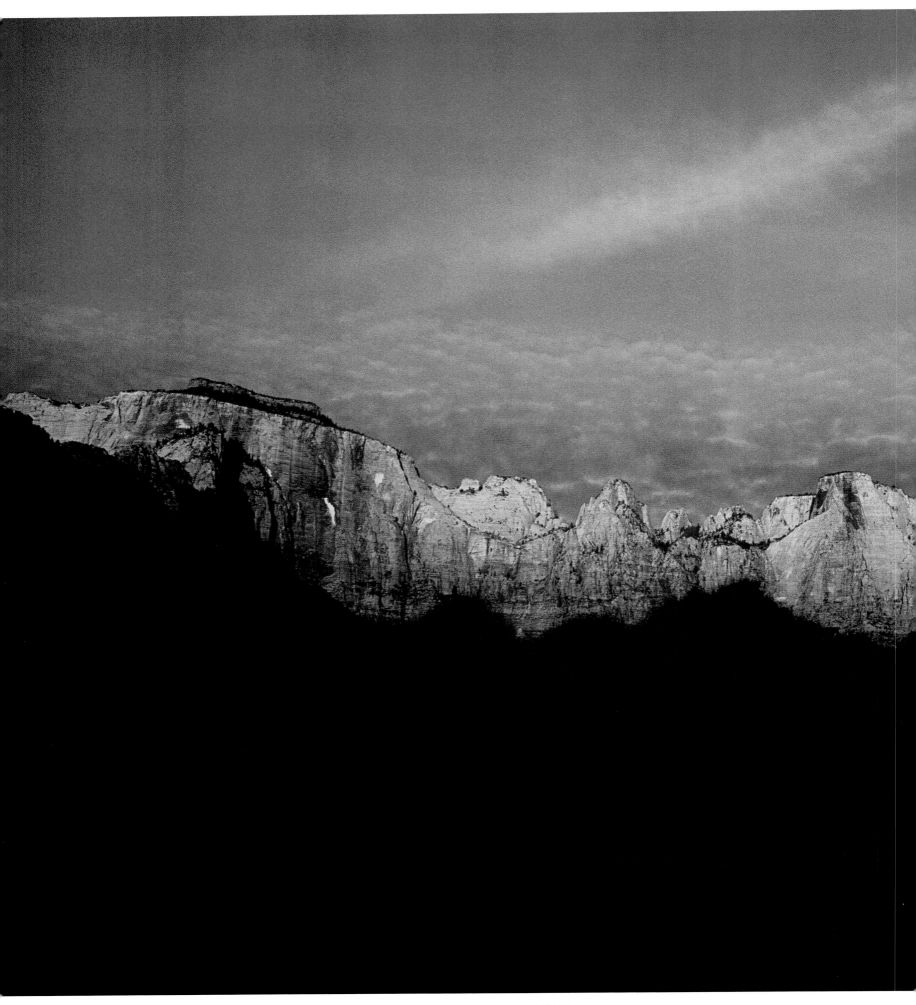

▲ WEST TEMPLE AND TOWERS OF THE VIRGIN

► KEYHOLE, SUBWAY POOLS

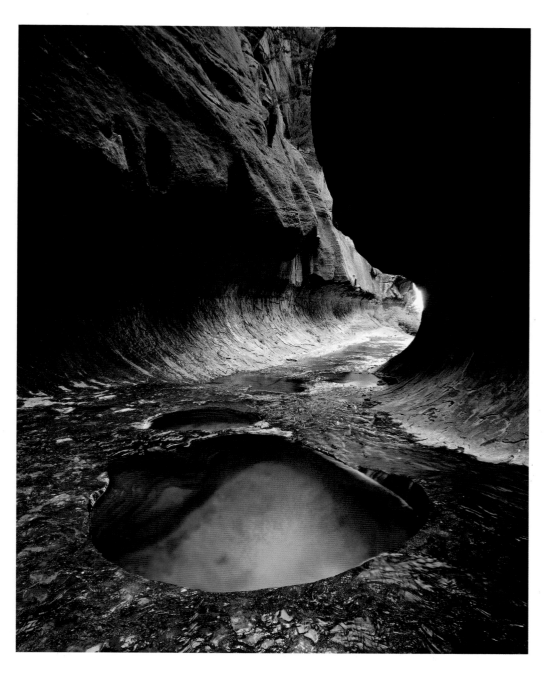

Zion

NATIONAL PARK, UTAH

The magnificence of Zion is a paean to the erosive power that carved and carves the valleys and almost vertical walls, and sculpted the monumental forms of this strange, magnificent geology. The colors of sandstone—pinks and reds and orange, yellow, almost white—glow like all the colors of gold in early and late sun. It is no wonder early Mormon settlers thought they had arrived at some city of God.

One autumn, we hiked the Canyon Overlook trail in the predawn dark. The sky was filled with stars, the air with night cold. Our flashlights lit the stone steps leading into the narrow world through which this trail winds, over rock, along rock walls, along the canyon edge, where twisted, leaning forms of junipers and pinyon pines reach out of the dark. All the forms of darkness in this dark walk are magnified.

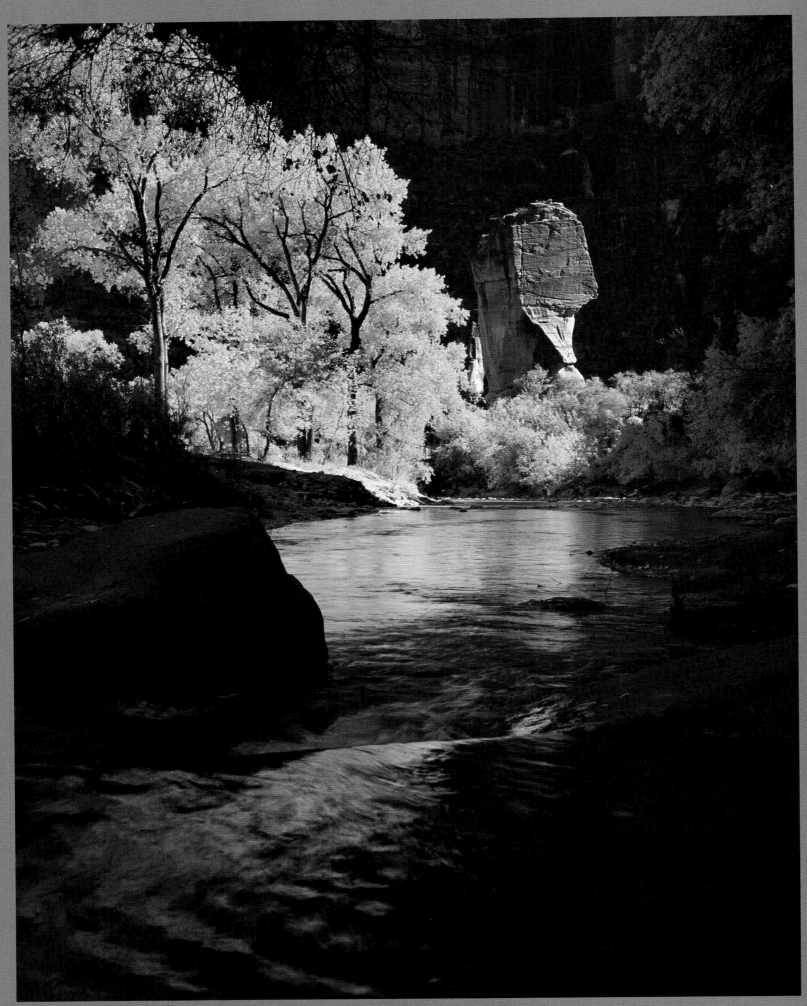

AUTUMN, TEMPLE OF SINAWAVA

Entering a huge cave, I did not dawdle, although I remembered the cave from earlier walks and knew it as a place of coolness on a hot day. Not long before the mile-long trail ends, the rock turns to sand and, in the faint beginning of light, I made out knee-high manzanita and prickly pear cactus. The sand gives way to rock again as we climbed the last few feet toward the overlook. One by one, light reclaimed the stars until all were swallowed by the dawn.

David waited with his usual patience for the first light on West Temple and Towers of the Virgin. We were present to the dawn a long time before other people arrived, some out for a morning run, others there to photograph what they believed to be first light. The colors of sandstone were well in place by then. First light was long gone, coming after last dark, the one evolving out of the other. In that evolution, that transition moment, there is all the wild mystery of night and of dawn. This trail is too busy to be a wild place during the day, although it is always habitat to wild creatures and wild plants and wild rock. But coming as we did, we entered wildness in this place.

In a world built of color and form, multicolored sandstone walls, deep canyons, and high cliffs create a glowing landscape. Elevation differences provide habitat for widely diverse plant communities. Proclaimed Mukuntuweap National Monument in 1909, incorporated into Zion National Monument in 1918, established as a national park in 1919. Acreage—146,592.31.

THE WATCHMAN AND THE VIRGIN RIVER, AUTUMN

Bryce Canyon NATIONAL PARK

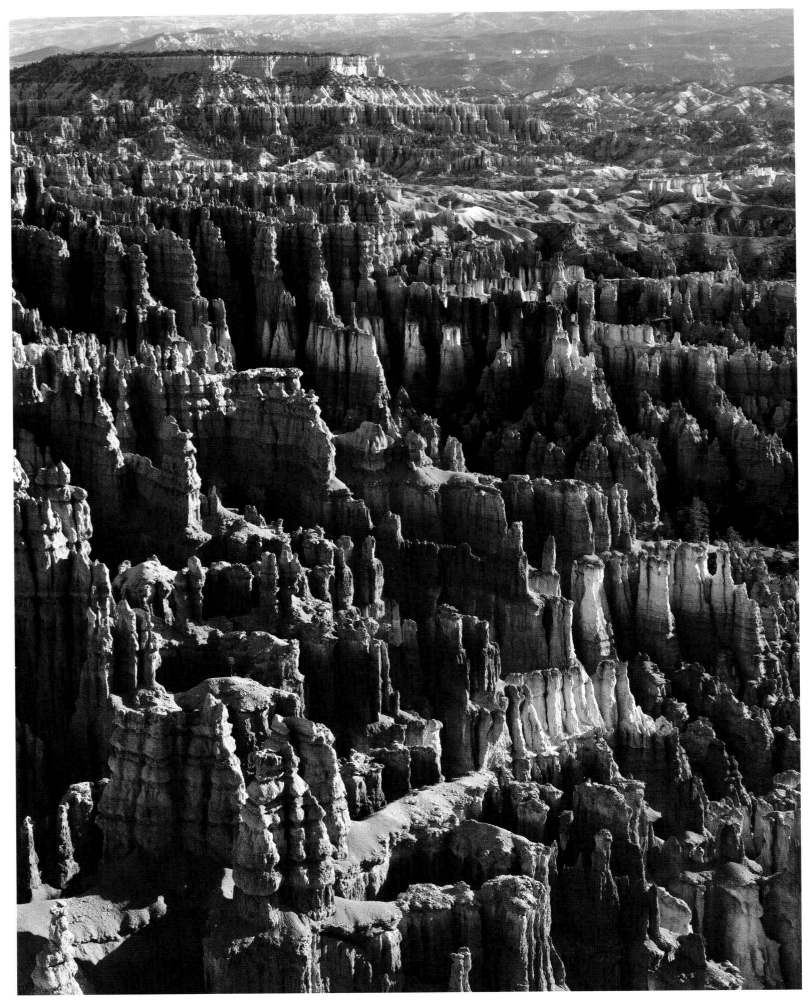

BRYCE AMPHITHEATER

Pinnacles, walls, and spires stand in horseshoe-shaped amphitheaters along southern Utah's high plateau country. Proclaimed a national monument in 1923, renamed and redesignated Utah National Park in 1924, renamed Bryce Canyon National Park in 1928. Acreage— 35,835.08.

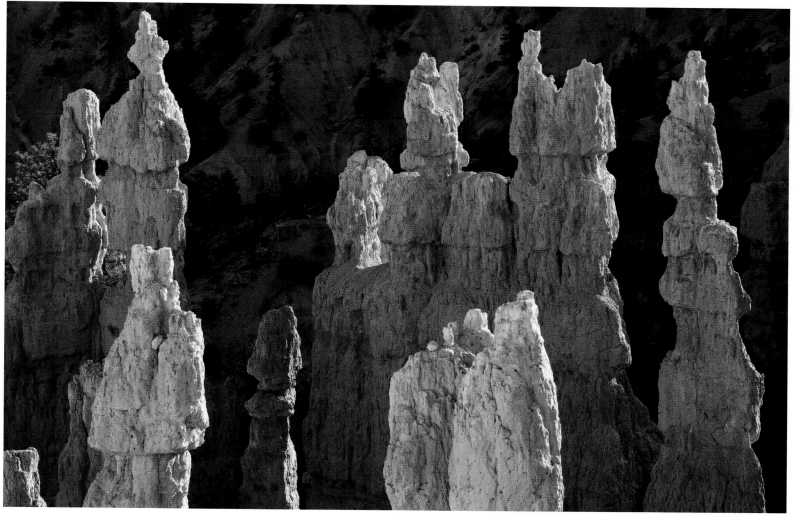

▲ ▲ WINTER'S BRIDGES, WALL STREET

▲ FAIRYLAND FORMATIONS

Capitol Reef NATIONAL PARK

The Waterpocket Fold, a 100-mile-long uplift of sandstone cliffs with highly colored sedimentary layers, is protected here. Dome-shaped white-cap rocks in every direction account for the name. Proclaimed a national monument in 1937, redesignated a national park in 1971.

Acreage—241,904.26.

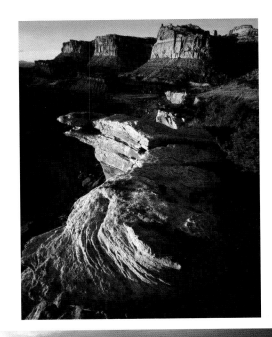

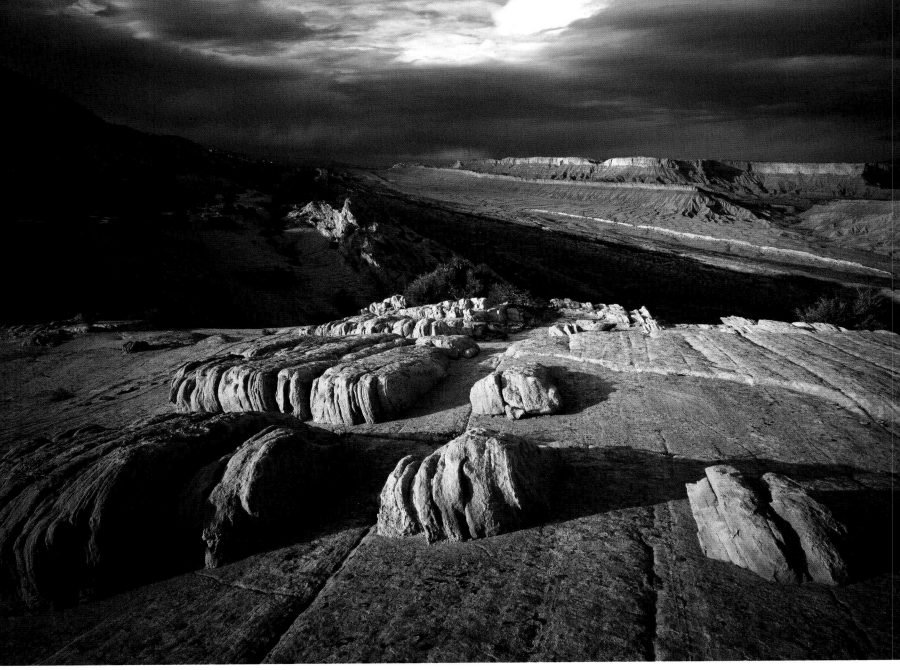

▲ ▲ PAINTBRUSH AND DRIFTWOOD ON CLAY ▲ ▶ LAND OF SLEEPING RAINBOW

▲ STRIKE VALLEY OVERLOOK

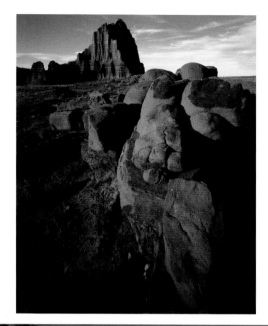

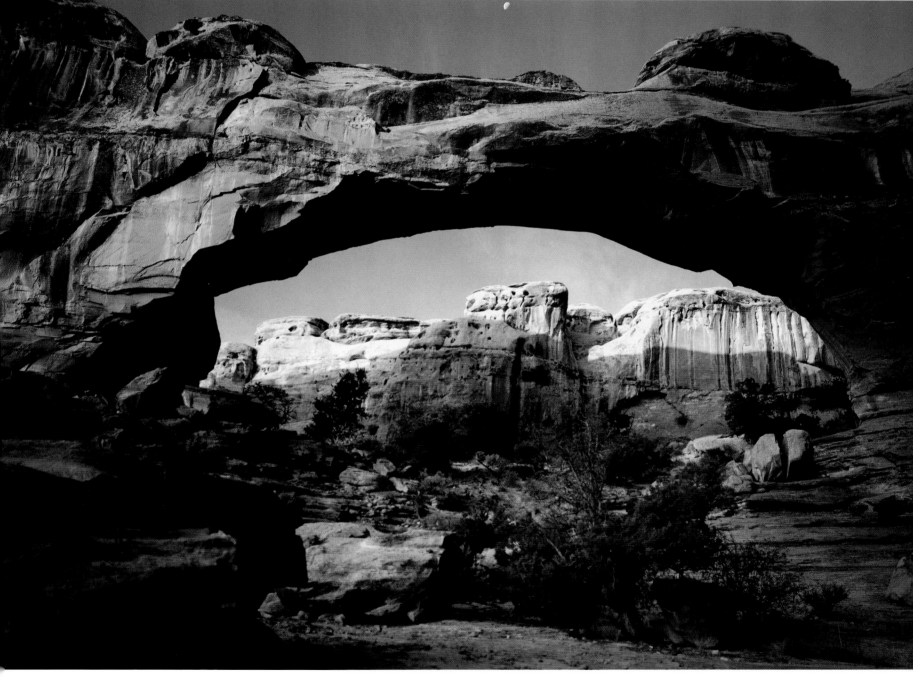

▲ ▲ CATHEDRAL VALLEY FORMATIONS ▲ ▶ CLARET CUP CACTUS

▲ HICKMAN BRIDGE

Canyonlands NATIONAL PARK

Canyons of the Green and Colorado Rivers cut the heart of the Colorado Plateau to sculpt a red-rock wonderland of spires and mesas. Established in 1964. Acreage—337,597.83.

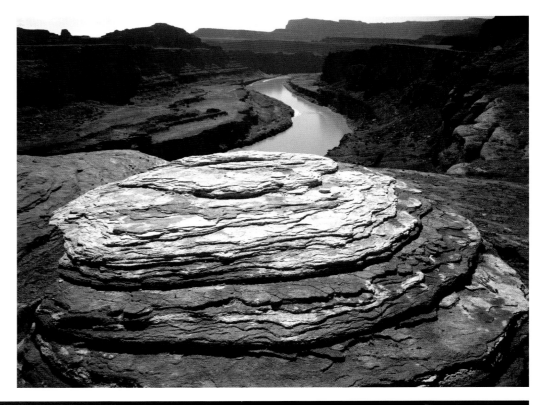

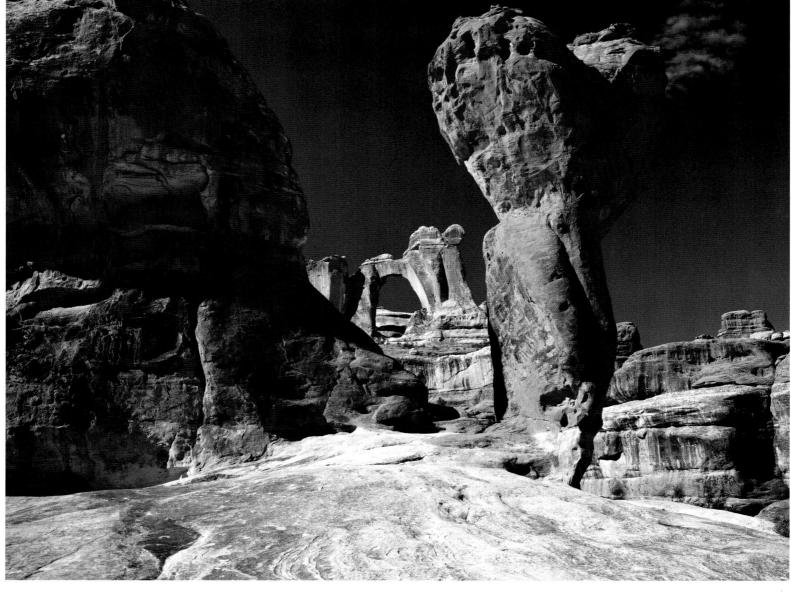

▲▲ COLORADO RIVER AND WHITE RIM

▲ ANGEL ARCH AND MOLAR ROCK, SALT CREEK

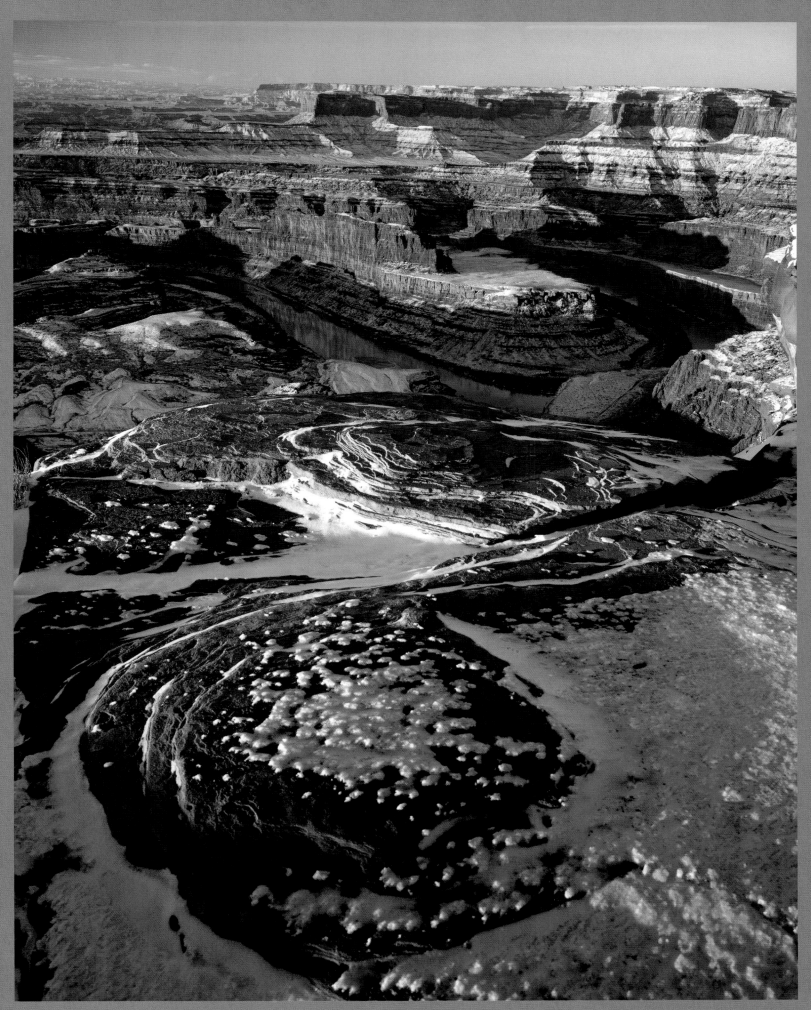

ICED RIMS, DEAD HORSE POINT

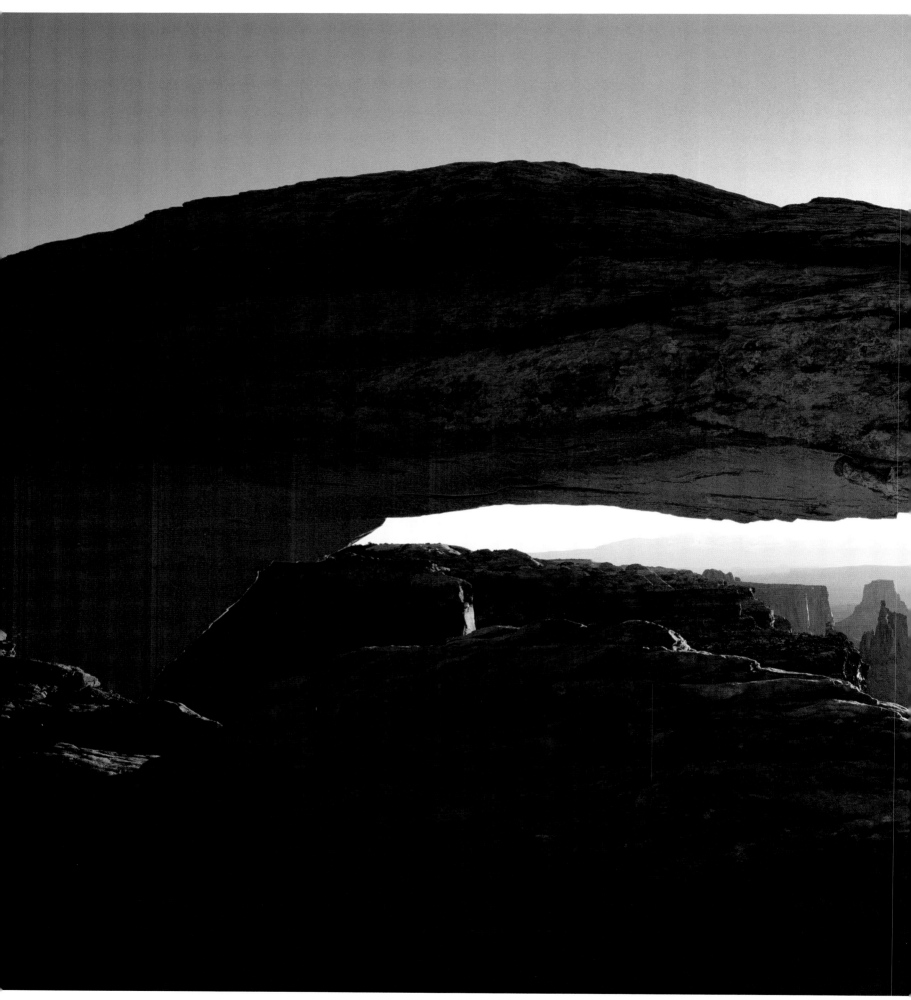

DAWN, MESA ARCH

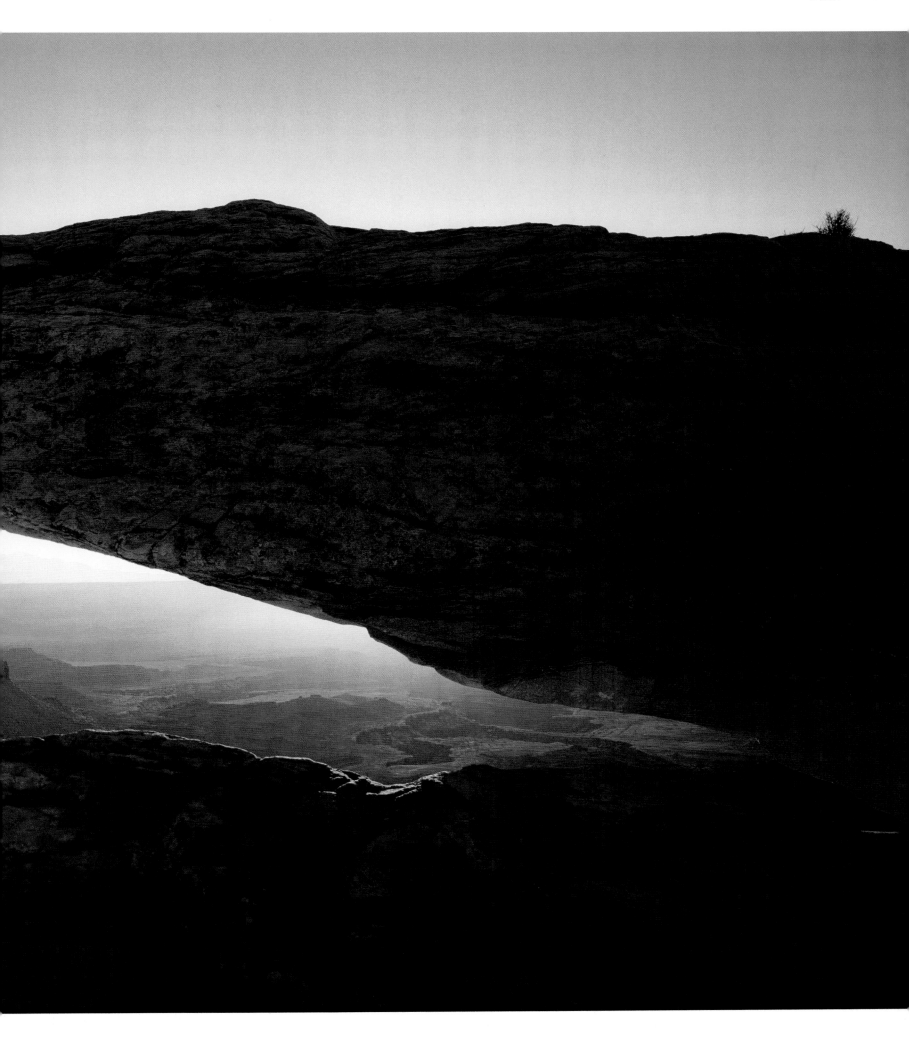

Arches NATIONAL PARK

This park celebrates the extraordinary products of erosion in some 2000 arches, windows, pinnacles, and pedestals. Proclaimed a national monument in 1929, redesignated a national park in 1971. Acreage—76,358.98.

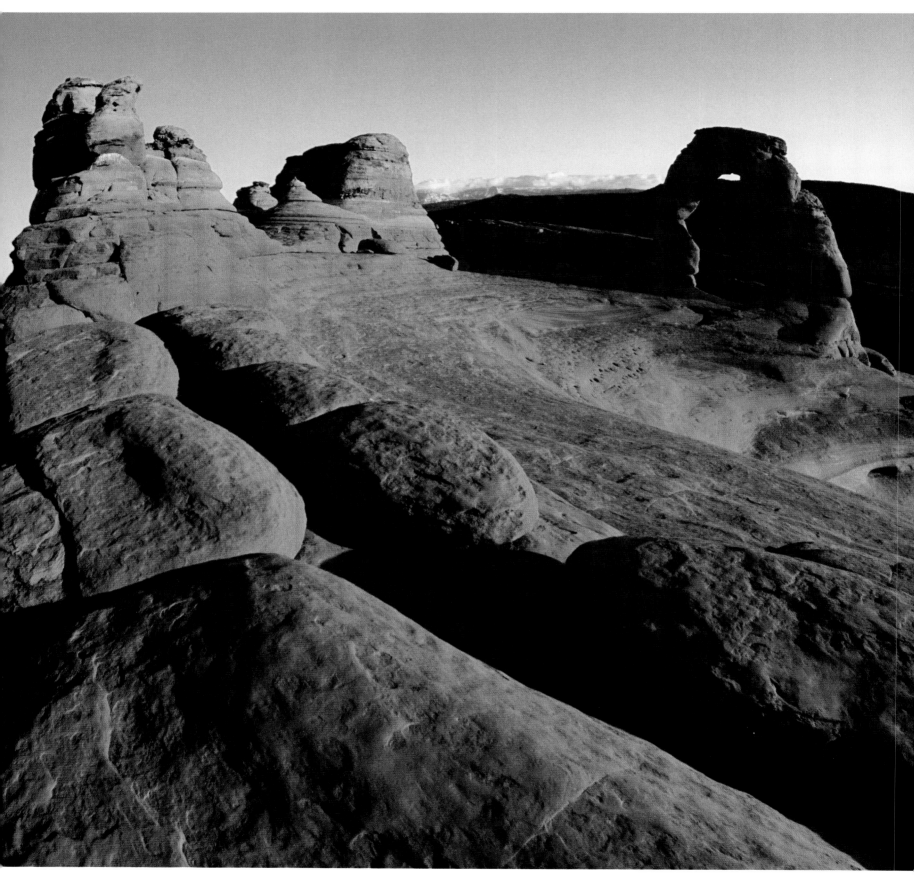

DELICATE ARCH AND AMPHITHEATER

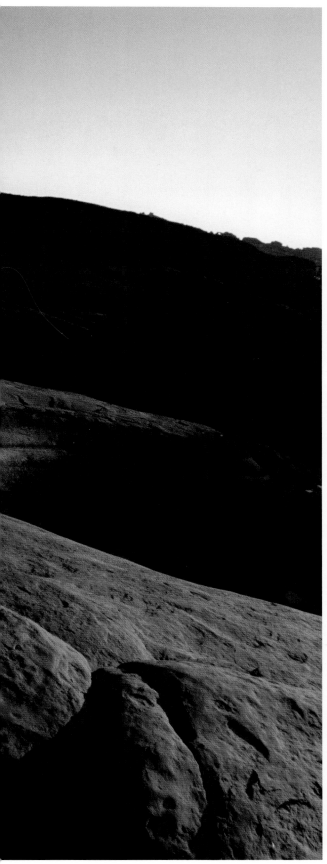

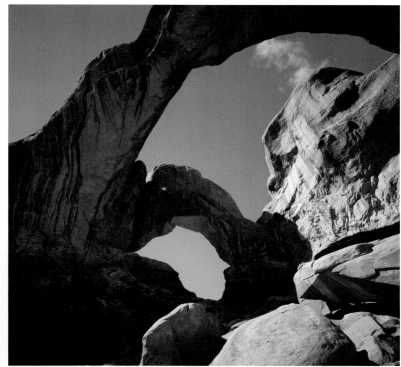

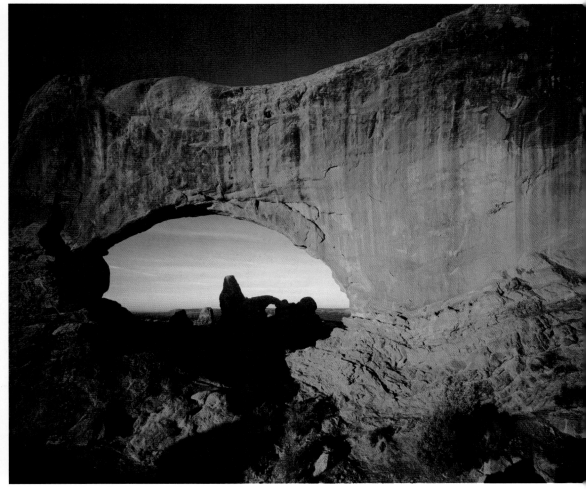

▲ ▲ DOUBLE ARCH

▲ TURRET ARCH THROUGH NORTH WINDOW

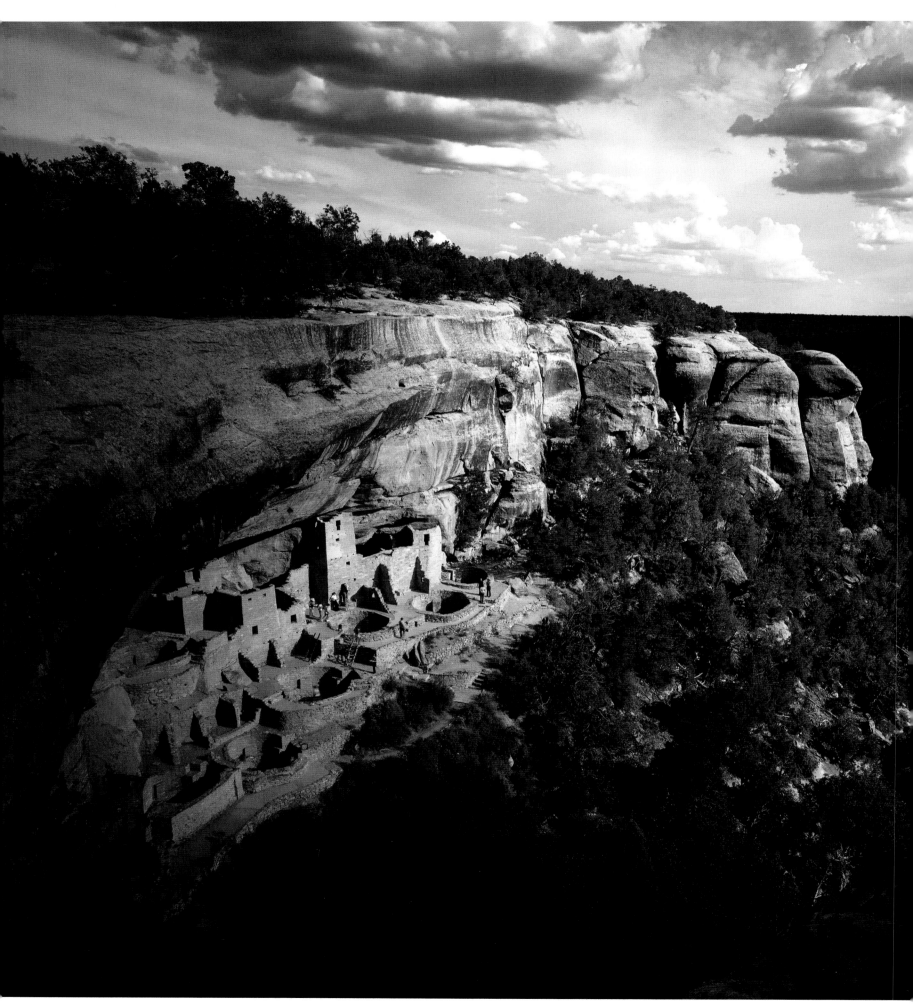

ANCESTRAL PUEBLOAN CLIFF PALACE

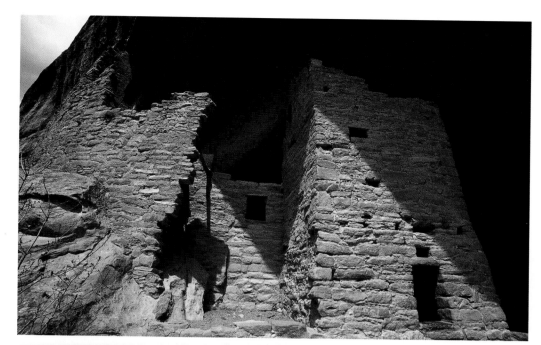

Cliff dwellings and other works of the Ancestral Puebloan People are the most notable and best preserved in the United States. Established in 1906. Wilderness designated in 1976. A World Heritage Site. Acreage—52,121.93. Wilderness—8500 acres.

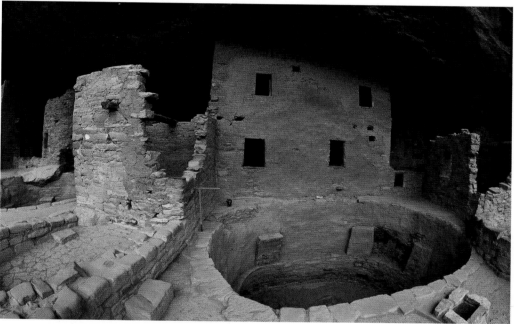

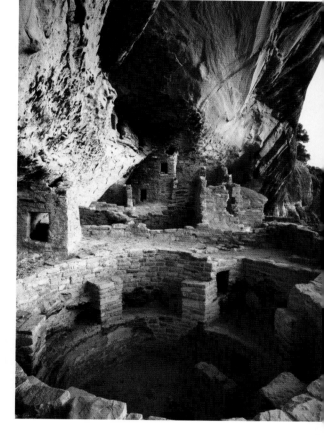

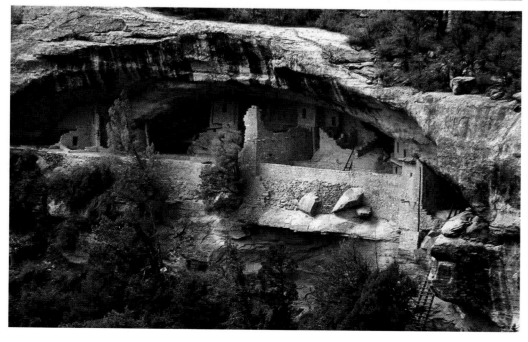

◄ ▲ ▲ SPRUCE TREE HOUSE, NORTH WALLS

◄ ▲ SPRUCE TREE HOUSE

◄ BALCONY HOUSE

▲ MUG HOUSE

Black Canyon of the Gunnison NATIONAL PARK

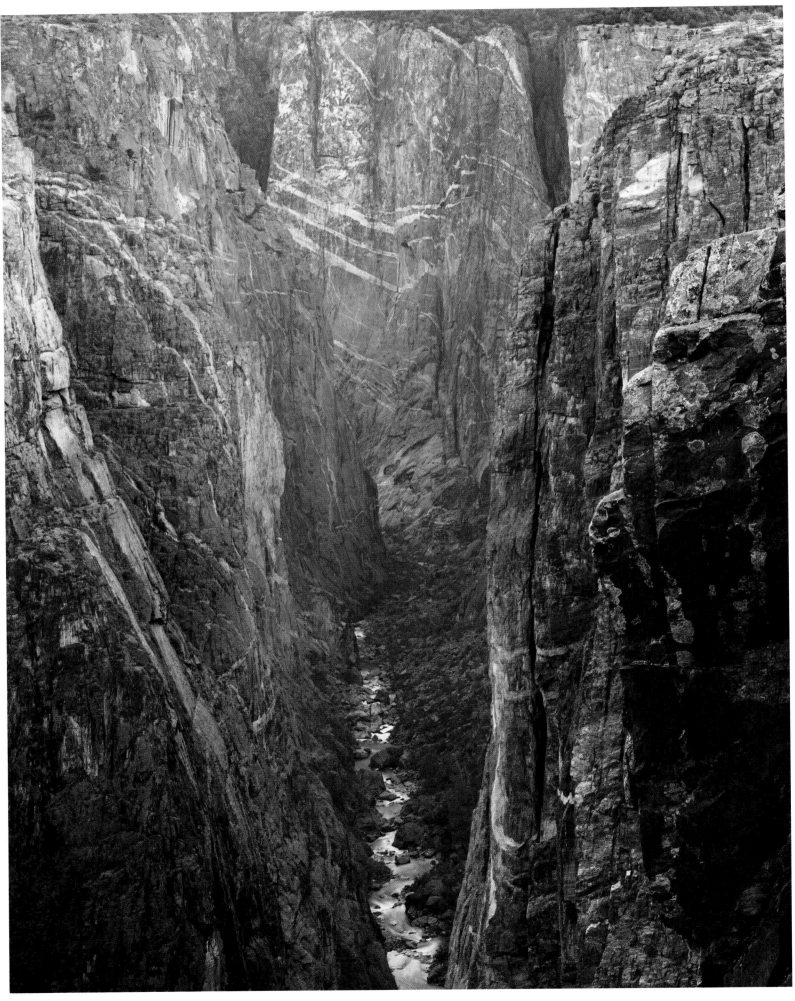

THE NARROWS FROM THE NORTH RIM

Monolithic rock walls rise 2000 feet above a river wedged in by volcanic deposits and committed to a course from which it could not escape. Proclaimed a national monument in 1933, redesignated as a national park in 1999. Wilderness designated in 1976 and 1999. Acreage—27,705.14. Wilderness—15,599 acres.

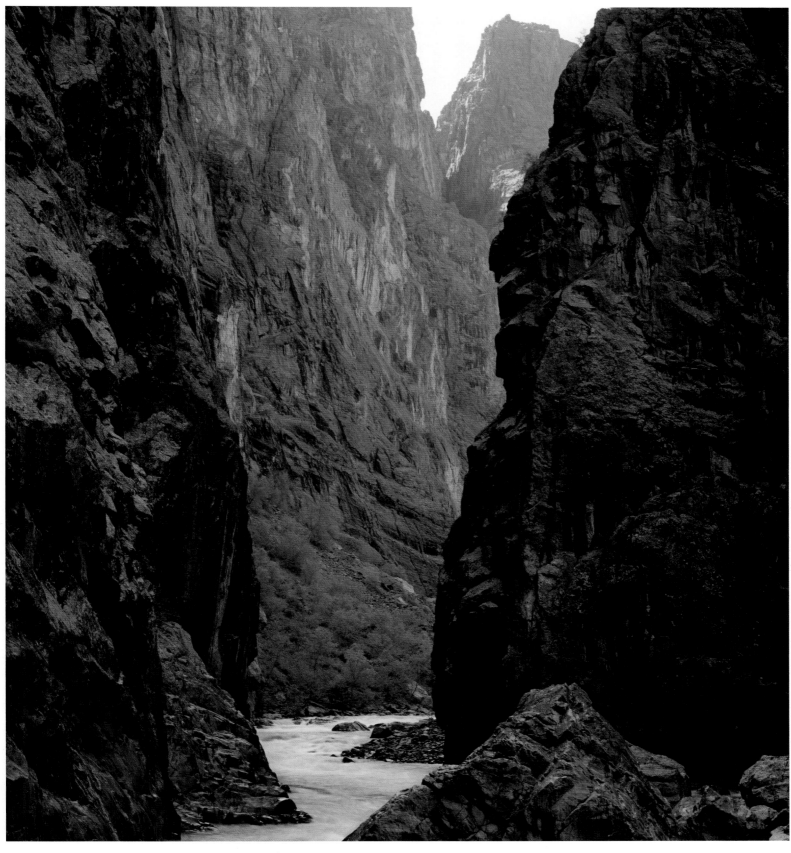

BLACK CANYON OF THE GUNNISON RIVER

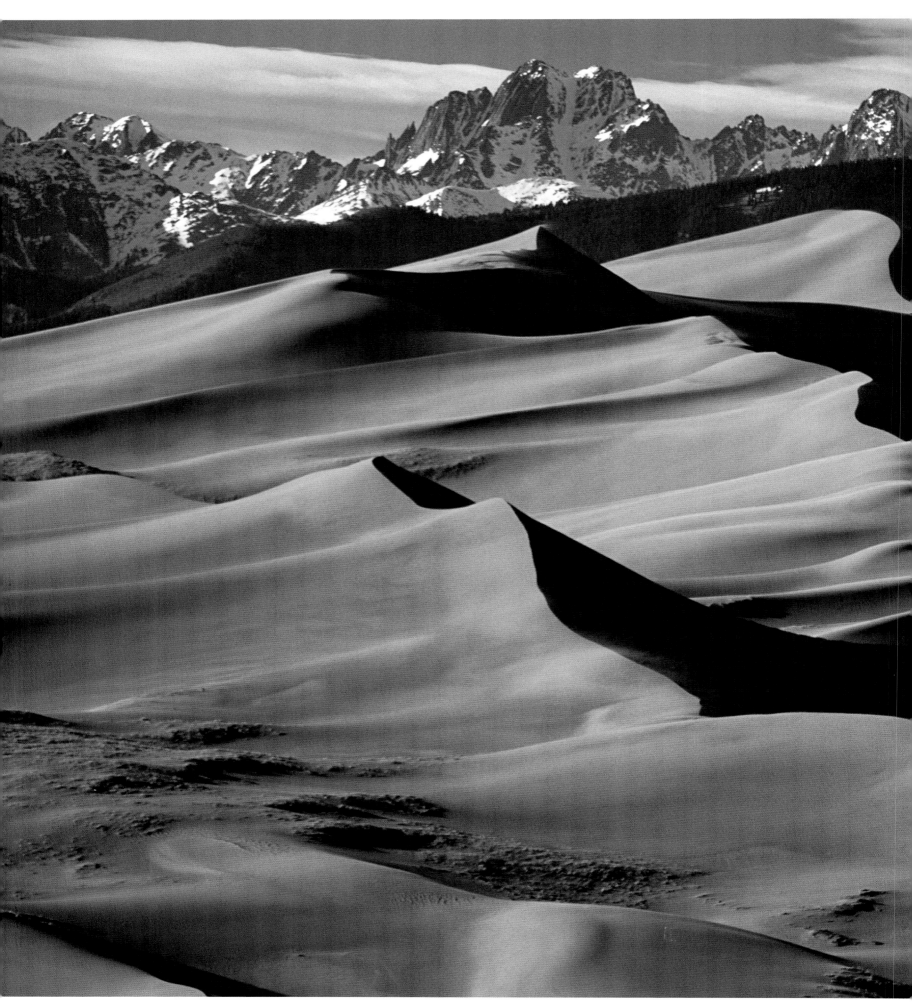

▲ DUNE FIELD AND CRESTONE PEAKS

► SUNFLOWER ON SAND SHEET

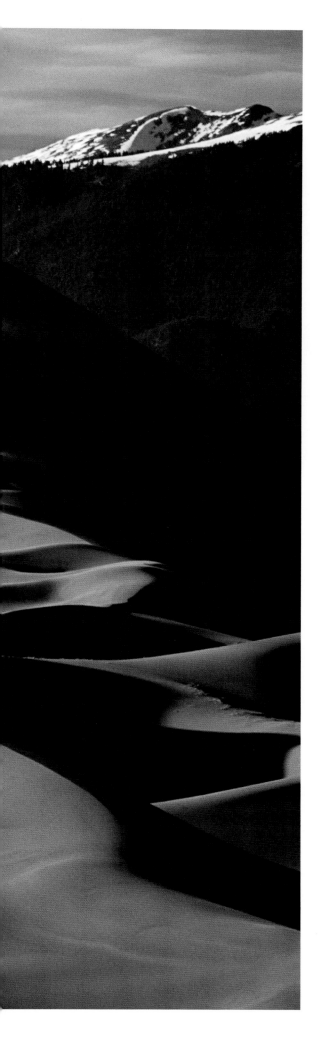

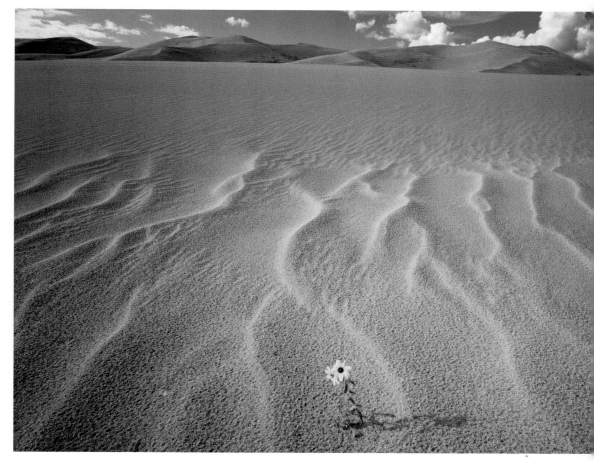

Great Sand Dunes

NATIONAL PARK AND PRESERVE, COLORADO

A mountain bluebird hovered above the rabbitbrush and grasses and old gray snags, the blue-bird's color brilliant against a deep gray sky. It hovered against the stiff wind battering brush and grass and the last remaining sunflowers. Suddenly a great flock of bluebirds appeared out of the sky, as if the sky had formed them.

In the dunes the stiff wind pounded me with sand, pounded sand with sand, the wind indifferent to it all. Sand flowed up the dunes, forming and re-forming these structures of the wind. This is a world built by eolian geology, a geology based on wind. Sand—fine-grained quartz, pumice, ash, and lava—is carried into the San Luis Valley by the Rio Grande, flowing from headwaters in the San Juan Mountains west of Great Sand Dunes National Park. Prevailing southwesterly winds carry this sand to the southwestern base of the Sangre de Cristo Mountains, where the winds become trapped by mountain walls rising over 14,000 feet in the Crestone Peaks. Storm winds from the northeast, blowing through passes in the Sangre de Cristo, carry sand in from that direction.

In spring, Medano Creek, running from the subalpine Medano Lake—formed by the snow-fields below 13,000-foot peaks in the Great Sand Dunes Preserve—flows in waves, driving fresh sand into its channels, then throwing it back onto the dunes when the creek dries up and heads underground. The complex wind patterns constructing a variety of dune shapes over the thirty-nine square miles of dune area have formed these into the tallest dunes in North America. Walking in them, when the valley is hidden from your view and there is nothing but sand thrust

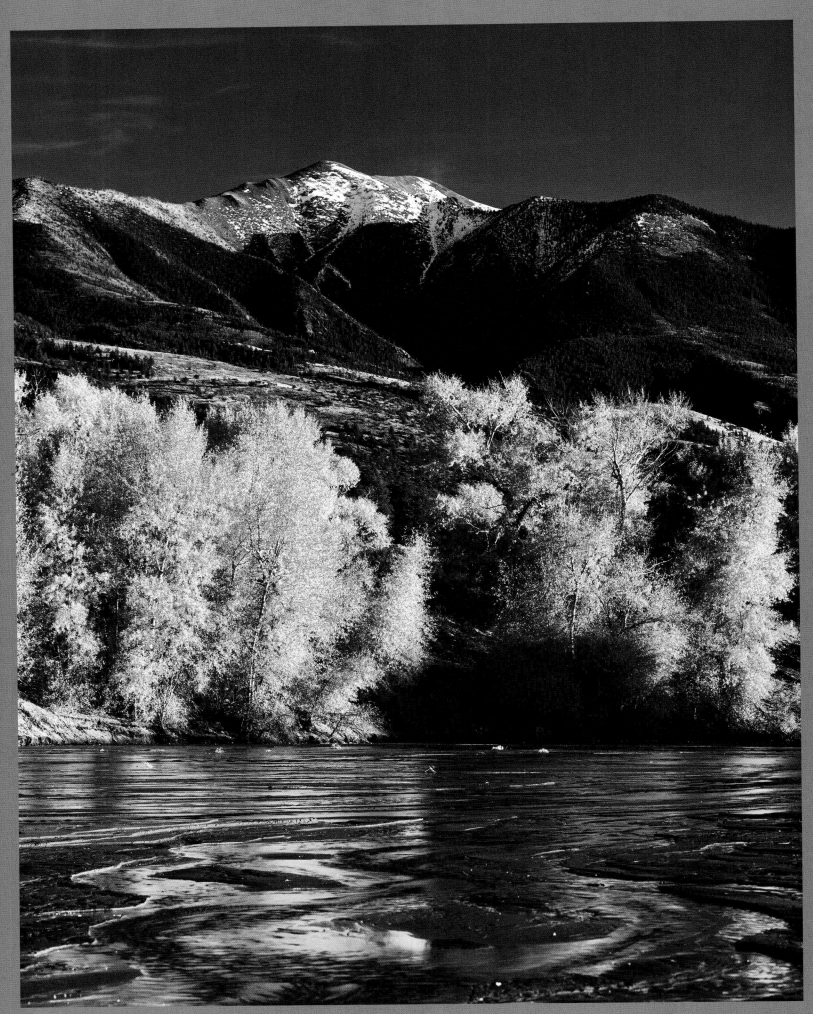

MEDANO CREEK IN AUTUMN

into wave after wave of dune, is like walking in some ancient Sahara. You are alone in the primeval desert.

Great Sand Dunes, a national monument since 1932, became a national park and preserve in September 2004, expanding from 32,000 acres to 150,000 in the process. The national preserve, which contains the watersheds of Medano and Sand Creeks, is a separate unit but administered by the national park. Once part of the Rio Grande National Forest, the preserve was a reintroduction site for Rocky Mountain sheep, and hunting is allowed. Indeed, it is a necessity for managing herds with no serious predators. Part of the Sangre de Cristo Wilderness Area, the addition of the preserve adds 40,512 acres of wilderness to the park's previously existing 32,643 acres of Great Sand Dunes Wilderness.

This landscape of color and line and texture is a model for diversity. The flat desert floor of the San Luis Valley gives way to dunes rising like shadows of the soaring Sangre de Cristo behind them. East of the dunes there are spruce and fir forests, ponderosas, pinyon and juniper, aspens and cottonwoods. Twenty different species of plants grow directly on the dunes that, with the surrounding shrubby areas, provide habitat for kangaroo rats, mice, ground squirrels, rabbits, and mule deer, and the bobcats and coyotes that eat them. The San Luis Valley, on the far western edge of the Central Flyway, is vital to a whole suite of migratory birds, among them 98 percent of the Rocky Mountain population of greater sandhill cranes.

I walked the mile back to the road from the dunes in cold wind, brief rain, under a snow-gray sky. As I crossed the brush, the clouds lifted, layering the sky with streaks of blue the color of bluebirds. White, blinding sun reflected off the tops of breaking clouds. Sunbeams fell on distant swirling sand at the farthest edges of the vast desert plain. The wind remained fierce. The bluebirds disappeared, as if existence had been a momentary thing.

Thousands of years of southwesterly winds through the passes of the Sangre de Cristo Mountains have created the tallest dunes in North America. Park and preserve elevations range from 8000 feet to over 13,000 feet, producing life zones from desert to alpine tundra. Proclaimed a national monument in 1932, redesignated as a national park and preserve in 2004. Wilderness designated in 1976 and 1993. Combined acreage of park and preserve—146,747. Wilderness—75,641 acres.

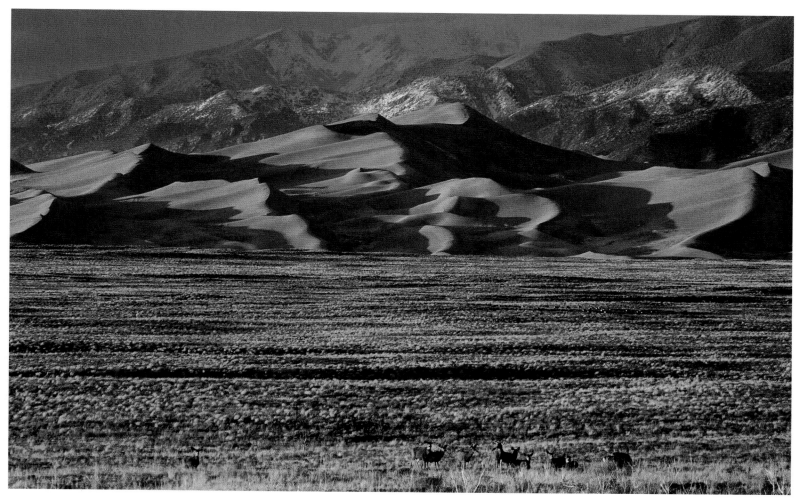

DEER BROWSE THE FLAT BELOW GREAT SAND DUNES

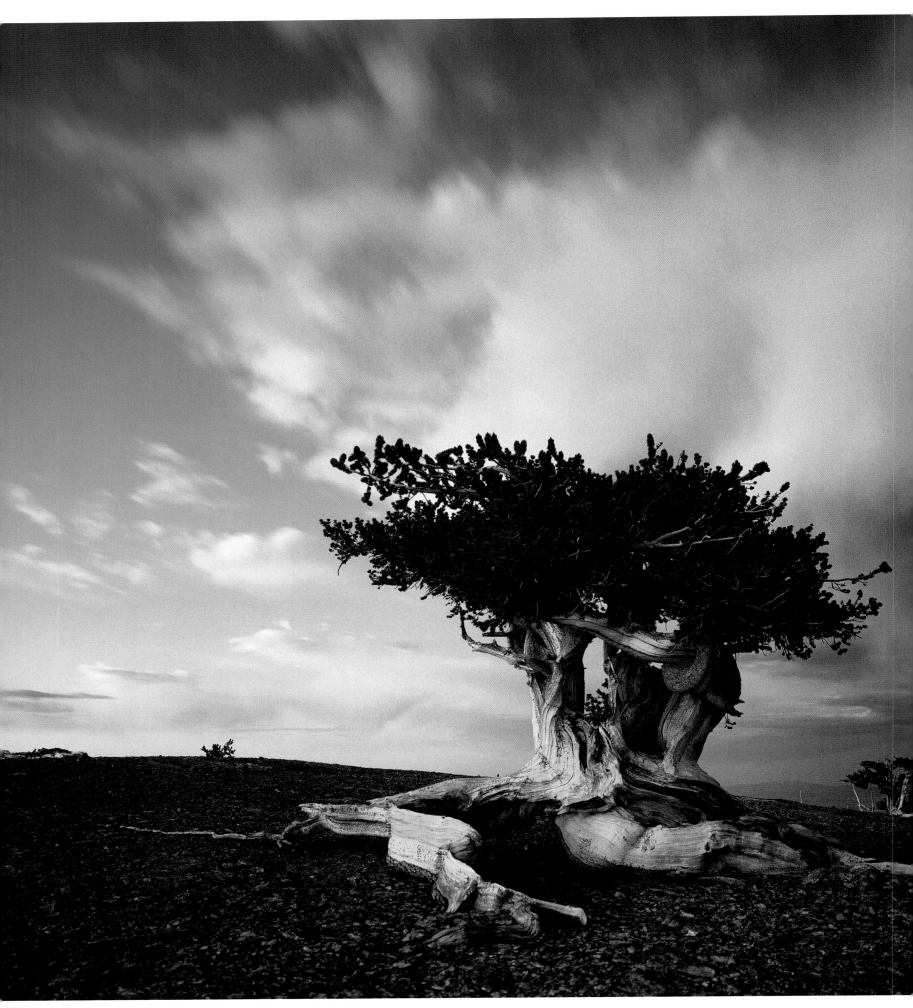

▲ BRISTLECONE EMBRACE, MOUNT WASHINGTON

▶ PARACHUTE FORMATION, LEHMAN CAVES

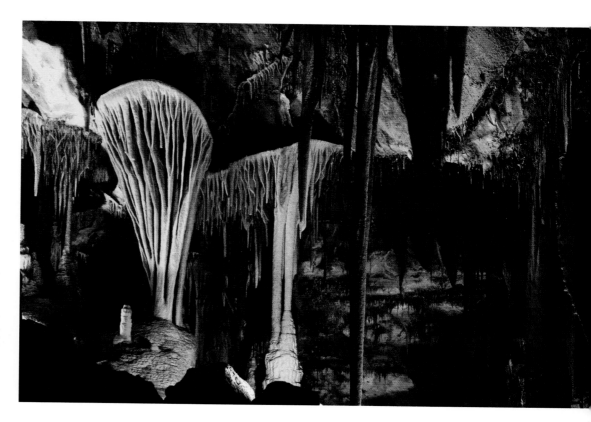

Great Basin

NATIONAL PARK, NEVADA

A world of high mountains and subterranean caverns carved from ancient limestone, Great Basin National Park celebrates the wild, lonesome landscape of the Nevada desert, the basin and range country extending across Nevada, southern Idaho, the west desert in Utah, eastern California, and a bit of eastern Oregon. This land, in which rivers do not run to the sea, is prime habitat for bristlecone pines. These, the oldest living trees on earth, live in the greatest adversity. They thrive at high altitudes, in sensitive sites where nutrients are scarce, where severe storms—snow, wind, extreme cold—form them, providing their life energy. Where life is hard, tree growth is slow and difficult. The annual rings are narrow, the wood compact and decay-resistant.

Bristlecones can live for 5000 years, which means that trees alive today were also alive while the Egyptians were building pyramids, the Chinese were constructing the Great Wall, and Alexander the Great was out conquering everything. The tree's venerable age and its ability to stand for centuries after death is directly related to the adversity of its life. Venerable age follows its own rules. Entering the presence of bristlecones, I am awed and jealous. I'd like to live in the same kind of places, see what that they see, share their storms and their silence. Bristlecone and limber pines appear between 9500 and 11,000 feet in the Snake Range, at the park's core. An island range surrounded by desert, it possesses thirteen peaks rising above 11,000 feet. Near the summit of 13,063-foot Wheeler Peak, there is a small alpine glacier, the only one in the Great Basin. One autumn morning I walked up from the 9886-foot-high campground the 1.4 miles to a bristlecone grove in the Wheeler Peak cirque. Interpretive signs placed in this grove make it easy to get a sense of the lives of these trees. Near a tree born in 1300 B.C. that died in A.D. 1700, there was a sign that said, "A great reluctance to die is common to bristlecones. They may cling to life for centuries after reaching old age." As the tree ages, it shuts down enough of its being to

A diverse landscape in this basin and range country contains a remnant icefield on 13,063-foot Wheeler Peak, an ancient bristlecone pine forest, a limestone arch, and Lehman Caves. Proclaimed Lehman Caves National Monument in 1922, incorporated into Great Basin National Park when established in 1986. Acreage—77,180.

concentrate all life in, perhaps, a single strip of life along an edge of bark, much as in extreme cold the blood flow to our extremities cuts off to maintain our core. What is not essential is sacrificed to maintain the living, breathing heart.

I sat for hours in a sunlit clearing in the middle of the grove surrounded by bristlecones and the bones of bristlecones, the magnificent sculpted skeletons standing long after the tree has lived its thousands of years and died. A few thin clouds drifted away after a gray start to the day. To the south, I watched clouds form and re-form over Wheeler Peak. It is a powerful mountain I have never climbed. It lures me to it. One day.

For that is part of wildness. That you are drawn to it. That it beckons forever with its promise of . . . what? Adventure, freedom, possibility, your personal unknown, challenge, connection. Next trip. So long as wilderness exists, we always have the expectation of the next trip.

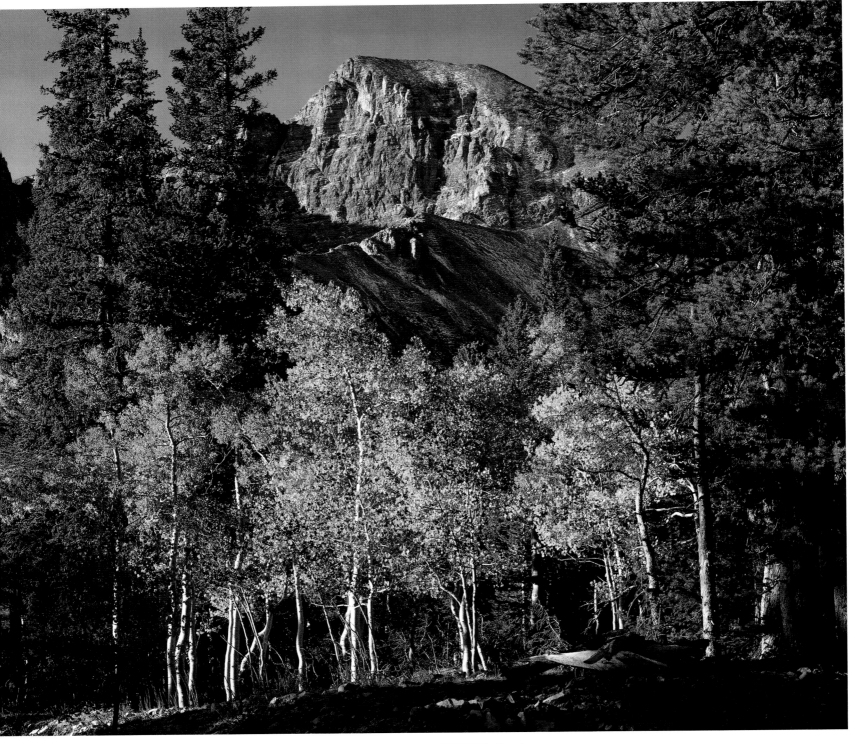

▲ WHEELER PEAK IN AUTUMN, *Nevada*

▶ ANCIENT BRISTLECONE PINE AND WHEELER PEAK, *Nevada*

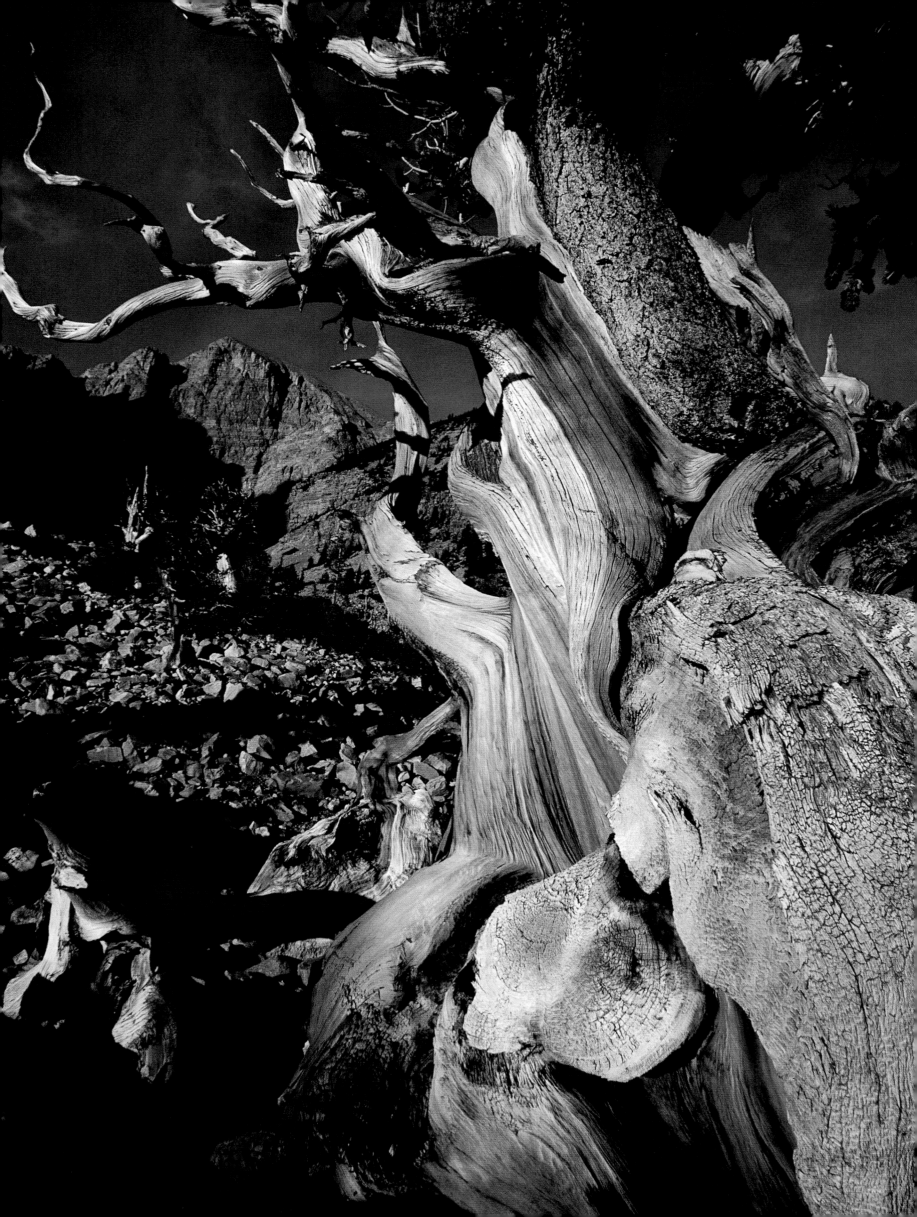

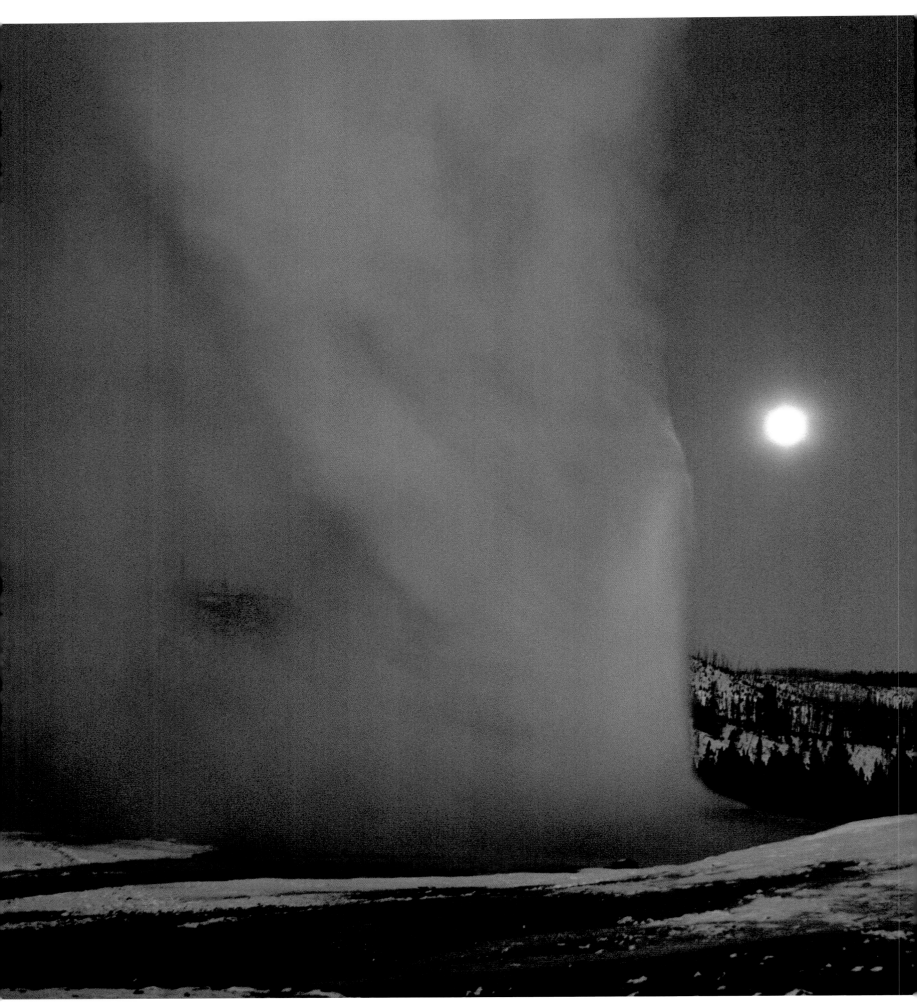

▲ MOONRISE AT OLD FAITHFUL GEYSER

▶ ICED PINES, LOWER GEYSER BASIN

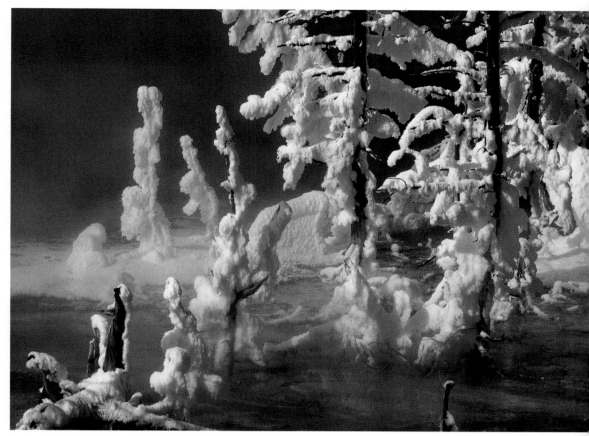

Yellowstone

NATIONAL PARK, WYOMING

We had chosen the time of the full moon for our visit. The snowcoach deposited us at Old Faithful Snowlodge in the late afternoon. With less than an hour of light left and the geyser soon to erupt, David waited near it with his camera while I headed out into the geyser basin toward Solitary Geyser. Solitary Geyser sits by itself on a hillside across the Firehole River from the multigeysered basin, looking down on it like some royal, isolated kin. Part of the boardwalk crossing the basin was covered by slanting ice, a tricky few steps to negotiate. I was glad when the boardwalk ended and the trail through forest began. Deep, glittering snow lay on both sides of the trail. On the trail, snow was firmly packed by the feet of snowshoers and walkers. This late in the day, I had it to myself. I intended to go only as far as Solitary Geyser but, once there, decided to continue on to Observation Point. Observation Point is a popular short walk in other seasons because it offers a terrific view of Old Faithful erupting. I thought I had time enough to make the hike and still return to the basin via a steeper, switchbacking trail before dark.

A lowering sun cast strips of gold between trees on the deeply forested slope cut by the trail. Dark shadows of snow-heavy trees framed the gold. Snow crunched under my boots. Warmed by my hurrying walk, I was comfortable on the trail, joyous in the winter landscape, grateful to be away from the few tourists waiting for the next eruption below.

Passing the junction with the switchback trail, I reached Observation Point at full dusk without time to linger if I wanted to return to Old Faithful before dark. At that moment, a wolf howled. Looking in the direction of the howl, I saw a brilliant yellow light at the edge of a hill. Although we had chosen the time of the full moon for our visit, it took me time to realize that

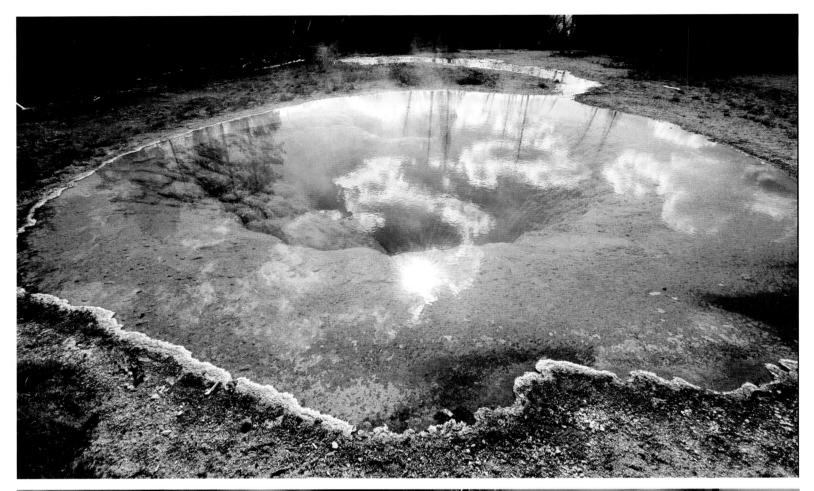

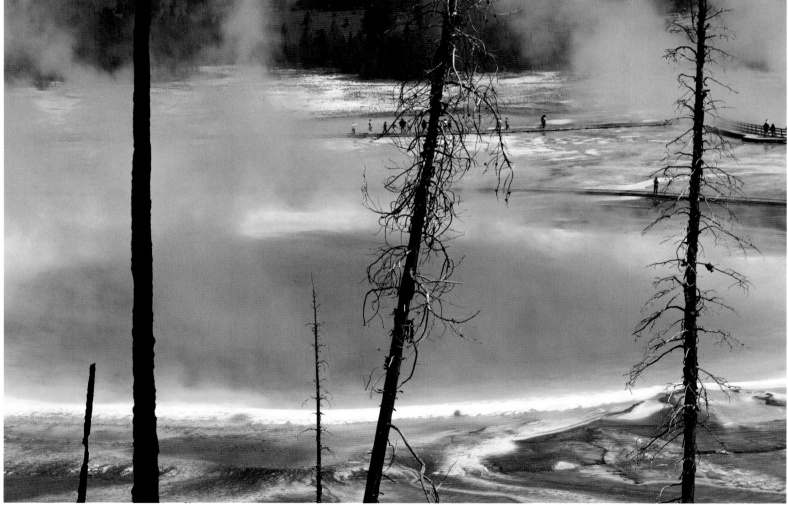

▲ ▲ EMERALD POOL

▲ GRAND PRISMATIC SPRING

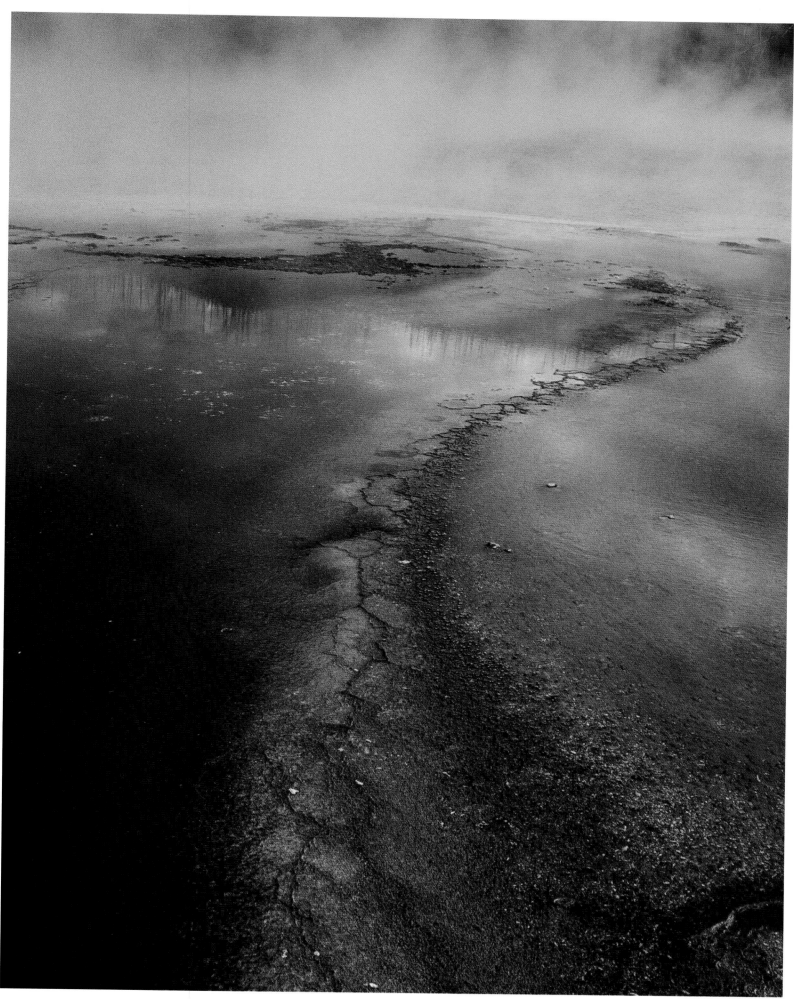

ALONG GRAND PRISMATIC SPRING

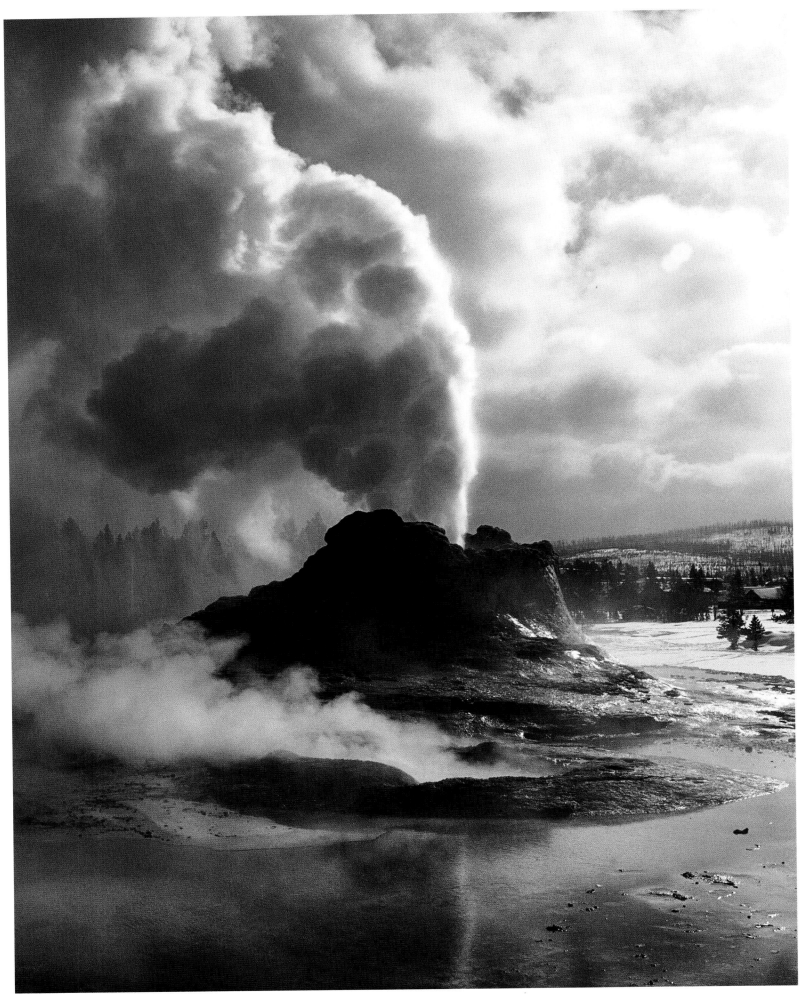

CASTLE GEYSER

the light was the rising moon. The wolf howled. A second wolf answered. The howls echoed off the moon. The moon expanded, rounded, freed itself from the hill, entered sky. Overwhelmed by the huge beauty of the place, I knelt in the snow.

I had come upon perfection. There seemed to me no further reason for anything. Here was all that had ever been necessary. I wanted to stay with the wolves, the moon, the depths of the winter night, to stay in that place and that moment forever.

How long was it before I felt the cold? The temperature, in the low single digits when I started, had sunk. Cold, I remembered the necessity of moving, of returning to Old Faithful. Maybe if I just dug down deeper into the snow . . . It occurred to me that David would worry. Reluctantly, I rose, and retraced my steps down the path to the switchback trail junction. The way was broad and clear, easily visible in the moonlight. I jogged down it feeling pleased with myself for having been present to an ultimate Yellowstone experience.

The most intact ecosystem in the temperate zones of the world, the park celebrates a diversity of wildness—including grizzly bears and wolves, lakes and waterfalls, high mountain meadows, the Grand Canyon of the Yellowstone, and some 10,000 thermal features. The world's first national park, established in 1872. A Biosphere Reserve and World Heritage Site. Acreage—2,219,790.71.

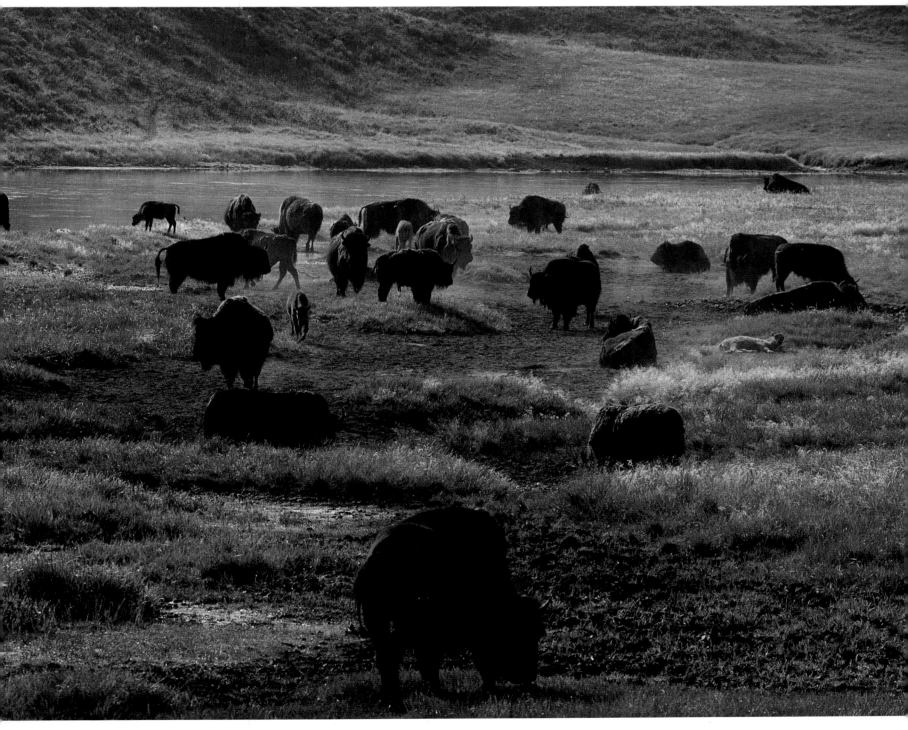

▲ BUFFALO ALONG YELLOWSTONE RIVER

▶ BUFFALO IN HOT SPRINGS FLOW

145

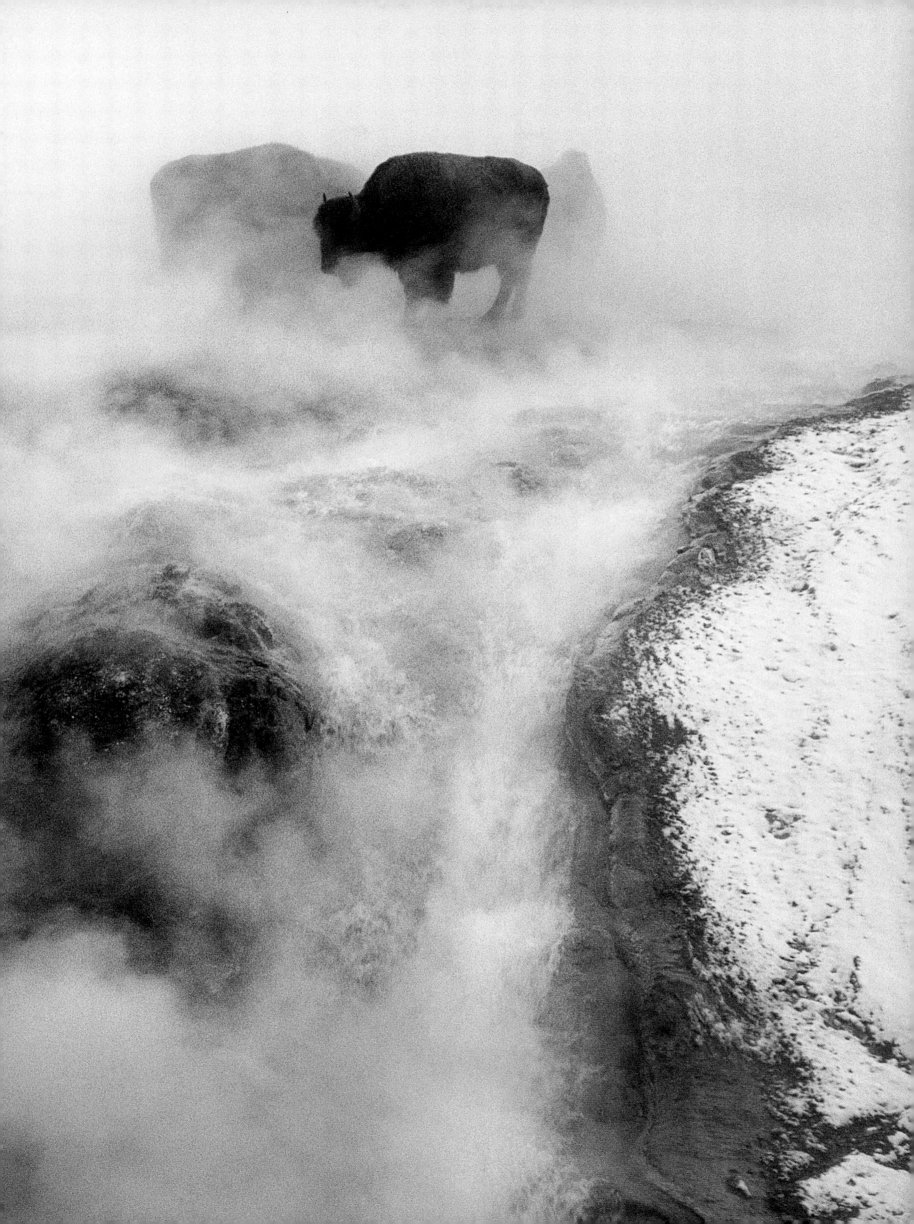

"It is characteristic of wilderness to impress its visitors with the relationship to other forms of life, and to afford those who linger an intimation of the interdependence of all life. In the wilderness it is thus possible to sense most keenly our human membership in the whole community of life on the Earth."

I have been making pack trips in the Yellowstone backcountry since 1988. For seven years, I worked as a guide and wrangler for a horse-packing outfitter. Much of Yellowstone's remote backcountry is familiar to me. At home there, I have had many ultimate Yellowstone experiences. But because I was always in the backcountry, I had never walked any of the trails around Old Faithful. In any season. The wolves and the full moon and the winter night were as deep and full an experience of wildness as I have had anywhere in my years in the park. I was feeling privileged. And invulnerable.

And not paying much attention because the trail was so easy.

Until I lost it. I missed a turn. Realizing it at once, I climbed back up to look for it, annoyed at having to backtrack when I was rushing, but figuring it would be easy to find in the full moon. A trail that wide doesn't just end. Reaching the spot where I had left the trail, I still could not see where it went. I was reluctant to climb all the way back to the trail between Observation Point and Solitary Geyser in order to return the way I had come. Besides, I did not want to negotiate that boardwalk slanted ice in the dark. Thinking I saw old ski tracks in front of me, I decided to walk them down through the snow, then follow the river to the bridge.

I know better than that. Within a few steps, I was ensnared by snow up to my hips. One foot did not touch bottom. I tried to turn and crawl back out. My arms simply swam without giving purchase. I was close enough to the solid snow I had just left that there was no reason for anxiety, yet an instant of panic rose in me. It was as quickly subdued, but in that instant, I understood how even experienced outdoorspeople can make a mistake that is deadly. And stupid. I understood how, even this close to people, I was in a wild country, in a wild season.

Few things strike me as so ignominious as dying out of stupidity. To die on Observation Point in the absolute peace offered by the magnificence of the wolves and the moon would be a gift. To die a couple of football fields away from Old Faithful out of stupidity would be idiotic. I turned slightly to one side, found enough support that I could push myself forward and crawl out of the snow hole, made my way upslope until I found the trail again, followed it to the trail to Solitary Geyser, descended from the geyser through forest shot with moonlight to the icy boardwalk, finessed it, returned to Old Faithful, and found David who, deciding I was lost, was out looking for me. Or, at least, hoping I would turn up.

When we went into the lodge for dinner, I ran into an old friend, a biologist who spends considerable time observing Yellowstone's wolves. "I was listening to wolves on Observation Point," I told him. "Then I got lost coming down."

"The wolves would have found you," he said.

Although its backcountry is not (yet) designated wilderness (it is among the recommendations for wilderness sent to Congress in the 1970s), Yellowstone is a wild place. In this most intact ecosystem in the temperate zones of the earth, almost everything that is supposed to be here, is here. Wolves, bears, mountain lions, coyotes, wolverines, moles, mice, elk, deer, sheep, hawks, eagles, falcons, fish, spiders, butterflies, buffalo, mosquitos, dragonflies, otters, bluebirds, woodpeckers, wildflowers, meadows, streams, forests, all the seasons, hope.

In May 1955, Howard Zahniser, framer of the Wilderness Act, delivered a paper, "The Need for Wilderness Areas," at the National Citizens Planning Conference on Parks and Open Spaces, and later printed in *The Living Wilderness*, the magazine of The Wilderness Society. In his paper, he said, "It is characteristic of wilderness to impress its visitors with the relationship to other forms of life, and to afford those who linger an intimation of the interdependence of all life. In the wilderness it is thus possible to sense most keenly our human membership in the whole community of life on the Earth."

In the essentially intact ecosystem of Yellowstone we can see this interdependence of all life. It is in recognition of that interdependence that hope exists.

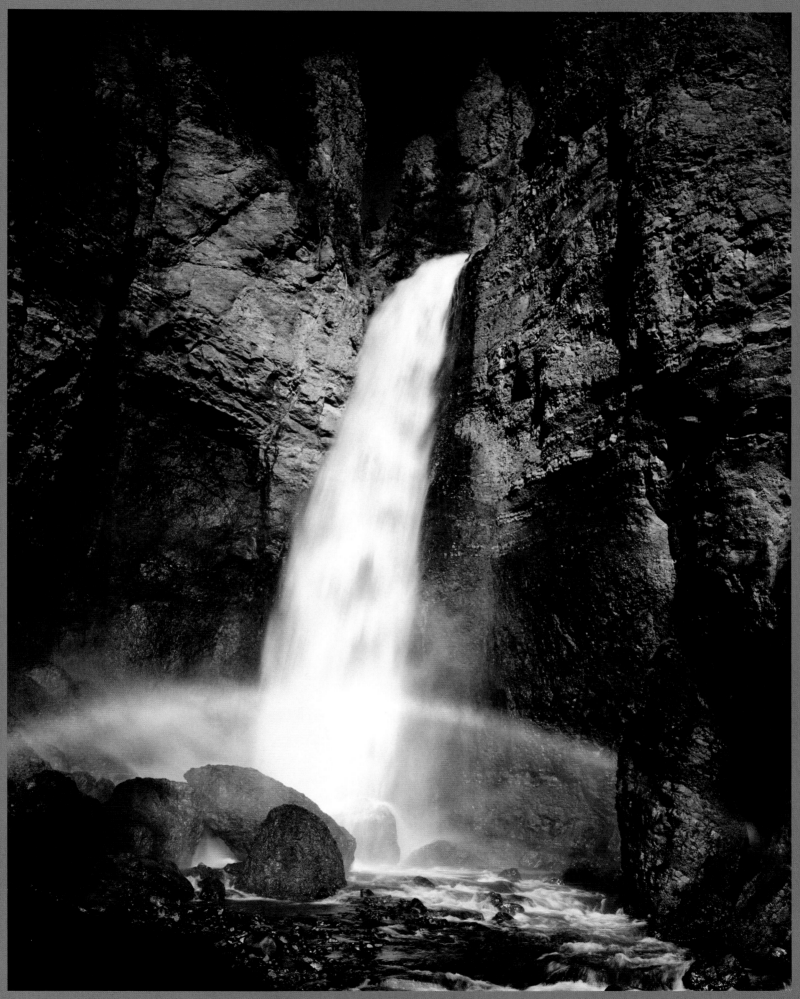

RAINBOW ON TOWER FALL

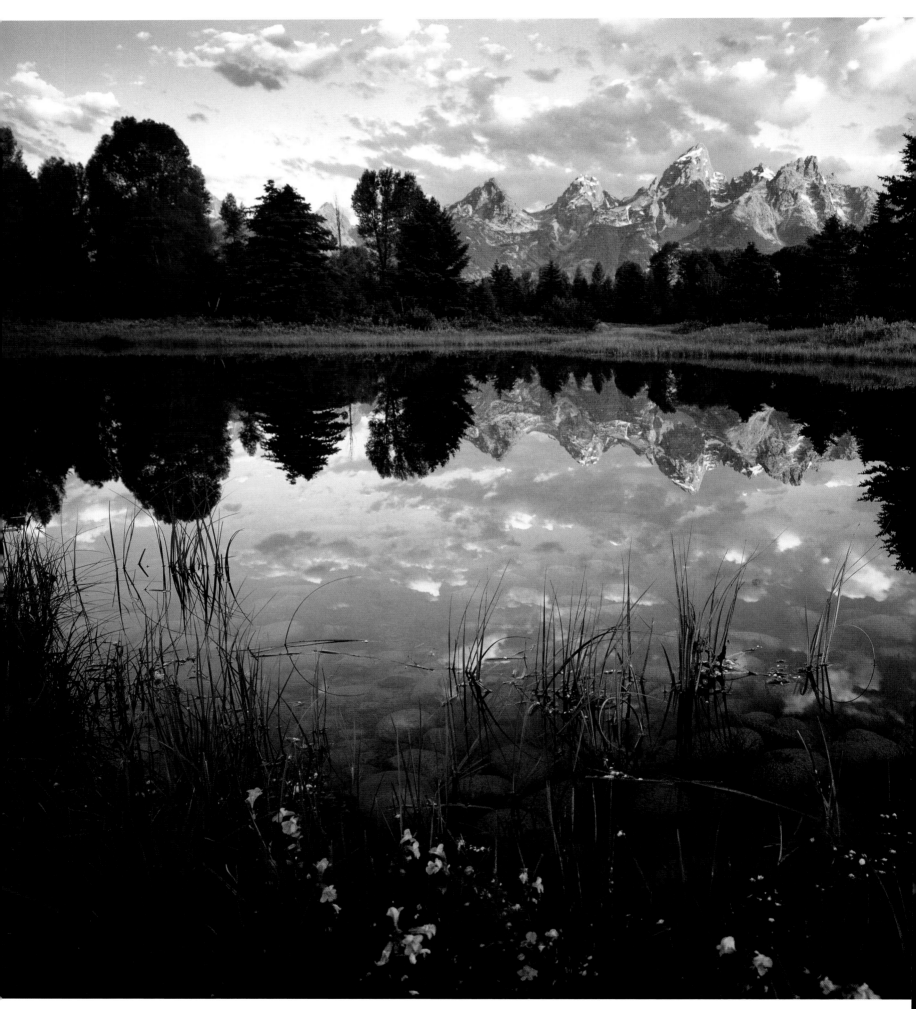

▲ DAWN REFLECTIONS, GRAND TETONS

► PLETHORA OF SUMMER FLOWERS, AND TETON RANGE

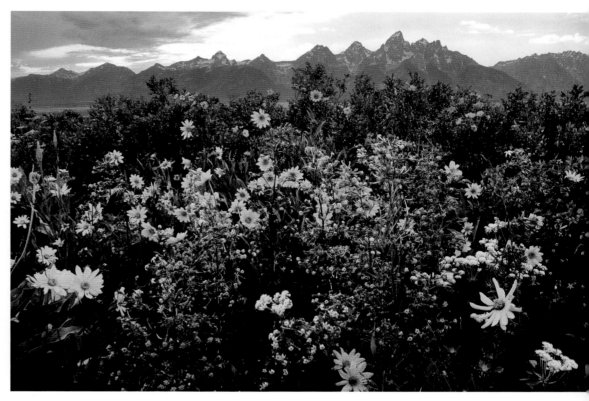

Grand Teton

NATIONAL PARK, WYOMING

Years ago I backpacked from Rendezvous Mountain to Lake Solitude and Paintbrush Canyon. When I stopped at the Moose Visitor Center the day before the hike to pick up my permit for campsites reserved in advance, I overheard the man ahead of me requesting a permit for an overnight hike somewhere in the Tetons the next day. "Where can I go?" he asked. The ranger checked her list. "I'm sorry," she said. "The backcountry is completely booked for tomorrow."

That was my first experience with the idea that wilderness and management were forever at odds. How could a wild place be booked at all? How could a bureaucrat say there is no room in the wilderness? It made no sense until I began my own hike and understood that the quality of my experience was related to the fact that, in the days I was out, I saw few other people until coming, near the end, within reach of day hikers. Even then, at night, I had the wilderness to myself. A wilderness experience. Available only because this hugely popular area was managed. Management and wildness are anathema, but they are also, at this point in history, a necessary marriage.

Marriage is a perfect example of anathema. Two totally unrelated people, coming together to form a union strong enough to survive the jolt of coming together, create a legacy unimaginable alone. What the union lacks in purity, it makes up for in possibility and in hope. The partners protect each other so that each may endure. For wildness will not long endure left to the uses of recreationists and exploiters, and neither management nor anything else will long endure without wildness. "In Wildness is the preservation of the World," Thoreau said. In "The Need for Wilderness Areas," Howard Zahniser wrote in 1955, "In preserving areas of wilderness we are recognizing our own true human interest. It seems good, ethical, to consider ourselves as members of a community of life that embraces the earth—and to see our own welfare as arising from the prosperity of the community."

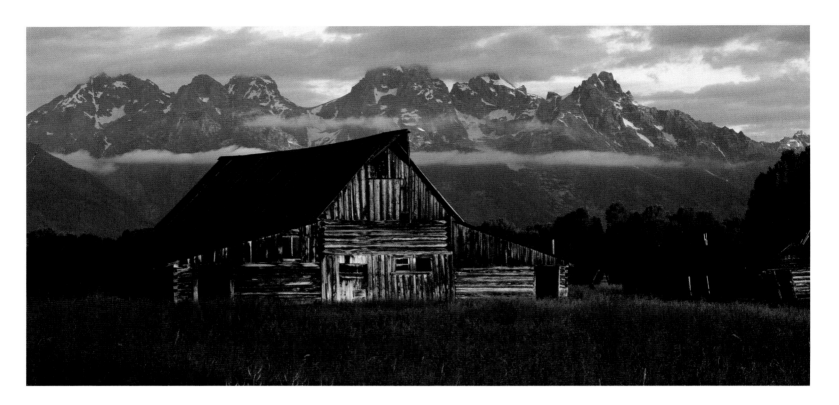

Not long ago, David and I revisited part of that route in Grand Teton National Park, although we hiked the opposite way, coming up Paintbrush Canyon then crossing the Divide into Cascade Canyon and Lake Solitude. We climbed out of the Holly Lake basin through meadows and krummholz and over vast talus slopes into an alpine world of rock and steep snowfields. We climbed into gray wind, into the high, magnificent, unforgiving world of crags and jagged peaks open to every whim of sky and weather. At times the wind allowed no dawdling. At times a sun-warmed rock invited lingering. We could see Jackson Lake and Mount Moran east and north of us. The sun had time to soften the snowfields we crossed; early in the day they would have been slick. The snowfield often covering 10,720-foot-high Paintbrush Divide was reduced to a few remnants.

The experience of walking a trail like this is always intense. Whether you find it easy or hard, it becomes all there is. There is only the trail and the world through which it climbs. Sometimes there is an exuberance in the doing of it, when everything feels right and you match the mountains in your strength. Sometimes it seems hard or long and the wind is too cold or the sun too hot. Then you are aware of each step, so that you know exactly where you are in a way impossible in a tame place and you would not trade one moment of weariness for the ease of civilization. You feel mountains and snow and scree and sky, and you are home.

"In the wilderness I am reminded of what culture lulls me into forgetting, that I have natural roots," writes environmental philosopher Holmes Rolston III in *Philosophy Gone Wild*.

"We are a wild species, as Darwin pointed out," Wallace Stegner wrote, in his now-famous 1960 letter to a natural resource manager, then published as the coda to *The Sound of Mountain Water*. "Nobody ever tamed or domesticated or scientifically bred us. But for at least three millennia we have been engaged in a cumulative and ambitious race to modify and gain control of our environment, and in the process we have come close to domesticating ourselves. . . . We simply need that wild country available to us, even if we never do more than drive to its edge and look in. For it can be a means of reassuring ourselves of our sanity as creatures, a part of the geography of hope."

We descended several feet from the pass onto alpine tundra. There were few flowers in bloom. Were we too late? The ground was damp and matted as if the snow had just left. Were we

too early? This, the last day of July, is still early in the alpine summer. Early and late. They are almost together in this brief, brilliant growing season.

Several long traverses took us down to a profusion of bluebells and paintbrush, asters and gentian dancing in the wind along the little snowmelt streams coursing down the rock. We stopped to get water from a spring that appeared from beneath the rocks. The gardens grew broader and longer, stands of trees appeared. We reached the grass-edged Lake Solitude, a popular day hike up Cascade Canyon, but at this hour—close to 6—there was no one here. Only a hard wind across the lake. Miles beyond it, we could see the Grand Teton, and the Cathedral Group surrounding it.

About a mile below the lake we came to camp. The stream running through it was deeply flanked by all the same wildflowers we had seen along our way. We set up our kitchen on a flat boulder surrounded by flowers. Bees dove into the bluebells, staying longer in some, flitting quickly from others. Two deer, a doe and a buck, walked separately, silently, through camp. A marmot perched on another boulder and whistled his presence to us.

At sunset, the Grand Teton was fully lit, a golden blessing on our hike.

A rugged, awe-inspiring mountain range laced with streams and lakes rises sharply out of the broad sagebrush flats of Jackson Hole. Established in 1929. Acreage—309,994.02.

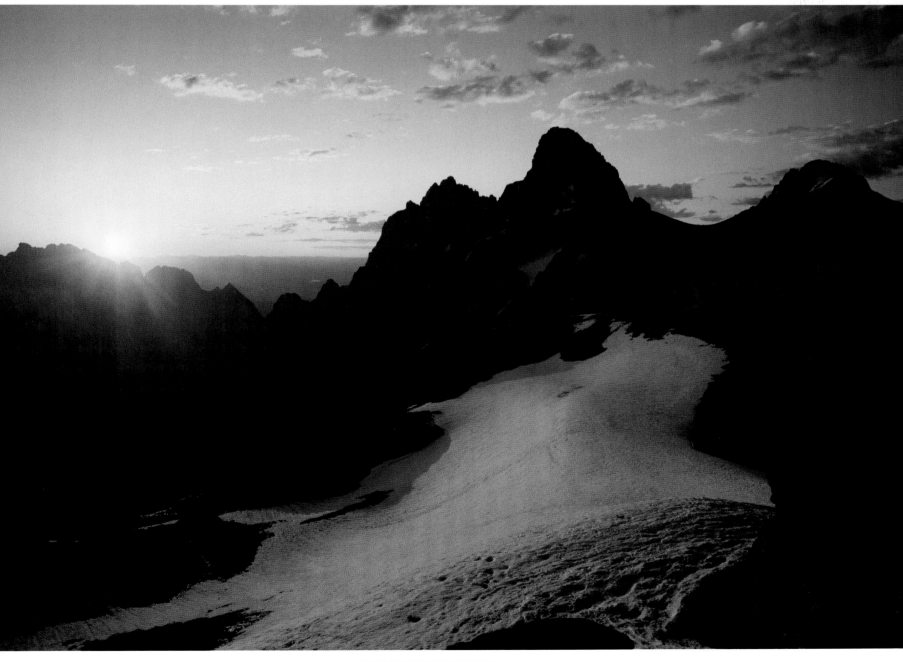

◄ MORMON ROW, TETON RANGE

▲ SUNRISE ON THE GRAND TETONS, FROM TABLE MOUNTAIN

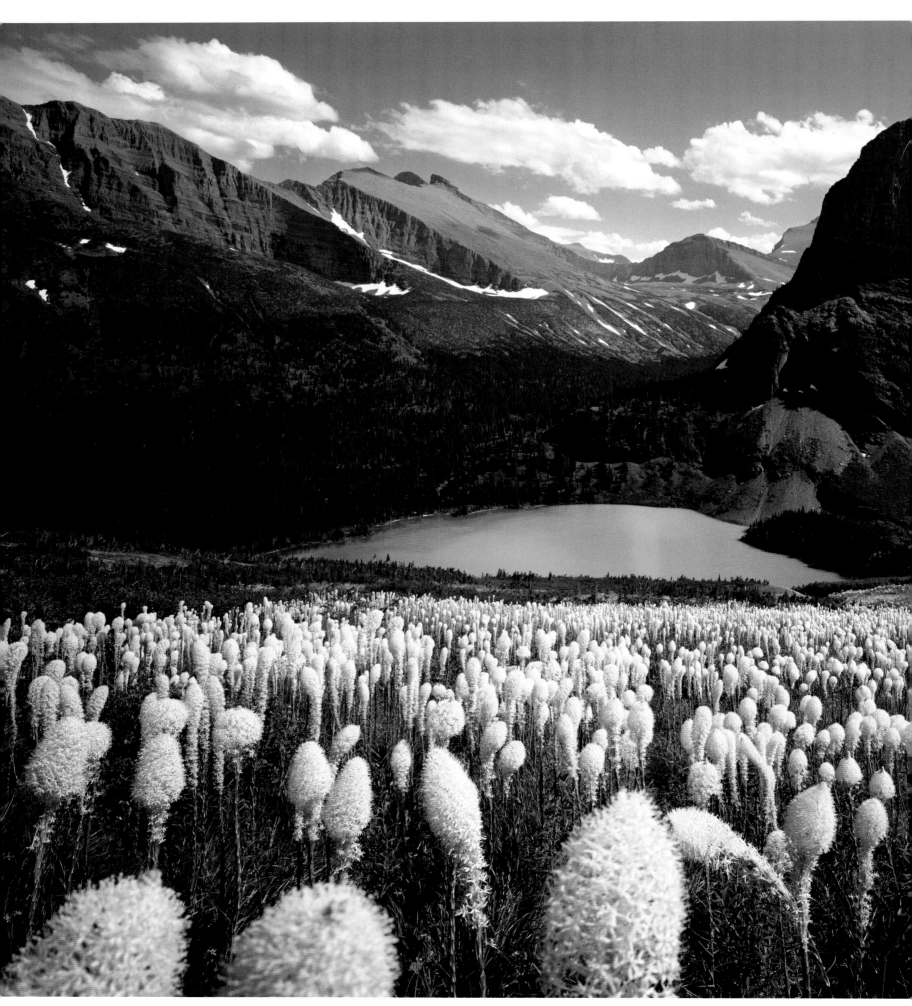

▲ BEARGRASS, GRINNELL LAKE

▶ COBBLE MOSAIC, HIDDEN LAKE

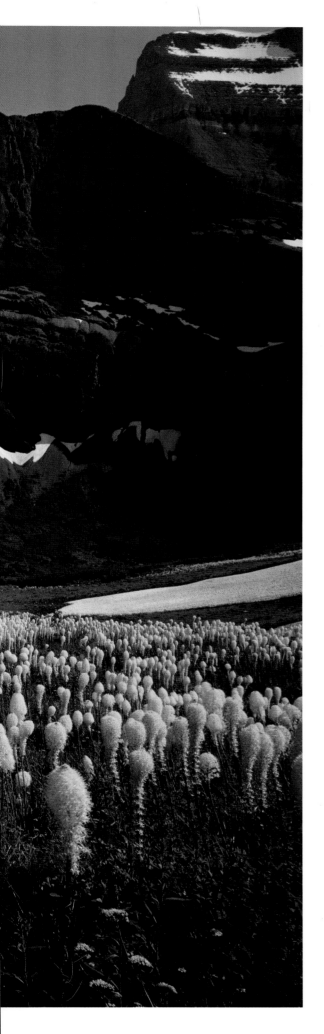

Glacier

NATIONAL PARK, MONTANA

We hiked to Sperry Chalet from the trailhead at MacDonald Lake, on a hot, overcast, muggy Sunday, a long uphill trudge through forest. I am never entirely comfortable in deep forest in Glacier where, always aware of grizzly bears, I am continually on watch for them. Indeed, we were told over dinner in the chalet that two other people who had come up that same afternoon had seen one on the trail.

Few things represent the idea of wilderness more than grizzly bears. They can only exist in a wild place, one big enough to accommodate their territorial needs. Mountain lions scare me as much as grizzlies do, but they have acclimated better to people moving into their territory and are, therefore, more frightening, but less symbolic, for me, of wildness. Bears need wild corridors to travel between territories, to spread out into new areas. They need areas big enough to provide them sustenance. And sustenance to their cubs, and their cubs, forever. (One calculation compared one grizzly per eight square miles in Glacier National Park with one per thirty-four square miles in Yellowstone. While males require larger territories than females, the habitat determines the ratio of bears to miles.)

A summer earlier, at Granite Park Chalet on the opposite side of the park, I watched from the hut as David returned from an afternoon of photographing on the Garden Wall, about a mile and a half away. A deer browsed just above the trail he took, between the hut and him. I watched the deer move across the hillside above the path. As the deer moved upslope, a grizzly bear appeared. The bear moved downslope, nearer to the path David walked from the pass. Everyone at the hut watched what seemed an inevitable collision course. I wondered if he had taken his bear spray. I wondered if he would be able to use it if necessary.

In a dramatic landscape of precipitous peaks ranging above 10,000 feet, nearly fifty glaciers feed lakes and streams and a colorful display of wildflowers fills high meadows. The array of wildlife includes grizzly bears, wolves, and mountain goats. Established in 1910. Authorized as part of Waterton–Glacier International Peace Park in 1932. A Biosphere Reserve and the Waterton–Glacier International Peace Park World Heritage Site. Acreage — 1,013,572.42

This is not a simple thing. I once helped put together a bear course for the Wyoming Outfitters and Guides who had been having too many bear encounters fatal to bears in the Shoshone National Forest, on the edge of Yellowstone. As part of the training, we were to shoot off canisters of bear spray at a cardboard cutout of a bear set on a cart pulled by a truck at thirty miles per hour—bear speed. This was to be done after a brief run to get adrenaline up as it would be naturally in the course of a bear encounter. I found that aiming at the bear, releasing the canister safety catch, actually letting go the spray and hitting the cardboard bear was very difficult. My hand was shaking and my heart beating so hugely that I felt even a cardboard bear could sense the fear. So I wondered how David would do, surprised by a bear headed toward him.

David was too far away to hear the warning shouts of people at the hut. Apparently the bear couldn't hear them either because he never hesitated in his slow ambling. David continued down the path, to our eyes completely unaware. He just kept walking his usual pace, seeming not to look around at all, moving closer and closer to the bear. The bear moved closer to the path, then, as David approached the spot on the path below the bear (and as everyone at the hut

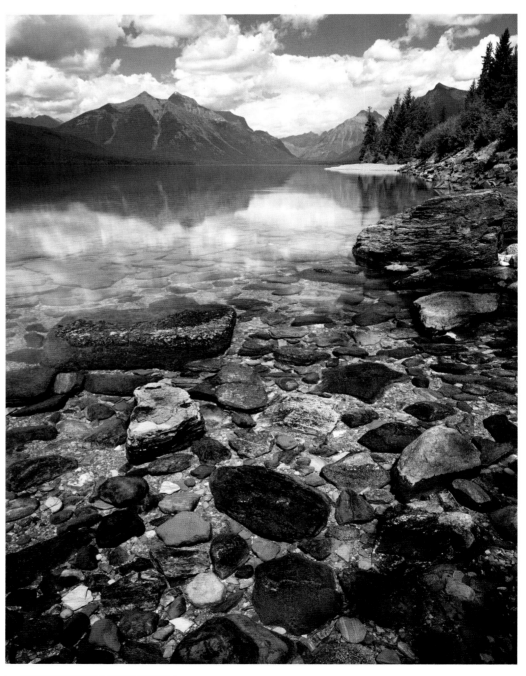

COBBLE MOSAIC, LAKE McDONALD

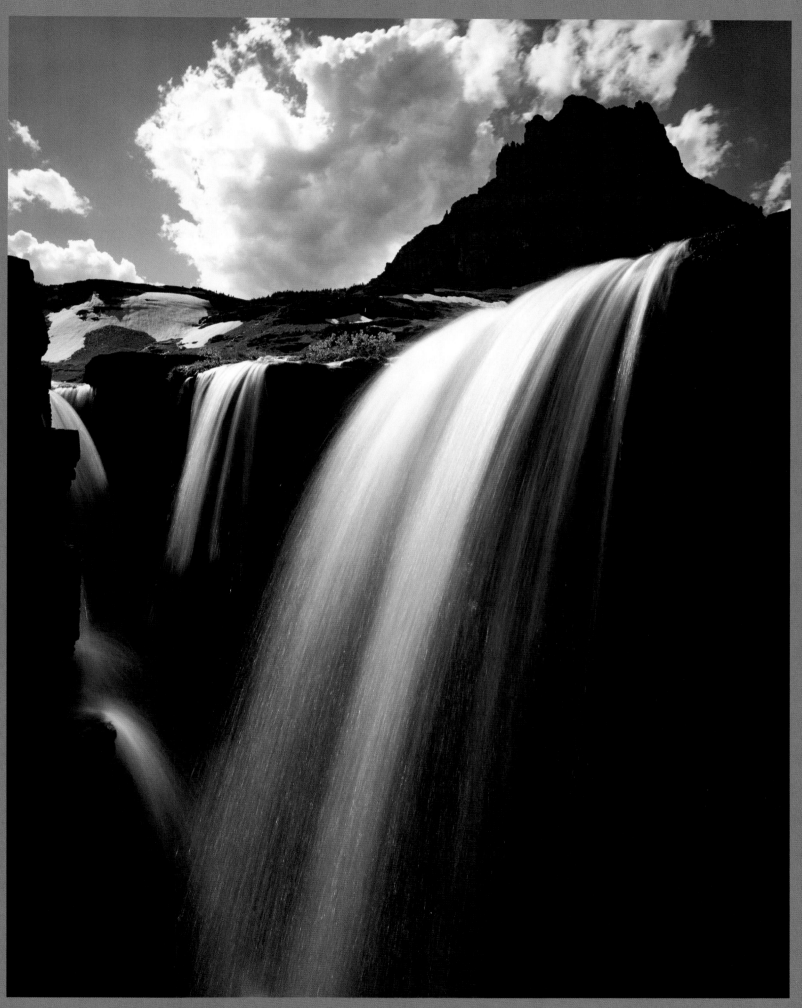

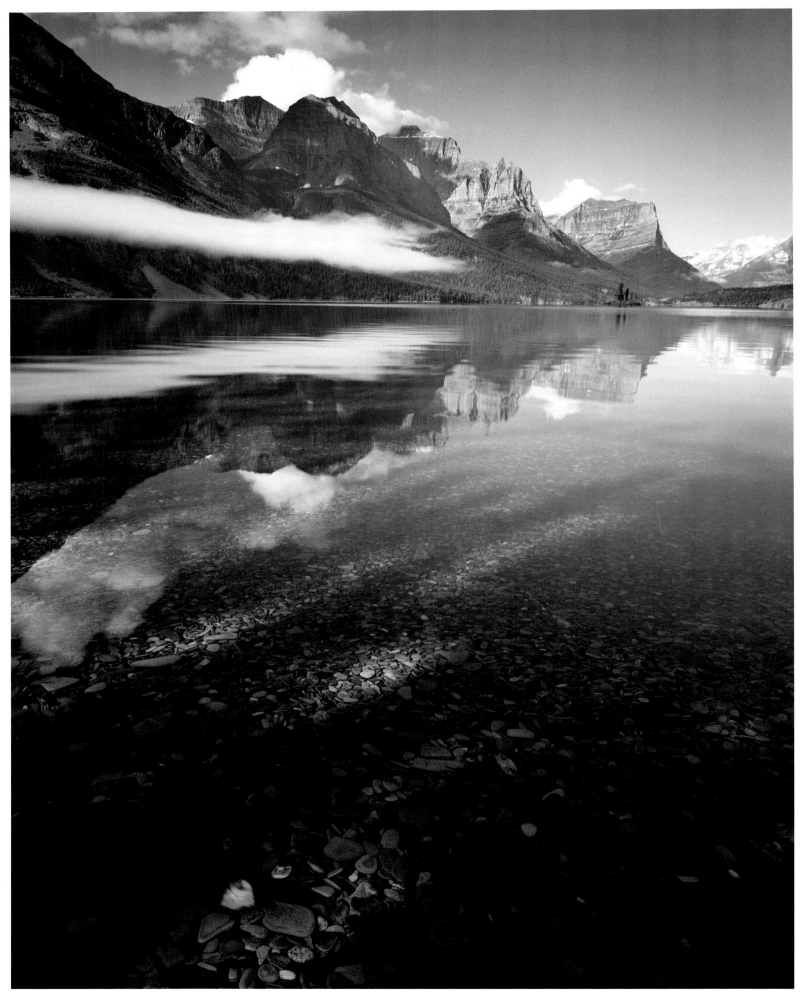

▲ COBBLE MOSAIC, ST. MARY LAKE

▶ SPERRY GLACIER

held their breath), the bear turned upslope toward the deer. David arrived at the hut in time for dinner. "I saw the deer," he said. "The bear was interested in the deer."

At Sperry Chalet, mountain goats wandered back and forth among the buildings. You had to be careful not to run into one if you went outside in the moonless nights. We hiked up to Sperry Glacier, the largest glacier in the park. All of Glacier's glaciers are shrinking as the world warms up, but Sperry remains the largest. As hot as it had been on our walk up to the chalet, so cold was it now on the glacier. As if the glacier wanted to impress upon us its history, its vastness, its power to invent the world. There had been sun in the alpine approach to the glacier, and there was sun again when we returned to the alpine, but on the glacier the sky grayed. Cold wind poured out of snow and ice to wrap itself around us. At lunch, in the shelter of a rock wall at an edge of the glacier, we sat very close together for warmth, David and I and our friend Georgette.

Not many days after we returned from the glacier and the chalet, fires began burning in Glacier Park. The trail to the chalet was closed by the Roberts fire, which started outside the park on July 23, and moved rapidly enough to warrant the closing of the park's entire west side the next day. Reopened on August 4, the west side was closed again after the fire made a big run six days later. Sperry Chalet reopened August 18. While ultimately 136,000 perimeter acres burned, this figure exaggerates the burned area, since much within a fire perimeter remains intact. In ten years, in Glacier's climate, new trees, which began sprouting the summer after the fires, will be ten to fifteen feet tall.

Photographers were upset, but in fact fire is a natural wild act, to be embraced as all wildness is to be embraced, for its restorative power on the land. Most ecosystems depend on fire to survive in a natural and healthy manner. During the fires of 1988, I was riding my horse through Yellowstone's backcountry where I was able to see its power firsthand. I spent time learning about wildfire's necessity for a series of articles I wrote at the time for the *Wall Street Journal*. I have to rejoice in the fact of fire in Glacier Park as I do in the fact of the grizzly bears who scare me, and the power of the glaciers, and the extraordinary grace of the flowers, the lakes, the wild streams, the rock, the goats—all things forming the wildness of this place.

In 1932 Glacier joined with Canada's Waterton Lakes National Park, established as a national park fifteen years before Glacier, to become the Waterton–Glacier International Peace Park. This land, traditional home to the Blackfeet, once possessed no arbitrary border. Indians and wildlife traveled throughout this landscape without formalities. Wildlife still does. "This sacred place is the living embodiment of hope," the Peace Park's brochure states. Indeed, wherever landscape is seen as a whole, without unnatural boundaries, there is hope.

Unfortunately, since 9/11, hope has developed some red tape. Anyone arriving at Goat Haunt, a remote area in the northeastern section of Glacier Park, by boat or by foot from Canada, and intending to leave the immediate shore area, is considered to be applying for admission to the United States. (Most people arrive at Goat Haunt on the Waterton Inter-Nation Shoreline cruise boat, which plies Waterton Lake from Waterton townsite to Goat Haunt summerlong.) An Immigration Park Ranger will demand a passport, naturalization or birth certificate, and a government-issued photo ID card of all hikers, and only U.S. and Canadian citizens and legal resident aliens of the United States (with proper ID) may leave the immediate shore area.

The International Peace Park (which, in a gentler political climate, should serve as a model for possibilities on the Mexico–U.S. border, as well as other areas along the Canada–U.S. border) is also recognized as a Biosphere Reserve and a World Heritage Site. The concepts of the Peace Park and the UNESCO designations are appropriate everywhere in natural areas, but perhaps never more so than on national borders. Nature's borders are ecological, not national. These designations acknowledge that.

I have to rejoice in the fact of fire in Glacier Park as I do in the fact of the grizzly bears who scare me, and the power of the glaciers, and the extraordinary grace of the flowers, the lakes, the wild streams, the rock, the goats—all things forming the wildness of this place.

Rocky Mountain NATIONAL PARK

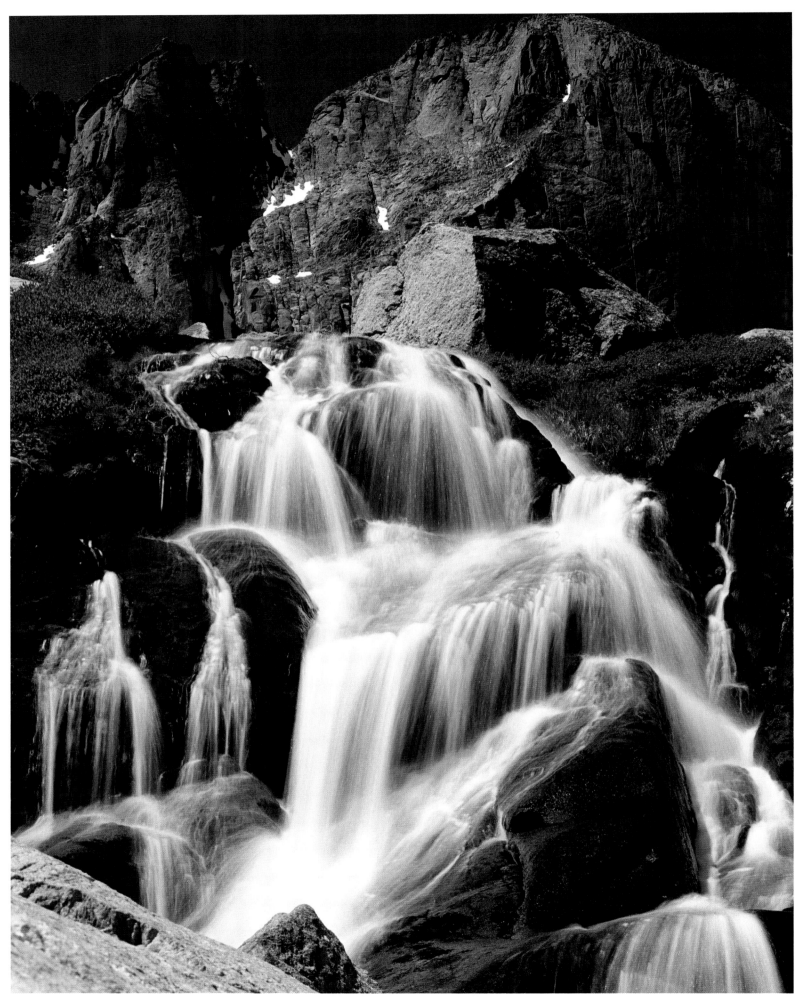

CASCADE ON CHASM CREEK, LONGS PEAK

Streams, lakes, meadows, and alpine tundra nestle beneath peaks towering more than 14,000 feet in this park celebrating the landscape of the Rockies. Established in 1915. Wilderness designated in 1980. A Biosphere Reserve. Acreage—265,769.14. Wilderness—2917 acres.

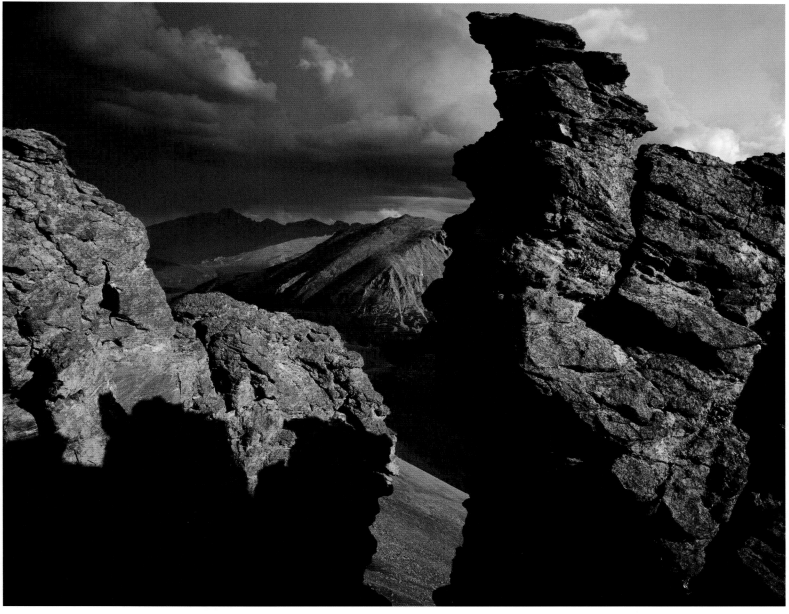

▲ ▲ RYDBERGIA ALONG TRAIL RIDGE ROAD

▲ LONGS PEAK AND STORM

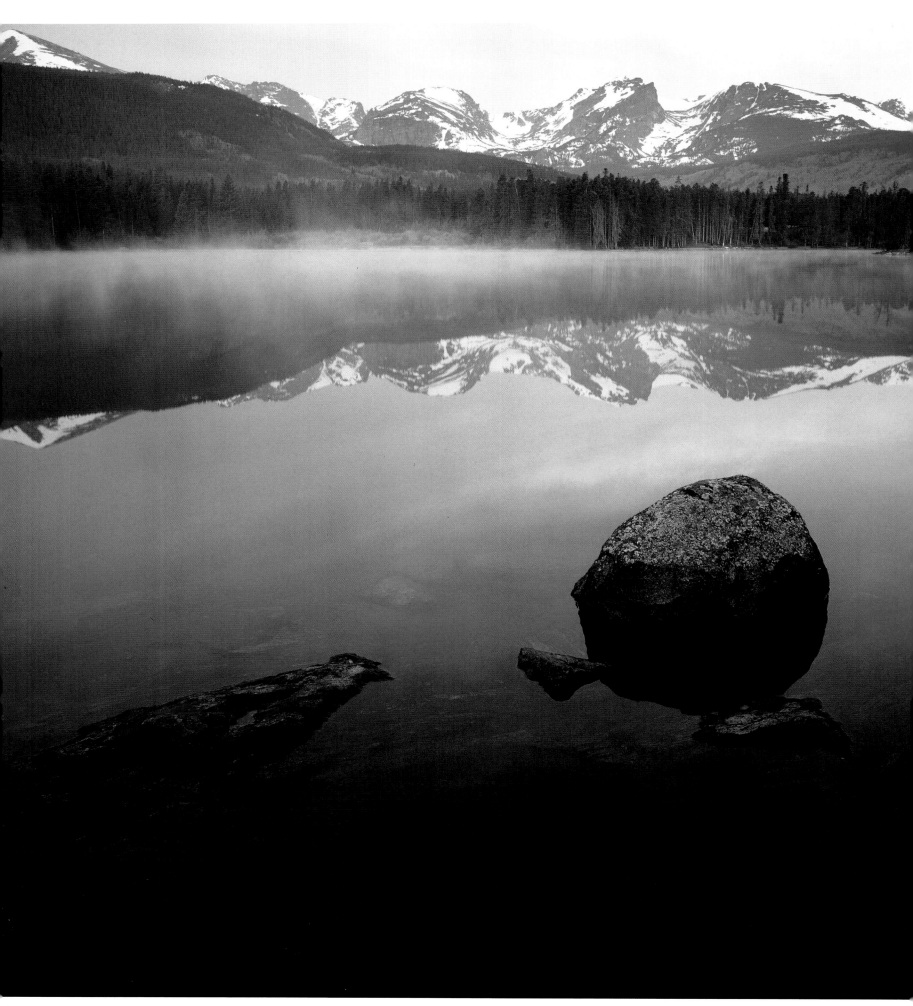

SPRAGUE LAKE, DAWN

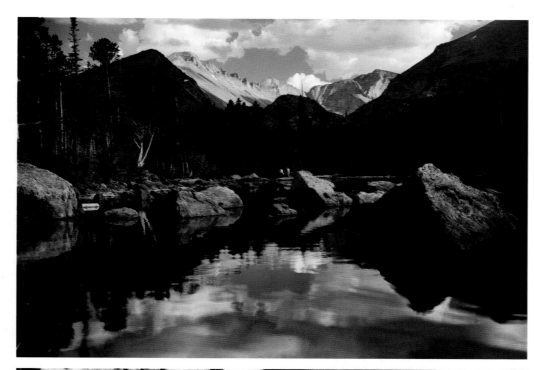

▲ ▲ BEAR LAKE REFLECTIONS

▲ WINTER'S COATING ALONG GLACIER CREEK

Guadalupe Mountains NATIONAL PARK

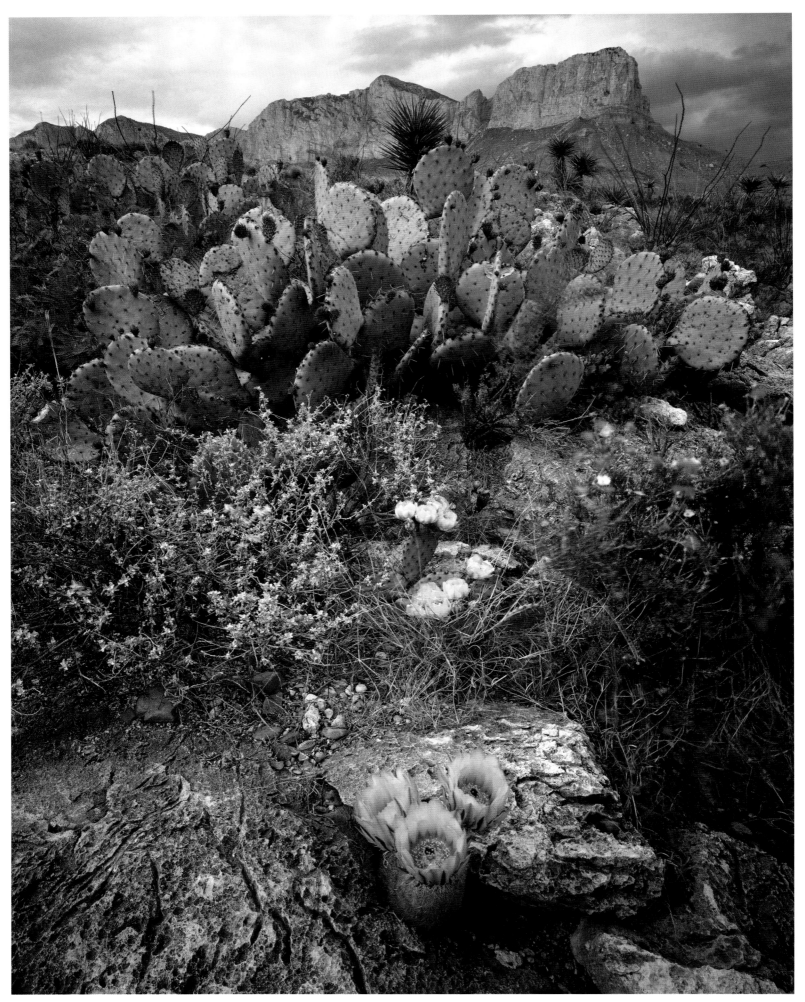

▲ SPRING FLORAL, GUADALUPE MOUNTAINS

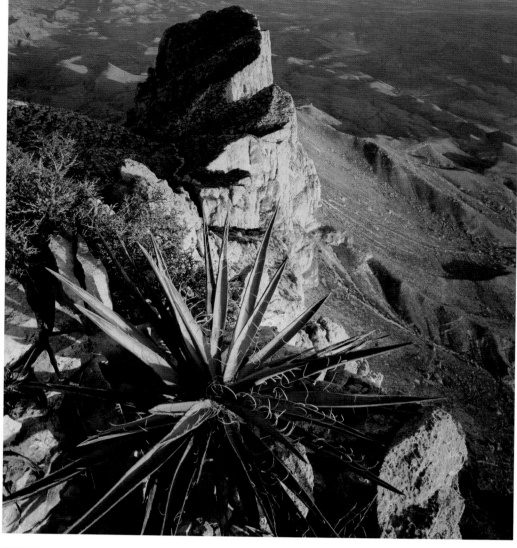

Rising out of the Chihuahuan Desert, this lofty mountain mass cut by spectacular canyons is part of the world's most significant Permian limestone fossil reef. Established in 1972. Wilderness designated in 1978. Acreage—86,415.97. Wilderness—46,850 acres.

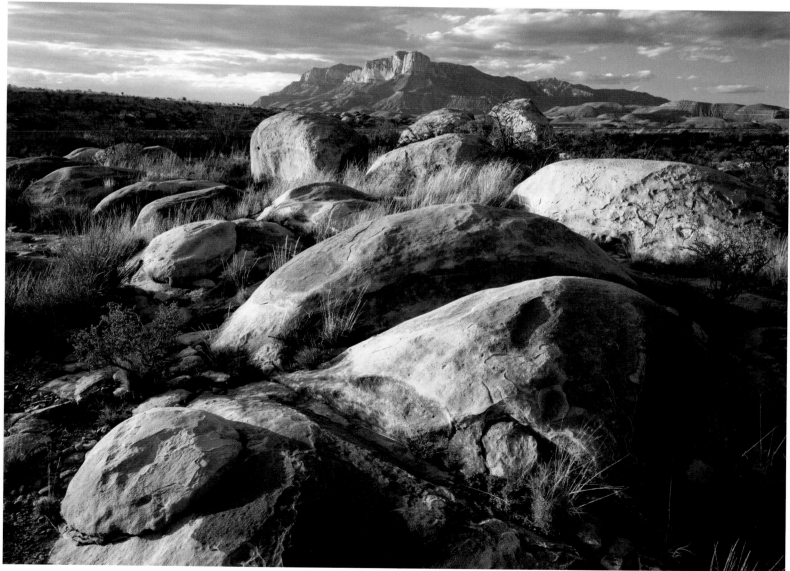

▲▲ YUCCA AND EL CAPITAN FROM GUADALUPE PEAK ▲ GUADALUPE MOUNTAINS AND BOULDER FIELD

▶ GYPSUM SAND DUNES AND GUADALUPE MOUNTAINS

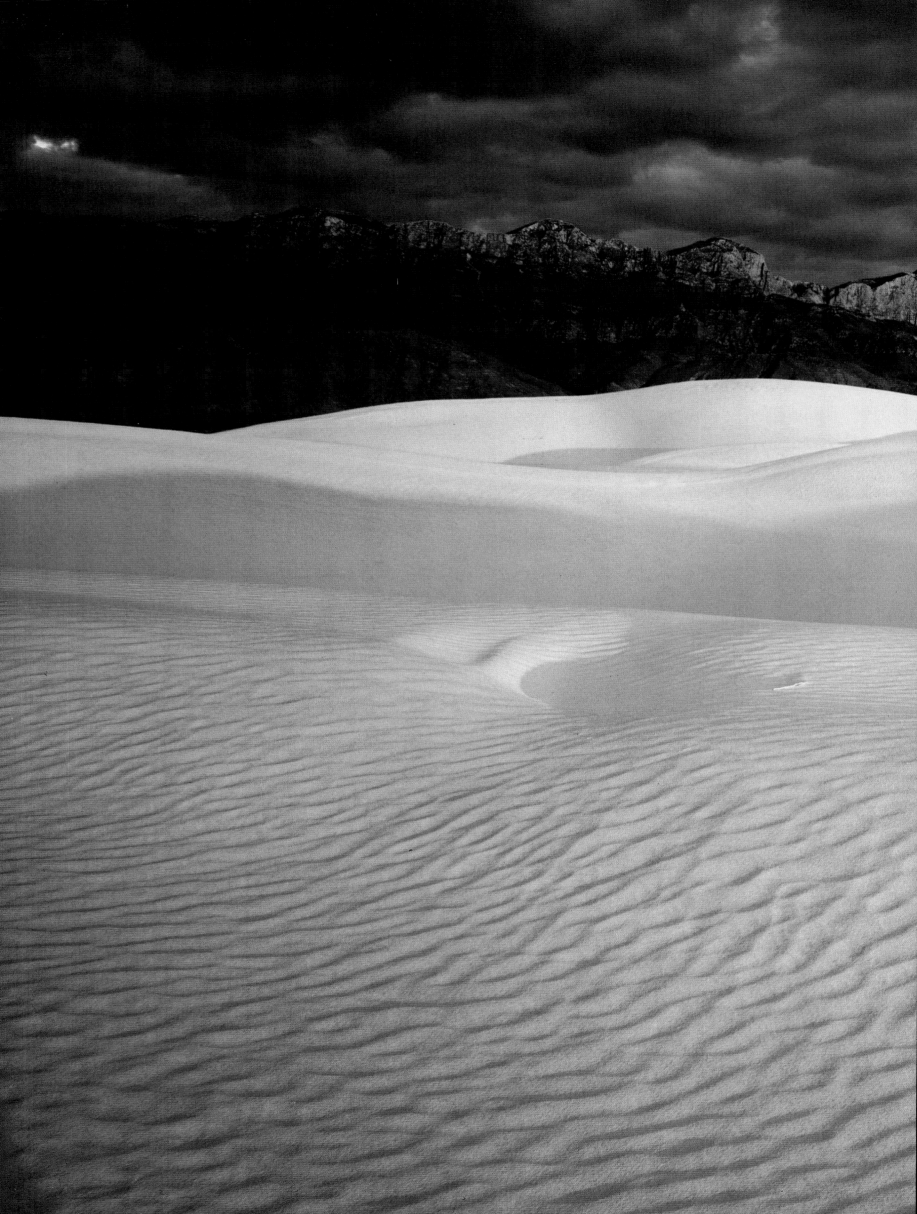

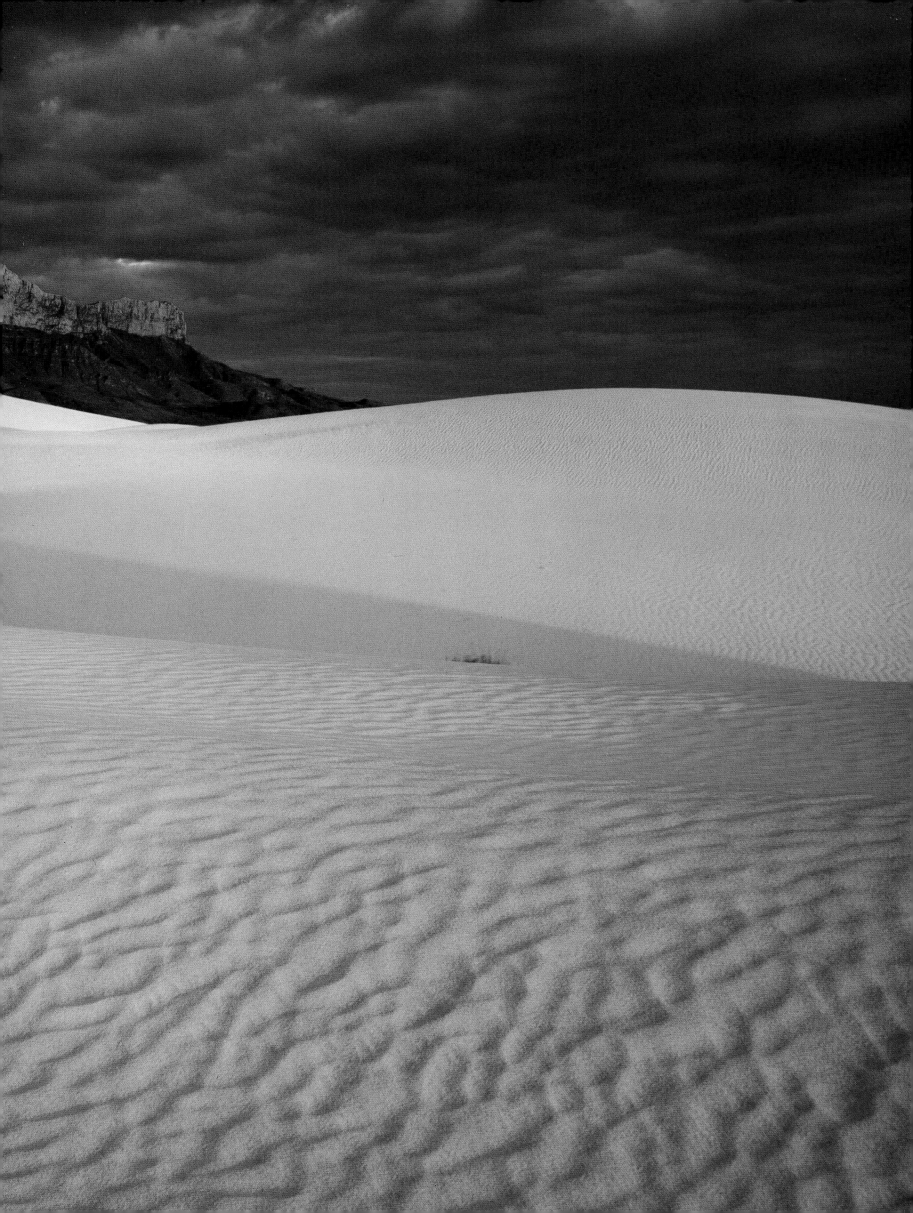

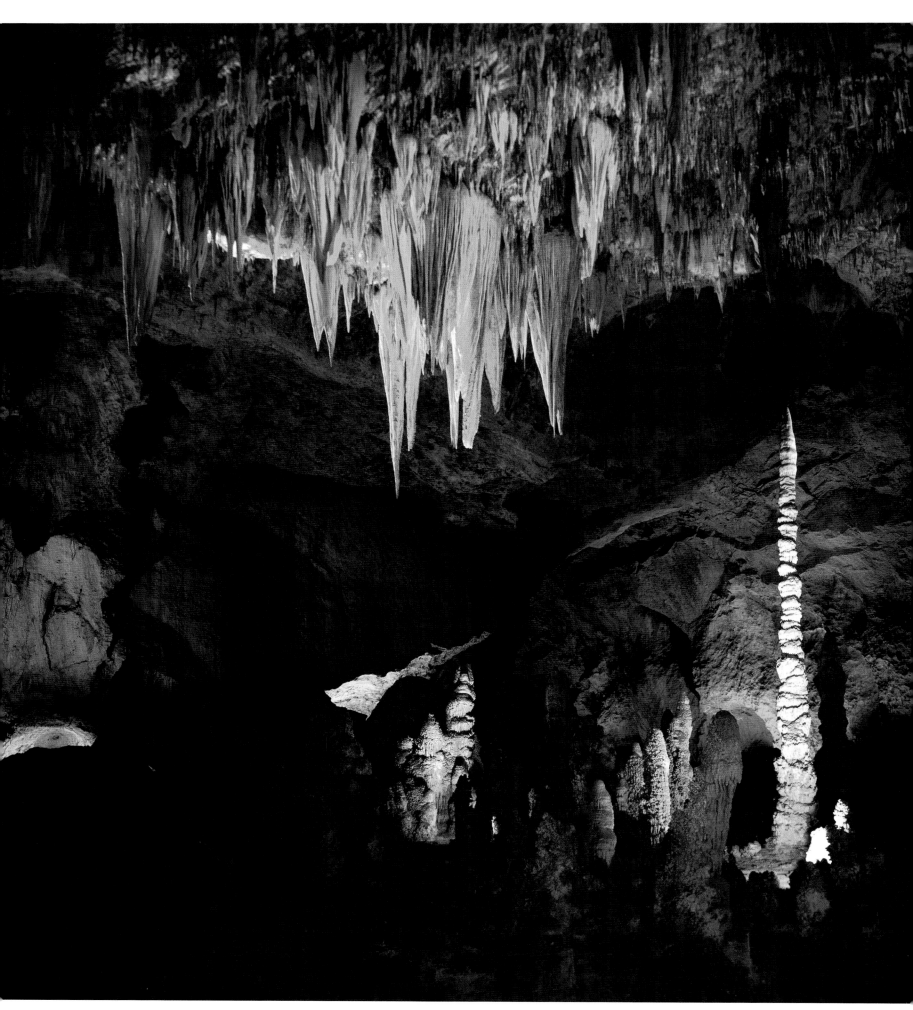

▲ TOTEM POLE, HALL OF GIANTS

► HALL OF GIANTS

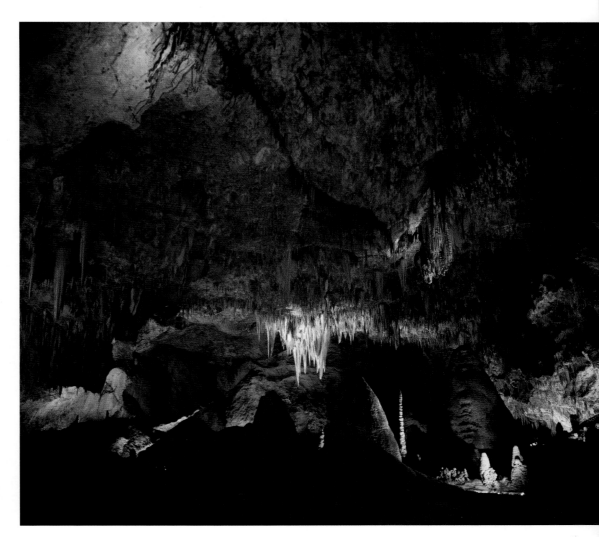

Carlsbad Caverns

NATIONAL PARK, NEW MEXICO

No wonder our imaginations grow underground cities on remote planets! Here is the model for whole worlds: rivers, canyons, passageways leading to fantastical places. Carlsbad Caverns lies under the northern end of the Capitan Reef, the world's largest exposed fossil reef, named for 8085-foot El Capitan at the reef's southern end in Guadalupe Mountains National Park. The two parks, both carved out of the Chihuahuan Desert, are separated by ten miles of Lincoln National Forest. The reef is part of the Guadalupe Mountains, the range containing the tallest peaks in Texas. Its formation from the remains of sea creatures left behind when an ancient sea evaporated set the groundwork for the processes that would ultimately produce gigantic subterranean chambers with their extraordinary features.

The cave that most park visitors enter, the fourteen-acre Big Room, with its smooth concrete floor, its lighting, railings, lunchroom, and elevator descending 750 feet (making this part of the caverns wheelchair-accessible), cannot be called wild. Even entering via the Natural Entrance, the mile-long path following the traditional explorers' route, is not wild by these standards, since it is not only paved, but leads to the lunchroom near the elevators. And yet, the caverns are wild. Everything natural within them is formed by wild processes. The amenities simply make available to everybody a sense of the wonder, the forms, the mystery, the whimsy, the natural history

Countless formations are contained in a series of connected caverns, including one of the world's largest underground chambers. The eighty-five separate caves in the park include the deepest limestone cave—1567 feet—in the United States. Proclaimed Carlsbad Cave National Monument in 1923, established as Carlsbad Caverns National Park in 1930. Wilderness designated in 1978. A World Heritage Site. Acreage—46,766.45. Wilderness—33,125 acres.

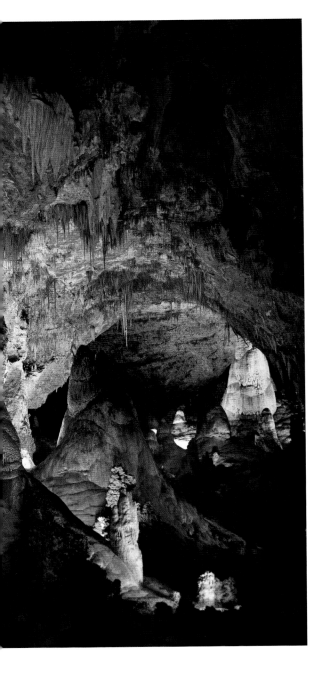

of this place. People walking here speak in whispers. Their soft voices are more protective of the geology, but they also display a proper awe. What the earth forms and the way it goes about its hidden business is wild. We know of Carlsbad Caverns and Mammoth Caves and Lehmann Caves by chance, but they would have existed, unlit forever, without us.

Once I spent a few days spelunking in a wild cave in Kentucky. Four of us crawled from a high rock platform through the entranceway of a cave and stood up inside the earth. But for the crack of light from the entrance and the beams from our flashlights, we were in utter darkness. By the time all of us were inside, we had light enough from flashlights to get some idea of the vastness of the space we had entered. The high-ceilinged room receding beyond the shadow of our lights was hung with hollow tubes of minerals slowly becoming the same solid rock as the stalactites and stalagmites already formed. A constant dripping from the ceiling was the only sound in awesome silence. Depositing minerals drop by drop, layer upon layer, each drop of water made its way into and through subterranean time. An opening at the far end of the room led us into a smaller room, where a broad ledge enclosed a black pool of water. We made our way cautiously toward another doorway, crawling when the ceiling proved too low for us to stand or crouch.

Above our heads, somewhat to the left of where we entered, a sliver of light slipped into this third room. It surprised us. Adjusted to a world of no light but the circles from our flashlights, we had forgotten the light of day. Playing our lights around the walls, we found them fully lined with bats. They hung there, a wild tapestry. Carefully staying away from the walls, we moved toward the light. The bats thinned out as we neared the light. (It had been the sight of hundreds of thousands of bats exploding out of the natural entrance to Carlsbad Caverns that alerted nineteenth-century settlers to its existence.) We hauled ourselves up onto a cold, damp shelf, then squeezed through the opening onto rock, blinded by sun after living so intensely without it. The heat of day felt good. We hadn't realized how cold we had become. Like reptiles eager to warm their sluggish blood in the first spring heat, we crawled out onto the rocks.

That venture was an experience of intimacy with the interior of the earth. It is what all caverns give us. In their original wildness is a dark world of phenomenal beauty. Although most of the more than eighty caves within the boundaries of Carlsbad Caverns National Park have no, or limited, public access, it is possible to experience the same kind of beauty I did in Kentucky at Carlsbad Caverns via a ranger-guided tour of a primitive cave route. But you can also get a sense of it surrounded by people. Sitting on a bench near Cavern Pools in the Big Room, I closed my eyes, so I could feel the space around me rather than see it. I felt the damp world that formed the speleothems (cave deposits or formations). I smelled the scent of the formations, the inside of the earth, the eons of its time. I came closer to being a cave creature, blind because in a life without light there is no necessity for eyes. Once a friend brought his blind brother to my apartment. "What a beautiful room," the man said when he came in and sat down. "It's almost square, isn't it?"

Deep caves are not a natural habitat for people. Our breath and body heat and voices change things. Lighting, however discreet, changes things. But, if we are careful, the processes of time do not change (which is to say, they are forever changing) and, when the lights are turned off and the voices disappear, the caves, in spite of concrete floors and iron railings, become what they have always been. Certainly they are that for the Mexican free-tailed bats who, spring through October, spiral out of the Natural Entrance at dusk. Erupting from the cave in a great whirlwind lasting from twenty minutes to two and a half hours, they head southeast to feed on moths and other night-flying insects in the Pecos and Black River Valleys, returning with the advent of dawn. Whatever the caverns are during the day, at night wildness is present.

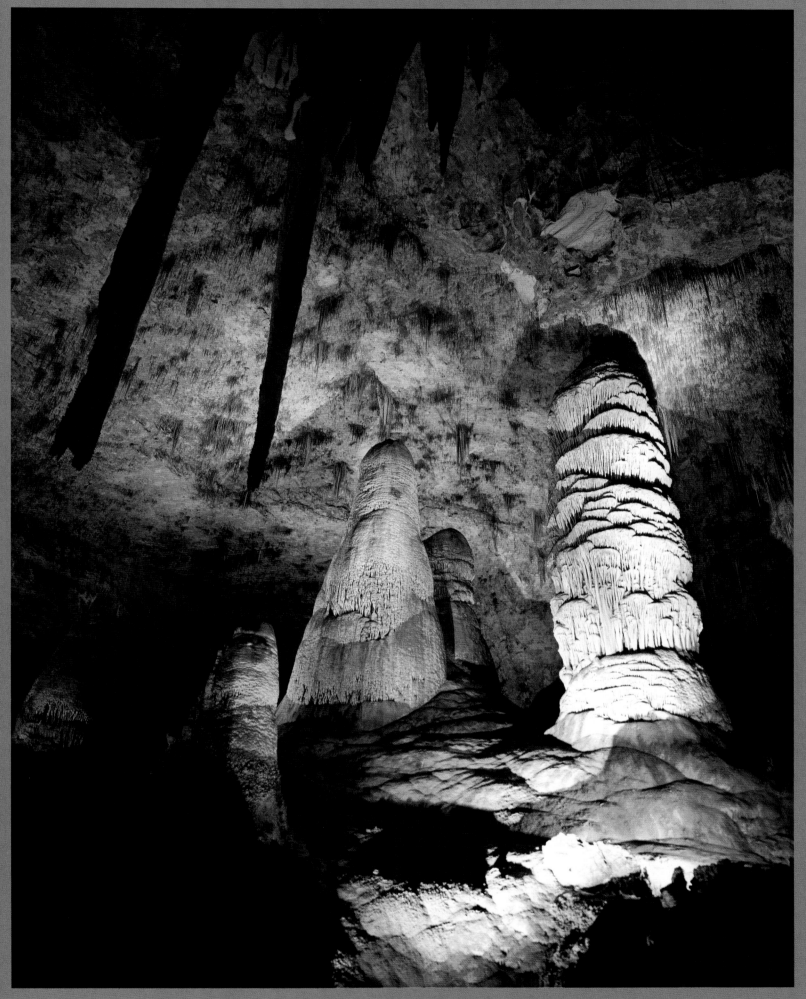

◄ CAVEMAN JUNCTION

▲ TEMPLE OF THE SUN

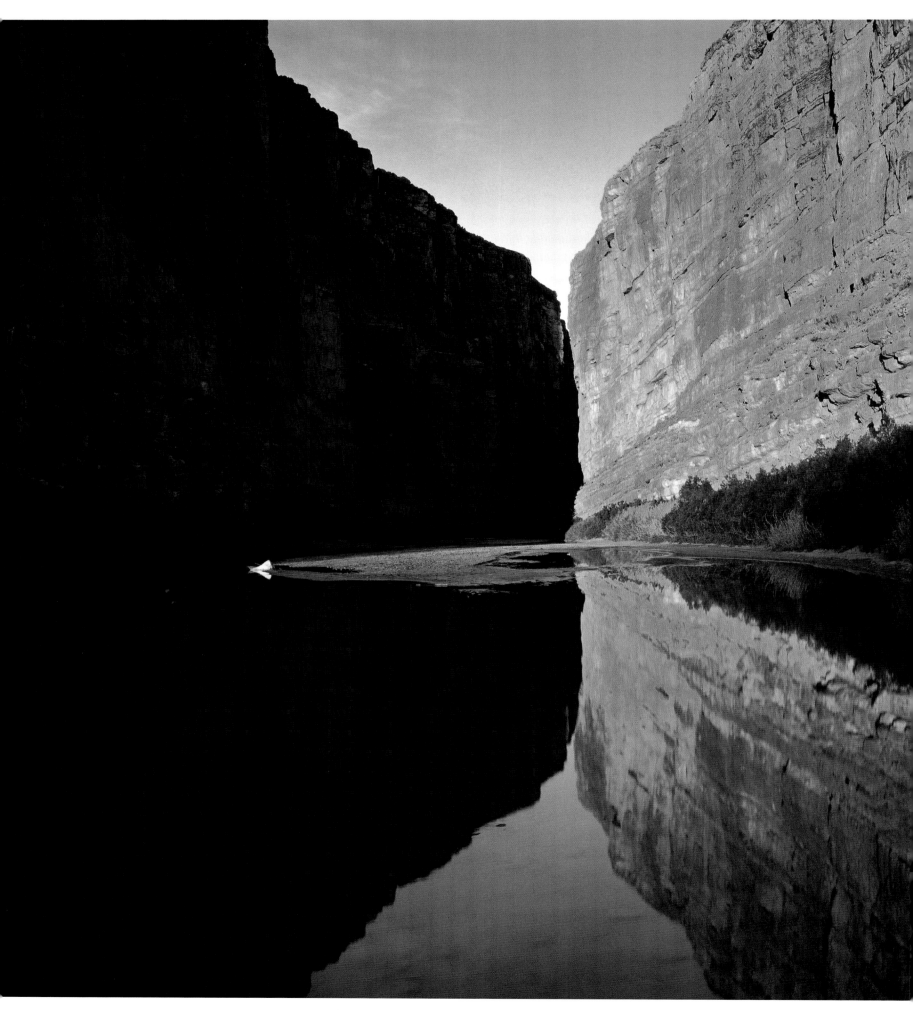

▲ RIO GRANDE REFLECTIONS, SANTA ELENA CANYON

► BUFFALO PICTOGRAPH

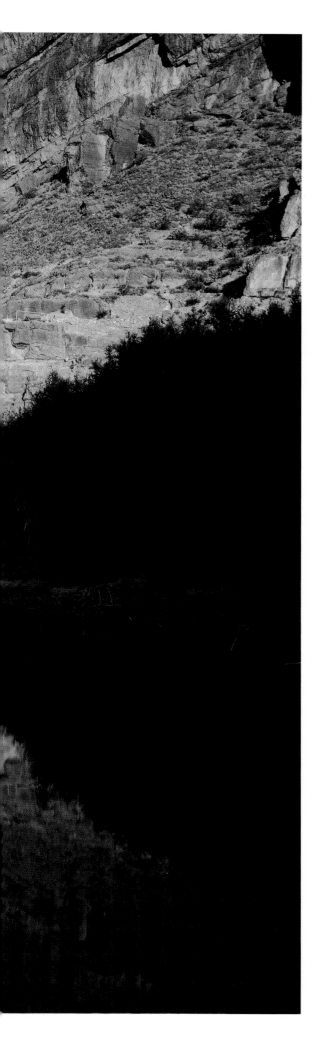

Big Bend

NATIONAL PARK, TEXAS

We drove miles across the endless Texas desert, the only vehicle on a road striping through sand and cactus and greasewood for so long that I forgot we were going somewhere. A remote frontier, hidden by its own distance, Spanish conquistadores called it the empty land. *Despoblado.* This is the Chihuahuan Desert, where ocotillo lifts thin, graceful, prickly limbs into a constant sky, thick barrel cactus nestle into rocks, and agave and lechuguilla sprout like daggers along the desert floor. A dark range of mountains rises like a mirage. The Chisos Mountains, the southernmost mountains in the United States and the center of the park, are an oasis, a land of pines and juniper, Arizona cypress, madrone, mountain mahogany, ash, maple, oak, and aspen, surrounded by hot desert.

South of the Chisos, the Rio Grande forms the border between the United States and Mexico. Running through the deep Boquillas and Santa Elena Canyons, the river makes the huge looping curve here that gives the park its name. Or rather, it is *supposed* to run through the canyons. In actual fact, between a long drought and too-heavy use of upstream water, parts of the riverbed are actually dry. One can easily walk across the riverbed to Mexico, or could, except that since 9/11 it is dangerously illegal to cross the border here, a fact that has created great hardship for the Mexican families who formerly worked in the park or made a living from tourists coming across the river on donkeys.

Even before you reach it, you feel the wildness of so remote a place. Then you enter the Chisos, where open areas of rock provide good views for mountain lions, and you walk a trail where mountain lions walk and you understand the wildness of it in every nerve. The lions prey on the small Sierra del Carmen whitetail deer that live only here and across the Rio Grande in Mexico's Sierra del Carmen. Mule deer are common below 5000 feet in Big Bend. The whitetail live above that.

Here are high mountains surrounded by the Chihuahuan Desert, all of it within the great bend of the Rio Grande rushing through deep canyons on the U.S.–Mexico border. Established in 1944. A Biosphere Reserve. Acreage—801,163.21.

Many trails here bear signs saying mountain lions have been seen frequenting the trail. Do not bring small children here, the signs advise. Do not run. Do not crouch.

I am afraid of mountain lions. They seem less rational than grizzly bears, because less like us. They are cats, after all, and we are legitimate prey to them. Grizzlies see us more as equals. Lions see us as food. How do I know this? I don't. But I suspect it is probably true. And yet the presence of mountain lions and the necessity of alertness they engender are to be treasured as one more heart of wildness.

The trail to 7550-foot-high Casa Grande Peak is closed to hikers from February to mid July to protect nesting zones for resident peregrine falcons. Several other area trails are closed as well. This is a delicate time during which any disturbance can interrupt the nesting process. Although peregrines are successful nesters on tall buildings in major cities, and prized by falconers, they are wild, a symbol and a reality of wildness. Because we always go to Big Bend in the spring for the cactus blossoms, we never get to hike to Casa Grande or on the Southeast Rim Trail. In some ways it doesn't matter. There is plenty of other wild beauty here. Once, while we hiked along the trail to 7825-foot Emory Peak, the highest in the park, we looked up to see a peregrine soaring between the pinnacles of Casa Grande.

The hike to Emory Peak follows a trail that strikes me as a nineteenth-century Romantic dream—a path through the forest, into mystery, into the sort of wildness that beckons poets.

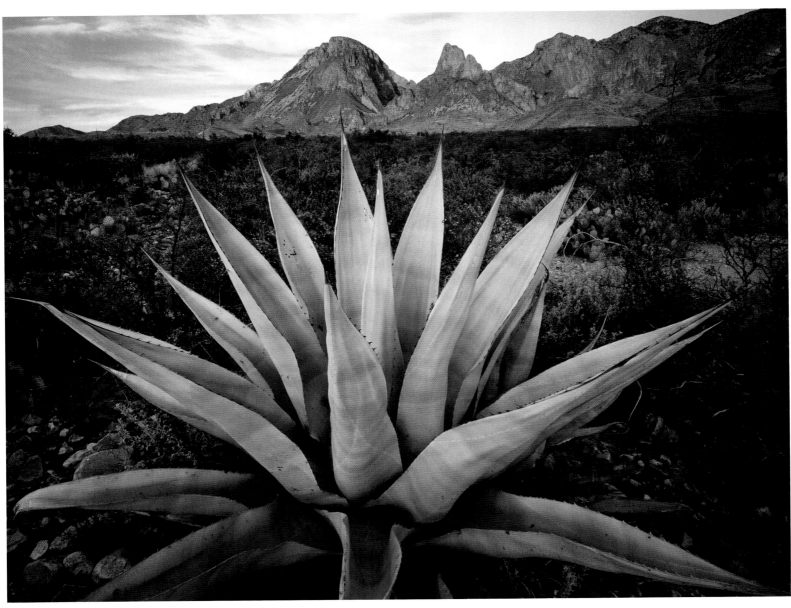

CENTURY PLANT AND CHISOS MOUNTAINS

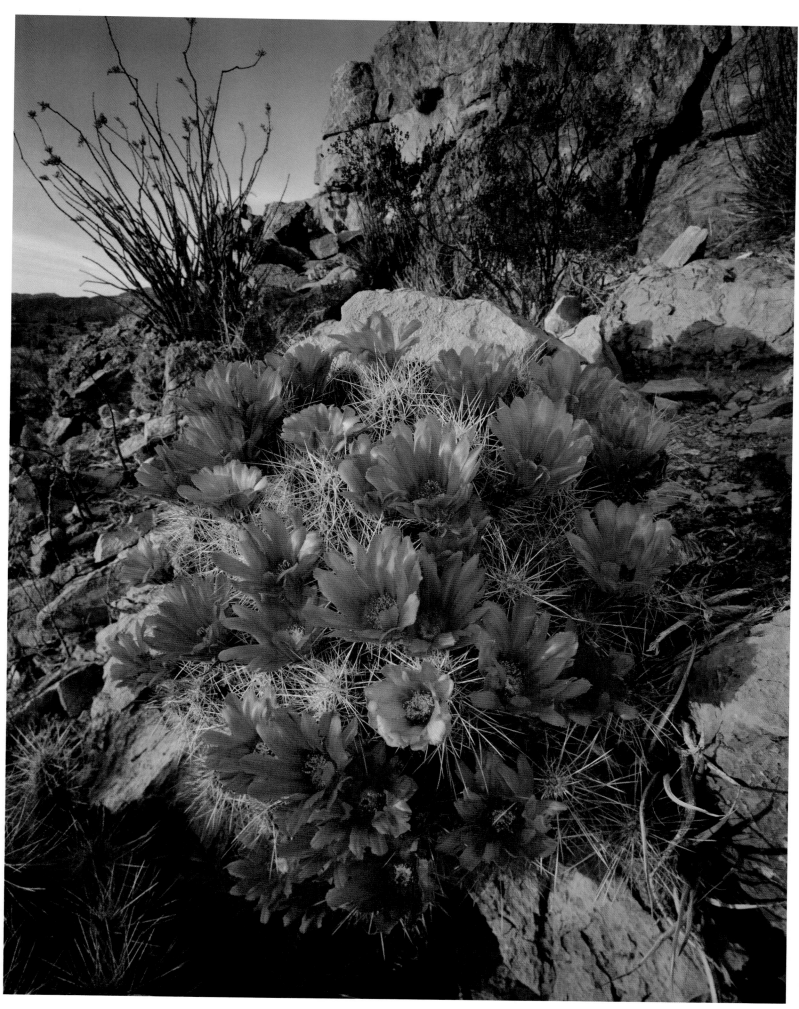

HEDGEHOG MOUND CACTUS, BOQUILLAS CANYON

With such a path, which makes Emory

Peak easily accessible by anyone who

can walk mountain miles, is wilderness

removed? Does anything humanmade

interfere with wilderness?

Sturdily constructed, the trail's existence forces me, again, to question my ideas of wilderness. With such a path, which makes Emory Peak easily accessible by anyone who can walk mountain miles, is wilderness removed? Does anything humanmade interfere with wilderness? Should all trails and bridges be removed from wilderness? Is wilderness a place where it is necessary to find your own way? Should there be maps of wilderness? Should guidebooks be banned?

If these things were done, there might be fewer people in wilderness. There have been attempts at this. A district ranger in the Bechler region of Yellowstone removed bridges over streams in the area, although this did not seem to cut down the numbers of people using the trails. She would have had to remove the trails as well. Should a job be half done in the name of wilderness? Not done at all? Completely done? One of the tenets of the Organic Act is to "provide for the enjoyment" of the natural qualities of the park, albeit in a way that does not affect those qualities.

We encountered only a few people on the winding, climbing trail to Emory Peak, a few more on the peak itself. The top of Emory is a scramble up good rock that offers long, vast views to the west and south and east so that you believe you see the entire Texas border and at least the

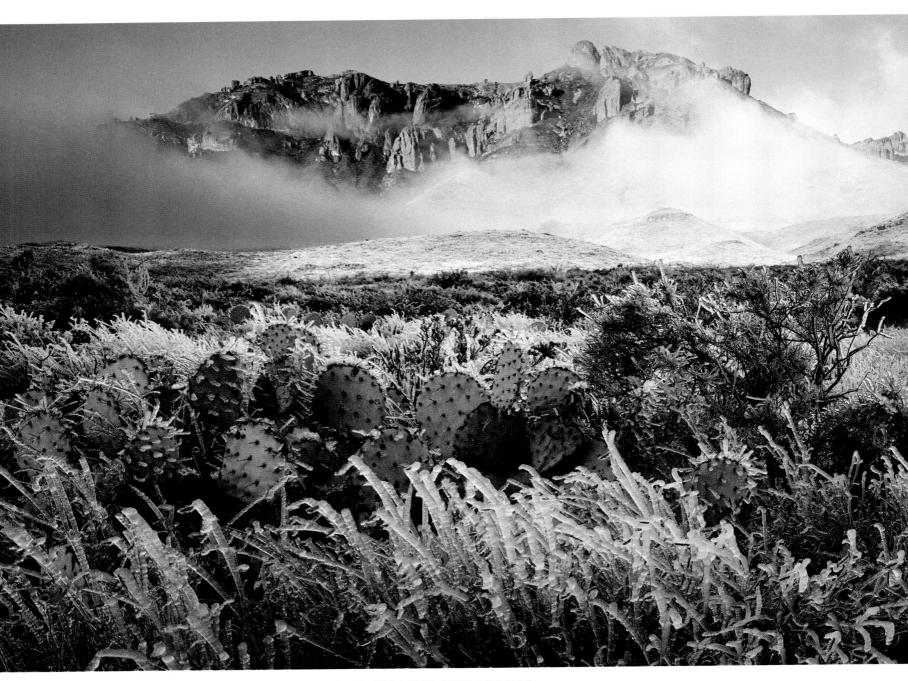

FROSTED DESERT, CHISOS MOUNTAINS

whole of Mexico. On the way up, stopping for water and a snack at a bend in the trail, we saw several Sierra del Carmen deer browsing in a small open space formed by the bend. Earlier, at a switchback bend, under an old madrone in the shadow of noon, three Mexican jays arranged themselves on the tree limbs, very aware of us and hopeful we would feed them, as so many who pass by obviously do.

I would love to feed them. As I would love to feed all wildlife. It must be instinctive, the way a courting bird brings food to his intended. We have the instinct to court wildlife so it will "love" us and be present to us and let us share, somehow, in the fact of wildness, or bring wildness into our own world of understanding. We understand eating. We understand giving. We understand begging.

I did not give them food. I cannot compromise wildness in any of its forms for my own gratification. I am grateful merely to enter these wild places of the earth. I must acknowledge its life by letting it be.

One afternoon we watched a herd of javelinas at the literal edge of the water, Terlingua Creek, where water simply stopped on the surface (at the time we happened by) before it could reach its junction with the Rio Grande exiting Santa Elena Canyon. Javelinas, who look a little like bristly pigs, are native to Texas, New Mexico, and Arizona. They are not pigs. Curious animals with poor eyesight, they might come up close to see what you are. Their hooves look like little high heels, surely the most elegant feet of any animal on the planet.

Another day, we crossed hot slopes of lechuguilla and sotol, turning finally toward the west wall of the Chisos, and then descending into a shaded grotto, where, in this dry year, a trickle of water slid down the blue gray wall.

Wilderness is a sensual experience. Cold, hot, steep, dense, easy, hard, etc. But this grotto bombards the senses. The sound of water gurgling through the spring; water trickling into the teardrop pool; a dove cooing on some cool roost. Dark rock edged by yellow columbine; ferns along the falls wall, cattails in the pool; agave and claret cup cactus and sotol clinging to the wall. The deep brilliance of the claret cup blossom, and two gaudy red monkeyflowers, like an explosion of passion in the cool, huge, watering silence of this deep green place.

Surely the mountain lion must come here to drink. Wilderness is as much a sense the lion knows this place as it is the presence of the lion.

A hummingbird comes to the slim waterfall, and hovering, the swift beat of its wings humming, bathes.

Wildness is as much time as it is place; as much absence as presence.

A canyon wren sings, his long trill rounding the circle of the grotto.

The Chisos Mountains end in this spectacular way, as if, in ending as in existing, they would defy the desert.

Can a short day's walk take one into wilderness? Does wilderness have to mean that you are so far from the beginning that you have no choice but to continue? I wonder this, even as I believe we find our own moments of wilderness anywhere a bit of original country has been left intact, or we enter into the presence of a wild creature. Yet, can any animal be wild if it stays in the presence of humans? The entire elk herd does not run from the grizzly intent on a single calf, or the whole flock of ducks from the peregrine who so deftly selects one. In Yellowstone I watched an old cow buffalo and her calf at Old Faithful. The cow, too old, too weak to make it over Mary Mountain to summer with the herd, chose proximity to the human herd as protection from predators for her calf until the herd returned after the rut. Surely she was entirely wild, using what she understood of her own wildness to protect her calf.

Is it not also possible for us to engage in wildness, even though we are not far from other people?

RAINBOW CACTUS

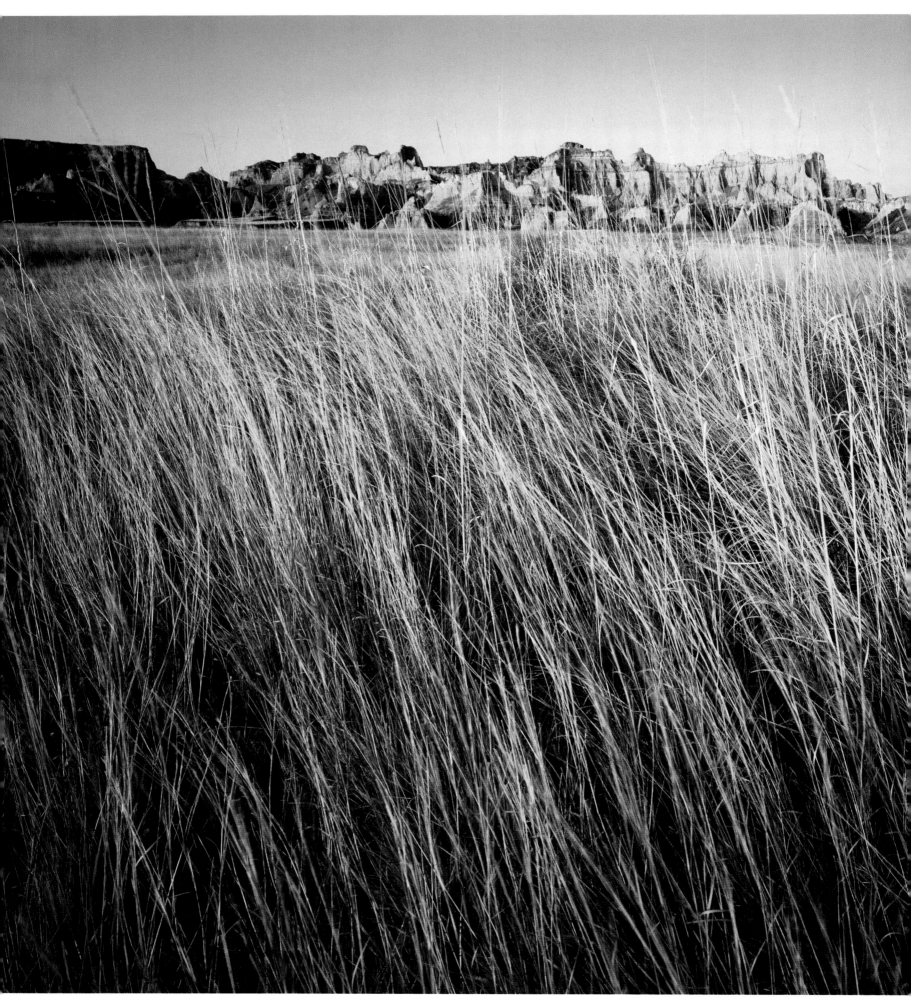

▲ GRASSLANDS, BADLANDS NORTH UNIT

► BUFFALO, BADLANDS WILDERNESS AREA

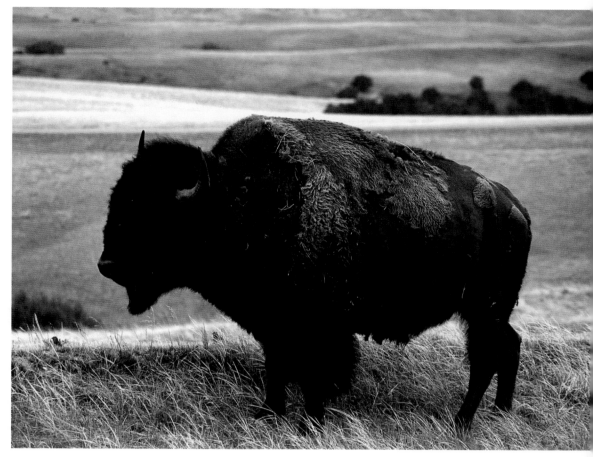

Badlands

NATIONAL PARK, SOUTH DAKOTA

At the edge of the Sage Creek Wilderness, we looked deep down the steep eroded cliff into a landscape of greening plateaus broken by rounded badland formations and streams of sand. Greening bushes and winter-brown grasses waved in the wind. Far below, a lone bull buffalo grazed a green sward. Meadowlarks sang the buffalo's existence. The wind caressed it. The gray storm sky enclosed it. The vast prairie badlands pressing to the horizon freed it. In the silence of late afternoon, in the solitude of the buffalo's hours, he made up for more than a hundred years of his extirpation from the Plains. He was here now, as he had always been.

One bull. Another. Farther on, a group of four. Then the herd, the cows, with the earliest of the calves.

This is a primeval landscape. Pinnacles, walls, and spires topping huge, splayed-out, layered bases stand on straw-grassed prairie. Flat, grass-topped mounds and buttes rise out of the absence of rivers. The erosion of sediments that molds these fantastical forms is movement, but in the plains lying like broad rivers between cliffs and formations, beneath heavy gray clouds lit here and there with a moment of sun, this landscape seems utterly still. It is light and shadow that measure time's movement. Winter and spring and the sound of cicadas. The wilderness area of Badlands is divided into two units, Sage Creek, the largest, in the northwest part of the park, and Conata, south of the Badlands Loop Road. Spreading across more than a quarter of the park, this is the largest mixed-grass prairie wilderness in the United States. The only trails across these 64,144 acres are those made by buffalo.

Sculpted by erosion, this landscape of badlands and prairie grasslands contains animal fossils 37 million years old and provides habitat for bison, bighorn sheep, pronghorn antelope, swift fox, and black-footed ferrets. Established as a national monument in 1939, redesignated as a national park in 1978. Wilderness designated in 1976. Acreage—242,755.94. Wilderness—64,144 acres.

In the early twentieth century, this area was dotted with homesteads. While remnants of these places remain throughout the park, vegetation introduced by settlers has been largely removed, an ongoing process in an attempt to restore the original prairie ecosystem mosaic of grasslands, woody draws, and shrublands. The prairie, an area too dry to support trees but too wet to become a desert, is prime habitat for black-tailed prairie dogs, the main food source for the black-footed ferret. When prairie dog populations were decimated by settlers who considered them pests to agriculture, the ferret disappeared. But when black-footed ferrets were reintroduced in 1994, prairie dog colonies were allowed to recover. While the ferret reintroduction has been successful so far, long-term success depends on how habitat is managed. The same thing is true for restored buffalo, bighorn sheep, and swift fox, although buffalo are adept at multiplying.

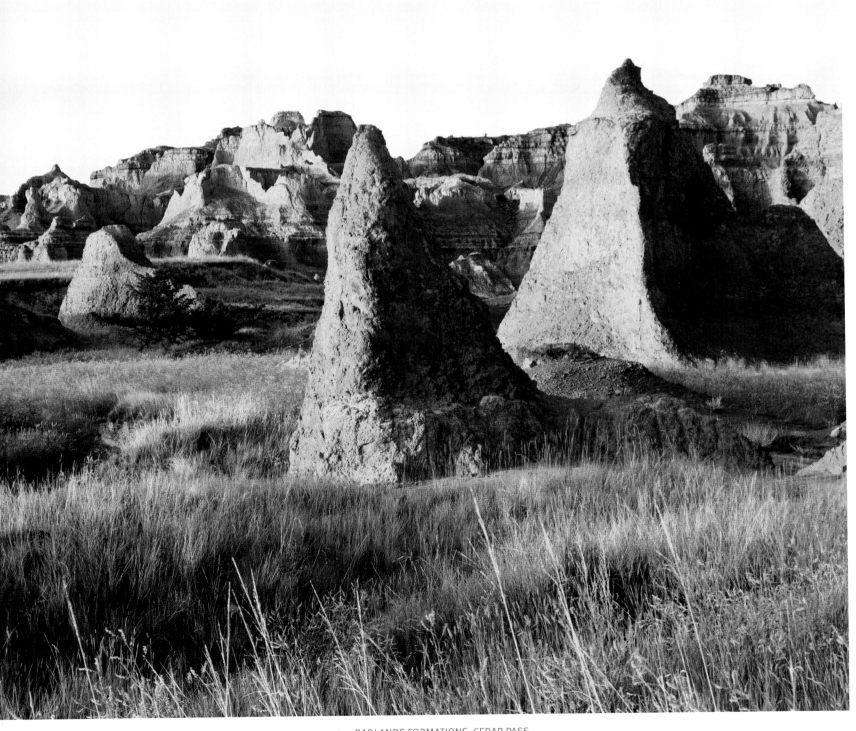

BADLANDS FORMATIONS, CEDAR PASS

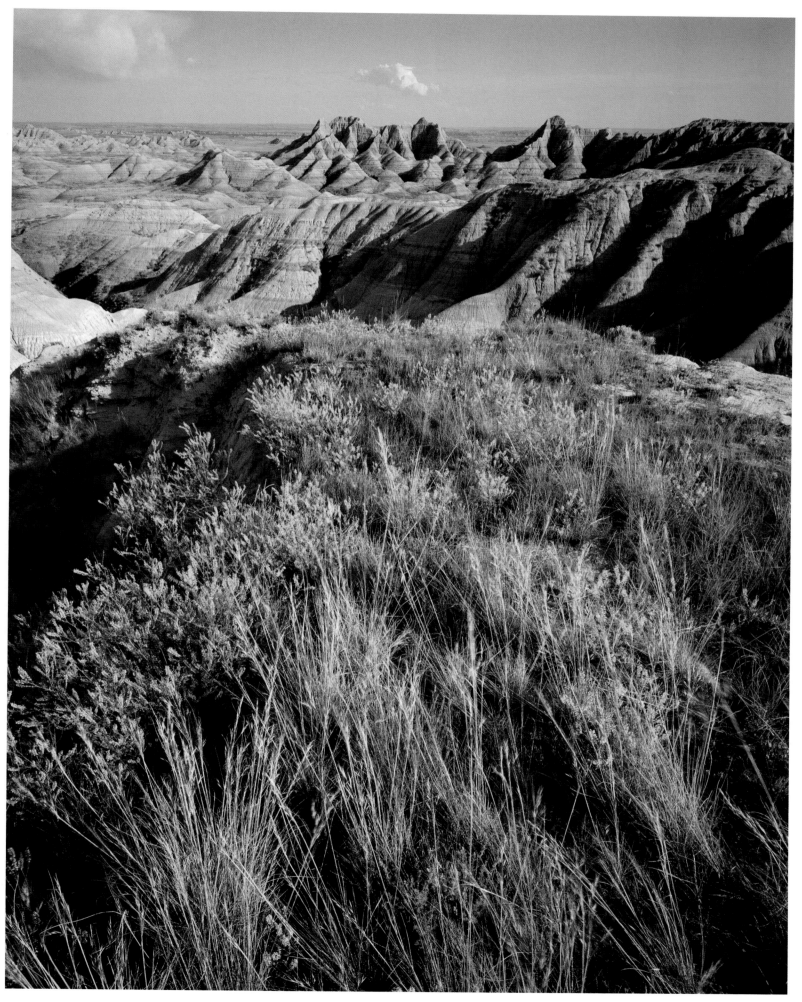

PRAIRIE EDGE, BADLANDS NORTH UNIT

Wind Cave NATIONAL PARK

A limestone cave in the sacred Black Hills is decorated by intricate boxwork and calcite crystal formations. A mixed-grass prairie provides habitat for bison, pronghorns, and other wildlife. Established in 1903. Acreage—28,295.03.

BOXWORK FORMATION

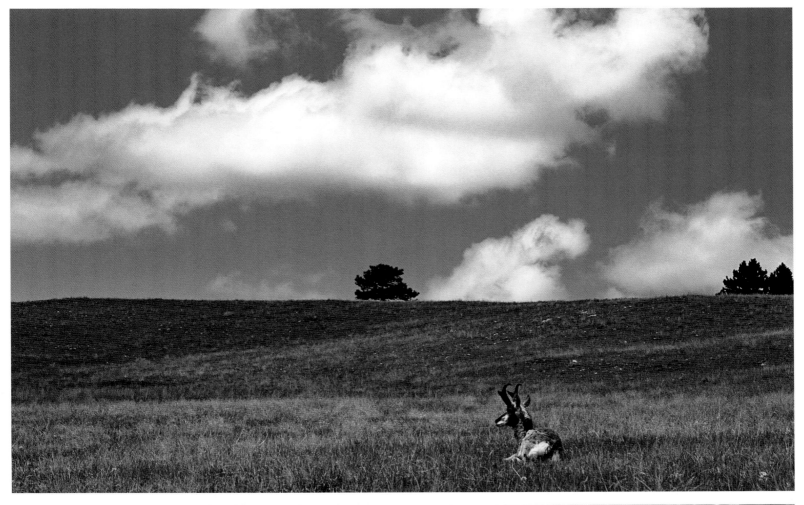

▲ ▲ PRONGHORN BUCK, PRAIRIE LANDS

▲ GENTIAN DETAIL IN PRAIRIE GRASSLANDS

Theodore Roosevelt NATIONAL PARK

The park includes part of Theodore Roosevelt's Elkhorn Ranch and scenic badlands along the Little Missouri River. Established as Theodore Roosevelt National Memorial Park in 1947, redesignated as a national park in 1978. Wilderness designated in 1978. Acreage— 70,446.89. Wilderness—29,920 acres.

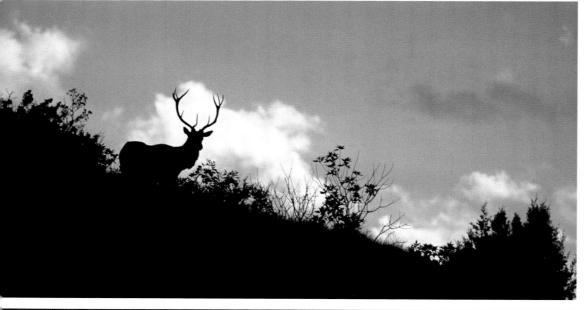

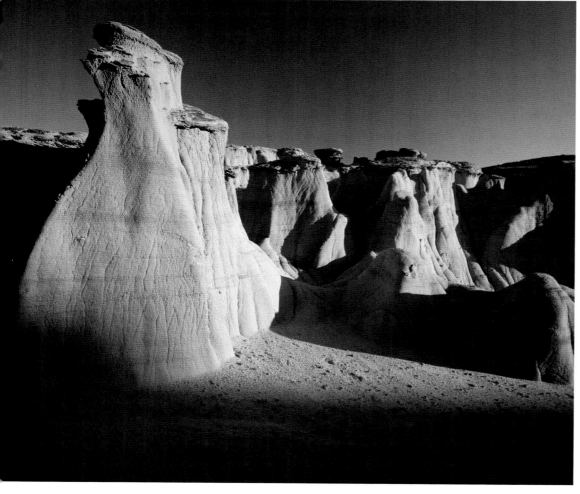

▲ ▲ ELK

▲ BADLANDS FORMATIONS

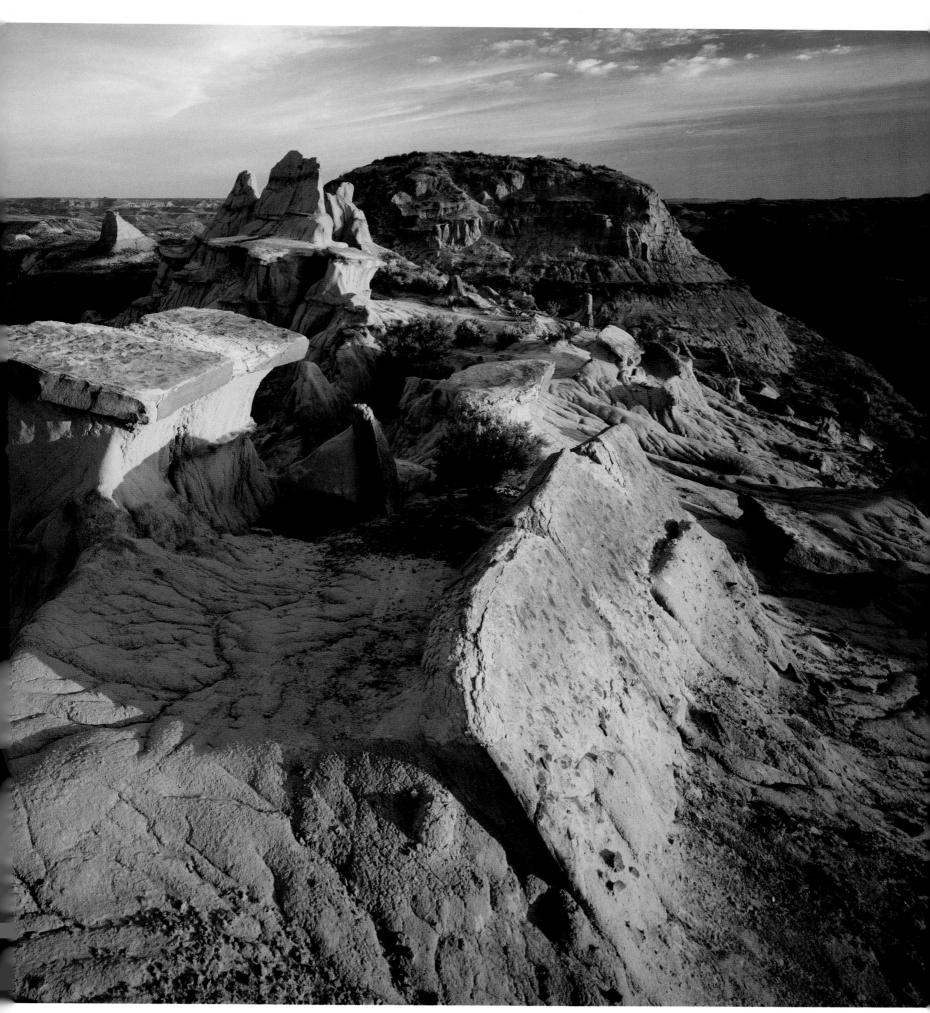

BADLANDS AT SUNRISE

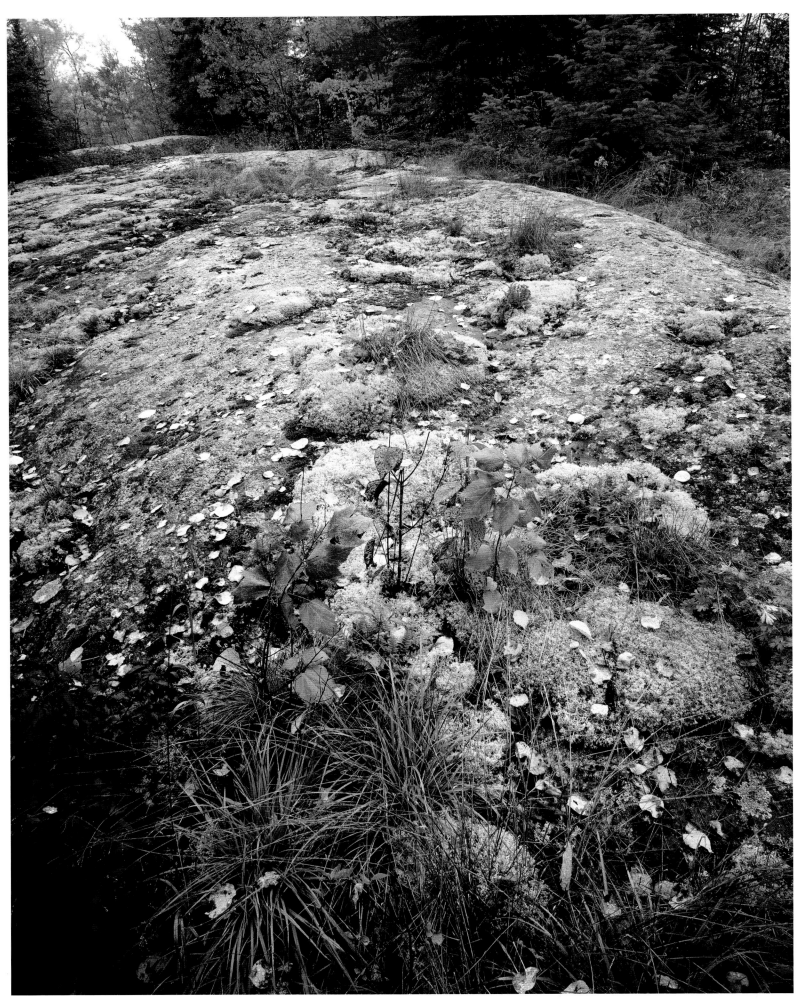

MOSS-COVERED GRANITE DOME

A waterway of four large lakes connected by narrows was once the route of the French-Canadian voyageurs. The lakes contain more than 500 islands of boreal forest. Established in 1975. Acreage—218,054. Land area—134,246 acres. Water area—83,808 acres.

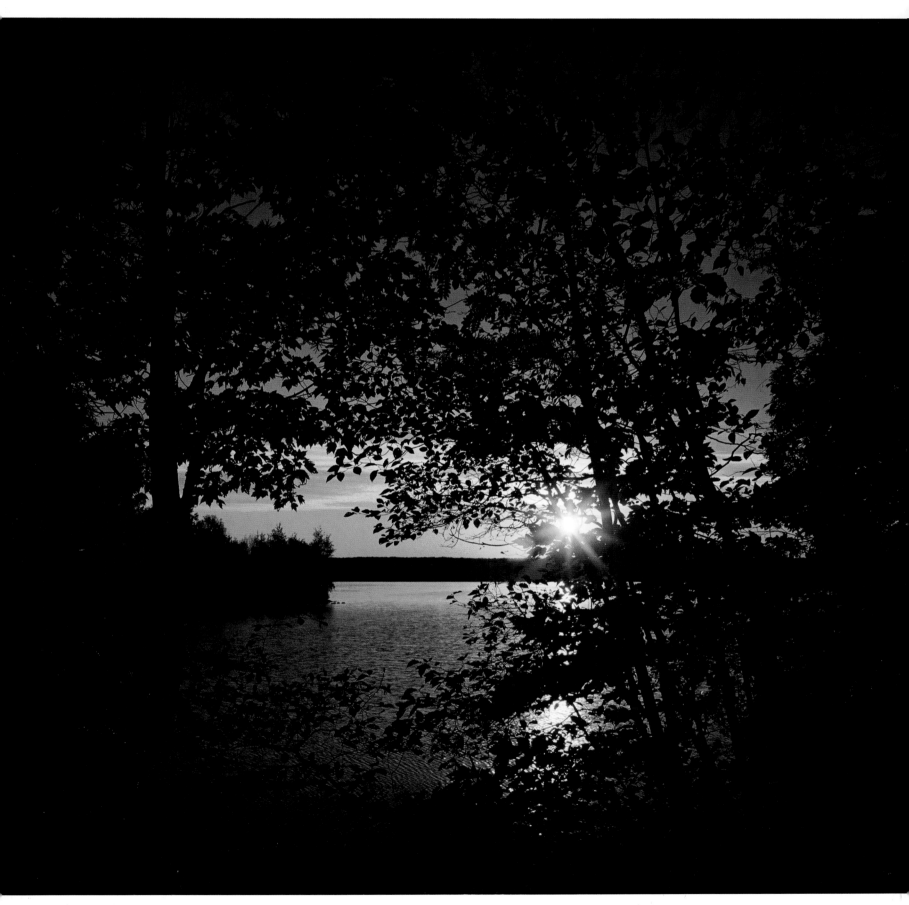

AUTUMN SUNSET, KABETOGAMA LAKE

▲ AUTUMN, BIRCH FOREST

▶ SUMMER GREENS, CHICKENBONE LAKE

Isle Royale

NATIONAL PARK, MICHIGAN

Isle Royale, the largest of an archipelago of more than 200 islands, is 99 percent designated wilderness, its interior accessible only by foot or canoe. Its 210 square land miles are cut by 165 miles of trails. Travel to Isle Royale from either Minnesota or Michigan is by concessioner boat or plane, or private boat (no cruise ships may dock here) across Lake Superior.

Parallel ridges and valleys line the forty-five-mile-long narrow island. Except for several ridge crests of bare rock, magnificently open to the largest freshwater lake in the world, this is a thickly vegetated place. Forests of maple, birch, oak, spruce, fir, and the ubiquitous thimbleberry dominate the landscape. What is extraordinary here is the wildlife. On an island fifteen miles from the nearest mainland (Ontario), there are wolves, moose, fox, otter, weasel, and muskrat. Some swam to get here. Some walked across a winter-frozen lake. The moose have been here since the early 1900s, and wolves since about 1948.

Isle Royale is the site of David Mech's landmark three-year study of wolf-moose relationships. Among his conclusions, with major ramifications for wildlife across America, wolves kept the moose herd within the boundaries of its food supply by culling out weakened individual moose. Mech noted that moose in their prime were not killed. The importance of the predator-prey relationship was graphically illustrated here when, in the early 1980s, a private boat visitor to the island illegally brought his dog and the canine parvo virus. In 1980 there were fifty wolves and a moose population of 664. By 1982, wolf numbers fell to fourteen. While the wolf population remained low, moose numbers shot up to a high of 2400 in 1995. As the wolves have gradually increased, reaching twenty-nine in 2004, moose decreased to 750 that same year. The island is divided into three wolf pack territories: the East, Middle, and Chippewa Harbor packs.

The largest forested island in Lake Superior preserves a wildland providing habitat for wolves and moose. Authorized in 1931. Wilderness designated in 1976. A Biosphere Reserve. Acreage—571,790.11. Land area—131,781.87 acres. Wilderness—132,018 acres.

Years before wolves were restored to Yellowstone, I went to Isle Royale for the wolves. Like many people, I was fascinated by them as symbols of wildness, as the missing necessary part of so many ecosystems, as romantic, beautiful creatures. Even if I never saw them, I wanted to be in a place where they lived. I didn't see them. But one night I heard howling and it was enough. In the wolf's howl is the essence of wildness.

Biologists never expected this shy creature to be so evident as it is in Yellowstone, where wolf-watching has become a full-time activity. In looking for wolves in Yellowstone, you just look for groups of people with spotting scopes along the road through Lamar. This kind of ease does not exist with the Isle Royale wolves, but summary results of the annual Winter Study program are available on the park's Web page, www.nps.gov/isro.

The island's two major trails follow its two long ridges. The Greenstone Ridge Trail extends forty miles from Windigo to Rock Harbor, following Isle Royale's highest points. The Minong Ridge Trail, more or less paralleling the western side of the island from Washington Harbor, near Windigo, twenty-six miles to McCargoe Cove, is a wilder trail. Minong is the Ojibway name for the island. (Although Indians mined copper here at least 4500 years ago, the Ojibway were not mining when they sold the island to the United States in 1842.) Largely unimproved, with no bridges across the many bogs, this trail gets less use.

The end point of my trip, Rock Harbor, is the busiest part of the island. But on a walk from Rock Harbor to Scoville Point, I regained a sense of wilderness the island's interior had provided. At Scoville Point I stood on a high, rocky, windswept island, feeling all the force of this great lake, of the isolation of this island, the wild, primitive nature that is the soul of this place.

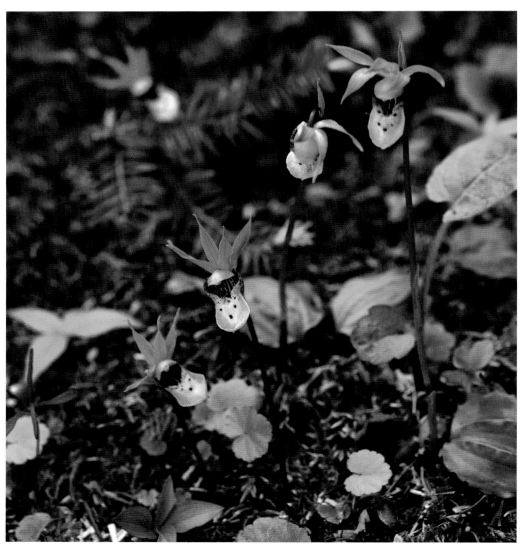

LADY SLIPPERS, GREENSTONE RIDGE

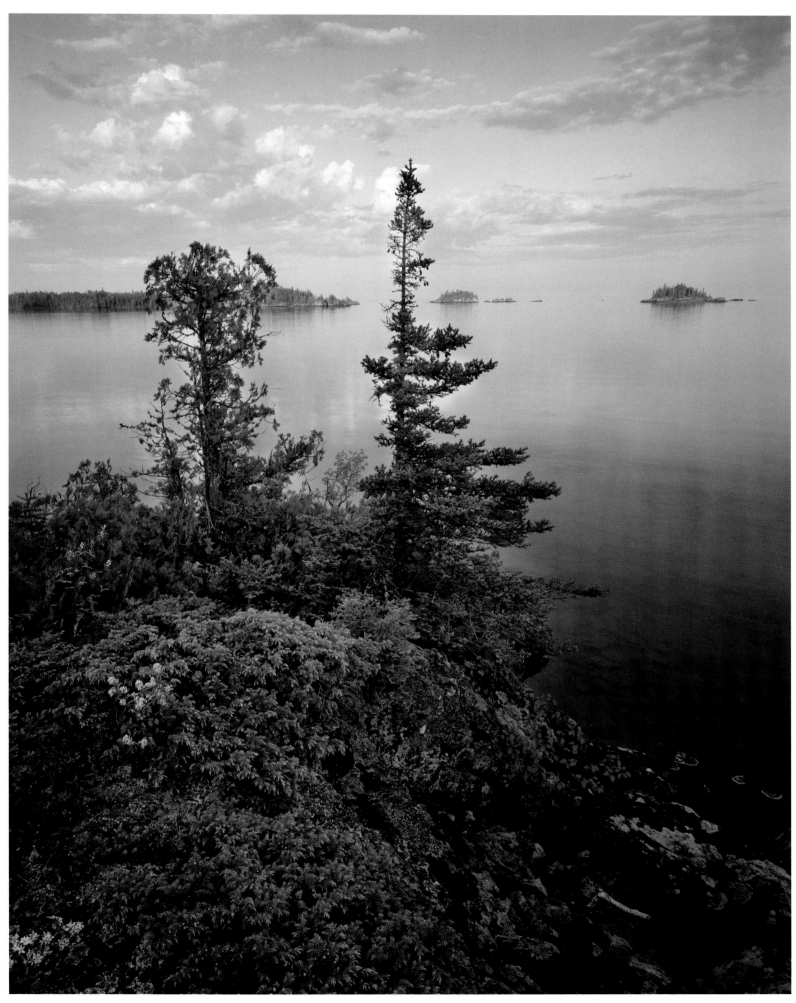

QUIET EVENING, ROCK HARBOR

Cuyahoga Valley <small>NATIONAL PARK</small>

The park preserves rural landscape along twenty-two miles of the Cuyahoga River between Cleveland and Akron. Established as the Cuyahoga Valley National Recreation Area in 1974, redesignated as a national park in 2000. Acreage—32,947.07.

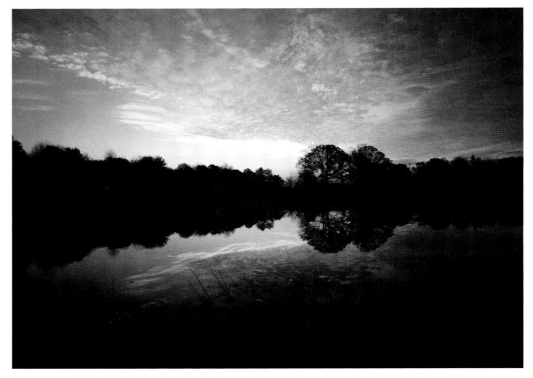

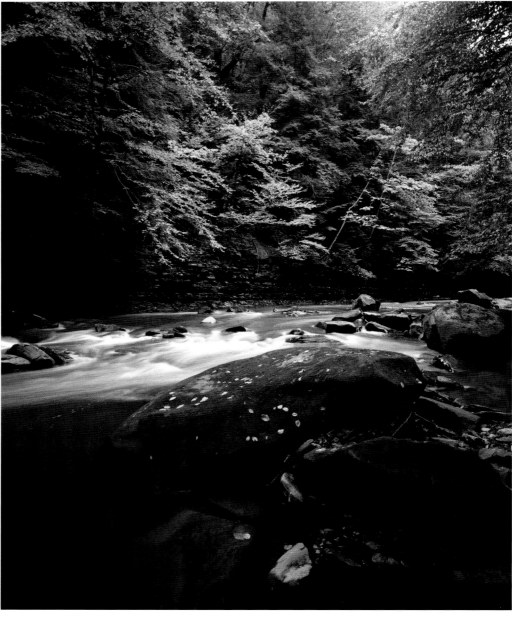

▲ ▲ AUTUMN POND, SUNRISE

▲ TINKER CREEK GORGE

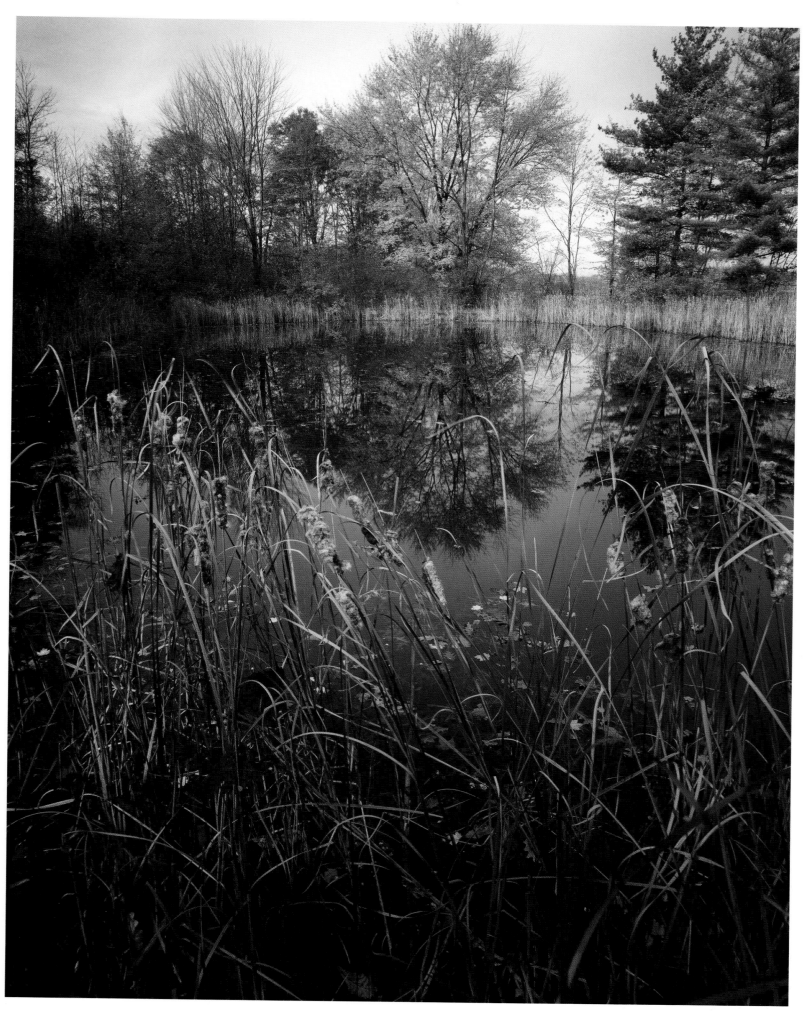

BEAVER MARSH ALONG CUYAHOGA RIVER

Mammoth Cave NATIONAL PARK

▲ ▲ UNNAMED ENTRANCE

▲ FROZEN NIAGARA, MAMMOTH CAVE

This park contains the longest recorded cave system in the world, with over 350 miles surveyed. Above ground, eastern hardwoods cover rolling hill country and the scenic river valleys of the Green and Nolin Rivers. Deer and wild turkeys are among the wildlife drawn to this diverse landscape. Established in 1941. A Biosphere Reserve and World Heritage Site. Acreage—52,830.19.

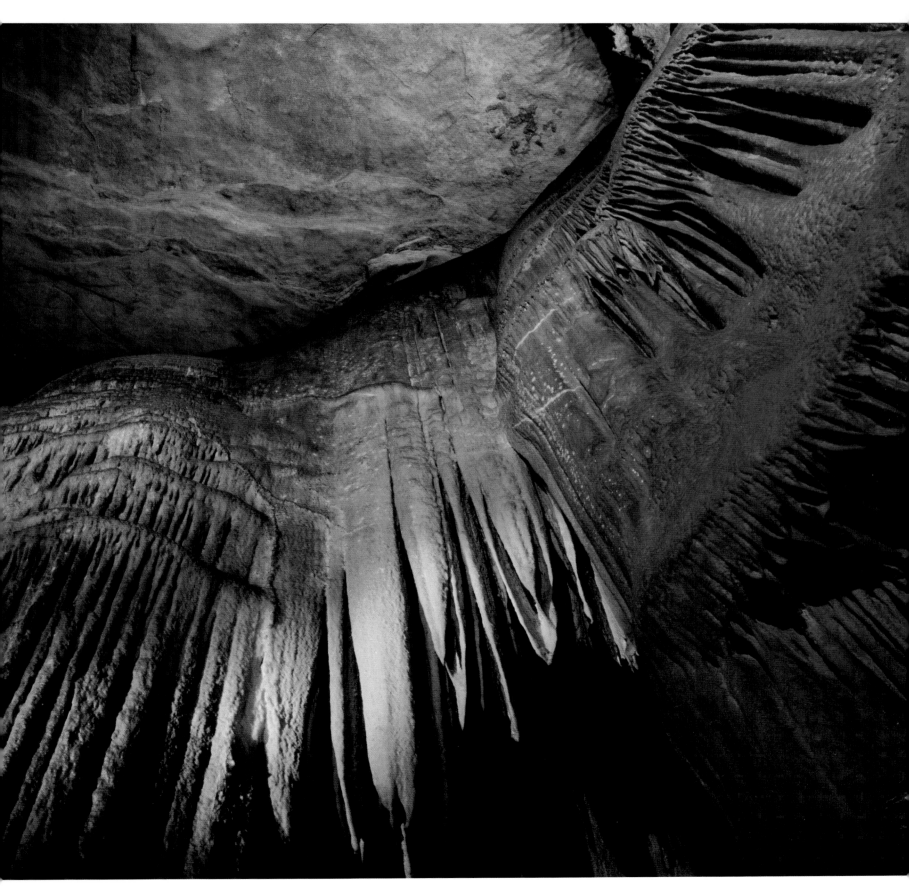

FROZEN NIAGARA

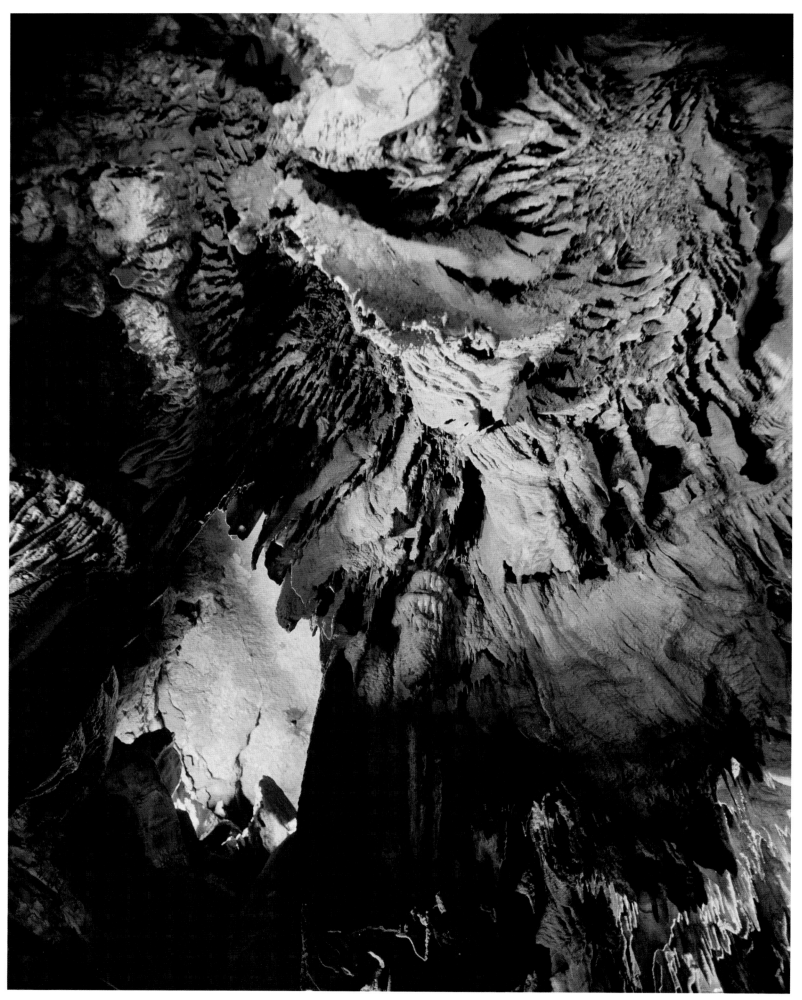

THERMAL SPRINGS FLOWING OVER TUFA TERRACE

Hot Springs NATIONAL PARK

Numerous hiking trails through the Ouachita Mountains add to the lure of forty-seven hot springs. Bathhouse Row is a National Historic Landmark District. Established as Hot Springs Reservation in 1832, redesignated as a national park in 1921. Acreage—5549.46.

THERMAL SPRINGS FLOWING OVER TUFA TERRACE

Virgin Islands NATIONAL PARK

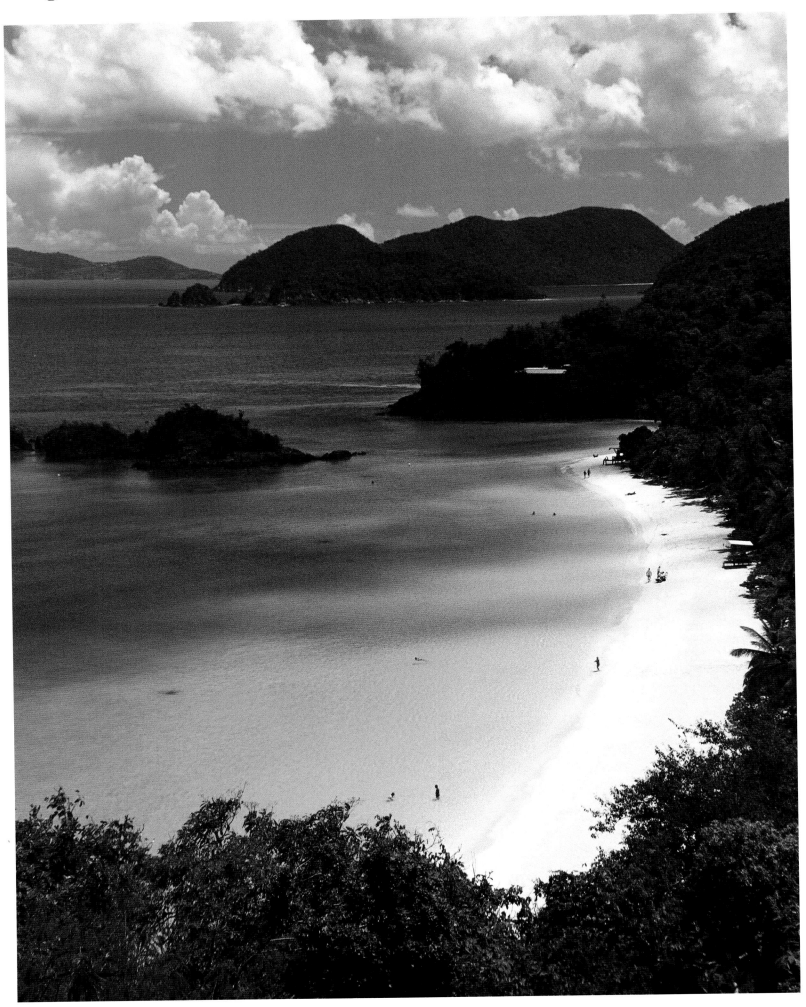

TRUNK BAY, ST. JOHN

The park covers much of the island of St. John. Here are coral reefs, blue-green water, and white sandy beaches fringed by green hills and tropical forests. Sanctuary for the endangered hawksbill and green sea turtles, and for iguanas, St. John is a breeding ground for over fifty species of tropical birds as well as winter habitat for many neotropical migrants. Established in 1956. A Biosphere Reserve. Acreage—14,688.87. Water area—5650 acres.

▲ ▲ CORAL REEF, ST. JOHN ▲ ▲ ▶ CORAL REEF, ST. JOHN

▲ CORAL REEF, ST. JOHN

A cluster of seven islands composed of coral reefs and sand almost seventy miles west of Key West, the area is known for bird and marine life, pirate legends, and the largest nineteenth-century American coastal fort. Established to protect both historical and natural features, it is habitat for the endangered green sea turtle and the threatened loggerhead turtle. In 1908 the area became a wildlife refuge to protect the sooty tern rookery. Proclaimed Fort Jefferson National Monument in 1935, it was renamed and redesignated as a national park in 1992. Acreage—64,700. Land area—39.28 acres.

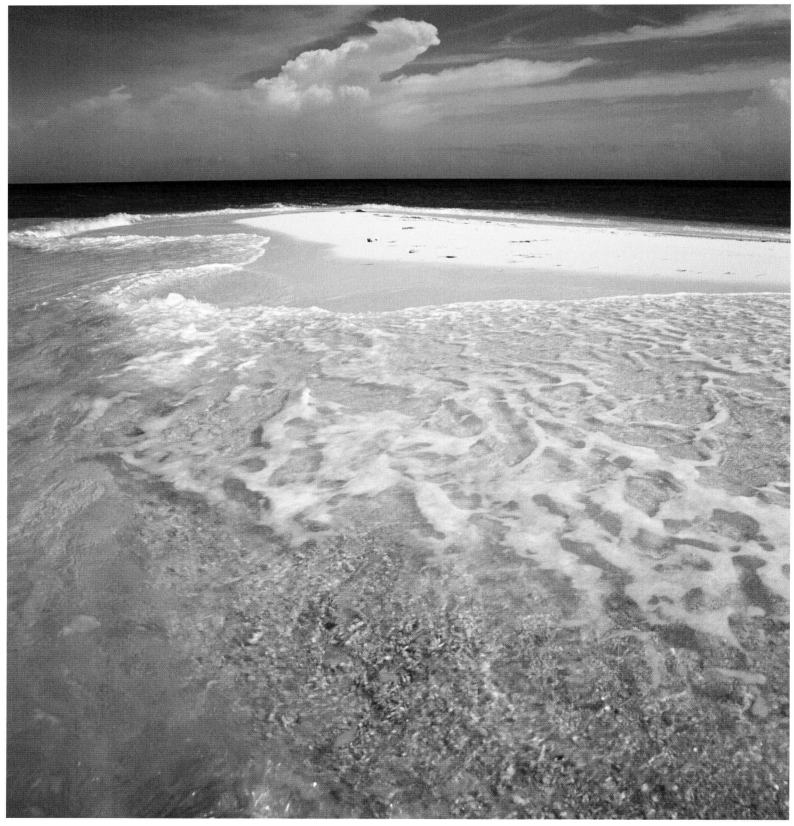

MIDDLE KEY

Biscayne NATIONAL PARK

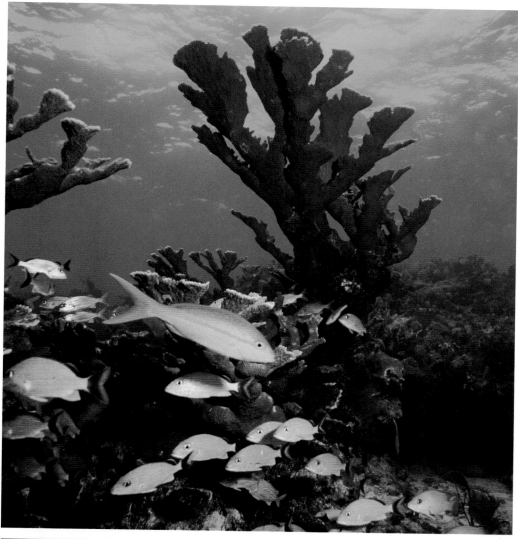

Subtropical islands form a north-south chain, with Biscayne Bay on the west and the Atlantic Ocean on the east. Water and sky are the dominant features in this paradise for marine life and waterbirds. The park protects interrelated marine systems and the northernmost coral reef in the United States. Proclaimed a national monument in 1968, redesignated as a national park in 1980. Acreage—172,924.07. Land area—4446.23 acres.

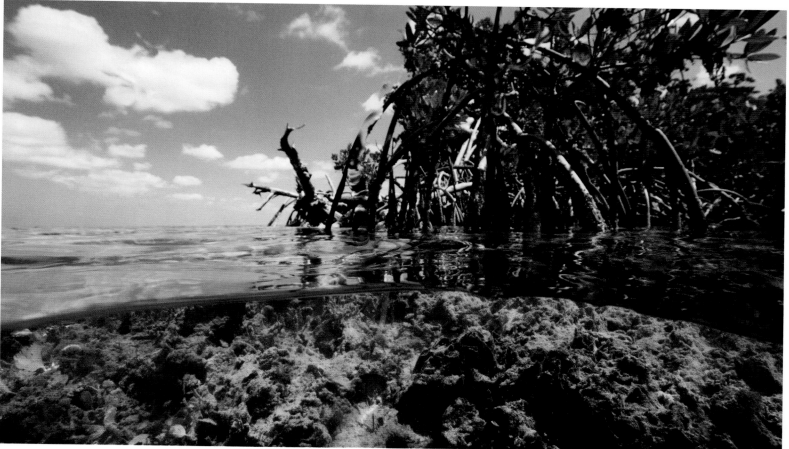

▲ ▲ ELKHORN CORAL

▲ RED MANGROVES

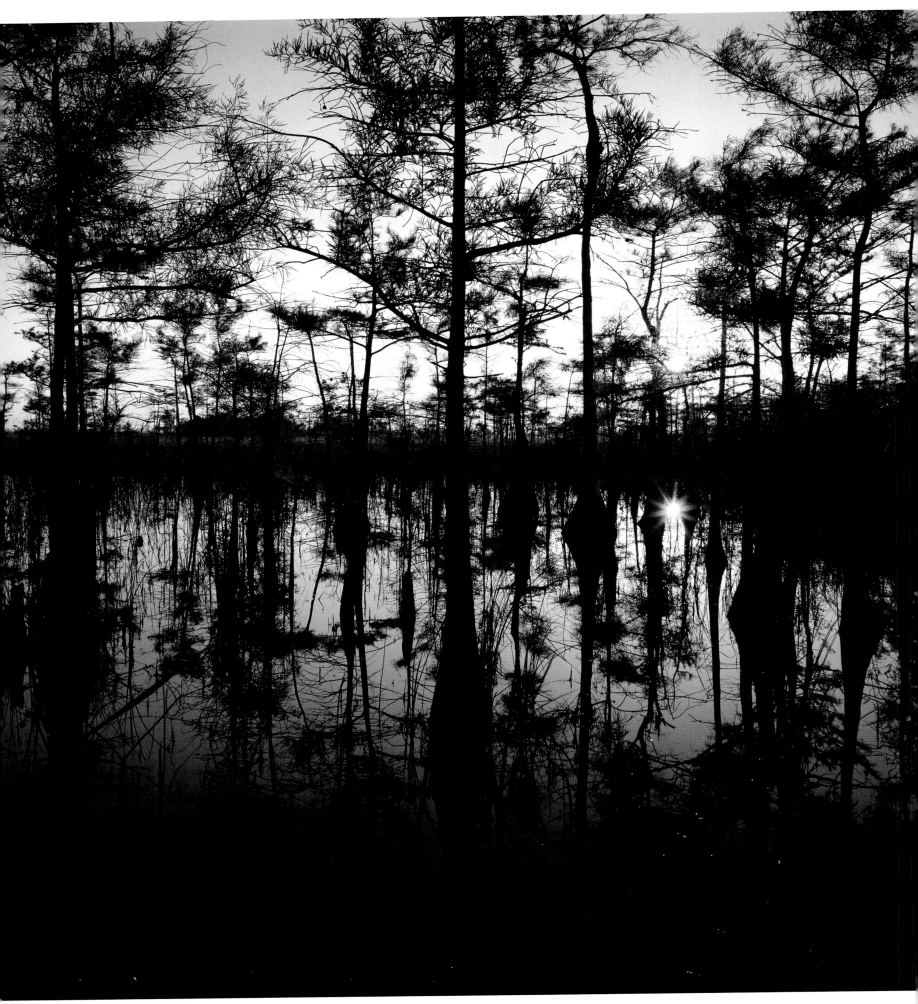

CYPRESS POND, DAWN

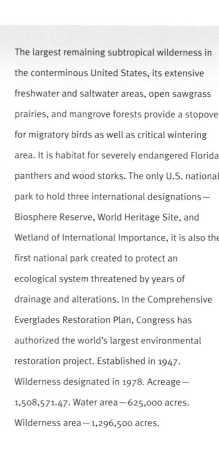

The largest remaining subtropical wilderness in the conterminous United States, its extensive freshwater and saltwater areas, open sawgrass prairies, and mangrove forests provide a stopover for migratory birds as well as critical wintering area. It is habitat for severely endangered Florida panthers and wood storks. The only U.S. national park to hold three international designations—Biosphere Reserve, World Heritage Site, and Wetland of International Importance, it is also the first national park created to protect an ecological system threatened by years of drainage and alterations. In the Comprehensive Everglades Restoration Plan, Congress has authorized the world's largest environmental restoration project. Established in 1947. Wilderness designated in 1978. Acreage—1,508,571.47. Water area—625,000 acres. Wilderness area—1,296,500 acres.

◄ ▲ SWAMP LILIES, PINELANDS

◄ HARDWOOD SWAMP, BIG CYPRESS PRESERVE

▲ BARRED OWL

203

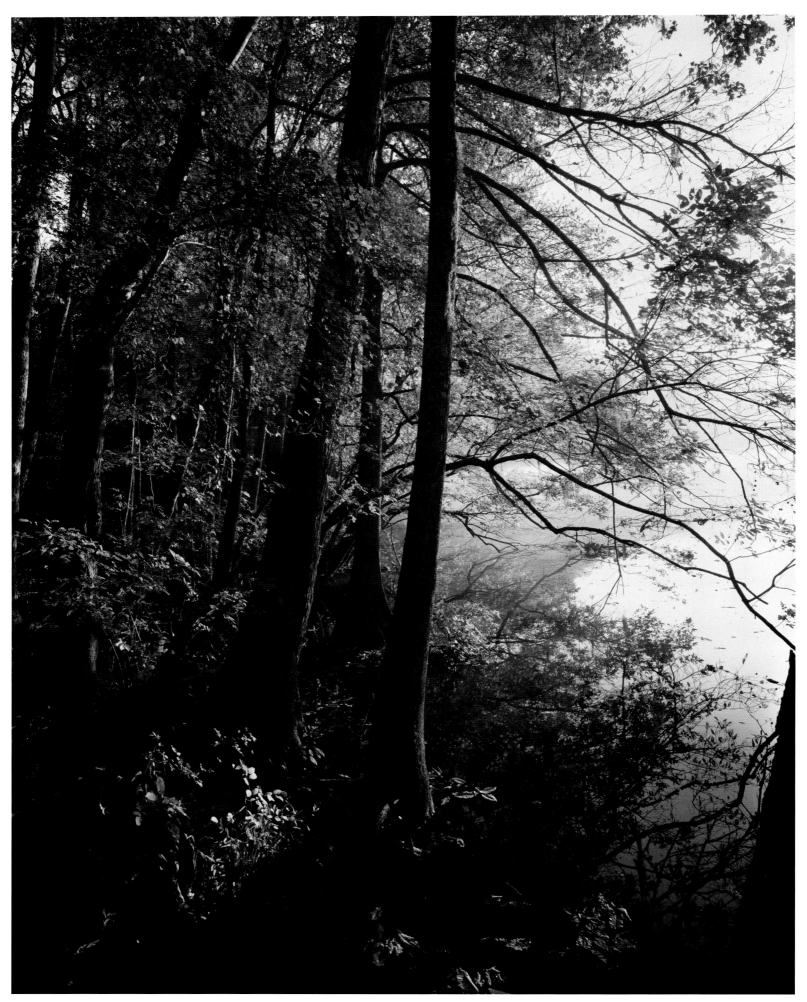

CONGAREE SWAMP FOREST ALONG WESTON LAKE

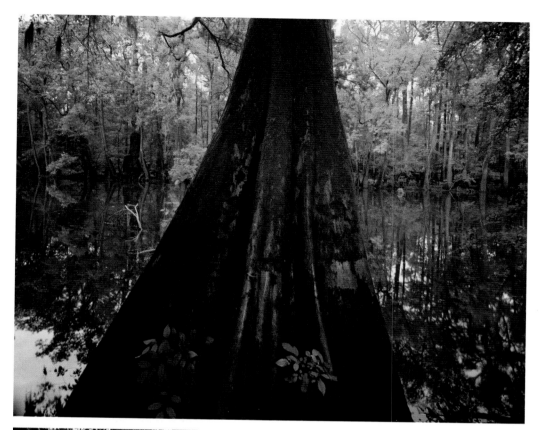

Protecting the last significant tract of southern bottomland hardwood forest in the United States, the park is home to a rich diversity of plant and animal species associated with an alluvial floodplain. Authorized as Congaree Swamp National Monument in 1976, renamed and redesignated as a national park in 2003. Wilderness designated in 1988. A Biosphere Reserve. Acreage—22,200. Wilderness area—15,010 acres.

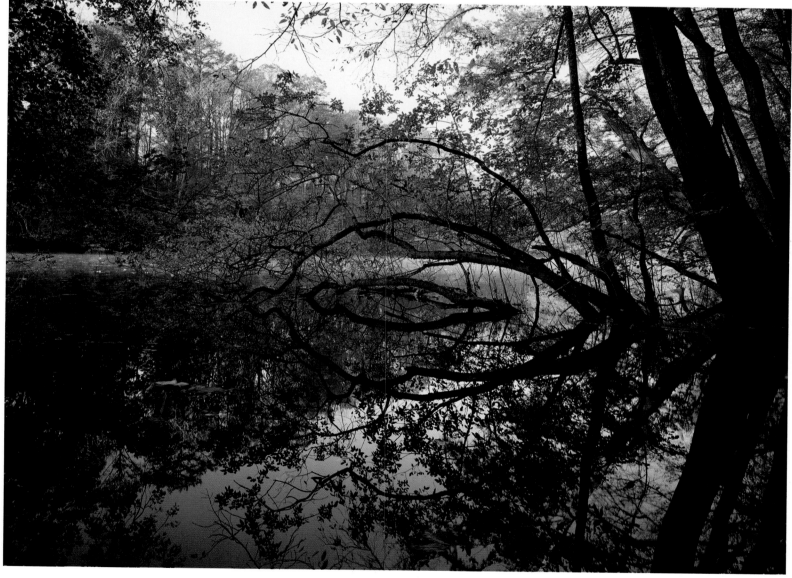

▲ ▲ BALD CYPRESS ALONG CEDAR CREEK

▲ AUTUMN MORNING, WESTON LAKE

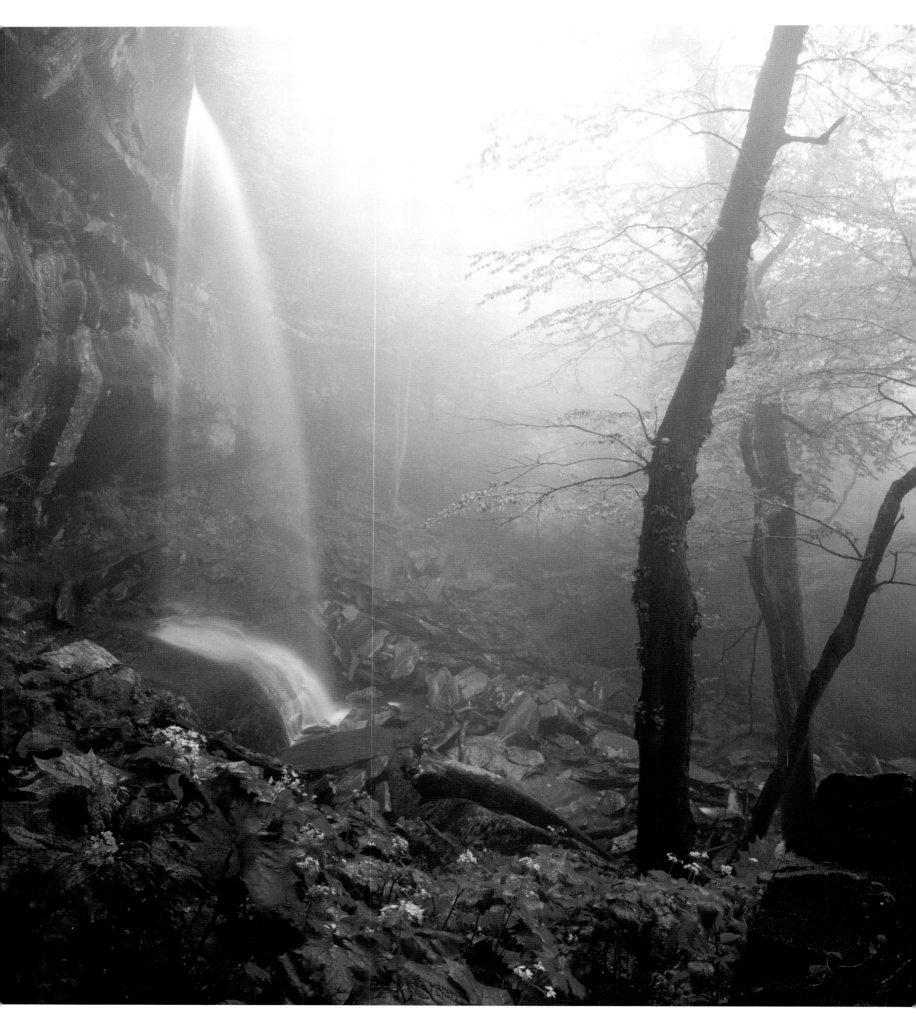

▲ RAINBOW FALLS IN FOG

► YELLOW TRILLIUM AND MAIDENHAIR FERN

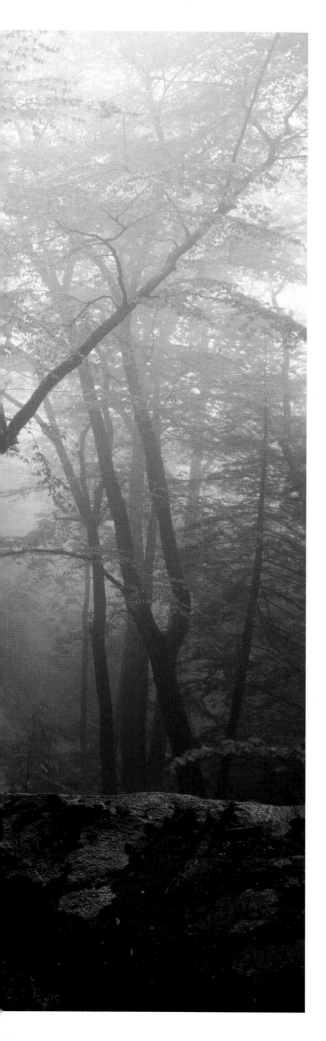

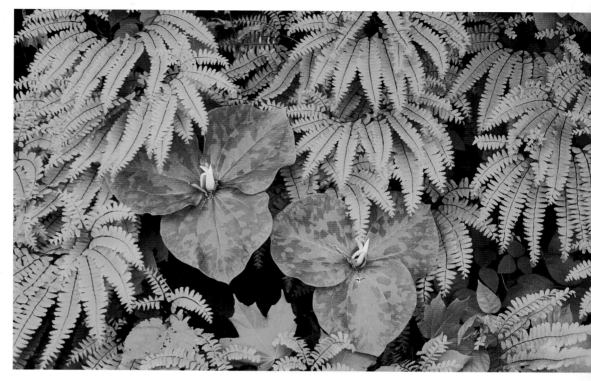

Great Smoky Mountains

NATIONAL PARK, TENNESSEE / NORTH CAROLINA

At Tremont, in the park's northwestern section, we walked a wide path along the Middle Prong of the Little River. When David went his own direction to photograph, I scrambled down to the stream, where, two steps out from the bank on submerged rock, I found a comfortable shaded boulder to sit on. It was late in the day. For all the crowds in the Smokies, we had the path and the river to ourselves. From my boulder I could see only the stream, the forested far bank, boulders in the stream, sun on the far side, shadow on my side. Upstream, I watched sun dance on water, a ribbon of white rapid-spume dance on water. Riffles molded themselves around boulders, dancing. The colors of light and of green danced. Rippled reflections of the far bank danced. The ripples themselves danced—circling, merging, parting, merging, running swiftly, folding back, dancing, dancing in the sun, the shadow.

The air was filled with butterflies and birdsong, and the sound of water flowing.

There is a sign at the beginning of the path along the Middle Prong. In the Smokies they call this kind of path (there are many of them) a "Quiet Walkway." The sign presents a wildness easily accessible. It invites without pressure, without challenge. Even if no one in the park seems to know who wrote the words, it states a truth about wilderness:

> The trail has no particular destination. A short walk on this easy trail offers close-up views, subtle aromas, and the serene quiet of protected woodland. You will be walking in one of the last great wild land areas in the east, but you won't need a backpack or hiking boots. Take your time. Have a seat on a rock or a log bench. The trail has no particular destination, so walk as far as you like and then return.

Great Smoky Mountains National Park, the most visited of our national parks, protects about half the remaining old-growth forest in the eastern United States. Among the most

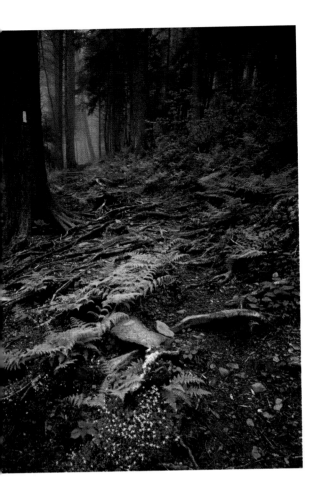

biodiverse parks in the country, it has been named a United Nations International Biosphere Reserve and World Heritage Site. The Cherokee, whose land this was, called it Place of Blue Smoke, for the deep blue haze hovering over dark, forested peaks and passes and the troughs between mountains. The wettest place in the United States besides the Pacific Northwest, average annual rainfall can be over ninety inches at altitudes above 6000 feet. It is this huge amount of moisture that produces the haze, the illusion of smoke. I am certain most of that moisture fell while I was backpacking there one May. The good thing about that is there were also fewer people in the backcountry than later in the season.

The Smokies include the third-highest peak in the east, 6642-foot Clingmans Dome. Even though the Appalachian Trail traverses this peak, the highest point on the trail, this is one place, with its broad paved path and elaborate viewing tower, even I can't translate into wilderness. (The Appalachian Trail actually passes about fifty yards below the peak so that hikers can avoid the busyness at the lookout.) But fifteen other peaks higher than 6000 feet offer a chance for wilderness, as do many of the more than 650 miles of trails lacing the park. Of these, sixty-eight are part of the 2146-mile Appalachian Trail from Maine to Georgia. The Appalachian Trail, a National Scenic Trail and a unit of the National Park System, is one of the original two components of the National Trails System. The other is the Pacific Crest Trail.

The remarkable biological diversity of the Smokies is unparalleled in the world's temperate zones. Here are more tree species than in northern Europe, 1500 flowering plants, 200 species of birds and 60 of mammals. The traditional homeland of the Cherokee, who described the mountains as "blue, like smoke," the park also celebrates the eighteenth- and nineteenth-century settlers who wrested livings from its abundance. Established for administration and protection in 1930, for full development in 1934. A Biosphere Reserve and World Heritage Site. Acreage — 521,490.13 acres.

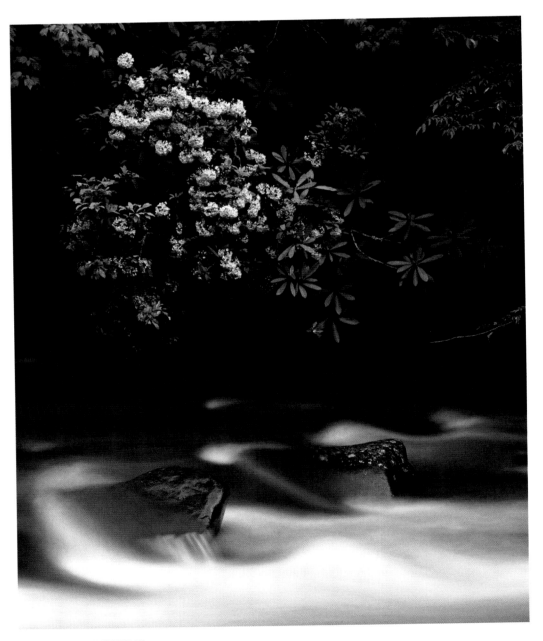

▲ ◄ APPALACHIAN TRAIL

▲ LAUREL BLOSSOMS ALONG LITTLE RIVER

The western escarpment of the Appalachians, the Smokies merge in the east with the Blue Ridge Mountains. Giant trees, spectacular displays of mountain laurel and rhododendron, a jumble of moss-covered ancient logs rotting into earth, glistening wood sorrel, dark violets, myriad waterfalls, the white, stark limbs of long-dead chestnut trees, their trunks swirled about, soaring skyward, all characterize the deep mystery of this place. In the omnipresent forest, something is always happening. A sudden fluttering of great wings and an owl lights in a tree beside the trail. Watching, waiting, finally lifting himself, he soars to a farther tree. A junco flitters up from the side of the path. There, where grass or moss or roots or mud hangs over to form a roof, he's built his nest. Three white eggs lie nestled in it. A salamander, one of the twenty-seven different species of salamander in the park, slithers out of the inside of a log, then disappears beneath it. A mouse runs across the path; a rabbit munches grass in a gentle clearing; a dark bear walks quietly through dark forest; a surprised bobcat hurries across the early morning trail; a boar, which is not native and causes enough destruction that it should be eliminated from the park, roots through the understory. (Backcountry shelters along the Appalachian Trail in the park are fenced to keep boars out.)

Inside these dark forests, the park seems remote from the world, invulnerable. But this is among the most endangered of our parks. Nonnative pests and diseases are killing Fraser firs,

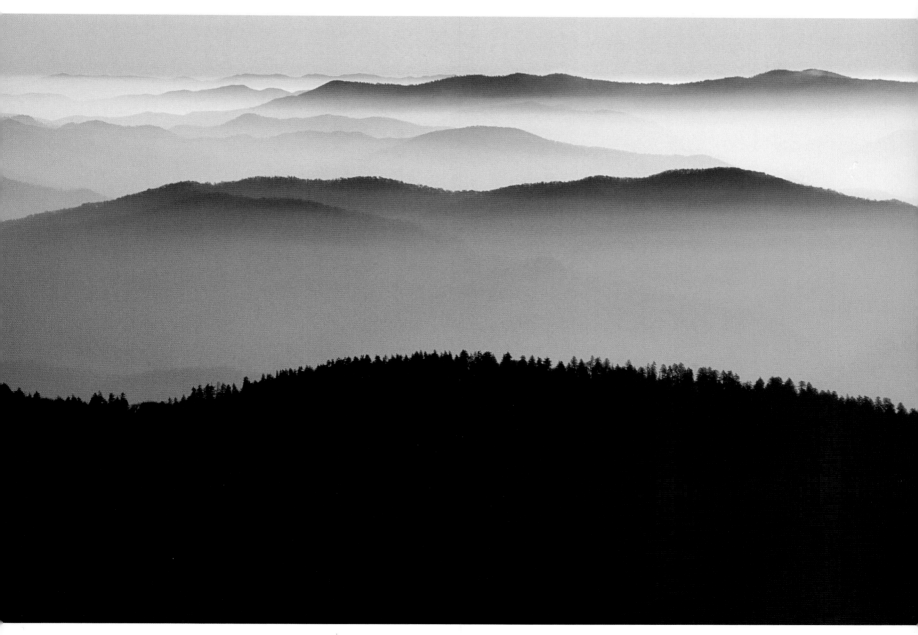

RIDGES EAST FROM CLINGMANS DOME

dogwoods, butternuts and beech trees. In May 2002, park botanists also found hemlocks under attack from the hemlock wooly adelgid, a nonnative aphid-like insect that originated in Japan. Problems associated with air pollution are among the greatest in the National Park System. Regional coal-fired plants, industry, and motor vehicles create health issues and seriously compromised visibility. Nine million annual park visitors, plus traffic on US 441, the Newfound Gap Road traversing the park from Cherokee, North Carolina, to Gatlinburg, Tennessee, can bring traffic to a halt. The Cades Cove Road is often so congested it can take four hours to drive its eleven-mile loop. Polluting vehicle emissions damage historic structures and the health of visitors and wildlife. A lack of ranger staff exposes structures to vandalism. According to the National Parks Conservation Association's State of the Parks Report on the Smokies, a proposal to build a road across the southwestern section of the park, "the largest unfragmented tract of mountain terrain in the eastern United States," has the potential to devastate wildlife, especially bears. Other problems have to do with serious budget shortfalls and a full-time

▲ ◄ CADES COVE HOMESTEAD

▲ AUTUMN FOREST, WEST PRONG, LITTLE PIGEON RIVER

staff that is too small, but this is equally true of many other units of the National Park Service.

The presence of crowds depends on where and when you go. On that wet May, six-day, sixty-one-plus–mile backpack through the eastern section of the park (I started and ended at Cataloochee), I actually saw few other people except on a Saturday night near Mount Sterling, which is not far from the road. In more recent years, David and I have made several visits to the Smokies, specifically to hike to waterfalls. If we had chosen other times than spring, when visitors come for the flowers, or fall, when they come for the foliage, we would have seen fewer people. But even in the busiest seasons, most people walk the easily accessible trails without lingering longer than to snap a photo at a waterfall.

By staying put in a place, I have had even the most popular areas to myself, for a little while at least. Hiking to Grotto Falls in clear, still, autumn air, I often felt as if I, alone, were involved in autumn. I had the company of leaves falling in a windless afternoon, twisting slowly to the forest floor, red and gold and orange, sounding in the stillness like a light rain.

I had the company of leaves falling in a windless afternoon, twisting slowly to the forest floor, red and gold and orange, sounding in the stillness like a light rain.

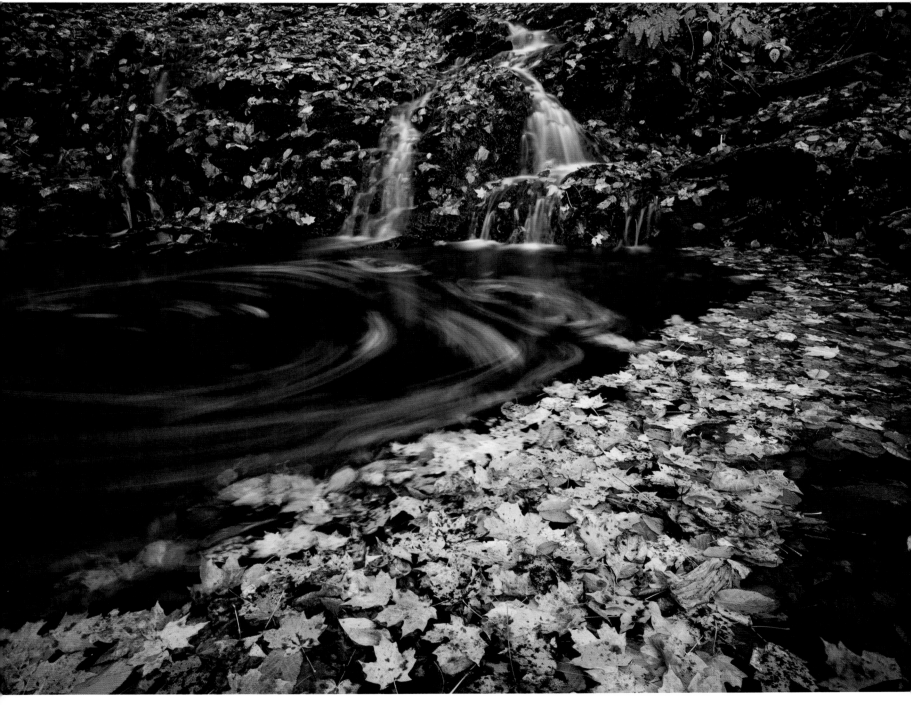

AUTUMN FLOW, WEST PRONG, LITTLE PIGEON RIVER

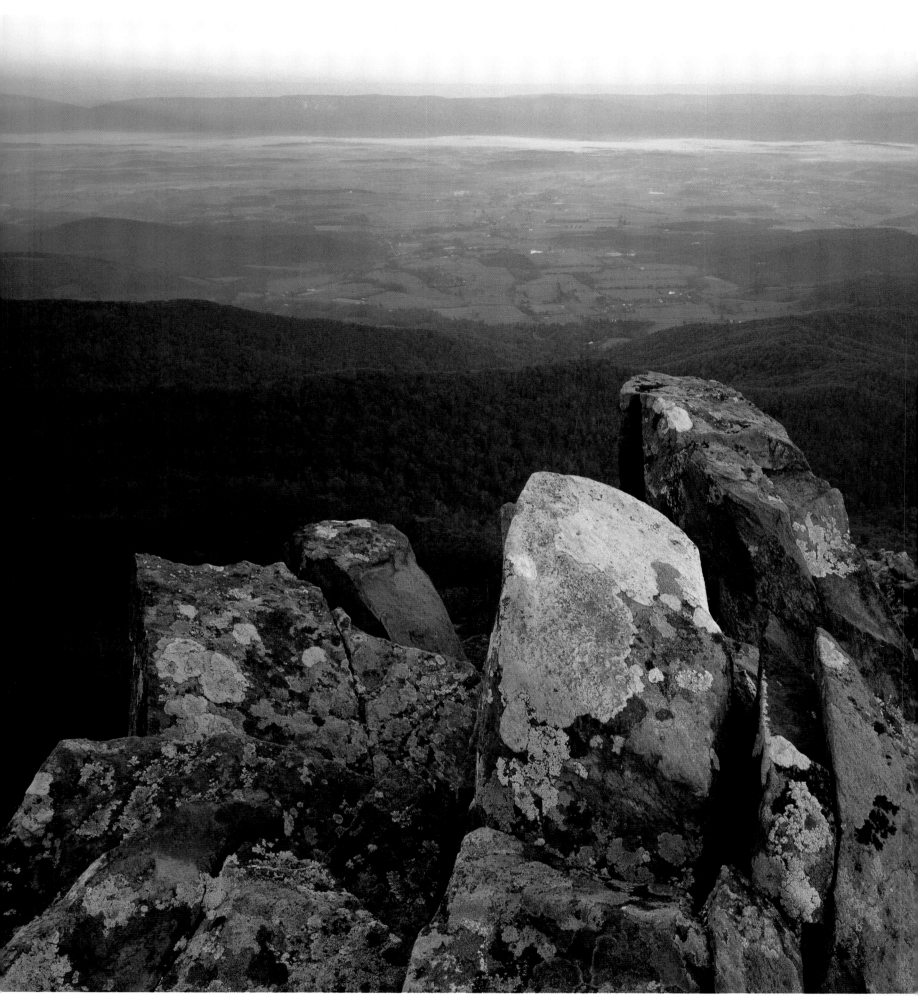

▲ STONY MAN MOUNTAIN, SHENANDOAH VALLEY

▶ FOREST SPRING, HAWKSBILL MOUNTAIN

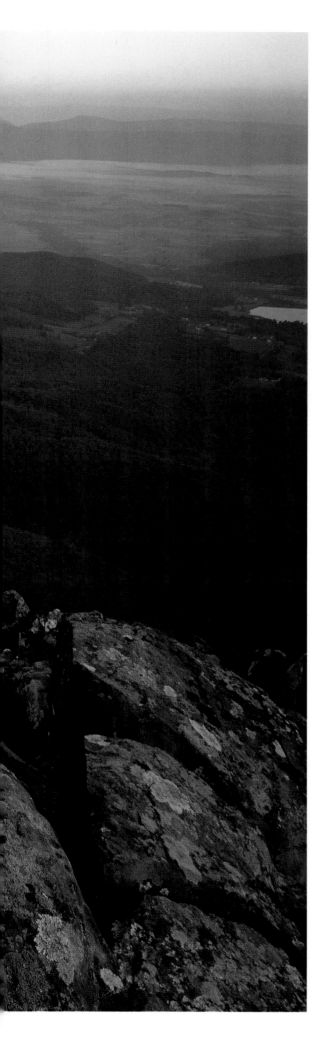

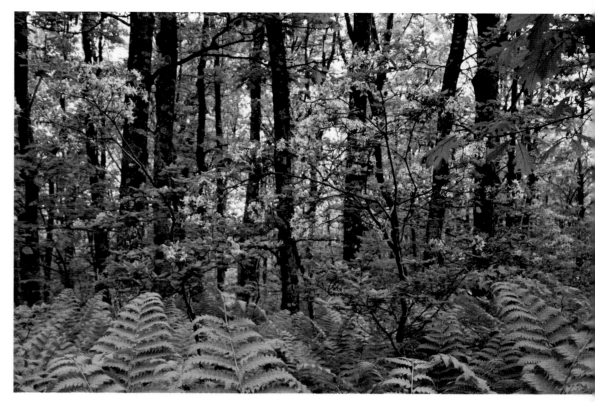

Shenandoah

NATIONAL PARK, VIRGINIA

The "recycled wilderness" of Shenandoah is a unique experiment among our national parks. When two-fifths of the park were designated wilderness in 1976, there remained remnants of life lived in the area since the eighteenth century. Letting previously settled areas revert to wilderness was a grand experiment that worked. "Wilderness, I think now, is where we feel it, and nature is not only the preserver but also the manufacturer. Leave her alone and wilderness is what she makes—on varying time schedules and in assorted styles," Darwin Lambert wrote in 1972 in *The Earth-Man Story*, quoting from an article he had written five years earlier for The Wilderness Society magazine, *The Living Wilderness*.

Long and narrow, Shenandoah's 307 square miles follow the crest of the Blue Ridge Mountains about eighty miles through Virginia from Front Royal to Waynesboro. The park is the heart of a wild land corridor that includes national forests, the Blue Ridge Parkway, itself a unit of the national park system, and a mosaic of wilderness and nonwilderness in both the park and the forests. Skyline Drive system, bisecting the length of the park, connects with the Blue Ridge Parkway to continue south to the Smokies. The Appalachian Trail, following the crest of the Appalachian Mountains from Maine to Georgia, passes through both parks.

A great many of Shenandoah's 520 miles of trails traverse wilderness, although backpackers never know when they're crossing boundaries between designated wilderness and nonwilderness. What this means is that the wilderness quality of all wildland trails is unequivocal, which is how nature does it.

One October afternoon we walked to the summit of 4050-foot Hawksbill Mountain, highest peak in the park, through a forest of oak, maple, hemlock, and young chestnuts. (There are only young chestnut trees in America. A fungus introduced by accident into the United States

early in the twentieth century kills them before they mature. Scientists at the American Chestnut Foundation are working to develop a blight-resistant strain of chestnut so that one day we may have mature chestnut trees again in America.) It should have been a time of spectacular color, but a freak hurricane, itself an act of wildness, passing through a few weeks earlier had stripped the trees of their usual autumn spectacle.

The wide, gentle, and short (a bit over a mile to the top) trail leads to a stone observation platform on the greenstone summit. Greenstone is a highly resistant rock metamorphosed from basalt formed by Precambrian lava flows. Capping high ridges and peaks in Shenandoah and forming prominent cliffs and holding most of the waterfalls, it keeps you aware that these are ancient mountains. From here, looking out over Page Valley and Massanutten Mountain and all the forested mountains rolling like wild, unbroken waves across the earth, you are given an ultimate picture of an eastern American wildland that, even at this point in history, seems impenetrable wilderness.

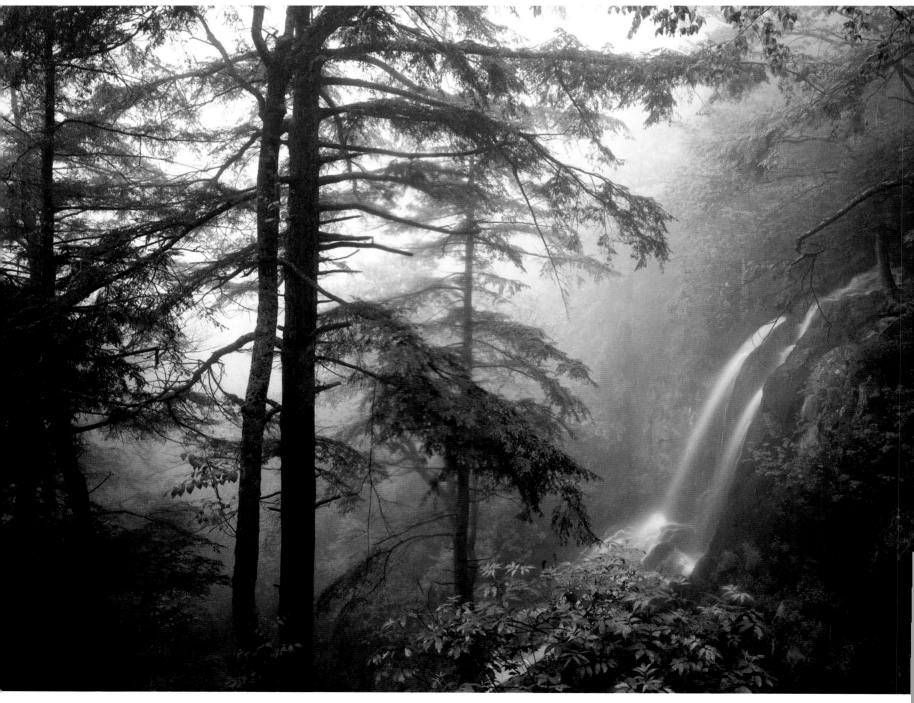

HEMLOCK FOREST AND LEWIS FALLS

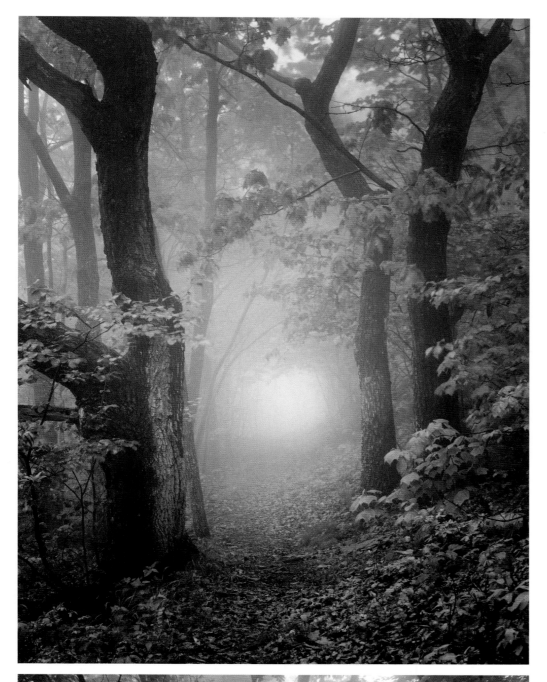

Ridges and valleys, hills and hollows laced
with sparkling streams and waterfalls cover
300 square miles astride the Blue Ridge Mountains.
The park celebrates a rugged eastern landscape,
and a wilderness reclaimed. Established in 1935.
Wilderness designated in 1976 and 1978.
Acreage—191,181.58. Wilderness—79,579 acres.

◄ APPALACHIAN TRAIL IN FOG
◄ ▼ MOUNTAIN LAUREL IN FOG
▲ LICHEN ON BOULDER IN FERNS,
LEWIS FALLS TRAIL

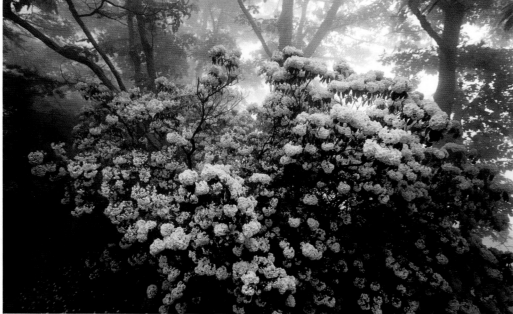

Migrating hawks circled below us. The sky above us darkened. We left the open summit at the first sounds of thunder, picked up the packs we'd dropped at the day-use shelter just short of the summit, and rushed down into the forest, eager to get there before the storm hit fully. Less than a quarter mile from the truck, we felt the force of lightning hitting nearby. Sheltered by low shrubbery entirely surrounded by forest, we squatted where we were until, hearing the storm move off a little, we ran for the truck. Lightning scares me. Ever since I saw two of the horses I worked with in Yellowstone killed by a single stroke of lightning a few years ago, my fear of it has escalated. The horses were in the safest possible spot. Where lightning strikes is totally arbitrary. Lightning is wild by any standard.

Perhaps because so much of Shenandoah's wilderness is reclaimed, and because it is so accessible from major metropolitan areas, it is a particularly precious entity. When about 40 percent of the park was designated wilderness in 1976, it was the greatest percentage of wilderness in the national park system. Since then, both acreage and percentage of designated wilderness have blossomed throughout the parks.

In 2004, Shenandoah's efforts on behalf of wilderness were recognized with the director's Wes Henry National Excellence in Wilderness Stewardship Group Award. Ranger Laura Buchheit, an education specialist whose expertise is in wilderness education, is charged with educating Shenandoah park staff, other federal agency employees, and the general public and with implementing Park Service education plans. Shenandoah is one of few parks with a fully staffed education department. Buchheit calls the Wilderness Act "an act of humility, a restraint. It serves as a reminder," she says, "of our background character, our history. By designating wilderness, we assure the absence of development."

At the 2001 Wilderness Seminar celebrating the twenty-fifth anniversary of the Shenandoah National Park Wilderness, Ed Zahniser gave the keynote address. Zahniser is a publications editor for the National Park Service, a wilderness advocate, and the son of Howard Zahniser. In his talk, "The Essential Character of Wilderness Is its Wildness" (the title is a quote from his father), he looked at the connection of wilderness with the very air we breathe, saying that without wildness we have no life. "That we might not inhabit the wild is only an illusion of those who forget we breathe air, which word in the Hebrew, Greek, and Latin is also the word for spirit and breath.

"Decades hence," he continued, "the Wilderness Act may come to be seen as the fulcrum with which our culture moved itself from a hierarchical world view to some post-ecological world view of the kinship of all life."

In "The Need for Wilderness Areas," his 1955 paper that became the basis for the Wilderness Act, Howard Zahniser wrote, "This need is for areas of the earth within which we . . . sense ourselves to be . . . dependent members of an interdependent community of living creatures that together derive their existence from the sun."

The hunger among us to acknowledge that connection is a growing thing. According to the 2002–2003 National Park Service Annual Wilderness Report, more than six in ten Americans believe that too little wilderness has been protected for future generations. Seventy-one percent of those polled believe that 10 percent or more of all lands in the United States should be protected as wilderness. Currently, 4 percent is. The report goes on to say, "As Americans deal with the continuing threat of terrorism, many unsettled international situations, and a difficult economic period, our special wild places are clearly more important to us than ever."

Whether we enter the wildernesses of our national parks as an antidote to personal or political turmoil, for the physical and mental challenges we find in its remoteness, the immediate connection it provides us with all other forms of life, or the spirituality it reflects, wilderness is a personal experience, offering itself to each of us on our own terms. Whether we even need to enter it, or are content simply knowing it exists, the *idea* of wilderness is the driving force of imagination, of wonder and exploration, of connection.

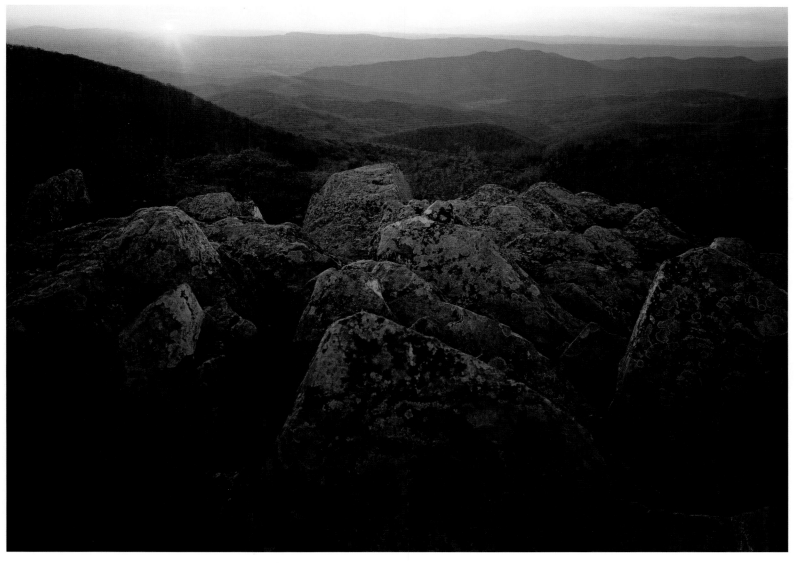

◄ AUTUMN FOREST, BEARFENCE MOUNTAIN

▲ SUNSET, STONY MAN MOUNTAIN

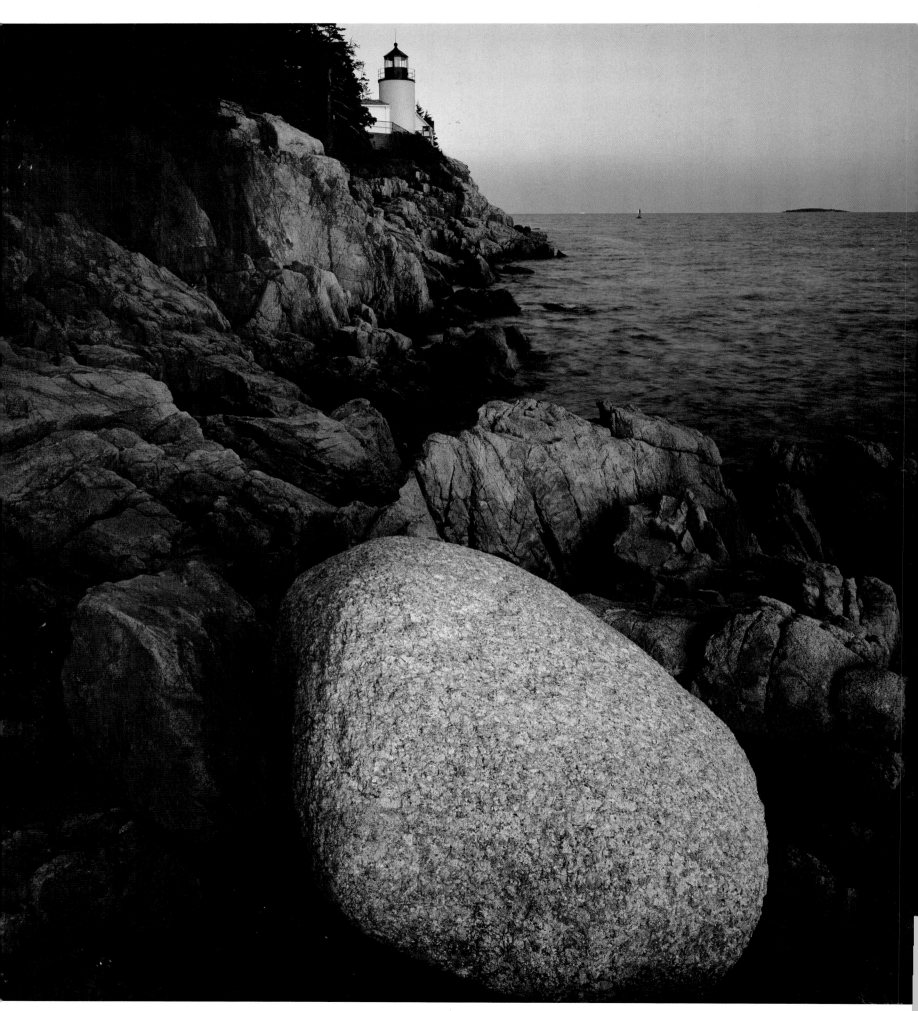

GLACIAL ERRATIC, BASS HARBOR HEAD LIGHTHOUSE

The sea sets the mood, uniting the rugged coastal area of Mount Desert Island, Schoodic Peninsula jutting into the ocean from the mainland, and the spectacular cliffs of Isle au Haut. Proclaimed Sieur de Monts National Monument in 1916, redesignated Lafayette National Park in 1919, renamed Acadia National Park in 1929. Acreage—47,737.78.

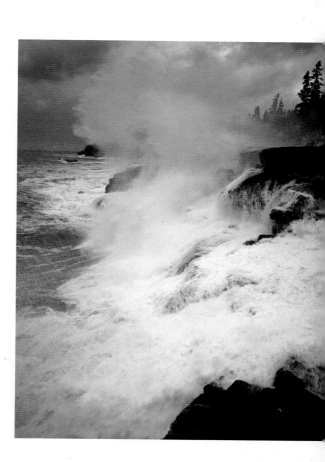

◄▲ COASTAL BOG AT SEAWALL
◄ OTTER COVE FROM CADILLAC MOUNTAIN
▲ ATLANTIC WAVE ACTION, SCHOONER HEAD

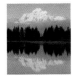

JACKET, FRONT COVER Mount McKinley Reflections, Denali National Park and Preserve, Alaska. The 20,320-foot mountain doubles its majestic image in a reflecting pond. September 2003, Linhof 4x5 camera, 75mm lens, Fujichrome Velvia film, polarizing filter.

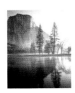

JACKET, BACK COVER Merced River Reflections and El Capitan, Yosemite National Park, California. A thin veil of mist sets a quiet mood at dawn along the Merced River. May 2001, Linhof 4x5 camera, 65mm lens, Fujichrome Velvia film, CC10R filter used to warm highlights slightly.

PAGE 1 Teton Reflections, Grand Teton National Park, Wyoming. Gentle mood of String Lake reflects Mount Owen and Grand Teton. July 1994, Linhof 4x5 camera, 300mm lens, Fujichrome Velvia film, no filtration.

PAGES 2–3 Moonset, Grand Teton National Park, Wyoming. An October moon lowers into dawn light on the Grand Teton National Park. October 2003, Canon 35mm camera, 28–135mm Canon zoom lens/approximately 90mm used, no filtration, half stop underexposed to convey the drama.

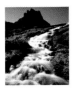

PAGE 4 Cascade and Clements Mountain, Glacier National Park, Montana. Snowmelt cascades down through Hanging Gardens near Logan Pass. July 1988, Linhof 4x5 camera, 75mm lens, Kodak Ektachrome E6 film. Slower flow of water was made possible by use of polarizing filter and longer exposure time.

PAGE 5 McKittrick Canyon, Autumn, Guadalupe Mountains National Park, Texas. October 1994, Linhof 4x5 camera, 75mm lens, Fujichrome Velvia film, CC10R filter used to warm up blues in shade.

PAGES 6–7 Fairyland, Bryce Canyon National Park, Utah. Direct frontal dawn light renders a reflective, incandescent glow to Wasatch pink formations in Bryce Canyon National Park. September 1995, Linhof 4x5 camera, 75mm lens, Fujichrome Velvia film, CC05R filter used.

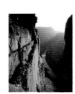

PAGE 8 Toroweap East, Grand Canyon National Park, Arizona. The Colorado River winds along below cliffs on the North Rim at Toroweap Point. Dawn light illuminates the canyon rims toward the east. June 1998, Linhof 4x5 camera, 75mm lens, Fujichrome Velvia film, CC05R filtration.

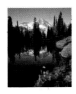

PAGE 10 Indian Henrys Hunting Ground, Mount Rainier National Park, Washington. Paintbrush, white fawn lily at pond's edge below Mount Rainier's west side. July 1978, Linhof 4x5 camera, 75mm lens, no filtration.

PAGE 11 Cholla Silhouette and Sunrise, Saguaro National Park (West Unit), Arizona. A chain fruit cholla cactus marks a bold form against a desert sunrise in the Tucson Mountains. April 1995, Linhof 4x5 camera, 75mm lens, Fujichrome Velvia film, no filtration.

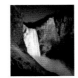

PAGE 14 Lower Falls, Yellowstone River, Yellowstone National Park, Wyoming. Huge and powerful spring runoff roars into Yellowstone River Canyon from the bottom of Uncle Tom's Trail early in the morning. June 2002, Linhof 4x5 camera, 75mm lens, no filtration.

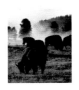

PAGE 15 Bison in Hayden Valley, Yellowstone National Park, Wyoming. July 2004, Canon 35mm camera, 100–400mm lens, Fujichrome Velvia 100F film.

PAGE 16 Old Faithful Geyser, Yellowstone National Park, Wyoming. July 2004, Canon 35mm Camera, Fujichrome Velvia 100F film.

PAGE 17 Autumn Dawn at Weston Pond, Congaree National Park, South Carolina. A brisk but quiet walk brings you to pond's edge deep in this swamp forest. October 1986, Linhof 4x5 camera, 75mm lens, Kodak Ektachrome Daylight E6 film, 81B warming filter used to warm up golden quality.

PAGES 18–19 Morning Fog, Great Sand Dunes National Park, Colorado. November 2000, Canon 35mm camera, 100–400mm lens, Fujichrome Provia 100F film.

PAGE 20 Frozan Niagara, Mammoth Cave National Park, Kentucky. Photo © by Marc Muench.

PAGE 21 Ice Sculpture, Mount St. Elias, Wrangell–St. Elias National Park and Preserve, Alaska. Ice sculpture melts down before 18,008-foot Mount St. Elias. August 1995, Linhof 4x5 camera, 210mm lens, Fujichrome Velvia film, no filtration.

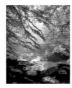

PAGE 22 Little Pigeon River, Great Smoky Mountains National Park, Tennessee/North Carolina. West Prong of the Little Pigeon River in the rain. June 1991, Linhof 4x5 camera, 75mm lens, Fujichrome Velvia film, no filtration.

PAGE 23 Blue Wall, Cattail Canyon, Big Bend National Park, Texas. The blue in the wall reflection is from reflected sky. May 2004, Linhof 4x5 camera, 75mm lens, Fujichrome Velvia film.

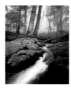

PAGE 24 Cascade in Hemlock Forest, Shenandoah National Park, Virginia. June 1995, Linhof 4x5 camera, 75mm lens, Fujichrome Velvia film.

PAGE 25 Lady Slipper Blooms, Shenandoah National Park, Virginia. April 1997, Linhof 4x5 camera, Fujichrome Velvia film.

PAGE 27 Canyon Reflections, National Canyon, Grand Canyon National Park, Arizona. July 2004, 35mm Canon camera, 28–135mm lens (approximately 35mm used).

PAGES 28-29 Pahoehoe Lava Flow, Kamoamoa, Hawai'i Volcanoes National Park, Hawai'i. April 2004, Canon 35mm camera, 28–135mm lens, Fujichrome Provia 100F film.

PAGE 29 Amau Fern and Ohia Lehua, Hawai'i Volcanoes National Park, Hawai'i. April 2004, Canon 35mm camera, 28–135mm lens, Fujichrome Provia 100F film.

PAGE 30, TOP Mauna Loa from Mauna Kea, Hawai'i Volcanoes National Park, Hawai'i. Ice cups from a recent snow lend contrasting forms to Mauna Kea's 13,796-foot elevation, with 13,677-foot Mauna Loa distant. March 1991, Linhof 4x5 camera, Kodak Ektachrome Daylight film, no filtration.

PAGE 30, BOTTOM Lava Explosion in Pacific Ocean, Hawai'i Volcanoes National Park, Hawai'i. Near Kamoamoa. Late 1970s, Leicaflex 35mm camera, 90mm lens, was hand-held and stabilized on my knees at exposures of $1/2$ and 1 second.

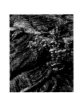

PAGE 31, BOTTOM (LEFT) Ohia Lehua on Pahoehoe Lava Flow, Holei Pali, Hawai'i Volcanoes National Park, Hawai'i. April 2004, 35mm Canon camera, 28–135mm lens, no filtration.

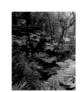

PAGE 31, TOP (RIGHT) Rain Forest at Thurston Lava Tube, Hawai'i Volcanoes National Park, Hawai'i. Ohia trees and large tree farms predominate in this tropical rain forest. April 1989, Linhof 4x5 camera, 75mm lens. Kodak Ektachrome Daylight film, no filtration.

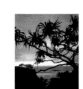

PAGE 32, TOP Sunrise at Oheo Gulch, Haleakala National Park, Maui, Hawai'i. Pandanus tree and Pacific Ocean. March 1995, Linhof 4x5 camera, 75mm lens, Fujichrome Velvia film.

PAGE 32, BOTTOM Fog in Haleakala Crater, Haleakala National Park, Maui, Hawai'i. Fog layer envelops cinder cones in Haleakala Wilderness, with Mauna Loa and Mauna Kea in distance. February 1976, Linhof 4x5 camera, 90mm lens, Kodak Ektachrome Daylight film, polarizing filter used.

PAGE 33 Silversword and Haleakala Sunrise, Haleakala National Park, Maui, Hawai'i. Silversword plant greets the sunrise over arriving fog layers from the rim. April 1985, Linhof 4x5 camera, Fujichrome Velvia film, no filtration.

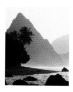

PAGE 34 Sunuitao Peak from the South Beach, early morning, Ofu Island, National Park of American Samoa, American Samoa. Photo © by QT Luong/terragalleria.com.

PAGE 35 Sunrise, Santa Cruz Island, Channel Islands National Park, California. Dawn mood comes to Smugglers Cove on Santa Cruz, with Anacapa Island in the distance. November 1986, Linhof 4x5 camera, Kodak Ektachrome Daylight film, CC10R filter used; a 5-second exposure gives a sense of time.

PAGE 36 Anacapa Island, Channel Islands National Park, California. Inspiration Point view is of Middle and West Anacapa. August 1974, Linhof 4x5 camera, 90mm lens, Kodak Ektachrome Daylight film.

PAGE 37, TOP Garibaldi, Channel Islands National Park, California. Photo © by Marc Muench.

PAGE 37, BOTTOM Sea Lions, Santa Barbara Island, Channel Islands National Park, California. Photo © by Marc Muench.

PAGE 38, TOP Del Norte Coastline, Del Norte Coast Redwoods State Park, within Redwoods National Park, California. Sea stars move about on rocks at low tide in False Klamath Cove under a canopy of summer fog. July 1992, Linhof 4x5 camera, 75mm lens, Fujichrome Velvia film.

PAGE 38, BOTTOM Rhododendron, Del Norte Coast Redwoods State Park, within Redwoods National Park, California. Coastal fog envelops redwood forest along Damnation Creek Trail. May 1985, Linhof 4x5 camera, 75mm lens, Fujichrome Velvia film.

PAGE 39, TOP Prairie Creek Redwoods, Prairie Creek Redwoods State Park, within Redwoods National Park, California. November 1986, Linhof 4x5 camera, 65mm wide-angle lens, Kodak Ektachrome Daylight film.

PAGE 39, BOTTOM Redwood Bole, Jedediah Redwoods State Park, within Redwood National Park, California. Trillium, sword fern, and oxalis decorate base of large redwood, along Howland Hill Road in Jedediah Redwoods State Park, California. May 2003, Linhof 4x5 camera, 75mm lens, Fujichrome Velvia film.

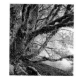

PAGES 40–41 Maple along Lake Crescent, Olympic National Park, Washington. Moss and ferns cling to bigleaf maple in a rain-forest motif. July 1991, Linhof 4x5 camera, 65mm wide-angle lens, Fujichrome Velvia film.

PAGE 41 Hoh Rain Forest, Olympic National Park, Washington. Moss and ferns cloak bigleaf maple and vine maple in the rain forest along the Hoh River, where rainfall may average 140 inches a year. July 1991, Linhof 4x5 camera, 75mm lens, Fujichrome Velvia film.

PAGES 42–43 Evening Coastline at Ozette, Olympic National Park, Washington. Ozette Island silhouettes at low tide near Ozette Indian Village on the Pacific coastline of Olympic National Park. August 1994, Linhof 4x5 camera, 65mm wide-angle lens, Fujichrome Velvia film, CC10M filter used to somewhat enhance reds and blues.

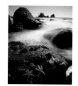

PAGE 44 Olympic Coastline at Third Beach, Olympic National Park, Washington. Sea stars cling to rocks at low tide, and offshore sea stacks suggest the ruggedness of this Pacific coastline. July 1998, Linhof 4x5 camera, 75mm lens, Fujichrome Velvia film.

PAGE 45 Lupine on Hurricane Ridge, and Mount Olympus in the Distance, Olympic National Park, Washington. Glaciers cling to 7965-foot Mount Olympus and nearby peaks beyond blue-lupine-covered Hurricane Ridge. July 1995, Linhof 4x5 camera, 300mm lens, Fujichrome Velvia film.

PAGE 46 Dwarf Fireweed and Lamplugh Glacier, Glacier Bay National Park and Preserve, Alaska. Dwarf fireweed announces the evolving landscape. Lamplugh Glacier is a tidewater reaching arm of the Brady Icefield, Johns Hopkins Inlet. August 1996, Linhof 4x5 camera, 75mm lens, Fujichrome Velvia film.

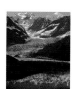

PAGE 47, TOP Margerie Glacier and Mount Fairweather, Glacier Bay National Park and Preserve, Alaska. 15,320-foot Fairweather looms directly above the sea. August 1996, Linhof 4x5 camera, Fujichrome Velvia film.

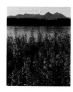

PAGE 47, BOTTOM Fireweed along Bartlett Cove, Glacier Bay National Park and Preserve, Alaska. A more pastoral shoreline of Glacier Bay greets you right in front of Glacier Bay Lodge and Visitor Center. August 1996, Linhof 4x5 camera, 75mm lens, Fujichrome Velvia film.

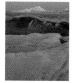

PAGES 48–49 Mount St. Elias above Bagley Icefield, Wrangell–St. Elias National Park and Preserve, Alaska. Layers of ice spread for 30 miles before reaching 18,008-foot Mount St. Elias. August 1996, Linhof 4x5 camera, 75mm lens, Fujichrome Velvia film.

PAGE 49, TOP Autumn, Mount Sanford, Wrangell–St. Elias National Park and Preserve, Alaska. The snow-clad 16,237-foot volcano pokes slowly out of the cloud layer, as seen through golden cottonwoods near Glennallen. September 1994, Linhof 4x5 camera, Fujichrome Velvia film, CC05R filter to slightly enhance warmer tones on trees.

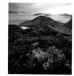

PAGE 49, BOTTOM Juniper Island and Bagley Icefield, Wrangell–St. Elias National Park and Preserve, Alaska. Isolated tundra plants begin turning color in August in this world of ice. August 1996, Linhof 4x5 camera, 75mm lens, Fujichrome Velvia film, CC05R filtration.

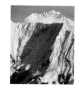

PAGES 50–51 Ice Wall, University Range, Wrangell–St. Elias National Park and Preserve, Alaska. This magnificent ice wall extends between Chitistone and Chitina Rivers. July 1998, Canon 35mm camera, 28–135mm lens, Fujichrome Provia 100F film.

PAGE 52 Exit Glacier and Fireweed, Kenai Fjords National Park, Alaska. Dwarf fireweed create a pastoral setting for this small arm coming down from the enormous Harding Icefield. July 1996, Linhof 4x5 camera, 75mm lens, Fujichrome Velvia film, CC05M filter used to pick up slightly on reds and blues.

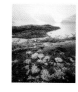

PAGE 53 Northwestern Glacier and Lagoon, Kenai Fjords National Park, Alaska. Evolutionary plants begin entering a world left by ice. The lagoon was made navigable by the 1964 earthquake. July 1996, Linhof 4x5 camera, 75mm lens, Fujichrome Velvia film.

PAGE 54, TOP Grizzly Sow Leading Four Cubs, Katmai National Park and Preserve, Alaska. Photo © by Gunther Matschke/AlaskaStock. 100SW#FV0010#001.

PAGE 54, BOTTOM Barrier Range and Volcanic Ash, Valley of the 10,000 Smokes, Katmai National Park and Preserve, Alaska. Photo © by Jim D. Barr/AlaskaStock. 399SW#EY006#001.

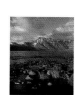

PAGE 55 Evening Light, Turquoise Lake, Chigmit Mountains, Lake Clark National Park and Preserve, Alaska. Photo © by Jim D. Barr/AlaskaStock. 400SW#EY0028#001.

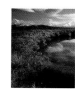

PAGES 56–57 Autumn Pond, Alaska Range, Denali National Park and Preserve, Alaska. Fresh snow on the peaks, pond willows turning gold, and warm sunshine made for a pleasant break from a week of rain. September 2003, Linhof 4x5 camera, 65mm lens, Fujichrome Velvia film.

PAGE 57 Autumn Tundra, Moose Creek, Denali National Park and Preserve, Alaska. September 2003, Linhof 4x5 camera, 210mm lens, Fujichrome Velvia film.

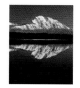

PAGES 58–59 Mount McKinley Reflections, Denali National Park and Preserve, Alaska. The 20,320-foot mountain doubles its majestic image in a reflecting pond. September 2003, Linhof 4x5 camera, 75mm lens, Fujichrome Velvia film, polarizing filter.

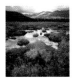

PAGE 60 September Reflections, Alaska Range, South, Denali National Park and Preserve, Alaska. Rich colors come to the tundra just for a few days in September. September 2003, Linhof 4x5 camera, 75mm lens, Fujichrome Velvia film, CC05R filtration to slightly enhance warmer colors.

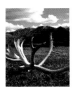

PAGE 61 Caribou Antlers, Alaska Range, Denali National Park and Preserve, Alaska. Natural display of antlers shed on the tundra seems quite fitting in the open spaces of the Alaska Range around Eielson Visitor Center. September 2003, Canon 35mm camera, 17–35mm lens, Fujichrome Provia 100F film.

PAGES 62–63 Taiga Forest Grasses in Autumn, Endicott Mountains, Gates of the Arctic National Park and Preserve, Alaska. Fragile meadows of grass mingle with spruce in this northernmost segment of the Rocky Mountains. September 2004, Canon 35mm camera, 17–35mm lens, Fujichrome Provia 100F film.

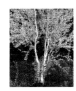

PAGE 63, TOP Birch Boles, Endicott Mountains, Gates of the Arctic National Park and Preserve, Alaska. September 2004, Canon 35mm camera, 28–135mm lens, Fujichrome Provia 100F film.

PAGE 63, BOTTOM Arctic Cotton, Gates of the Arctic National Park and Preserve, Alaska. September 2004, Canon 35mm camera, 28–135mm lens, Fujichrome Provia 100F film.

PAGE 64, TOP Fresh Snow, Brooks Range, Gates of the Arctic National Park and Preserve, Alaska. A North Slope storm clears briefly for glimpses of these northernmost peaks of the Rocky Mountains. September 2004, Canon 35mm camera, 100–400mm telephoto zoom lens, Fujichrome Provia 100F film.

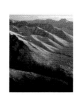

PAGE 64, BOTTOM Gates of the Arctic, Gates of the Arctic National Park and Preserve, Alaska. September 2004, Canon 35mm camera, 28–135mm lens, Fujichrome Provia 100F film.

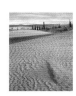

PAGE 65 Great Sand Dunes, Fall, Kobuk Valley National Park, Alaska. Photo © by Nick Jans/AlaskaStock. 400AR#DU0002#001.

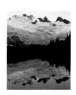

PAGES 66–67 Mount Challenger and Challenger Glacier, North Cascades National Park, Washington. 8207-foot Mount Challenger and peaks of the Picket Range hold a large but retreating glacier above Whatcom Pass in the North Unit of the park. August 2004, Linhof 4x5 camera, 300mm lens, Fujichrome Velvia film.

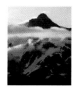

PAGE 67 Mount Shuksan from Kulshan Ridge, North Cascades National Park, Washington. Moving fog drapes the 9131-foot peak, which is visibly prominent from Artist Point and Heather Meadows in Mount Baker National Forest. August 2000, Linhof 4x5 camera, 500mm lens, Fujichrome Velvia film.

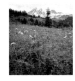

PAGE 68 Mount Rainier from Paradise Valley, Mount Rainier National Park, Washington. Lupine, paintbrush, Gray's lovage, and other blooms fill an alpine meadow below Mount Rainier at Paradise. July 1995, Linhof 4x5 camera, 75mm lens, Fujichrome Velvia film.

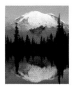

PAGE 69 Mount Rainier from Chinook Pass, Mount Rainier National Park, Washington. The 14,410-foot volcano reflects its ice-clad summit in a small pond next to Tipsoo Lake. July 2002, Linhof 4x5 camera, 210mm lens, Fujichrome Velvia film.

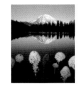

PAGES 70–71 Beargrass and Mount Rainier, Eunice Lake, Mount Rainier National Park, Washington. Beargrass spikes offer a certain majesty to this stunning view of Mount Rainier from the northwest corner of the park. July 1995, Linhof 4x5 camera, 65mm lens, Fujichrome Velvia film.

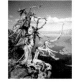

PAGES 72–73 Whitebark Ghost and Wizard Island, Crater Lake National Park, Oregon. Whitebark pine finally gives up, surviving well for many years at rim's edge 2000 feet above intense azure blue waters of Crater Lake. Wizard Island cone was formed by the last eruptions of ancient Mount Mazama. August 1994, Linhof 4x5 camera, 75mm lens, Fujichrome Velvia film.

PAGE 74 Cinder Cone Silhouette, Lassen Volcanic National Park, California. Sun and cinder cone create a stark lunar landscape in the northeast corner of the park. July 1985, Linhof 4x5 camera, 300mm lens, Kodak Ektachrome Daylight film.

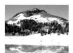

PAGE 75 Snowmelt, Lake Helen, Lassen Peak, Lassen Volcanic National Park, California. Blues are reflected after other colors in the spectrum are absorbed in the underwater ice. June 1992, Linhof 4x5 camera, 90mm lens, Fujichrome Velvia film.

PAGES 76–77 Sierra Juniper and Half Dome, Yosemite National Park, California. A juniper is battered yet surviving well in the solid granite of North Dome. Shadows partially obscure Half Dome across Yosemite Valley. August 1998, Linhof 4x5 camera, 210mm lens, Fujichrome Velvia film.

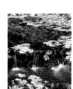

PAGE 77 Autumn Pond, Yosemite Valley, Yosemite National Park, California. A quiet reflective moment can be found around this spring-fed pool, only a short walk from the roadway and the Merced River. November 1995, Linhof 4x5 camera, 300mm lens, Fujichrome Velvia film.

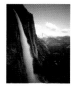

PAGE 78 Yosemite Falls and Half Dome, Yosemite National Park, California. The unique wildness of Yosemite includes the icons Upper Yosemite Falls and Half Dome. This view is from partway up the Yosemite Falls Trail. June 1998, Linhof 4x5 camera, 75mm lens, Fujichrome Velvia film.

PAGE 79 Garden on Granite Wall, Snow Creek Canyon, Yosemite National Park, California. Moss and flowers cling to terraced granite along Upper Snow Creek. June 2004, Linhof 4x5 camera, 300mm lens, Fujichrome Velvia film.

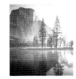

PAGE 80 Merced River Reflections and El Capitan, Yosemite National Park, California. A thin veil of mist sets a quiet mood at dawn along the Merced River. May 2001, Linhof 4x5 camera, 65mm lens, Fujichrome Velvia film, CC10R filter used to warm highlights slightly.

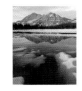

PAGE 81 Snowmelt and Young Lakes, Mount Conness, Yosemite National Park, California. 12,590-foot Mount Conness predominates the skyline along the Yosemite crest. June 1995, Linhof 4x5 camera, 210mm lens, Fujichrome Velvia film.

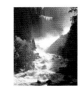

PAGE 82 Vernal Falls, Merced River, Yosemite National Park, California. Drama abounds in this backlit morning display of water and light on the Merced River. May 1976, Linhof 4x5 camera, 90mm lens, Kodak Ektachrome Daylight film.

PAGE 83 Mount Lyell and Dwarf Lupine, Yosemite National Park, California. The highest peak in Yosemite, at 13,114 feet, Mount Lyell holds one of very few glaciers left in the Sierras. Canon 35mm camera, 17–35mm lens, Fujichrome Provia 100F film.

PAGES 84–85 Parker Group Sequoias, Sequoia National Park, California. Giants soar skyward, representing the world's largest living plant. May 1998, Linhof 4x5 camera, 65mm lens, Fujichrome Velvia film, CC10R red filter used to retain warmth of trunk color.

PAGE 85 Arch in Granite, Mount Whitney and Lone Pine Peak, Sequoia National Park and John Muir Wilderness, California. Granite expression of this arch form is made more magical with early dawn light and a fresh heavy snow on the Sierra Nevada's east side. February 1992, Linhof 4x5 camera, 75mm lens, Fujichrome Velvia film, CC10 magenta filter used.

PAGES 86–87 Granite Silhouettes and Mount Whitney, Sequoia National Park, California, and John Muir Wilderness in front. Dawn light bathes 14,494-foot Mount Whitney, the highest peak in the contiguous United States. Granite boulders in the shade are in the Alabama Hills. March 1997, Linhof 4x5 camera, 500mm lens, Fujichrome Velvia film, CC05 red filter used.

PAGE 88 General Sherman Tree, Giant Forest, Sequoia National Park, California. The world's largest living tree, this sequoia, *Sequoiadendron giganteum*, reigns over the snow-clad Sierra Nevada forest. January 1968, Linhof 4x5 camera, 90mm lens, Kodak Ektachrome Daylight film.

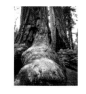

PAGE 89 Bulbous Base, Giant Sequoias, Sequoia National Park, California. Large base growth helps stabilize these magnificent giant sequoias. June 1996, Linhof 4x5 camera, 75mm lens, Fujichrome Velvia film, CC05 red filter used.

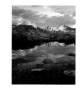

PAGES 90–91 Mount Clarence King, Sixty Lakes Basin, Kings Canyon National Park, California. Morning quiet reflects Sierra Nevada peaks in the Rae Lakes area. August 1975, Linhof 4x5 camera, 90mm lens, Kodak Ektachrome Daylight film.

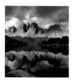

PAGE 91 Kearsarge Peaks Reflection, Kings Canyon National Park, California. This particular morning brought a brief passing storm, making for interesting patterns of light and shade. July 2003, Canon 35mm camera, 17–35mm lens, Fujichrome Proviá 100F film.

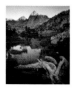

PAGE 92 Painted Lady above Rae Lakes, Kings Canyon National Park, California. Evening quiet settles over Rae Lakes on the crest of the Sierra Nevada. Delicate magenta shooting stars are sheltered by a driftwood log. July 2004, Linhof 4x5 camera, 75mm lens, Fujichrome Velvia film, 1-stop magenta split-density filter used to bring peak tops into balance.

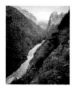

PAGE 93 South Fork, Kings River, Kings Canyon National Park, California. May 1984, Linhof 4x5 camera, 75mm lens, Kodak Ektachrome Daylight film.

PAGE 94, TOP Palisade Crest from Mount Sill, Kings Canyon National Park, California. North Palisade, Thunderbolt Peak, Mount Winchell, and Mount Agassiz line up to the northwest above Palisade Glacier, in a view from the top of Mount Sill (14,153 feet). August 1984, Leicaflex 35mm camera, approximately 20mm lens, Kodak Ektachrome film.

PAGE 94, BOTTOM Whitebark Pine, East Creek, Kings Canyon National Park, California. August 1994, Linhof 4x5 camera, 75mm lens, Fujichrome Velvia film.

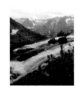

PAGE 95 Dusy Branch and LeConte Canyon, Kings Canyon National Park, California. Dusy Branch of the Middle Fork, Kings River, bounds along into LeConte Canyon below; paintbrush are close. August 1994, Canon 35mm camera, 28–135mm lens, Fujichrome Provia 100F film.

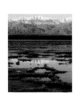

PAGE 96 Telescope Peak Reflections, Badwater, Death Valley National Park, California. Telescope Peak, at 11,049 feet, plunges 11,049 feet directly down to sea level, and even extends an additional 282 feet below sea level at Badwater. February 2003, Linhof 4x5 camera, 300mm lens, Fujichrome Velvia film.

PAGE 97, TOP Artist's Palette, Amargosa Range, Death Valley National Park, California. A volcanic mix is on display, in this remarkable landscape. April 1994, Linhof 4x5 camera, 500mm lens, Fujichrome Velvia film.

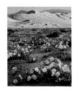

PAGE 97, BOTTOM Spring Floral, Eureka Dunes, Death Valley National Park, California. A plethora of desert wildflowers contrasts with stark Eureka Dunes. April 1997, Linhof 4x5 camera, 300mm lens, Fujichrome Velvia film.

PAGES 98–99 Sand Dunes, Mesquite Flat, Death Valley National Park, California. A mix of desert plants space themselves with a will to survive in a harsh desert environment. May 2004, Linhof 4x5 camera, 300mm lens, Fujichrome Velvia film.

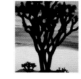

PAGE 100 Evening, Joshua Trees, Joshua Tree National Park, California. A Joshua tree forest is silhouetted at sunset in the Hidden Valley area. February 1978, Linhof 4x5 camera, 500mm lens, Kodak Ektachrome Daylight film.

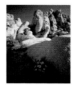

PAGE 101, TOP Mojave Mound Cactus, Jumbo Rocks Area, Joshua Tree National Park, California. Monolithic granite formations hold various life systems, including a Mojave mound cactus in full bloom. April 1994, Linhof 4x5 camera, 75mm lens, Fujichrome Velvia film.

PAGE 101, BOTTOM Lost Palms Oasis, Joshua Tree National Park, California. Barrel cacti, cholla, and ocotillo colonies surround native California fan palm oasis in the Eagle Mountains. March 1988, Linhof 4x5 camera, 75mm lens, Kodak Ektachrome Daylight film.

PAGE 102, TOP (LEFT) Petroglyphs, Signal Hill, Saguaro National Park (West), Arizona. Circular motifs and bighorn sheep on rock were probably made by Hohokam Tradition people in prehistoric times. April 1985, Linhof 4x5 camera, 90mm lens, Kodak Ektachrome Daylight film.

PAGE 102, TOP (RIGHT) Crown of Barrel Cactus Blooms, Saguaro National Park (East), Arizona. A mature saguaro cactus stands prominently between blossom crown and distant Santa Catalina Mountains. July 1998, Linhof 4x5 camera, 75mm lens, Fujichrome Velvia film.

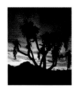

PAGE 102, BOTTOM Cholla Silhouette and Sunrise, Saguaro National Park (West Unit), Arizona. A chain fruit cholla cactus marks a bold form against a desert sunrise in the Tucson Mountains. April 1995, Linhof 4x5 camera, 75mm lens, Fujichrome Velvia film.

PAGE 103 Saguaro, *Carnegiea gigantea*, with Blossoms, Saguaro National Park, Arizona. Monarch of the Sonoran Desert, its blooms bold and numerous, the saguaro lays host to many forms of desert life. June 1984, Linhof 4x5 camera, 75mm lens, Kodak Ektachrome Daylight film.

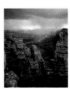

PAGES 104–5 Grand Canyon Storm, South Rim, Grand Canyon National Park, Arizona. A somber mood settles over limestone and sandstone rims. The Colorado River begins its journey in Grand Canyon proper under a canopy of snow showers. February 1996, Linhof 4x5 camera, 75mm lens, Fujichrome Velvia film.

PAGE 105, TOP Sandbar Cobbles and Primrose, Colorado River, Grand Canyon National Park, Arizona. Delicate primrose blooms mingle with sandbar creations, a mix of rocks from different layers of rock farther upstream. June 2004, Canon 35mm camera, 28–135mm lens, Fujichrome Provia 100F film.

PAGE 106, TOP Middle Granite Gorge, Colorado River, Grand Canyon National Park, Arizona. Metamorphosed rock, known as gneiss, Vishnu schist, and Zoroaster granite, displays itself prominently in an area called the Doll House. June 2004, Canon 35mm camera, 16–35mm lens, Fujichrome Velvia 100F film.

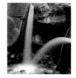

PAGE 106, BOTTOM Cascade in Lower Shinumo Creek, Grand Canyon National Park, Arizona. Surprising and refreshing, this small multiple cascade offers a pause of beauty on river trips. June 2004, Canon 35mm camera, Fujichrome Velvia 100F film.

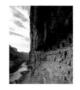

PAGE 107 Ancient Puebloan Dwellings, Nankoweap, Grand Canyon National Park, Arizona. June 2004. Colorado River heads southwest into Grand Canyon at Nankoweap Canyon. June 2004, Canon 35mm camera, 16–35mm lens, Fujichrome Velvia 100F film.

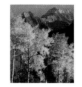

PAGE 108 Aspens, Brahma, and Zoroaster Temples, North Rim, Grand Canyon National Park, Arizona. Autumn gold graces Uncle Tom's Point on the North Rim. October 1991, Linhof 4x5 camera, 300mm lens, Fujichrome Velvia film.

PAGE 109 Winterscape, Mather Point, Grand Canyon National Park, Arizona. February 1995, Linhof 4x5 camera, 75mm lens, Fujichrome Velvia film.

PAGE 110 Limestone Rim, above Marble Canyon, Grand Canyon National Park, Arizona. Rough and well-weathered Kaibab limestone forms the edge of the rim above President Harding Rapids on the Colorado River. March 1994, Linhof 4x5 camera, 75mm lens, Fujichrome Velvia film.

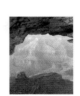

PAGE 111 Limestone Window, South Rim, Grand Canyon National Park, Arizona. Kaibab limestone opening frames temples and buttes on the South Rim. March 1978, Linhof 4x5 camera, 210mm lens, Kodak Ektachrome Daylight film.

PAGE 112 Pedestal Logs, Blue Mesa, Petrified Forest National Park, Arizona. Pedestal logs like these are currently eroding in a continuing process. Fortunately the logs in this photograph are somewhat intact. May 1991, Linhof 4x5 camera, 75mm lens, Fujichrome Velvia film.

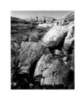

PAGE 113, TOP (LEFT) Petrified Log Bridge, Petrified Forest National Park, Arizona. John Muir called this area the "Blue Forest." May 1991, Linhof 4x5 camera, 75mm lens, Fujichrome Velvia film.

PAGE 113, BOTTOM (LEFT) Log Fragments, Rainbow Forest, Petrified Forest National Park, Arizona. May 1991, Linhof 4x5 camera, 75mm lens, Fujichrome Velvia film.

PAGE 113, MIDDLE (RIGHT) Ancient Petroglyphs, Petrified Forest National Park, Arizona. Newspaper Rock area. May 1989, Linhof 4x5 camera, 210mm lens, Fujichrome Velvia film.

PAGES 114–15 West Temple and Towers of the Virgin, Zion National Park, Utah. Dawn light captures prominent west wall of Zion Canyon. October 2004, Canon 35mm camera, 16–35mm lens, Fujichrome Velvia 100F film.

PAGE 115 Keyhole, Subway Pools, Zion National Park, Utah. The Narrows on the Left Fork, North Creek. May 1994, Linhof 4x5 camera, 75mm lens, Fujichrome Velvia film.

PAGE 116 Autumn, Temple of Sinawava, Zion National Park, Utah. The Pulpit and cottonwoods reflect in the Virgin River. November 1976, Linhof 4x5 camera, 90mm lens, Kodak Ektachrome Daylight film.

PAGE 117 The Watchman and the Virgin River, Autumn, Zion National Park, Utah. November 2004, Canon 35mm camera, 16–35mm lens, Fujichrome Velvia film.

PAGE 118 Bryce Amphitheater, Bryce Canyon National Park, Utah. Pinnacles and spires of erosion, called hoodoos, form pink cliffs of the Claron Formation, in this view north from Bryce Point. May 1986, Linhof 4x5 camera, 300mm lens, Kodak Ektachrome Daylight film.

PAGE 119, TOP Winter's Bridges, Wall Street, Bryce Canyon National Park, Utah. This view is one along a quiet walk on Navajo Loop Trail. February 1985, Linhof 4x5 camera, 210mm lens, Kodak Ektachrome Daylight film.

PAGE 119, BOTTOM Fairyland Formations, Bryce Canyon National Park, Utah. October 1995, Linhof 4x5 camera, 500mm lens, Fujichrome Velvia film.

PAGE 120, TOP (LEFT) Paintbrush and Driftwood on Clay, Capitol Reef National Park, Utah. Detail on Morrison Formation clay. April 1995, Linhof 4x5 camera, 210mm lens, Fujichrome Velvia film.

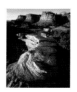

PAGE 120, TOP (RIGHT) Land of Sleeping Rainbow, Capitol Reef National Park, Utah. Tilted rim formations are along Waterpocket Fold. April 1995, Linhof 4x5 camera, 75mm lens, Fujichrome Velvia film.

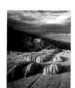

PAGE 120, BOTTOM Strike Valley Overlook, Capitol Reef National Park, Utah. Tilted forms of Waterpocket Fold give a strange look to the landscape, in a view across Strike Valley to Tarantula Mesa. April 1995, Linhof 4x5 camera, 65mm lens, Fujichrome Velvia film, polarizing filter used to enhance drama.

PAGE 121, TOP (LEFT) Cathedral Valley Formations, Capitol Reef National Park, Utah. Temple of the Moon and Temple of the Sun are the prominent formations in this most northern part of the park. October 1996, Linhof 4x5 camera, 75mm lens, Fujichrome Velvia film.

PAGE 121, TOP (RIGHT) Claret Cup Cactus, Capitol Reef National Park, Utah. May 1986, Linhof 4x5 camera, 210mm lens, Fujichrome Velvia film.

PAGE 121, BOTTOM Hickman Bridge, Capitol Reef National Park, Utah. This eroded sandstone span is in the Waterpocket Fold. March 1994, Linhof 4x5 camera, 65mm lens, Fujichrome Velvia film.

PAGE 122, TOP Colorado River and White Rim, Canyonlands National Park, Utah. Sandstone Dome is a White Rim feature above the Colorado River in the Little Bridge Canyon area. March 1997, Linhof 4x5 camera, 75mm lens, Fujichrome Velvia film.

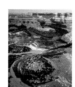

PAGE 122, BOTTOM Angel Arch and Molar Rock, Salt Creek, Canyonlands National Park, Utah. Prominent land forms are in the banded red and white Cedar Mesa Formation of the Needles District. May 1992, Linhof 4x5 camera, 75mm lens, Fujichrome Velvia film, polarizing filter used.

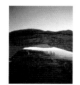

PAGE 123 Iced Rims, Dead Horse Point, Canyonlands National Park, Utah. Gooseneck of the Colorado River is below the foreground rim, Dead Horse Point State Park. January 1985, Linhof 4x5 camera, 90mm lens, Kodak Ektachrome Daylight film.

PAGES 124–25 Dawn, Mesa Arch, Canyonlands National Park, Utah. Light bouncing from the wall below creates a magnificent glow underneath the span. Washerwoman Arch embraces the silhouette of the distant La Sal Mountains. February 1975, Linhof 4x5 camera, 65mm lens, Kodak Ektachrome Daylight film.

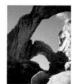

PAGES 126–27 Delicate Arch and Amphitheater, Arches National Park, Utah. April 1998, Linhof 4x5 camera, 75mm lens, Fujichrome Velvia film.

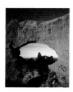

PAGE 127, TOP Double Arch, Arches National Park, Utah. April 1998, Linhof 4x5 camera, 75mm lens, Fujichrome Velvia film.

PAGE 127, BOTTOM Turret Arch through North Window, Arches National Park, Utah. These spans are in the Entrada Formation, the Windows Section. March 1995, Linhof 4x5 camera, 65mm lens, Fujichrome Velvia film.

PAGE 128 Ancestral Puebloan Cliff Palace, Mesa Verde National Park, Colorado. People once called the Anasazi, now called Ancestral Puebloan, lived in these structures. Chapin Mesa. July 1985, Linhof 4x5 camera. 75mm lens, Kodak Ektachrome Daylight film.

PAGE 129, TOP (LEFT) Spruce Tree House, North Walls, Mesa Verde National Park, Colorado. April 2005, Canon 35mm camera, 17–35mm lens, Fujichrome Velvia 100F film.

PAGE 129, MIDDLE (LEFT) Spruce Tree House, Mesa Verde National Park, Colorado. Kiva and central structures. April 2005, Canon 35mm camera, 17–35mm lens, Fujichrome Velvia film.

PAGE 129, BOTTOM (LEFT) Balcony House, Mesa Verde National Park, Colorado. Overlook view from across the canyon, Chapin Mesa. April 2005, Canon 35mm camera, 100–400mm 200mm lens, Fujichrome Velvia film.

PAGE 129, RIGHT Mug House, Mesa Verde National Park, Colorado. Wetherill Mesa. July 1975, Linhof 4x5 camera, 75mm lens, Kodak Ektachrome film.

PAGE 130 The Narrows from the North Rim, Black Canyon of the Gunnison National Park, Colorado. September 1985, Linhof 4x5 camera, 300mm lens, Kodak Ektachrome Daylight film.

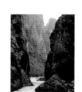

PAGE 131 Black Canyon of the Gunnison River, Black Canyon of the Gunnison National Park, Colorado. September 1985, Linhof 4x5 camera, 90mm lens, Kodak Ektachrome Daylight film.

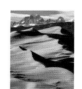

PAGES 132–33 Dune Field and Crestone Peaks, Great Sand Dunes National Park and Preserve, Colorado. Sands blown across San Luis Valley accumulate before the Sangre de Cristo Mountains. October 2004, Canon 35mm camera, 100–400mm lens, Fujichrome Velvia 100F film.

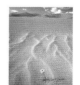

PAGE 133 Sunflower on Sand Sheet, Great Sand Dunes National Park and Preserve, Colorado. June 1985, Linhof 4x5 camera, 75mm lens, Kodak Ektachrome Daylight film.

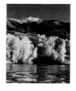

PAGE 134 Medano Creek in Autumn, Great Sand Dunes National Park and Preserve, Colorado. October 1968, Linhof 4x5 camera, 300mm lens, Kodak Ektachrome Daylight film.

PAGE 135 Deer Browse the Flat below Great Sand Dunes, Great Sand Dunes National Park and Preserve, Colorado. Sangre de Cristo Mountains. October 2004, Canon 35mm camera, 28–135mm lens, Fujichrome Velvia 100F film.

PAGES 136–37 Bristlecone Embrace, Mount Washington, Great Basin National Park, Nevada. An ancient bristlecone pine survives well and is a magnificent plant in a harsh environment. August 1989, Linhof 4x5 camera, 75mm lens, Kodak Ektachrome Daylight film.

PAGE 137 Parachute Formation, Lehman Caves, Great Basin National Park, Nevada. June 1980, Linhof 4x5 camera, 90mm lens, Kodak Ektachrome Daylight film.

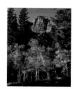

PAGE 138 Wheeler Peak in Autumn, Great Basin National Park, Nevada. Wheeler Peak is a 13,063-foot peak, a high point in the Basin and Range complex of Nevada. Aspen trees lend their golden fall leaves to the forest-mountain landscape. October 2004, Linhof 4x5 camera, 500mm lens, Fujichrome Velvia 100F film.

PAGE 139 Ancient Bristlecone Pine and Wheeler Peak, Great Basin National Park, Nevada. October 2004, Canon 35mm camera, 17–35mm lens, Fujichrome Velvia 100F film.

PAGES 140–41 Moonrise at Old Faithful Geyser, Yellowstone National Park, Wyoming. February 2004, Canon 35mm camera, 28–135mm lens, Fujichrome Velvia 100F film.

PAGE 141 Iced Pines, Lower Geyser Basin, Yellowstone National Park, Wyoming. February 1998, Canon 35mm camera, 28–135mm lens, Fujichrome Provia 100F film.

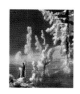

PAGE 142, TOP Emerald Pool, Yellowstone National Park, Wyoming. July 2004, Canon 35mm camera, 17–35mm lens, Fujichrome Velvia 100F film.

PAGE 142, BOTTOM Grand Prismatic Spring, Yellowstone National Park, Wyoming. Lower Geyser Basin. July 2004, Canon 35mm camera, Fujichrome Velvia 100F film.

PAGE 143 Along Grand Prismatic Spring, Yellowstone National Park, Wyoming. Lower Geyser Basin. July 2004, Canon 35mm camera, 28–135mm lens, Fujichrome Velvia 100F film.

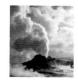

PAGE 144 Castle Geyser, Yellowstone National Park, Wyoming. Upper Geyser Basin. February 2004, Canon 35mm camera, 28–135 lens, Fujichrome Velvia 100F film.

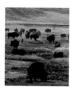

PAGE 145 Buffalo along Yellowstone River, Yellowstone National Park, Wyoming. Hayden Valley. June 2004, Canon 35mm camera, 100–400mm lens, Fujichrome Velvia 100F film.

PAGES 146–47 Buffalo in Hot Springs Flow, Yellowstone National Park, Wyoming. Grand Prismatic overflow. February 2004, Canon 35mm camera, 28–135mm lens, Fujichrome Velvia 100F film.

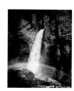

PAGE 149 Rainbow on Tower Fall, Yellowstone National Park, Wyoming. June 1975, Linhof 4x5 camera, 90mm lens, Kodak Ektachrome Daylight film.

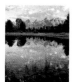

PAGES 150–51 Dawn Reflections, Grand Tetons, Grand Teton National Park, Wyoming. Beaver pond reflections at Schwabacher's Landing. July 1976, Linhof 4x5 camera, 90mm lens, Kodak Ektachrome Daylight film.

PAGE 151 Plethora of Summer Flowers, and Teton Range, Grand Teton National Park, Wyoming. July 2004, Canon 35mm camera, 28–135mm lens, Fujichrome Velvia 100F film.

PAGE 152 Mormon Row, Teton Range, Grand Teton National Park, Wyoming. Historic barns lend a romantic note to the western scene of Jackson Hole. July 1991, Linhof 4x5 camera, 300mm lens, Fujichrome Velvia film.

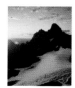

PAGE 153 Sunrise on the Grand Tetons, from Table Mountain, Grand Teton National Park, Wyoming. July 1983, Linhof 4x5 camera, 90mm lens, Kodak Ektachrome Daylight film.

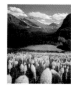

PAGES 154–55 Beargrass, Grinnell Lake, Glacier National Park, Montana. Many such enticing views are available along Grinnell Glacier Trail from Many Glacier. July 1992, Linhof 4x5 camera, 75mm lens, Fujichrome Velvia film.

PAGE 155 Cobble Mosaic, Hidden Lake, Glacier National Park, Montana. Hidden Creek shallow stream flows over stones representing many layers of tilted strata. July 2003, Canon 35mm camera, 28–135mm lens, Fujichrome Velvia 100F film.

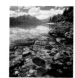

PAGE 156 Cobble Mosaic, Lake McDonald, Glacier National Park, Montana. Receding glaciers have left stones representing the many rock layers above. July 1985, Linhof 4x5 camera, 90mm lens, Kodak Ektachrome Daylight film.

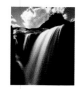

PAGE 157 Gathering of the Waters, Glacier National Park, Montana. Clements Mountain, as seen above the gardens of Logan Pass. July 1995, Linhof 4x5 camera, 75mm lens, Kodak Ektachrome Daylight film.

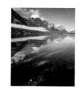

PAGE 158 Cobble Mosaic, St. Mary Lake, Glacier National Park, Montana. Various cobblestones decorate beds of rock in clear waters of St. Mary Lake. Morning reflections after a storm. August 1997, Linhof 4x5 camera, 75mm lens, Fujichrome Velvia film.

PAGE 159 Sperry Glacier, Glacier National Park, Montana. Now receding, Sperry Glacier is the park's largest body of ice. August 2004, Canon 35mm camera, 16–35mm lens, Fujichrome Provia 100F film.

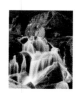

PAGE 160 Cascade on Chasm Creek, Longs Peak, Rocky Mountain National Park, Colorado. Longs Peak, at 14,255 feet, looms above the flow of waters from Chasm Lake. July 1969, Linhof 4x5 camera, 300mm lens, Kodak Ektachrome Daylight film.

PAGE 161, TOP Rydbergia along Trail Ridge Road, Rocky Mountain National Park, Colorado. July 1985, Linhof 4x5 camera, 360mm lens, Kodak Ektachrome Daylight film.

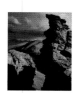

PAGE 161, BOTTOM Longs Peak and Storm, Rocky Mountain National Park, Colorado. Rock formations at the highest point on Trail Ridge Road, 12,183 feet, and Longs Peak under heavy canopy of clouds. August 1974, Linhof 4x5 camera, 90mm lens, Kodak Ektachrome Daylight film.

PAGES 162–63 Sprague Lake, Dawn, Rocky Mountain National Park, Colorado. Morning fog floats across reflection of peaks along the Continental Divide. July 1992, Linhof 4x5 camera, 75mm lens, Fujichrome Velvia film, CC10M magenta filter.

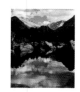

PAGE 163, TOP Bear Lake Reflections, Rocky Mountain National Park, Colorado. July 1992, Linhof 4x5 camera, 210mm lens, Fujichrome Velvia film.

PAGE 163, BOTTOM Winter's Coating along Glacier Creek, Rocky Mountain National Park, Colorado. May 1995, Linhof 4x5 camera, 210mm lens, Fujichrome Velvia film.

PAGE 164 Spring Floral, Guadalupe Mountains, Guadalupe Mountains National Park, Texas. Rainbow cactus and prickly pear bloom in Chihauhaun Desert below El Capitan and Guadalupe Peak. May 1998, Linhof 4x5 camera, 75mm lens, Fujichrome Velvia film.

PAGE 165, TOP Yucca and El Capitan from Guadalupe Peak, Guadalupe Mountains National Park, Texas. June 1986, Linhof 4x5 camera, Kodak Ektachrome Daylight film.

PAGE 165, BOTTOM Guadalupe Mountains and Boulder Field, Guadalupe Mountains National Park, Texas. April 1982, Linhof 4x5 camera, 75mm lens, Fujichrome Velvia film.

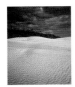

PAGES 166–67 Gypsum Sand Dunes and Guadalupe Mountains, Guadalupe Mountains National Park, Texas. February 1976, Linhof 4x5 camera, 90mm lens, Kodak Ektachrome Daylight film.

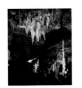

PAGES 168–69 Totem Pole, Hall of Giants, Carlsbad Caverns National Park, New Mexico. April 2004, Linhof 4x5 camera, 210mm lens, Fujichrome Provia 100F film, no filtration.

PAGE 169 Hall of Giants, Carlsbad Caverns National Park, New Mexico. In the Big Room. April 2004, Linhof 4x5 camera, 75mm lens, Fujichrome Provia 100F film.

PAGE 170 Caveman Junction, Carlsbad Caverns National Park, New Mexico. In the Hall of Giants. April 2004, Linhof 4x5 camera, 75mm lens, Fujichrome Provia 100F film.

PAGE 171 Temple of the Sun, Carlsbad Caverns National Park, New Mexico. In the Hall of Giants, Big Room. April 2004, Linhof 4x5 camera, 75mm lens, Fujichrome Provia 100F film.

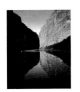

PAGES 172–73 Rio Grande Reflections, Santa Elena Canyon, Big Bend National Park, Texas. April 1004, Linhof 4x5 camera, 65mm lens, Fujichrome Velvia film.

PAGE 173 Buffalo Pictograph, Big Bend National Park, Texas. Left by ancient people, the image suggests that buffalo roamed in this country when the climate was more moist. April 2004, Canon 35mm camera, 28–135mm lens, Fujichrome Velvia 100F film.

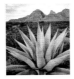

PAGE 174 Century Plant and Chisos Mountains, Big Bend National Park, Texas. April 2004, Linhof 4x5 camera, 75mm lens, Fujichrome Velvia 100F film.

PAGE 175 Hedgehog Mound Cactus, Boquillas Canyon, Big Bend National Park, Texas. Pitaya cactus and ocotillo bloom with bright reds. April 2004, Linhof 4x5 camera, 75mm lens, Fujichrome Velvia 100F film.

PAGE 176 Frosted Desert, Chisos Mountains, Big Bend National Park, Texas. March 1989, Canon 35mm camera, 20mm lens, Kodak Ektachrome Daylight film.

PAGE 177 Rainbow Cactus, Big Bend National Park, Texas. April 2004, Canon 35mm camera, 28–135mm lens, Fujichrome Provia 100F film.

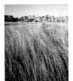

PAGES 178–79 Grasslands, Badlands North Unit, Badlands National Park, South Dakota. August 1988, Linhof 4x5 camera, 75mm lens, Kodak Ektachrome Daylight film.

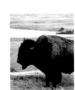

PAGE 179 Buffalo, Badlands Wilderness Area, Badlands National Park, South Dakota. August 2004, Canon 35mm camera, 100–400mm lens, Fujichrome Provia 100F film.

PAGE 180 Badlands Formations, Cedar Pass, Badlands National Park, South Dakota. August 1988, Linhof 4x5 camera, 210mm lens, Kodak Ektachrome Daylight film.

PAGE 181 Prairie Edge, Badlands North Unit, Badlands National Park, South Dakota. August 1988, Linhof 4x5 camera, 75mm lens, Ektachrome Daylight film.

PAGE 182 Boxwork Formation, Wind Cave National Park, South Dakota. A prominent Wind Cave feature, boxwork is a thin, honeycomb structure of calcite protruding from walls and ceiling. July 1984, Linhof 4x5 camera, 90mm lens, Kodak Ektachrome Daylight film.

PAGE 183, TOP Pronghorn Buck, Prairie Lands, Wind Cave National Park, South Dakota. I was privileged to spend 10 minutes with the pronghorn, and he was not more than 50 feet away. July 2004, Canon 35mm camera, 28–135mm lens, Fujichrome Velvia 100F film.

PAGE 183, BOTTOM Gentian Detail in Prairie Grasslands, Wind Cave National Park, South Dakota. July 2004, Canon 35mm camera, 28–135mm lens, Fujichrome Velvia 100F film.

PAGE 184, TOP (LEFT) Elk, Theodore Roosevelt National Park, North Dakota. Photo © by Marc Muench.

PAGE 184, BOTTOM (LEFT) Badlands Formations, Theodore Roosevelt National Park, North Dakota. July 1986, Linhof 4x5 camera, 90mm lens, Kodak Ektachrome Daylight film.

PAGES 184–85 Badlands at Sunrise, Theodore Roosevelt National Park, North Dakota. Photo © by Marc Muench.

PAGE 186 Moss-Covered Granite Dome, Voyageurs National Park, Minnesota. Ash River Trail in autumn. October 1995, Linhof 4x5 camera, Fujichrome Velvia film.

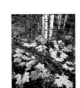

PAGE 187 Autumn Sunset, Kabetogama Lake, Voyageurs National Park, Minnesota. October 1976, Linhof 4x5 camera, 90mm lens, Kodak Ektachrome Daylight film.

PAGES 188–89 Autumn, Birch Forest, Isle Royale National Park, Michigan. October 1981, Linhof 4x5 camera, 75mm lens, Kodak Ektachrome Daylight film.

PAGE 189 Summer Greens, Chickenbone Lake, Isle Royale National Park, Michigan. June 1981, Linhof 4x5 camera, 210mm lens, Kodak Ektachrome Daylight film.

PAGE 190 Lady Slippers, Greenstone Ridge, Isle Royale National Park, Michigan. June 1981, Linhof 4x5 camera, 210mm lens, Kodak Ektachrome Daylight film.

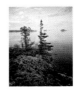

PAGE 191 Quiet Evening, Rock Harbor, Isle Royale National Park, Michigan. June 1981, Linhof 4x5 camera, 90mm lens, Kodak Ektachrome Daylight film.

PAGE 192, TOP Autumn Pond, Sunrise, Cuyahoga River, Cuyahoga Valley National Park, Ohio. June 1988, Linhof 4x5 camera, 75mm lens, Kodak Ektachrome Daylight film.

PAGE 192, BOTTOM Tinker Creek Gorge, Cuyahoga Valley National Park, Ohio. June 1988, Linhof 4x5 camera, 75mm lens, Kodak Ektachrome Daylight film.

PAGE 193 Beaver Marsh along Cuyahoga River, Cuyahoga Valley National Park, Ohio. September 1988, Linhof 4x5 camera, 75mm lens, Kodak Ektachrome Daylight film.

PAGE 194, TOP (LEFT) Unnamed Entrance, Mammoth Cave National Park, Kentucky. Photo © by Marc Muench.

PAGE 194, BOTTOM (LEFT) Frozen Niagara, Mammoth Cave, Mammoth Cave National Park, Kentucky. June 2003, Linhof 4x5 camera, 210mm lens, Fujichrome Velvia film.

PAGES 194–95 Frozen Niagara, Mammoth Cave National Park, Kentucky. Photo © by Marc Muench.

PAGE 196 Thermal Springs Flowing over Tufa Terrace, Hot Springs National Park, Arkansas. Photo © by QT Luong/terragalleria.com.

PAGE 197 Thermal Springs Flowing over Tufa Terrace, Hot Springs National Park, Arkansas. Photo © by QT Luong/terragalleria.com.

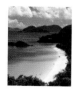

PAGE 198 Trunk Bay, St. John, Virgin Islands National Park, Virgin Islands. Photo © by Marc Muench.

PAGE 199, TOP (LEFT) Coral Reef, St. John, Virgin Islands National Park, Virgin Islands. Photo © by Marc Muench.

PAGE 199, TOP (RIGHT) Coral Reef, St. John, Virgin Islands National Park, Virgin Islands. Photo © by Marc Muench.

PAGE 199, BOTTOM Coral Reef, St. John, Virgin Islands National Park, Virgin Islands. Photo © by Marc Muench.

PAGE 200 Middle Key, Dry Tortugas National Park, Florida. Photo © by Marc Muench.

PAGE 201, TOP Elkhorn Coral, Biscayne National Park, Florida. Photo © by Marc Muench.

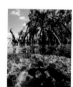

PAGE 201, BOTTOM Red Mangroves, Rubicon Keys, Biscayne National Park, Florida. Photo © by Marc Muench.

PAGE 202 Cypress Pond, Dawn, Everglades National Park, Florida. Sunrise with Pond Cypress. April 1988, Linhof 4x5 camera, 75mm lens, Kodak Ektachrome Daylight film.

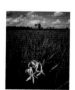

PAGE 203, TOP Swamp Lilies, Pinelands, Everglades National Park, Florida. May 1985, Linhof 4x5 camera, 75mm lens, Kodak Ektachrome film.

PAGE 203, BOTTOM (LEFT) Hardwood Swamp, Big Cypress Preserve, Everglades National Park, Florida. Deep Lake Strand. May 1985, Linhof 4x5 camera, Kodak Ektachrome film.

PAGE 203, BOTTOM (RIGHT) Barred Owl, Everglades National Park, Florida. May 1985, Leicaflex 35mm camera, 90mm lens, Kodak Ektachrome film.

PAGE 204 Congaree Swamp Forest along Weston Lake, Congaree National Park, South Carolina. October 1988, Linhof 4x5 camera, 75mm lens, Kodak Ektachrome Daylight film.

PAGE 205, TOP Bald Cypress along Cedar Creek, Congaree National Park, South Carolina. October 1988, Linhof 4x5 camera, 210mm lens, Kodak Ektachrome Daylight film.

PAGE 205, BOTTOM Autumn Morning, Weston Lake, Congaree National Park, South Carolina. October 1988, Linhof 4x5 camera, 75mm lens, Kodak Ektachrome Daylight film.

PAGES 206–7 Rainbow Falls in Fog, Great Smoky Mountains National Park, Tennessee/North Carolina. May 1994, Linhof 4x5 camera, 75mm lens, Fujichrome Velvia film.

PAGE 207 Yellow Trillium and Maidenhair Fern, Great Smoky Mountains National Park, Tennessee/North Carolina. May 2004, Canon 35mm camera, 28–135mm lens, Fujichrome Velvia 100F film.

PAGE 208, TOP Appalachian Trail, Great Smoky Mountains National Park, Tennessee/North Carolina. May 1984, Linhof 4x5 camera, 75mm lens, Kodak Ektachrome Daylight film.

PAGE 208, BOTTOM Laurel Blossoms along Little River, Great Smoky Mountains National Park, Tennessee/North Carolina. May 1992, Linhof 4x5 camera, 500mm lens, Fujichrome Velvia film.

PAGE 209 Ridges East from Clingmans Dome, Great Smoky Mountains National Park, Tennessee/North Carolina. May 2004, Canon 35mm camera, 28–135mm lens, Fujichrome Velvia 100F film.

PAGE 210, TOP Cades Cove Homestead, Great Smoky Mountains National Park, Tennessee/North Carolina. May 1994, Linhof 4x5 camera, 75mm lens, Fujichrome Velvia film.

PAGE 210, BOTTOM Autumn Forest, West Prong, Little Pigeon River, Great Smoky Mountains National Park, Tennessee/North Carolina. October 2004, Linhof 4x5 camera, Fujichrome Velvia film.

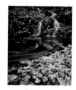

PAGE 211 Autumn Flow, West Prong, Little Pigeon River, Great Smoky Mountains National Park, Tennessee/North Carolina. October 1994, Linhof 4x5 camera, 75mm lens, Fujichrome Velvia film.

PAGES 212–13 Stony Man Mountain, Shenandoah Valley, Shenandoah National Park, Virginia. May 2004, Linhof 4x5 camera, 75mm lens, Fujichrome Velvia film.

PAGE 213 Forest Spring, Hawksbill Mountain, Shenandoah National Park, Virginia. May 1984, Linhof 4x5 camera, 360mm lens, Kodak Ektachrome Daylight film.

PAGE 214 Hemlock Forest and Lewis Falls, Shenandoah National Park, Virginia. May 1992, Linhof 4x5 camera, 75mm lens, Fujichrome Velvia film.

PAGE 215, TOP (LEFT) Appalachian Trail in Fog, Shenandoah National Park, Virginia. May 1992, Linhof 4x5 camera, 300mm lens, Fujichrome Velvia film.

PAGE 215, BOTTOM (LEFT) Mountain Laurel in Fog, Shenandoah National Park, Virginia. A viewpoint near Skyland. June 2001, Canon 35mm camera, 17–35mm lens, Fujichrome Velvia film.

PAGE 215, MIDDLE (RIGHT) Lichen on Boulder in Ferns, Lewis Falls Trail, Shenandoah National Park, Virginia. June 2001, Canon 35mm camera, 28–135mm lens, Fujichrome Velvia film.

PAGE 216 Autumn Forest, Bearfence Mountain, Shenandoah National Park, Virginia. October 2004, Linhof 4x5 camera, Fujichrome Velvia film.

PAGE 217 Sunset, Stony Man Mountain, Shenandoah National Park, Virginia. Shenandoah Valley view. May 2004, Linhof 4x5 camera, 75mm lens, Fujichrome Velvia film.

PAGE 218 Glacial Erratic, Bass Harbor Head Lighthouse, Acadia National Park, Maine. Evening. May 1986, Linhof 4x5 camera, 75mm lens, Kodak Ektachrome Daylight film.

PAGE 219, TOP (LEFT) Coastal Bog at Seawall, Acadia National Park, Maine. Spruce-lined coastal bog includes a beautiful trumpet pitcher plant, *Sarracenia*, in the center. May 1986, Linhof 4x5, 75mm lens, Kodak Ektachrome Daylight film.

PAGE 219, BOTTOM (LEFT) Otter Cove from Cadillac Mountain, Acadia National Park, Maine. October 1993, Linhof 4x5 camera, 75mm lens, Fujichrome Velvia film, CC05R red filter used.

PAGE 219, TOP (RIGHT) Atlantic Wave Action, Schooner Head, Acadia National Park, Maine. May 1986, Linhof 4x5 camera, 360mm lens, Kodak Ektachrome Daylight film.

PAGES 228–29 Crater Lake Sunrise, Crater Lake National Park, Oregon. Wizard Island and Mount Scott reflect in lake formed from ancient Mountain Mazama eruption. July 1994, Linhof 4x5 camera, 65mm lens, Fujichrome Velvia film.

PAGE 230 Blue Ice Interior, Pederson Glacier, Kenai Fjords National Park, Alaska. July 1992, Linhof 4x5 camera, 210mm lens, Fujichrome Velvia film.

PAGE 231 Petrified Wood Cross Section, Petrified Forest National Park, Arizona. Photographed inside Visitors Museum. 1986, Linhof 4x5 camera, 210mm lens, Kodak Ektachrome Daylight film.

PAGE 232 Century Plant Stalk, Sunset, Big Bend National Park, Texas. May 1978, Linhof 4x5 camera, 360mm lens, Kodak Ektachrome Daylight film.

JACKET, FRONT FLAP Autumn Morning, Weston Lake, Congaree National Park, South Carolina. October 1988, Linhof 4x5 camera, 75mm lens, Kodak Ektachrome Daylight film.

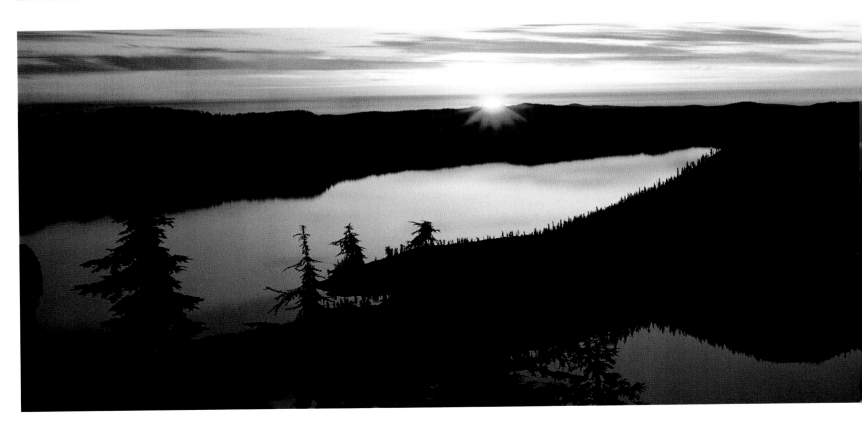

Acknowledgments

Many people in the National Park Service have been helpful over the course of the years we have each spent in our national parks. We are as grateful to them as we are to the land itself, to the wild places that have formed our idea of what is possible in life.

In the course of writing and photographing this book, there are some specific people to whom we owe thanks. I am especially grateful to Rick Potts, National Wilderness Program Manager for the NPS, who took time to read over the information on wilderness while in the middle of major park planning, and to NPS Chief Historian Dr. Dwight Pitcaithley. In Shenandoah National Park, Wilderness Educator Laura Buckheit and Steve Bair, Branch Chief, Backcountry Wilderness and Trails, spent several hours with us just talking about wilderness. It was a wonderful several hours. NPS International Cooperation Specialist Rudy D'Alessandro and Acting Chief of International Affairs Steve Morris spent time talking with me about International Heritage Sites, and Deputy Chief Scientist John Dennis provided me with good information about Biosphere Reserves. Amy Vanderbilt at Glacier National Park and Cheryl Matthews at Yellowstone, Shirley Chase at the Arthur Carhart National Wilderness Training Center in Missoula and Amy McNamara at the Greater Yellowstone Coalition in Bozeman were patient with my questions.

The public affairs officers with whom I spoke in various parks were all helpful. Their willingness to answer questions or to connect me with the people who could answer the questions contributes to my feeling that these are, indeed, our parks. Sometimes the questions were about difficult situations in the parks. No one has ever been unwilling to deal with the tough stuff. Among the tough stuff for me is the constantly changing acreage of the parks and wilderness within the parks. As various boundaries were revised, I've done my best to be accurate. I've used the official index of the National Park System, but by this printing, there will be differences.

—RR

For my initial photography on the new Petrified Forest National Park land additions, I am grateful to Park Superintendent Lee Baiza and Chief Ranger Gregg Caffey for their assistance. Museum Curator/Photographer Scott Williams served as a wonderful guide in photographing the new additions. My special thanks to ranger Mike Fitzgerald for his generous gift of time to guide us on his land at Petrified Forest, and to Elise Liguori of the National Parks Conservation Association for coordinating my Petrified Forest work.

—DM

Both of us owe (again) enormous thanks to editor Ellen Wheat for her inordinate sensitivity to the work—writing and photography—and to designer Betty Watson, for her gracious understanding of the intricate selection and designing of the photographic images for a subject as varied and complex as the National Parks of America. We are also most grateful for Betty's patience in working with the photographer. It is a privilege for us to work with people who truly care about our work and whose own work serves as so great a model for how to do things.

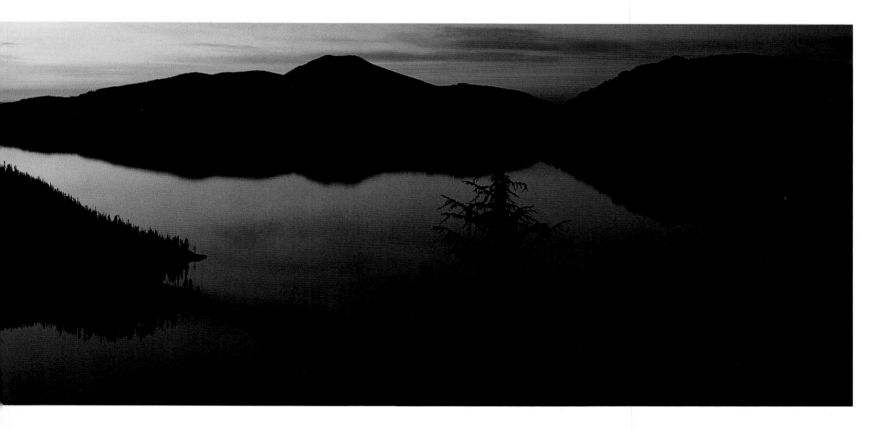

Sources

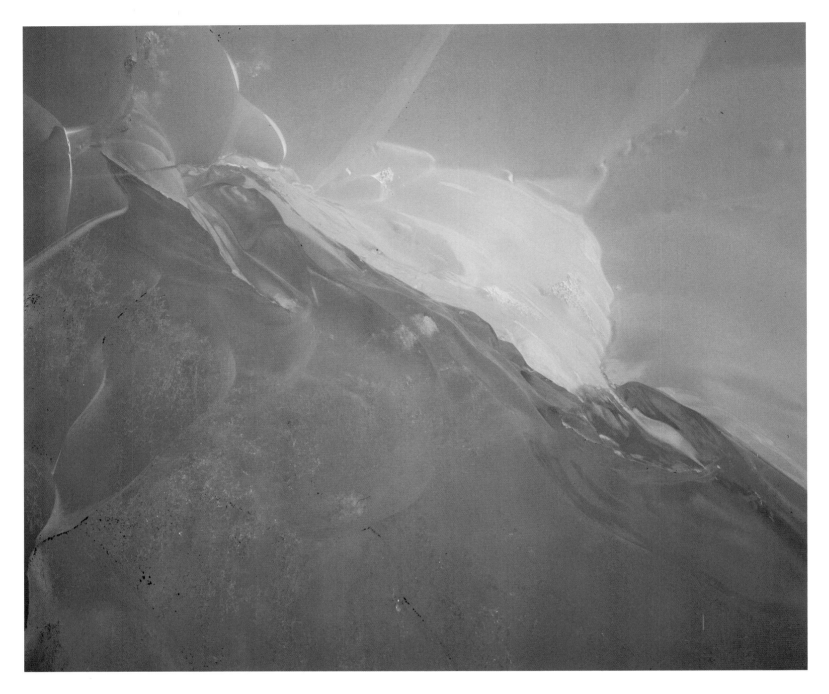

Berry, Thomas. *The Dream of the Earth*. San Francisco, CA: Sierra Club Books, 1988, 1990.

Cohen, Michael P. *A Garden of Bristlecones*. Las Vegas: University of Nevada Press, 1998.

Harris, Ann G., Esther Tuttle, and Sherwood D. Tuttle. *Geology of National Parks*. Dubuque, IA: Kendall/Hunt, 1997.

Huth, Hans. *Nature and the American*. Lincoln: University of Nebraska Press, 1990.

Lambert, Darwin. *The Earth-Man Story*. New York: Exposition Press, 1972.

Leopold, Aldo. *Sand County Almanac*. New York: Oxford University Press, 1949.

Lowry, William R. *The Capacity for Wonder*. Washington, D.C.: Brookings Institution Press, 1994.

Mech, L. David. *The Wolves of Isle Royale*. Washington, D.C.: U.S. Government Printing Office/National Park Service, 1966.

Miles, John C. *Guardians of the Parks*. Taylor & Francis Group/National Parks & Conservation Association, 1995.

Nash, Roderick Frazier. *Wilderness and the American Mind*. New Haven, CT: Yale University Press, 1967, 1973, 1982.

————. *The Rights of Nature*. Madison: University of Wisconsin Press, 1989.

Peattie, Donald Culross. *A Natural History of Western Trees*. Lincoln: University of Nebraska Press, 1950, 1953.

Rolston, Holmes, III. *Philosophy Gone Wild*. Amherst, NY: Prometheus Books, 1986.

Rudner, Ruth. *Off and Walking*. New York: Holt, Rinehart & Winston, 1977.

Sax, Joseph L. *Mountains Without Handrails*. Ann Arbor: University of Michigan Press, 1980.

Schullery, Paul. *Searching for Yellowstone*. Boston: Houghton Mifflin, 1997.

————. *Real Alaska*. Mechanicsburg, PA: Stackpole Books, 2001.

Sellars, Richard West. *Preserving Nature in the National Parks*. New Haven, CT: Yale University Press, 1997.

Stegner, Wallace. *The Sound of Mountain Water*. New York: Ballantine Books, 1946, 1969.

Tilden, Freeman. *The National Parks*. New York: Alfred A. Knopf, 1955.

Vale, Thomas R., and Geraldine R. Vale. *Walking with Muir Across Yosemite*. Madison: University of Wisconsin Press, 1998.

Graphic Arts Books, an imprint of
Graphic Arts Center Publishing Company
P.O. Box 10306, Portland, Oregon 97296-0306
503/226-2402; www.gacpc.com

President: Charles M. Hopkins
Associate Publisher: Douglas A. Pfeiffer
Editorial Staff: Timothy W. Frew, Jean Andrews,
Kathy Howard, Jean Bond-Slaughter
Production Staff: Richard L. Owsiany,
Heather Doornink
Designer: Elizabeth Watson
Editor: Ellen Wheat
Digital Pre-Press: Marc Muench, Tom Dietrich,
Haagen Printing
Printer: Haagen Printing
Binding: Lincoln & Allen Co.

Printed and bound in the United States
of America.

Library of Congress Cataloging-in-Publication
Data

Muench, David.
Our national parks / photography by David
Muench ; essay by Ruth Rudner.
p. cm.
Includes bibliographical references.
ISBN 1-55868-918-4 (hardbound)
1. National parks and reserves—United
States—Pictorial works. I. Rudner, Ruth.
II. Title.
E160.M937 2005
363.6'8'0973022—dc22

2005019200

ADDITIONAL PHOTO CAPTIONS:

Page 1 TETON REFLECTIONS,
Grand Teton National Park, Wyoming
Pages 2–3 MOONSET,
Grand Teton National Park, Wyoming
Page 4 CASCADE AND CLEMENTS MOUNTAIN,
Glacier National Park, Montana
Page 5 McKITTRICK CANYON, *Autumn,*
Guadalupe Mountains National Park, Texas
Pages 6–7 FAIRYLAND,
Bryce Canyon National Park, Utah
Page 8 TOROWEAP EAST,
Grand Canyon National Park, Arizona
Page 10 INDIAN HENRYS HUNTING GROUND,
Mount Rainier National Park, Washington
Page 11 CHOLLA AND SUNRISE,
Saguaro National Park (West Unit), Arizona
Pages 228–29 CRATER LAKE SUNRISE,
Crater Lake National Park, Oregon
Page 230 BLUE ICE INTERIOR, *Pederson Glacier,*
Kenai Fjords National Park, Alaska
Page 231 PETRIFIED WOOD CROSS SECTION,
Petrified Forest National Park, Arizona
Page 232 CENTURY PLANT STALK, *Sunset,*
Big Bend National Park, Texas

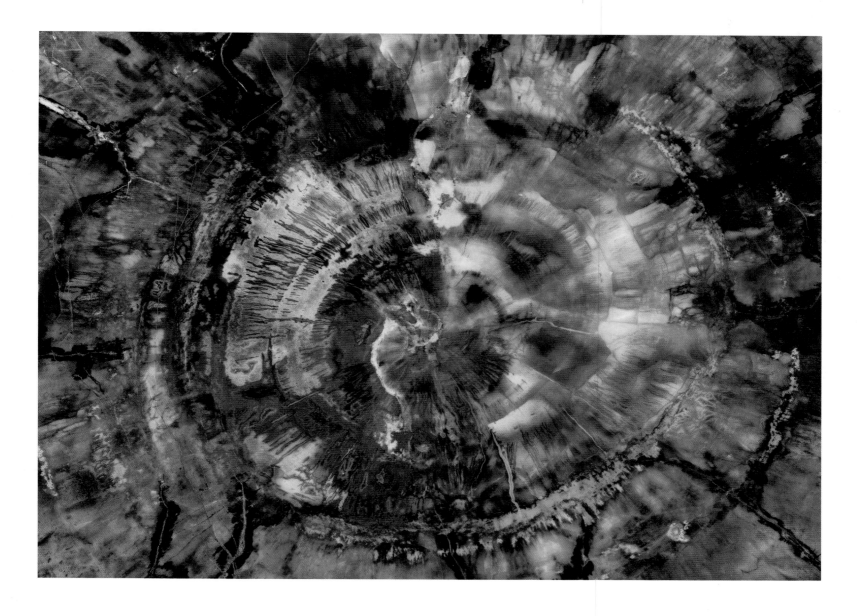